BIG BIG LOVE

a sourcebook on sex
for people of size
and those who love them

by Hanne Blank

greenery press

Published in the United States by Greenery Press, 1447 Park St., Emeryville, CA 94608.

http://www.bigbiglove.com

ISBN 1-890159-16-6

TABLE OF CONTENTS

ACKNOWLEDGMENTS

Despite the long hours spent alone at the keyboard, writing a book is not a solo endeavor. This one is certainly no exception, and there are many, many people who deserve gratitude for their assistance, time, interest, and support.

First and foremost, I'd like to thank all the people who spent time at their computers filling out the surveys from which I've quoted liberally throughout the book (survey statistics are found in Appendix A: The Survey), and the numerous other people who spent time on the phone with me or sitting in my office, letting me interview them about some of the most intimate parts of their lives. This book is infinitely richer for your input, thoughts, words, and voices. Your lives and libidos were a gift to me every time I sat down to work.

In no particular order, and for many different reasons, I would also like to thank the following people – a woefully incomplete list: Marilyn Wann, Shelley Bovey, Heather Corinna, Elizabeth Tamny, Heyoka, Kim Airs, Jim De Rogatis, the librarians at the Tufts Medical School, Brandeis University, and the Harvard Medical School Libraries, Daniel Pinkwater (for many reasons, but especially for the "Milo... the weiner is good..." scene in *The Afterlife Diet*), Hilary Nudell, Glenn Josephson, Debra Chwast, Lynn McAfee, David Pay and his marvellous family, Rivka Edelson, David Burbach, Jack Dietz, Sondra Solovay, Rhetta Wiley, M. Christian, Joani Blank, Amelia Copeland, Bill Brent, Barbara Altman Bruno, David Spelman, Rolly Hofstedt, Yohannon, Mary Wyninger, the denizens of the virtual community known as DownMOO, and, of course, all my lovers past and present... with gratitude for all the "field research."

My continued sanity, and much of what is good about this book, are owed in part to the delightful and talented Erin Karper, my intern at a critical stage of this project, and to Leah Strock, R.N., of Beth Israel

Hospital in New York City, the sexiest nurse any girl could hope to know. Thanks go as well to all the people who've written letters to my "Ask The Fat Broad" sex advice column and participated in my workshops and seminars, for teaching me and and keeping me helpfully unfocused. I am also grateful to Joël Barraquiel Tan, Elizabeth Tamny/*Gastrolater*, The Big Folks FAQ, Martha Koester and Marty Hale-Evans of SeaFATtle, and several anonymous correspondents for some of the words and thoughts that make up this book. Any errors or flaws, of course, are my own fault.

Most of all, however, my profoundest thanks go to my beloved partner, who has given so much, put up with so much (including my long work hours), and loved me so well throughout my work on this project. Blowing kisses of joy and thanks to the deities that have granted me the good fortune of entwining my life with eirs, it is to Malcolm Gin that I dedicate this book.

Hanne Blank
September, 1999
Boston, Massachusetts

Introduction:
A book about *what* and sex?

FAT, SEX, FACTS AND FALLACIES

If you go by what you see in the media or read in most porn and erotica, fat people simply cease to exist when it comes to sex. This might even seem logical, a reasonable extension of the notion that fat people aren't sexual and fat isn't sexy, until you stop to think about it.

The simple fact of the matter is that current (National Institutes of Health) estimates suggest that about 97 million Americans are considered fat. Notwithstanding the fact that that this covers everyone from the guy down the street with a bit of a beer belly to the very largest of our brothers and sisters, that's still an awful lot of fat folks. You simply can't look at a group of 97 million people and assume they're all sexless or celibate, no matter how disturbed you may personally be by the notion of any one of them doing the wild thing. When people insist automatically that fat people are not sexual, it's just a good example of just how far out of their way some people will go to avoid having to confront the truth. The invisibility of fat sexuality doesn't merely mean that we as a culture miss out on useful information and a point of solidarity, but it also means that we miss out on a crucial piece of reality.

Human beings are sexual creatures. Having a sex drive is part of being alive, and being fat doesn't change that. Where you have 97 million human beings, you have 97 million sets of genitalia, 97 million libidos, 97 million sexual fantasies (at least!), and 97 million bloodstreams with

sex hormones pumping through them twenty-four hours a day, seven days a week. Just imagine the sexual energy of 97 million orgasms! It's high time that the sexual lives of fat people and their partners around the world is reflected in the larger fabric of sexual information, education, lifestyles, literature, goods, services, and politics. The combination of fat people and sex isn't just a good idea, it's a flesh-and-blood reality.

Still, on the subject of fat, as with the subject of sex, we tend to accept what we hear and believe what we're told, not often being willing to take the social risk of calling volatile topics into question. Fat and sex, after all, are both issues that make almost all of us feel vulnerable. Both issues are infused with hefty doses of social and moral judgement, and all that baggage can make it very hard to say anything about fatness and sex that might run contrary to majority opinion, whether that majority is your particular family, the community in which you spend your time, or merely the amorphous presumed "majority" presented by the media.

As a result, most of what does get discussed where fatness is concerned simply repeats the larger cultural conversation of magazines and television, advertisements and newspaper articles about the latest weight loss fads, celebrity liposuction, scientific (or pseudoscientific) theories, or diet center ad "before and afters." Discussions about sex are somewhat more advanced and have somewhat more dependable content these days, thanks to the increased awareness of safer sex and sex information in much of the mainstream media, but even so we end up reading a lot of the same old things.

As far as fat and sexuality are concerned, if we're told anything at all, we're told this: fat and sex don't mix. The assumptions behind this "logic" make it seem temptingly tidy... but it's just not so. Fat and sex do mix, and mingle, bump and grind, sweat, wiggle, shout, and sigh with pleasure. The daily lives of millions of fat people and their partners prove it. The assumption that fat people aren't sexual people must be dealt with.

In dismantling the so-called "logic" that leads so many people to believe that fat and sex just don't mix, we scratch the surface of a lot of the major themes of this book. To arrive at this conclusion, we have to start with what people think about fat and sex individually. Culturally, we're taught to believe that sexual activity happens as a result of sexual desire. Sexual desire, in turn, happens as a result of beauty, sexiness, sex appeal, love, and so forth.

Fat, on the other hand, is seen as being ugly, undesirable, unlovable, and possibly even an illness. Those who see it otherwise are in the

minority. And so it follows rather neatly in many people's worldviews that fat people rarely, if ever, have sex lives. If a fat person does have a sex life, or a good romantic life, people tend to think of it as the exception to the rule, a fluke... and they certainly don't want to know about it. The thought of those blubbery bodies engaged in amorous activity, some people seem to think, is almost enough to have any normal, thin person reaching for an air sickness bag. After all, as everybody knows, fat is disgusting, and fat people are never, ever beautiful or desirable...

...Or are they?

The truth of the matter is that fatter bodies, and fat people, are attractive, desirable, and beautiful, and there are plenty of people of all sizes who agree. Human beings come in an enormous range of sizes, shapes, colors, and configurations. Generally speaking, no matter what your size, shape, color, or dimensions, there's someone out there who will be attracted to your particular combination of physical attributes.

Few people are attracted to one body type and one body type only. Most people are attracted to a range of body types, some thinner, some fatter, some taller, some shorter, some curvier, some lankier. Just as the famous Kinsey Scale (below) has levels for six different levels of sexual orientation based on the sex of the preferred partner, from exclusively heterosexual through exclusively homosexual, different people have different preferences in terms of body types.

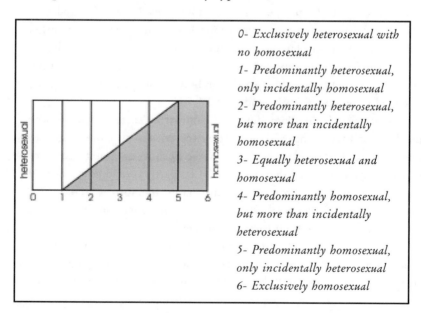

0- *Exclusively heterosexual with no homosexual*

1- *Predominantly heterosexual, only incidentally homosexual*

2- *Predominantly heterosexual, but more than incidentally homosexual*

3- *Equally heterosexual and homosexual*

4- *Predominantly homosexual, but more than incidentally heterosexual*

5- *Predominantly homosexual, only incidentally heterosexual*

6- *Exclusively homosexual*

Just as "exclusively heterosexual" is still sometimes believed by the ignorant and intolerant to be the only "normal" kind of sexuality, it is often also considered "normal," at least at this point in history, to express attraction only to body sizes/shapes which fall into a fairly narrow, and thin, range of body types. But just as we know that there are, indeed, people whose sexual orientation and sex lives are both healthy, functional, and non-heterosexual, there are also healthy, functional, normal folks whose preferences in terms of their partners' bodies don't match up either partly or entirely with the so-called "norm."

If we concede that Kinsey was on to something with the notion that there are at least six degrees of relative homo- and heterosexuality, we can extrapolate that there are probably at least as many (and probably many more) degrees of possible preference in terms of a partner's body size, weight, or shape. In fact, we could probably rework the Kinsey Scale to reflect sexual orientation or partner preference in terms of preferred body size and weight.

Let's call it the "Plumpdex." To the far left of the Plumpdex, we'd have those people whose range of attraction excludes people with any visible body fat whatsoever. To the far right of the Plumpdex, where we would otherwise find the "Kinsey 6" homosexuals – i.e., people who have no attraction to anyone who is not of their own sex – we would find "Plumpdex 6" fat admirers, people who are and have always been exclusively attracted to fat partners. At the "Plumpdex 2" and "Plumpdex 4" points would be people who were somewhat attracted toward the other end of the spectrum, but not in a 50/50 proportion. A "Plumpdex 3" person would be a person who was equally attracted to fat and non-fat potential partners, analogous to the archetypal bisexual who is equally attracted to people of both genders.

If it existed, the Plumpdex would show that there are people who like their partners to have some meat on the bone, a bit more bounce to the ounce, and some extra cushion for the pushin'. It would also show that the degree to which they are fond of fat partners, and how much fat they're fond of, varies from person to person. In short, it would show that sexual preferences for body types exist on a spectrum in the same way as the preference for a partner's gender.

We don't have to have a Plumpdex to prove that there have always been people who are fat to some degree or other, whether voluptuous, stocky, pleasingly plump, Rubenesque, or just plain big and beautiful. We

don't need it to prove that there have always been people who have found fat bodies beautiful and worthy of admiration. Statues and paintings from many eras survive to tell us that bigger bodies have always been loved and revered enough for people to be drawn to sculpt, paint, draw, and monumentalize them. Uncounted artists, from the unknown prehistoric sculptors who made innumerable fat Venus figurines (like the famous Venus of Willendorf) to Titian, Rubens, and Renoir, all the way up to twentieth-century masters like Lucien Freud, Tamara de Lempicka, and Fernando Botero, have brushed and caressed the forms, folds, curves, and contours of big bodies into the historical record of art. Looking at the visual record alone, it seems self-evident that there have always been fat people around... and even more self-evident that there have always been people around who felt that those fat people were well worth looking at.

This is true even today, in our presently thin-obsessed culture. No matter how skinny fashion models have become since the 1950's, there are indeed people out there who mean it when they say that "Thin may be in, but fat is where it's at!" There are fat people out there in a variety of sizes, body sizes, shapes, genders, sexual preferences, ages, ethnicities, and religions who, even as you read these words, are having wonderful, exciting sex lives, desiring and being desired, loving and being loved, making love and being made love to.

And yet, in much the same way that the sexualities of gay, lesbian, bisexual, and transsexual (GLBT) people have often been publicly invisible because people didn't want to have to admit that they existed, the sexuality of fat people has also been mostly invisible. Like GLBT sexuality, and for many similar reasons, sex involving fat people is often seen by the intolerant and narrow-minded as being disgusting, possibly unnatural, and probably immoral. Many people are uncomfortable with the idea that fat people are sexual beings at all, much less that they are desirable, lusted after, and loved for who and what they are. Fat sex has long been the subject of cruel, crass jokes and bigoted and hateful journalism. Stereotypes around fat and sexuality have even been used as the lamest sort of excuses for physical and sexual assaults, harassment, and even medical malpractice.

Like GLBT people, fat people and people who prefer fat partners come from all backgrounds and all genders. Furthermore, fat sexuality includes people of *all* sexual orientations. Those among us whose sexual-

ity has something to do with fat have only two things in common: we're fat (or think we are) or are partners of people of size, first of all. Second, our sex lives are for the most part either completely ignored, or else made the butt of jokes. Every last one of us knows what it feels like to be forcibly desexualized in the eyes of a culture in which the phrase "fat and sex" most often elicits nervous, perhaps horrified, laughter — as if the combination were simply unimaginable.

What does it mean to have your sexuality be invisible unless it's being made an object of ridicule? For starters, it means that you often can't find good information about sexuality that pertains to your specific situation. It often means that you can't even ask, for fear of being laughed at. Where do you go to find information on sexual positions that are comfortable for lovers who have big bellies? Who do you ask if you want to know where or even whether you can buy a frilly garter belt in a size 26, since you know you've never seen anything that size in the Victoria's Secret catalogue? Where do you turn when an old standby like *The Joy of Sex* not only tells you you're going to be impotent if you're fat, but ominously intones "If you are grossly overweight, set about losing it, whether you value your sex life or only your life. That applies to both sexes." What recourse do you have when even hip, forward-thinking popular sex advisors like Dan Savage and the widely-aired *Loveline* radio show basically have nothing good, let alone useful, to say about fat people who have sex? Who's going to give you the real lowdown on questions like "can it crush me if I let my 300-pound girlfriend get on top?" or "Is it true that fat men have fat penises?" Where, in other words, is the 55% of the American population which is estimated to be "overweight" supposed to go to get sex information that actually pertains to them and their issues?

Generally, there has never been any place a person of any size *could* take these kinds of questions. Even now, you'll probably never see them answered in the sex advice columns in *Cosmopolitan* or *Playboy*, the same way that you'll probably never see a sexy, self-confident fat woman in lingerie posing for the cover or centerfold of either one. Of course, you're also likely to go through life without ever seeing a happy fat couple celebrating their fiftieth wedding anniversary in a television ad for Viagra, either, and you'll probably never witness a beefcake calendar featuring John Goodman, Drew Carrey, and similarly hunky chunky stars strutting their stuff in skimpy little swimsuits. *[Author's note: I'll be more*

*than happy to be proven wrong on either or both counts and would be happy
to entertain offers to direct any such projects.]*

That's the nature of the void into which this book has been born.

It's really pretty simple. Fatness isn't an issue that only affects an
exotic few, after all, and neither is sexuality. You may or may not be fat
now. You might or might not have been fat to some degree or another
during your lifetime. You may or may not have ever experienced a sexual
or romantic attraction to a person who was chubby, round, or fat. It
doesn't really matter if you have or not — you might. Chances are good
that you know someone who is fat. You probably know at least one per-
son who has dated, loved, or married someone who is larger than the
putative "norm." Someday you could fall for some gorgeous, well-pad-
ded individual, or, if you haven't had the good fortune already, you could
become a gorgeous, well-padded individual yourself. You just never know
where you might end up.

We are all affected in very real and significant ways by issues of
sexuality, body size, and body image. In our current culture, body size
and body fat are so heavily demonized that many thin people go through
just as much struggle with their own bodies and feelings of desirability
as fat people do. People of all sizes – from the proverbial seventy-eight
pound weakling right on up to the biggest among us – often end up go-
ing through a great deal of confusion, frustration, pain, guilt, and unhap-
piness in their sex lives simply because they've been conditioned to be-
lieve that their bodies are unacceptable, unsexy, and undesirable the way
they are. The fear that they'll be irretrievably unacceptable if they are
even a tiny bit fat is one of the chief causes of eating disorders, particu-
larly among women and girls. To acknowledge that bodies can be attrac-
tive, loveable, sexual, and sexy in a vast range of sizes and shapes is to
pave the way for better and happier lives – not just sex lives – for every-
one, no matter what their size, shape, or weight.

It is true that not all bodies are attractive to all people. It's a
simple fact of life: you don't think that everyone you see is desirable.
Logically enough, not everyone who sees you will find you desirable,
either, and that's just as true whether you're a Brad Pitt or a Joe Sixpack.

Some people have a narrow notion of what they find attractive, while
for others, the range of qualities they might find desirable is quite large.
Just as some people are born with a propensity to be tall and lanky and
some other people have a tendency to find those tall, lanky bodies ex-
tremely sexy, there are people whose bodies have a propensity to be

chubby, voluptuous, or just plain fat and there are people for whom such size and weight is the sexiest thing around. Some people would find both of those body types attractive, and some people wouldn't find either of them to be of much interest at all.

It bears repeating that people become attracted to one another for many reasons, tangible and intangible. To some, appearance-related factors don't matter much, and to others they do. Still, it's just as specious to claim, as often happens, that a person who gets into a relationship with a fat person does so "in spite of" that person's weight as it would be to insist that someone is in a relationship with a thin person purely because that person was thin. For some people, a fat partner's body is just part of the package: they find the *person* attractive, and their partner's body is desirable because it's part of who that person is. For other people, fatter bodies are genuinely much more attractive, much more beautiful, and much more desirable than thinner ones in general. People for whom this is strongly the case, often called "Fat Admirers" or "FAs," will usually seek out fatter partners over thinner ones whenever the choice presents itself.

It's both useful and humane to be able to see a wide variety of sexual attractions and preferences as valid attractions. All of us, at one point or another, have experienced a moment of astonishment when someone expressed an attraction we simply didn't share. That "what on earth could possibly be sexy about that person?" feeling dissipates a lot more quickly if you just remind yourself that, like they say, it takes all kinds – and that at some point, someone has probably wondered the very same thing about one of your crushes too. Accepting the reality that fat bodies can be sexy, that there are people of all types who *are* attracted to fat bodies, and that body size, shape, and weight are no barriers to a happy, healthy, delightful sex life is just another part of embracing the variety of the human experience.

People often wonder just what it is that people find attractive about fatter partners. It's a good indicator of just how deeply ingrained our biases really *are* that this question comes not just from thin people, but also from many fat people who actually have fabulous partners and wonderful sex lives – folks who might be expected to have some inkling of what their partners find so desirable. It's a little sad that sometimes they don't, despite their partners' attempts to explain to them why they desire, love, and want them. Our culture makes fat such an overarching evil

that any other positive qualities a person of size might have often feel as if they don't even count.

People who prefer partners of size usually are attracted to the same sorts of things that people who prefer thinner partners like: good looks, intelligence, style, a sense of humor, and most of all, self-confidence. In the numerous surveys and interviews of fat people, self-defined FAs, and partners of fat people that have been conducted for this book (see Appendix A – The Survey), the single thing that people most often described as being sexy was nothing more or less than simple confidence, an attribute which truly knows no size. Echoing the opinions of many respondents, one young woman wrote that "If someone is confident of themselves, then I think they are attractive. The people I find attractive are usually the people that it's obvious are okay with who they are. If they are fat and confident it is even more beautiful because they've overcome society pushing them down." Sophie, a 29 year old bisexual woman, wrote that she tends to feel that larger people are attractive because "they're not struggling to conform to society's standards – willing to be an independent thinker; they're not afraid to take up space... not afraid to draw attention to themselves." Another respondent said that in terms of an "ideal" partner, "[The] physical isn't really a question. The personality says it all for me. The eyes have to be sparkly and honest. That's the only real physical attribute I am drawn to."

Self-confidence and a sense of self-worth are undeniably sexy, as are intelligence, a good sense of humor, kindness and courtesy, honesty, and a sense of fun. The qualities that people seek in fatter partners are, in other words, no different than the ones that are sought in thinner partners. They just prefer to find them in a partner of size instead of someone who more closely fits the media-thin ideal.

The reasons for any sexual attraction are notoriously difficult to pin down. It's a little like talking about art or music – an art historian or a musicologist can tell you a lot of things about a Michelangelo sculpture or a Beethoven symphony, but explaining exactly what makes something beautiful isn't one of the things you can do in words. When we talk about sexual attraction, all arguments ultimately boil down to "I like it because I like it," a purely libidinal assertion of pleasure that really doesn't allow analysis. It is possible, though, to talk in general terms about the attributes and characteristics people find desirable in fatter partners.

A lot of people who are attracted specifically to fatter partners talk about things like softness, the sense of luxury, and the voluptuous sensuality of fatter bodies. Sam, a gay man, writes that he is attracted to fatter partners because they are "soft to squeeze... warm. I love being under all that soft skin in the winter." Another woman who is both fat and likes fatter partners wrote that she finds fat partners attractive because "Fat people are soft. You don't get poked by a collarbone or elbow, and they feel cushy and luxurious. It's like one of those 6-way adjustable power seats in a Cadillac versus the one-size-fits-all, hard-as-wire-hangers seats in a Toyota Tercel. As a bonus, you don't have to spend lots of hours discussing how you're trying to lose weight or what you weighed in high school, what size dress/pants/whatever you wear, why you look awful in a bathing suit, or why you think so-and-so is fat."

Because fat can enhance the size, shape, and appearance of certain body parts like women's breasts or men's potbellies, some people find fat people more appealingly masculine or feminine than their thinner counterparts. A man who identified himself as "Scandinavian FA" wrote that in his eyes, "Thin women look like boys. And if I wanted to be with boys, I'd be with boys." He also points out that there are specific body parts that he finds especially attractive, such as a "soft, fat back (some fat women don't have it, to my disappointment!), two big fat-rolls in the belly, big butts, breasts which are big enough to produce the famous Liz Taylor Effect, moderate double chins. And the tiny bulge of fat visible on the "upside" of the foot when a fat woman wears high heels – very sexy!" Clearly, just as people who prefer thinner partners might have a preference for a bubble butt, a thick beard, breasts of a given size, or long legs, fat admirers can have analogous preferences. Just being fat is no guarantee that a given fat admirer will find a person attractive, just as there's no guarantee that a thin person will be found attractive just because he or she is thin.

Although it sometimes seems as if fat women get the lion's share of the erotic attention in the fat-admiring world, fat men's bodies can also be objects of profound desire. There is a large and well-developed subculture of gay men who are specifically attracted to men of size. In describing his ideal partner from a physical standpoint, one 26 year old gay man writes that he fantasizes a man "taller than me... bull neck, barrel chest, firm, round belly, round, wide, meaty behind. Think Russian superheavyweight Olympic weightlifters. That shape has just always been my ideal." Mike G. writes that "my very first sexual feelings were toward

a friend of my father's who had a massive belly. I wanted to be with him and be like him. I still melt when I see a man with a huge drooping belly." From the female point of view, writer Suzeanne Peak, who happily identifies herself as a victim of "teddy lust," speaks for a large number of women with a preference for big, heavy, round men: "John Belushi. God, take me now. Yum. Then there was Dom DeLouise. Homina! Teddy. I love teddies, and he was a hunk. John Goodman still makes my knees weak."

The pronounced round shapes of fat bodies can be very exciting to fat admirers. Some people who like fat partners are attracted to pronounced bellies, others to those who are "pear shaped" or "bottom heavy," and still others have a strong preference for women with the classic large-breasted, wide-hipped hourglass figure, proportionately enlarged to the woman's overall size. People who are attracted to fat men may have a yen for a man with particularly thick thighs and calves, a big beer belly, or the famed "he-boobies," a pet name for male breasts enlarged by extra body fat. These body type preferences, along with more typical types of preferences in terms of hair color, facial hair, height, and age, appear in personal ads targeted at people of size the same way that things like "athletic," "busty," "long legs," and "petite" show up in personal ads targeted at a slimmer population.

The reasons people may be attracted to larger bodies are as many and varied as the people themselves. No one can say for sure why or how someone develops an attraction to fatter partners, any more than we can say for sure why or how someone develops any other specific sexual interest. All we know for sure is that they definitely do! Like other groups of people with special interests, the group of people who can loosely be called the "fat community" or the "size acceptance" community – fat people, their allies, and the people who love fat people – have developed their own jargon and terminology. These terms will be used frequently throughout this book. You've already encountered several, like "fat admirer."

One of the things you've probably already noticed is that this book freely uses the word "fat." There are a lot of good reasons to use the word "fat" where appropriate, rather than relying on euphemisms like "plump," "chubby," "rotund," "overweight," "heavy," or "large," or the medical term "obese."

"Fat" is a perfectly serviceable Anglo-Saxon monosyllable, although, like other perfectly serviceable Anglo-Saxon monosyllables, it's garnered

a reputation far worse than it deserves. "Fat" indicates a specific physical substance, or the condition of having that substance in or on something or someone. You can also indicate metaphorical fat, such as a "fat bank-roll," a "big fat kiss," to suggest the proportions of some big, lavish, grand thing.

Euphemisms aren't always accurate, though they can come in handy for variety's sake. Fat people aren't always "large" or "statuesque," they may or may not be "pudgy" or "stout" or "roly-poly." A fat person might be "Rubenesque," but they might just as easily not look at all like a Rubens model. Fat people can be fat in many different ways and still all be fat. "Fat" isn't too different from adjectives like "bald," "short," "green," "heterosexual," "left-handed," or "red-haired." It's just one of the things people are. There's no reason not to call 'em like you see 'em if you do so with honesty and without malice.

Secondly, using the word "fat" correctly, especially when you are a fat person, is a political gesture. In the same way that homosexual, bi-sexual, and transgendered people have reclaimed words like "queer," "fag," "dyke," "tranny," and "gay," fat people and those who love them can re-claim the word "fat" by using it in an accurate, non-judgemental context. When "fat" stops meaning "ugly" or "stupid" or "lazy" and just means "fat," it loses a lot of its power as a weapon. When any derogatory term can no longer be used as a bludgeon, or at least can't be used as easily, the people against whom it was once used as a weapon gain in strength and dignity. Don't be afraid to use the "f-word." It can even be used in polite conversation: there's nothing at all wrong with saying things like "Wow, what a sexy fat woman!" or "Boy, I really would like to spend some qual-ity time with that foxy fat lad over by the bar."

Other terminology used throughout this book is a little less emotionally and socially charged. The following list of terms are terms you'll come across at various points in the book, and is offered here for reference purposes. Generally speaking, these terms will be defined in context when they are used as well.

FA or Fat Admirer	Generally speaking, anyone who prefers fat partners, regardless of the degree. In prac-tice, however, this often refers specifically to heterosexual men who prefer their women partners to be fat and who identify their sexual preference this way, as "FA,"

the same way a gay man might identify himself as being gay.

FFA or Female Fat Admirer The heterosexual female equivalent of FA, although it can also be used to indicate any woman of any sexual orientation who likes fatter partners.

BBW or Big Beautiful Woman An often-used euphemism that indicates an attractive fat woman. Because the word "fat" is so often used as an insult, this is a way for big women to claim their size *and* their attractiveness without using the problematic word "fat."

BHM or Big Handsome Man The male equivalent of BBW, not as widely used.

Bear Almost always a gay man of husky/muscular/large-framed build and with a good deal of body/facial hair, who may or may not also be fat. The variant "teddy bear," however, can be used to refer to any man with this type of build, whether he is gay or not.

Chub Chub or chubby are used to refer to fat gay men who do not fit the Bear type. Generally, Chubs have less facial/body hair, and are more likely to be genuinely fat rather than simply husky or large in frame.

Chubby Chaser or Chaser A gay male Fat Admirer specifically, but this term is also used to refer to anyone who "chases" bigger partners, be they gay or straight, male or female.

Gainer Someone who gains weight intentionally, whether for reasons of sexual attractiveness or otherwise.

Feedee Someone who gains weight intentionally, but at a partner's request. Feedees may or may not also be gainers, who would gain weight intentionally without a partner requesting or requiring them to.

Encourager	A person, not interested in gaining weight him/herself, who encourages a partner who wants to gain weight intentionally to do so and may help him or her to do it.
Feeder	A person who requests or requires a partner to gain weight, usually for his/her own sexual gratification. Feeders often also help their partners gain weight in various ways.
Midsized	A somewhat vague term used generally to indicate people who are fat but who weigh less than approximately 300 pounds.
Supersized	A likewise somewhat vague term used generally to indicate people who are fat but who weigh more than about 300 pounds.

Myth Information vs. The Fat Facts

It's probably a symptom of our sexual immaturity as a culture, but sexuality as a public topic nearly always seems to elicit boorishness and generally bad behavior. Despite the fact that no one is really immune to the sting of sexual humiliation (and perhaps because of it) any source of sexual or personal difference ends up being grist for the stereotype and mockery mill. The more stigmatized the difference or the group of people who are the target, the worse the treatment. Since fatness is held in deeper disdain than almost any other sort of physical difference, fat people's sexuality is all too often considered aberrant, disgusting, or just a very crass joke.

Unfortunately, the myths around fat and sex don't just stay in the realm of locker room humor and jokes the guys tell at the bar. Assumptions, presumptions, projections, and outright lies form the preponderance of what most people think they know about fat people and sex, to the point where even those we assume to be in a position to know better (doctors, psychologists, sex columnists) fall back on the hoary old myths.

For instance, in the 1972 edition of *The Joy Of Sex*, one of the "bibles" of the sexual revolution, "obesity" was listed in the "Problems" section, with the implications that fatness is always a problem for people's sex lives, that fatness directly causes impotence (it doesn't), and that only thin people really had any business having sex. Here's some of what author Alex Comfort had to say about fat people and sex:

> *"Fatness in our culture is unlovely. We know someone whose pretty, fat daughter can only get Middle Eastern boyfriends because of this norm. Renoir's women, who, when naked, look ideal for sex, would look a little too plump if clothed.*
>
> *"What isn't realized is that in men overweight is a physical cause of impotence. If neither this nor the esthetics of it bother you, you may still have to circumvent it. King Edward VII of Britain ('Tum-Tum') had a special couch resembling a gynecological table made to enable him to get on target. Most stout men can manage with the woman astride, backing or facing. If this doesn't work, try lying face-up over the edge of the bed, feet on the floor, while she stands astride. An over-heavy man is a bad problem – Cleopatra could say, "O happy horse, to bear the weight of Anthony," but he didn't weigh 200 pounds. If you are grossly overweight, set about losing it, whether you value your sex life or only your life. That applies to both sexes. Modern girls, though supple, tend to be underweight by the sexual standards of the past, especially for rear-entry positions and for making love on a firm surface."*

One wonders how Comfort could've been so sanguine about knowing a long-dead Roman's weight... but more than that, one wonders if he'd ever actually had sex with a fat person, or spoken to any about their sex lives. If the most pertinent examples he could come up with were Renoir paintings (beautiful, but they're paintings, not flesh-and-blood people), a long-dead British ruler (who was in any case a well-known lover of fat in all its guises who would sometimes weigh his guests before and after meals), and a Shakespeare play (the speech from which Comfort draws his lines, incidentally, has nothing to do with fatness), he wasn't trying very hard. It wouldn't be too surprising if he didn't try at all, if this section had been something of an afterthought.

But nonetheless, there it was in *The Joy Of Sex*. As a result, this sort of thing has loomed large as an authoritative statement about sex and fat in the minds of an awful lot of people for an awfully long time. It jibes with the "received wisdom" we get about fat people, and therefore few people question it. Doubtless this is why it's been perpetuated in a lot of other sex-advice books and columns. Even well-read, intelligent, thinking folks who question the other received wisdom that has a role to play in their lives tend to buy into opinion and aesthetic judgement when it comes dressed up as fact and fits in with the stereotypes which inform their lives. After all, there are still a lot of people who believe that all Black men have enormous penises (nope), that all Asian men have tiny ones (nope again), that Frenchmen are uniformly impeccably wonderful lovers (sorry, no), that bisexuals are just confused (wrong), and that gay men like sticking live rodents into their rectums (not even kinda). If a prevailing cultural prejudice makes it convenient to put a sexual stereotype on any discriminated-against minority, you can bet it'll have its adherents. The more widespread the discrimination, and the more acceptable that discrimination within the culture, the broader the sexual misinformation and mythology will reach. But stereotypes can be lessened or eradicated, given time, effort, and education.

Unfortunately, we still live in a world where it's still entirely acceptable to say "Oh, all fat women are desperate," "People who are fat are hiding from their sexuality," or "Fat girls love to give head because they're obviously orally fixated." As a result, not too surprisingly, many people behave accordingly, methodically denigrating fat people's sexual integrity, desirability, and worth every step of the way. Sometimes, the people who do this are fat themselves. They say that "homophobia begins at home," and the same is true of anti-fat prejudice: fat people are taught, and taught very well, to internalize negative stereotypes about fat people. Members of minority groups are not immune from having to overcome their own internalized stereotyping, or from harming themselves or other fellow members of that minority when they don't do so.

In this section, we go head to head with some of the biggest fattest lies about fat people's sexuality. The sexual denigration and/or disenfranchisement of any group of people is an injustice and a denial of the birthright that each of us has, as a human animal, to be happily, healthily, and pleasurably sexual. Read on, and learn the reality behind the stereotypes – what you find out may well surprise you.

Fat is universally ugly. No one thinks fat people are sexually attractive.

In a word: bullshit.

Not only are there plenty of people nowadays who find fat people attractive, there always have been. Plenty of wonderful artworks, from the fat fertility goddess statuettes of prehistory to the paintings of artists like Titian, Rubens, Renoir, Cassatt, and the great contemporary painter Botero stand as testament to the fact that not only do some people like to look at fat bodies, some people like them well enough to keep their images around just because they're beautiful. From Lillian "Diamond Lil" Russell to Jessye Norman, Sophie Tucker to Roseanne Barr, and not forgetting the likes of Kate Smith, Camryn Manheim, "Mama" Cass Elliot, Carnie Wilson, Kathy Bates, Wendy Jo Sperber, Anna Nicole Smith, Missy "Misdemeanor" Elliott, Bessie Smith, and Martha Wash, there have always been sexy fat women in the world of entertainment whose abundant bodies have helped keep the fans entranced. And fat men – many of them comic geniuses like John Belushi, John Candy, Dom De Louise, and Oliver Hardy (of Laurel and Hardy fame), but also including other luminaries like Luciano Pavarotti, Orson Welles, Drew Carey, Brian Dennehy, and John Goodman – have been no slouches at garnering acclaim and interest, both professional and otherwise.

By and large, the notion of fat being "automatically" sexually revolting is a conceit developed by and most prominent in first-world, white, Christian culture. In other cultures, fatness is not regarded in the same ways. Recent research has shown that in many far-flung cultures that are traditionally fat-positive – Fiji was a recent case in point – an obsessive preoccupation with thinness and corresponding increases in the occurrence of eating disorders like bulimia and anorexia come along with the introduction of Western culture, particularly television.

In many cultures, the most traditionally desirable body types are those which are considerably plumper than would be considered conventionally sexy in North America. In these cultures – and within many minority cultural groups in North America as well, most notably much of the African-American and Latino communities – fatter people are much more often expected to be fully participatory sexual beings. Fat American women traveling in the Middle East, Africa, parts of Latin and South America, the Pacific Islands and Micronesia, and other locales often report their surprise when they are treated as sex objects in the same way

that thin, big-busted California-tan blondes generally are at home. Fat men often find greater social and sexual acceptance in other cultural settings, too.

Not so long ago, a degree of fatness was a status symbol. In some cultures it still is. Being fat, after all, means you have enough to eat, and that you probably don't have to do backbreaking physical labor to survive. But times change, and in a culture where very few people have to do physical labor much of the time, it becomes a valued commodity to have time to go and do physical exercise as a form of leisure activity. Historically, as it's become easier for most Westerners to lead fairly comfortable and well-nourished lives with a minimum of hard labor involved in the processes of daily life, it's gotten easier to get fat. Not too surprisingly, it's become less socially and culturally valuable to be so.

Regardless of whether fat is presently fashionable, there are and have always been some people who simply are attracted to fatter bodies. There are countless more who have the potential to be attracted to fatter bodies but who don't necessarily count fatness in the abstract as a specific turn-on. There's no more rhyme or reason to this than there is to any other physical attraction. Some people think fat people are hot. That's just the way it is.

When we see someone, we evaluate their weight and size in the same way that we evaluate height, bone structure, hair color, the size or ratio of certain parts of the body, musculature, face shape, and numerous other factors. Depending on our tastes, we might think that what we see is attractive, repugnant, or nothing special. Just as there are "leg men" and "breast men," women who like men with cleft chins and women who like men with big hands, people who like redheads or goatees or big nipples or bubble butts, there are people who find fatter, plumper, rounder bodies attractive.

Most people are capable of finding a range of body types and shapes attractive. This is an advantage, since human beings are so varied. Most people find that there are limits to the range of things that they find attractive – but where these limits fall depends on the individual. Some people's range of attraction excludes fatter bodies. But some people's range of attraction excludes thin bodies. Yes, Virginia, there are actually people in the world who will turn down an advance made by a thin person because they just don't happen to find thinness at all sexually interesting. One self-identified fat admirer writes: "Sometimes, if a woman is

too thin, I fear beforehand that I will have difficulties with erection. So to prevent a mutual disappointment, I may refuse."

And of course, there are a great many people – probably the majority – who are attracted to people for a combination of different factors, and for whom the "intangibles" like intelligence, sense of humor, compassion, political and religious views, supportiveness, and so on are actually just as important as anything physical, if not sometimes more so. Deke Hammel, the owner of *Generous.net*, a size-accepting website that has an extensive online personals board for people of size and those who love them, is an ardent supporter of big people's sexuality, but as he says of himself: "To be honest, I'm not a fat-admirer. I'm a smile fetishist. Both of my wives had smiles that measured in the hundreds of watts. And my second wife wasn't just slender, she was downright skinny. Like sleeping with a bicycle. But if sex is the only reason you're getting married, I don't think the marriage has any chance of surviving."

It's very common for people to become attracted to one another in a nonsexual way first, and to have the sexual side of things develop out of that emotional attachment. This happens with thin people, fat people, old people, young people, differently-abled people, able-bodied people, and everyone in between. Sometimes people think of this negatively, as "Oh, my partner loves me in spite of my size," but the fact of the matter is that there are people of all sizes who are in wonderful, loving, sexy, fulfilling relationships that are not predicated on intense gut-wrenching sexual attraction to physical characteristics. In other words, it's not "in spite of your size," it's "because you're a wonderful loveable person who also happens to be fat." Some of the qualities a partner likes may even be qualities – like compassion, understanding of difference, resilience, and ability to cope with stressful situations – that have been enhanced because of the many difficulties you've faced going through life as a fat person. Being different can teach you a lot, after all. Some of the things you can learn from being different are very attractive to the kinds of people who are looking for more than just another pretty face when they look for a romantic or sexual partner.

Fat people are fat because they're hiding from their sexuality.

Being sexual is a human characteristic that exists irrespective of size. Fat people have the same range of sexual preferences, interests, fantasies, libido levels, hang-ups, and persuasions as thin people. Fat people have the same genitalia as thin people, and their genitals work in the

same ways. Fat people fall in and out of love, get married and divorced, have affairs, scope out attractive strangers, have one-night-stands, go to sex parties, have long monogamous relationships, and do everything that everybody else does that has to do with sex or sexuality or sexual relationships.

At the same time, it is true that because of the way society generally regards fat people, fat people often don't receive the same amount of generalized sexual attention that thinner people generically do. Because there is a social stigma attached to it, there are fewer people who are willing to be open about finding fat people attractive. This doesn't necessarily mean they don't, just that they're less likely to be public about it. Because of the presumption that fat people are not sexually attractive, there is often less pressure on fat people to package themselves or behave in ways that are generally considered sexually alluring. For example, no one finds it odd if a fat person stays home from the dance, or if there aren't any fat people at a singles' gathering. In fact, people might find it distressing if fat people do show up to these events. Not surprisingly, fat people who show up to these events often feel very pressured, uncomfortably exposed, and set up for failure.

For these reasons and more, it can be very reassuring and comforting to a person who is insecure about their ability to be sexual when they are not expected to be sexual. It minimizes the risk of rejection and other unpleasant experiences. But not participating in the social parts of sexual life is a double-edged sword, providing a certain amount of immediate comfort, but at a price. Insecurity and lack of participation in a full social and sexual life can become a chicken-and-egg problem: insecurity makes it more tempting to hide, and hiding makes it harder to shuck that insecurity. As their insecurity gets worse, some people become fatter, because some people do eat as a response to emotional stress and insecurity, but this is far from universal. The insecurity/hiding cycle is also not limited to fat people. There are a lot of thin people who are different from the mainstream in one way – queer people often go through similar situations – who also experience it.

Generally speaking, people don't become fat because they're afraid of sex – fat people become intimidated by sexuality because they see what the culture holds up as ideals of sexual attractiveness and because it's made clear to them that they don't match up to those ideals. Heaven knows that people in general have enough angst about sex in general that

it doesn't take much to make people feel paralyzed. You don't have to be fat to worry that you're not good enough, that you don't know what you're doing, that your penis or breasts are too small to please a partner, and so forth. When you combine those everyday sexual anxieties with the threat of being sexually rejected lock, stock, and barrel because you're fat, it's amazing that more fat people don't completely give up the game. That there are so many sexually vital fat people is testament to their will, self-confidence, and perseverance.

It isn't a fear of sex that makes people fat. People gain weight for a lot of reasons, but mostly fat people are fat because they're fat, just like tall people are tall because they're tall or left-handers are left-handed because they're left-handed, as a result of genetics, upbringing, and dumb luck. Fatness can indeed have negative effects on sexuality because of the way in which fat people are treated in the social and sexual arenas, and negative sexual experiences can lead to emotionally-triggered over-eating, which may or may not result in weight gain. But implying a causal relationship between fear of sex and becoming fat is pretty shaky logic. After all, lots of fat people actually have great sex lives and have no problems being sexual. There are fat people on every point of the spectrum of sexual orientation and behavior right next to their thin brothers and sisters – and getting busy with them, too.

Likewise shaky is the notion that people become fat to put a "wall" between themselves and the outside world. Sure, it's possible for fat people to react to their fat that way, and make their fatness their "space maintainer" between themselves and the demands of the world. People have any lot of ways of doing that. The yen for escape is hardly unique to fat people. Some people sit at home and watch television by themselves all the time. Some people move to distant rural areas and live in homesteader cabins without electricity or phones. Some people become obsessive workaholics. There are those who choose drugs or alcohol to make their worlds more palatable. Some people take an organized spiritual path to remove themselves from the world at large and become monks, nuns, or other spiritual seekers or pilgrims. There's nothing about the desire to wall one's self off from the madding crowd and all its demands that is in any way a specifically "fat" desire. The only difference is that fat people's bodies provide the locus for a temptingly tidy, but usually incorrect, visual metaphor.

Fat people are desperate, because it's so hard for them to find anyone who will sleep with them.

It'd be a lie to say that fat people are never desperate for a date or for sex. But it'd be a lie to say that thin people never get desperate, either. Even conventionally drop-dead gorgeous, thin, magazine-cover bombshells are sometimes desperate for a date or for sex – people can be as lonely because they're perceived as unattainable and thus unapproachable as they can be if they're seen as undesirable. No one gets to have sex whenever they want it, however they want it, with whomever they want. That's just the way the cookie crumbles.

People of all kinds go through dry spells, have insecurities about whether or not they're desirable, and worry that there's something about them that people secretly find off-putting or unattractive. You'll notice that ad campaigns, particularly for health and beauty aids, are designed to capitalize on these fears with their "Use our product to avoid being unattractive!" messages, implying, of course, that without outside help, your average Joe or Jane is, in their raw state, going to be a hideous mess who couldn't attract so much as an ant at a picnic.

People of all kinds can get a bit neurotic and obsessive when they're insecure about their attractiveness. Insecurity and obsessiveness, in turn, tend more often than not to make people seem less attractive than they would otherwise, thus compounding the problem. When people are told that they're not going to be able to find sexual or romantic partners, that no one will find them attractive, or that they're "losers" – as is the case with most people who are not thin, who are often told these things by family members as well as classmates and co-workers as well as the culture at large – they end up with a significant extra obstacle that they must overcome in order to get on with the business of having full, interesting, active sex and romantic lives with all the usual joys, disappointments, and triumphs.

Part of what makes people (fat or not) feel desperate for love or sexual attention is what might be characterized as a famine mentality. This paradoxical mindset is well summed-up in Auntie Mame's oft-quoted phrase, "Life's a banquet, and some poor suckers are starving to death." In other words, if you believe that any much-desired commodity is critically rare, you'll be fearful of not getting enough (or not getting any at all), no matter how abundant that commodity might really be. Desperate, fearful people are not generally at their best, and they're prone to making bad, panicky decisions. That's human nature.

In sexual situations, this can mean that, out of the fear produced by the famine mentality, people will sometimes agree to things that are not mentally or physically healthy for them. They may think that they'd better go along with what's being offered, since they might not get another chance anytime soon. They may worry that if they don't, their partner might decide to discard them for someone more desirable or just more compliant. If someone thinks they might not get another chance, or feels that they should put out for whoever's interested since they're convinced that few people ever will be, they're likely to make decisions about sex that they would neither make nor defend under other circumstances. As a result, fear and a "famine mentality" often mean that people end up having rotten sexual experiences when there's no earthly reason for them to have to have sex that isn't the way they want it to be.

Sometimes people also end up contracting sexually transmitted diseases, including HIV, because they were afraid to insist on safer sex in a situation where they felt that to insist on any personal limits would result in their being rejected. Having a famine mentality in regard to your sex life isn't just bad for your mental health, it can be disastrous for your physical health as well.

Once these kinds of unpleasant sexual experiences have taken place, they tend to compound the fear that having happened that way once, things will always be that way. Thus, the whole "desperate" famine-mentality circle renews and reinforces itself.

However, not all fat people fall victim to the "desperate" cycle, just as not all thin people are immune to it. Fortunately, people find ways to break the cycle and go from "what will I do if no one out there ever wants me" to "hmm, there are lots of people out there, someone's bound to be interesting to get to know." Generally speaking, people's lives (not just their love lives) improve immeasurably for the change.

Whether by dint of conscious effort, finding a partner whose attentions help break the "no one's ever going to want me" loop, or just the passage of time and increased maturity, there are a lot of fat people who are in no way desperate. One of the most powerful forces in helping people get loose of the "fat and ugly and desperate" cycle is finding friends, family, and philosophies that help reinforce self-confidence and self-worth. Finding sources of support like the ones described here is vital to having a full and self-loving life, and in turn, vital to being able to love and live to the top of your ability.

"When I met my best friend Christi, that changed my life. She is a BBW and introduced me to that whole world. I didn't know it existed before then. She gave me that gift and I gave her some of my backbone. Today we are both in long-term monogamous relationships that we would not be in without each other, helping each other, supporting each other, and educating each other." – Katrina

"In middle school, I had no confidence. I felt fat and undesirable. In high school, I became close friends with a very attractive fat girl, who had confidence to spare, and it rubbed off on me. She told me many many times that I am attractive, and should assert myself, that is was my fear and not my unattractiveness that kept boys at a distance. In the past year, since becoming romantically involved for the first time (I am 19), I have begun to feel a lot more desirable. I know that several guys find me attractive and sexy. My own confidence doesn't depend any more on my lovers, but they do give it a nice boost." – Jade

"My mother has always worked on me about my self-esteem, trying to convince me of my own natural beauty. Having a boyfriend that seriously thought I was the hottest creature alive helped too. I came to a lot of conclusions on my own, however, and I cannot downplay the importance of becoming a feminist." – C. S.

To have sex with a fat woman, you have to roll her in flour to find the wet spot, or slap a thigh and ride the wave in.

If you can't figure out roughly where a woman's vagina, a man's penis, or anyone's ass should be just by looking at them and seeing where their head, arms, legs, and feet are, you're clearly not savvy enough about human bodies to be having sex with anyone regardless of their size. Consult *Gray's Anatomy* or *The New Our Bodies, Ourselves* for further details. While you're looking things up, see if you can figure out how to pull your head out of your ass.

Seriously now – if someone hasn't got enough tact, compassion, and taste not to make these kinds of jokes, why on earth would anyone with good taste, a sense of humanity, and a sense of their own self-worth be getting close enough to them to allow them access to their genitals? Boors should not be tolerated, and that rule of thumb doesn't change

with your weight. There are much more refined and less narrow-minded fish in the sea!

Fat men have tiny penises.

Some do, some don't. Statistically speaking, average hard penis length is about five and a half to six inches. The way men's penises look when they are soft, and the size they appear to have when soft, is not a reliable indicator of how large they may be when they're erect (hand size, foot size, or the size of a man's nose, by the way, are also unreliable guides). Generally, just as fat people's libidos, sexual orientations, desires, and fantasies come in the same range as that of the population as a whole, the same is true of genitalia, whether it's male or female. Some are big, some are small, some are thick, some are thin, experience and statistics both suggest that penis size doesn't necessarily have anything to do with the size of the rest of a man's body.

However, fat men's penises may *appear* to be smaller than thinner men's. There are a couple of reasons this may appear to be the case. A fat man's penis is likely to appear smaller by comparison to the rest of his size simply because of the proportions of things. If belly, hips, and thighs are quite large, an average-sized penis is not going to appear "average sized" because everything else in the vicinity is bigger than "average." Another reason that fat men's penises may seem smaller or shorter is that, just as fatter women can have a fat deposit over the pubic bone, resulting in a considerably bigger mound of venus (or mons veneris) than a thinner woman might have, men also develop fat deposits in the same general place. A pad of fat around the base of the penis may make the penis appear, and in some positions effectively be, shorter than it would be if that fat pad were not present.

For many men, lying on their backs (with or without a pillow under the hips) will let the fat around the base of the penis spread out sideways more than usual, which can reduce the amount of fat padding that is directly around the base of the penis. For this reason, big men often find they achieve their deepest penetration when their partner is on top of them. More on sexual positions for fatter partners can be found in Section Six of this book.

Fat people are sexless.

Not at all! Fat people have the same wide range of sexualities, libidos, preferences, hang-ups, fantasies, and desires that everybody else does.

In willful ignorance of this rather salient fact, the culture in which we live has a tendency to desexualize fat people, insisting that they are not sexually attractive, don't have sex easily or well, and they don't "look sexual."

Saying that someone doesn't "look sexual" is saying two things: first that someone doesn't conform to standard ideals of what sexual attractiveness is "supposed to be," and secondly that their body doesn't conform to what a member of a given sex is "supposed" to look like. Our culture currently considers a very slim, almost childlike body shape to be the most sexually attractive body shape. Some commentators have suggested that the preferred feminine body shape of the 1990s is not really female, but that it more closely resembles the body shape achieved by men in drag. This is ironic in light of the fact that sometimes fat bodies are seen as "between genders" or "devoid of gender," as amorphous, hard to place à la the "It's Pat" character in the well-known *Saturday Night Live* skits – and there are some real explanations for why fat bodies can sometimes seem hard to place or hard to conceptualize in terms of gender and what we expect gender to mean.

There is an enormous range of shape diversity in fatter people's bodies, and because the scale is large, it's easy to see. There is a similar diversity in non-fat bodies, but it's not always as noticeable. You can, for instance, find thin women who have small breasts and very pronounced hips – but add fifty pounds, and have a lot of it be carried on the hips and butt, and it becomes that much more noticeable.

When fat is deposited in places like the hips, buttocks, or breasts, it tends to enhance those secondary sexual characteristics. However, bodies can also carry fat deposits in places like the belly and waist, thighs, upper arms, and men's breasts, places in which the fat may obscure, lessen, or take away the sex-linked body shaping that is a big part of how we learn to identify sex and gender and to determine which bodies are sexually attractive. Women who are "hourglass" shaped, with big breasts, big butt and hips, but who have a comparatively narrow waist can carry quite a bit of fat but still be still identifiably female and feminine. Anna Nicole Smith, Marilyn Monroe, and Mae West all capitalized on this classic shape, and that "hourglass" waist-to-bust/hip ratio is part of what gives Camryn Manheim her on-screen appeal, too. Women who are "pearshaped," where the weight is carried mostly from the waist down in the hips, butt, and thighs, still retain the female/feminine visual shape signifier of narrow

waist and broad hips, even if their breasts are not proportionately large enough to make them into the "hourglass" silhouette.

An "apple shaped" woman of the same actual weight, who carries her fat mostly in her belly and torso, however, is less likely to be seen as sexually desirable and less likely to be identified as feminine (not the same as female). If her breasts are small, she may be even more confusing to the eye, since fat men often develop small breasts and tend to be "apple shaped" too. This can be an asset to some transgendered women, or to women who enjoy crossdressing, but to many apple-shaped women, it's a source of consternation. The "hourglass" is the way women are "supposed to be" shaped, the quintessential shape that people see and immediately identify as female and feminine. No matter whether a woman is too thin to be curvy, or has her curves in what she might consider to be the "wrong places" to have that overall body shape, she may feel that she looks less than feminine.

Male bodies, on the other hand, are not expected to be rounded and curved in the same fat-padded way that women's are. The lines associated with men's bodies tend to be straighter and whatever curves are there are generally supposed to be muscular. Consequently, the more a fat man's body maintains those straight and muscular lines, the more he will be perceived as masculine and manly. The "teddy bear," "lumberjack," or "bear" archetype is a fat man who is built on the stereotypical male plan, skeletally speaking: broad shoulders, narrow hips, and usually quite tall. Bears carry their weight in their bellies almost exclusively, and as an adjunct often have a fair amount of body and facial hair, both of which contribute to their being seen as very male and masculine.

However, not all fat men are built like bears. Men who are less broadshouldered, who tend to carry their fat along their sides and back more than in their bellies, or whose fat rides in their lower belly, hips, and thighs tend to become more or less "pearshaped." This body shape is more often seen as female, with its visual connotations of "childbearing hips" and the typically broader woman's pelvis, than it is seen as male. Fat men aren't the only men to be seen as less masculine because of their body shape, though. Very thin-framed men with narrow shoulders are also more likely to seem more androgynous, and very skinny men without much muscle mass often get pasted with the "98-pound weakling" label no matter how strong they may in fact be.

Breasts are another gender-complicating issue that fat men face. Not all fat men will develop fat deposits in their breasts, but many do.

It's perfectly reasonable that this should happen: breasts are breasts because of fat, and women's breasts and men's breasts aren't all that different structurally. Sometimes, enlarged breasts in men are diagnosed as a medical condition called gynecomastia or gynomastia (woman-breastness), but strictly speaking, there's nothing at all medically wrong with most fat men who happen to have fat deposition in their breasts. Basically, they're just another place for the body to store fat, but since people usually equate visible breasts with femaleness, it might be disturbing or confusing to come across a man with who has them.

There are also some hormonal issues that can affect fat men and women. Some of these can result in visible body changes that can create gender confusion. Fat, as a tissue, is one of the sites in the body which produces estrogen. Therefore, the fatter you are, the more estrogen you're likely to have in your body. Higher estrogen has a couple of side effects: first, it means that many fat people's skin is very soft and supple and may feel "satiny" to the touch – an asset to women, but possibly less so for men, for whom very soft skin might be seen as an effeminate trait. In some men, high estrogen may also mean less facial and body hair, giving a baby-faced look. The softness of fat people's bodies is one of the things that a lot of fat admirers find very sensual and attractive.

Sometimes there are other fat-related hormonal conditions that have the opposite effect. Polycystic Ovarian Syndrome (PCOS), a condition that is found in women of all sizes, has a strong propensity to encourage weight gain and to make weight loss difficult or impossible. One of the classic symptoms of PCOS is hirsutism, or excess growth of facial and body hair – a normally-occurring male secondary sex characteristic. Some women who have facial hair decide to shave it, pluck it, or undergo electrolysis. Other women prefer to let it grow and enjoy their lives as "bearded ladies." It should be noted that not all women with hirsutism have PCOS, and not all women with hirsutism are fat. However, there is a correlation between these conditions in some cases.

Clearly, fat people's bodies can create some serious confusion among the clues people unconsciously use to assign gender and to make assumptions about sexuality, sex drive, and sexual prowess. Does this actually mean that a person's sexuality, sex drive, or sexual prowess is diminished, even in cases where there are hormonal imbalances? Probably not. Perceptions of fat people as sexless have more to do with the power of visual

cues than they do with the truth of any individual fat person's sexuality, libido, sexual identity, or sexual prowess.

Fat people are grateful for any sexual attention at all. They'll do anything you want.

Don't bet on it. While it is true that people who are routinely sexually disenfranchised often have feelings of sexual insecurity and undesirability, and this sometimes leads to people feeling that they need to "compensate" for their perceived lack of worth or attractiveness by being overly compliant with any partner's wishes, this is not always the case. People with low self-confidence and a low opinion of their own sexual worth are far more likely to subjugate their own desires to those of a partner regardless of what they weigh. This is particularly true of people who have internalized emotional abuse about their worthiness as human beings and as sexual beings.

Many fat people are threatened with a loveless life from childhood and are told that they "won't have a boyfriend/girlfriend" or "won't find a husband/wife" unless they lose weight. This sort of message in childhood alone, but particularly when it is coupled with rejection, abuse from a partner, or repeated experiences of feeling sexually humiliated, can scar just about anyone. Most people do carry around some scars of this ilk, regardless of their size. Life is like that, unfortunately. Most people chalk up their scars to experience, the "school of hard knocks," or perhaps "that man (or woman) who done me wrong." For fat people, though, with all the training we get that our fat makes us horrible human beings who deserve whatever bad comes to us, it becomes awfully easy to assume that any bad relationship or any rejection is due explicitly to our being fat. We lose our sense of what is legitimately related to fatness and what is not.

This is just one way in which it can be very difficult for fat people to identify and establish their personal boundaries. Psychologist Dr. Barbara Altman Bruno remarks that fat people are often likely to have problems establishing and maintaining healthy sexual boundaries because they've often had other people ignore or deliberately crush their own personal and bodily boundaries from the time they were small. Fat kids and teenagers are often forced to subject their bodies and their appetites to other people's ideas of what they should be like. Parents force kids to go on diets and take them to intrusive, often abusive, doctors to be treated for the non-disease of being fat. Parents often withhold affection from

their "bad" fat children, whose bodies defy their parents' wishes, in a form of emotional blackmail. Sometimes this is subconscious, and sometimes it is overt. Kids and teenagers feel a lot of media and peer pressure about body image and often end up with eating disorders. People in restaurants and grocery stores often seem to feel quite entitled to comment on a fat kid (or adult) eating in public. And, as we all know, kids on the playground can be ruthless to anyone who is different.

People who are used to having to try to force their own bodies and appetites to conform to other people's notions of what is appropriate are likely not to have very much experience with making decisions to do things that feel authentically right for them. They may not have ever learned to trust their own instincts about their physical appetites and desires, whether food-related or sexual. They may simply assume that they shouldn't ever express their own desires lest it turn out not to be something a partner (or parent, or whomever) wants to hear. Fat people often grow up learning that the way to be accepted is to conform what someone else wants regardless of your own boundaries or comfort level.

Fat people are not alone in fearing that they won't be loved, or alone in feeling that they have to continually try to subjugate their needs and desires to other people's in order not to lose love and acceptance, but it is a problem with particular resonance to the fat community. This kind of codependence plays itself out in all kinds of relationships, but can have particularly disastrous consequences in the sexual arena. It's okay to have boundaries, and perfectly justifiable to insist on having your limits respected, no matter what your size. People who seek out fat partners in the belief that they will have fewer boundaries and can thus be more easily exploited are being predatory. This sort of behavior is simply insupportable.

Often having overcome many obstacles to learn how, many people of size have excellent skills at defining and maintaining personal and sexual boundaries. They know how to express their desires and how to say no to things they're not interested in doing. They know their limits and their capabilities, and aren't afraid to speak up. People usually find that the more confident they are in general, the easier it is to be confident with maintaining sexual boundaries. Don't assume that any fat person is going to be an easier mark or have lower standards than any thin person. Assuming wrong might earn you a tight slap across the face from a justifiably offended fat hand.

Fat people stink and are filthy, especially their genitals.

Unless there's some sort of illness or infection at work that's causing it, people generally don't smell bad as long as they bring some soap and water into contact with their epidermis on a fairly regular basis. Soap and water work the same way no matter who's using them.

Among Westerners, Americans are notoriously hypersensitive about matters of body odor. We use legendary quantities of scented soaps, antibacterial soaps, antiperspirants, deodorants, scented detergents, and all the rest to try to render our bodies unnaturally antiseptic and scentless. Because of this, we tend to be hyper-reactive whenever we do happen to smell normal bodily scents, and we also tend to stigmatize body odors more highly whenever they happen to come from a person of a class that we don't happen to like too much.

On the average, however, most fat people don't smell any different from anyone else. Fat people wash, use deodorants, and so forth, according to their personal preferences just like everyone else you know. Some fat people do have reach problems. Occasionally this can make it difficult for them to easily wash and/or examine their genitals. However, necessity is the mother of invention, and people come up with ingenious solutions to their problems. Companies like Ample Stuff (see Resource Guide) provide catalogs of products designed with the needs of big people in mind, many of which are designed to make good hygiene easy for everyone.

If you sleep with a fat person, you'll get crushed or smothered.

The truth of the matter is that sex with a fat person won't crush you, suffocate you, or smother you any more than eating watermelon seeds will make watermelons grow inside your stomach. Notwithstanding the many jokes, rumors, urban legends, pornographic cartoons, old wives' tales, and other testimonials to the inevitability of a fat person crushing their sexual partners, it just doesn't work that way. Human beings are pretty sturdy. Moreover, having sex with a fat person doesn't put weight on your body in the same way that it would if, for instance, a grand piano fell out of a second story window onto your head. Yes. fat people do weigh more than thin people, but that doesn't mean that they have no control over how or whether they put their weight on their partners. Furthermore, having weight on your body doesn't necessarily hurt or do anyone any harm. Some people rather like the sensation. A few of them even pay rather handsomely for it on the rare occasions when they

find a dominatrix who is both physically and mentally equipped to provide it.

It seems odd that no one bats an eyelash at the thought of a 280-pound football player having sex with a tiny hundred-pound cheerleader type, but somehow people are capable of believing that a 280-pound woman could somehow manage to crush a male partner inadvertently during sex and not even know it. This is patently ludicrous. It's just not all that probable that a fat person will do any damage to a sexual partner unless, God forbid, they are actually *trying* to do them harm.

Fat people are just as capable as anyone else of moving out of the way if a partner expresses distress or displeasure (and their partners are just as capable of doing their best to signal their distress and to move out of harm's way if the need arises). Moreover, fat people are fat, not insensible. Skin is sensitive to pressure and touch whether it covers bone, muscle, or fat. You might sit on a penny and not know it was there, sure. But no matter what their size, people do not simply sit on or roll over on top of large objects – especially something as large as another human being – and not notice. People are also notoriously difficult to sit on. As size-acceptance activist and *Fat!So?* author Marilyn Wann said when giving a tongue-in-cheek description of an experiment she and her fat boyfriend conducted to see if they could crush one another during sex: "People just thrash too much when they're suffocating. It's just not very much fun." In all seriousness, it would indeed be rather a remarkable feat to crush someone to death with your own body, and even more remarkable not to notice it.

For more on crushing, smothering, and other related issues, please see "The Truth About Crushing, Smothering, and Suffocation," in Section Six.

Anyone who thinks fat people are sexy has to have some psychological problem.

While it is often more socially challenging to be in a relationship that isn't the kind of relationship mainstream society holds up as ideal, it's not crazy to want to have a relationship with a person whom you love and find sexy and desirable, no matter what society thinks. Generalizations like "anyone who thinks fat people are sexy has to be crazy..." just beg to be debunked by being applied across the board. Try inserting "Black," "short," "left-handed," "French," "Catholic," "men with small

penises," or any generic adjective that refers to a generic group of people into that sentence in place "fat." Pretty illuminating, isn't it?

The moral of the story is simply that not everyone has the same tastes and not everyone wants the same things in their relationships or from their partners. Not sharing your tastes doesn't mean someone "has a psychological problem," it just means that they're different from you. People like what they like for a number of complex reasons. There's no more reason or logic for liking tall skinny blondes with gravity-defying breast implants than there is for liking short plump brunettes with small, firm breasts and meaty, hearty thighs. *De gustibus non est disputandum* – there's no accounting for taste.

Fat women love to give oral sex because they're orally fixated.

Why is it that people say this about fat people, but not about cigarette smokers, gum-chewers, people who habitually gnaw the ends of their pens and pencils, or who engage in any of the other classic oral fixation behaviors? Sure, it's tempting – if wildly incorrect – to assume that fat people are fat because they have oral fixations which cause them to eat constantly, but that's just not the case. Some people who are fat probably do have oral fixations, given the laws of probability, but an oral fixation doesn't necessarily lead to becoming fat. Furthermore, oral fixation isn't necessarily a condition that plays itself out sexually. Some fat people (male and female) love giving oral sex. Some fat people don't. Some fat people love receiving oral sex. Some fat people don't. Some fat people would rather read a book than do either one. Same with thinner people.

The upshot is that sometimes, yes, you'll find a fat person who would rather give head than just about anything else, but probably no more or less often than you'd find that proclivity among thinner partners. If you'd like your partner to perform oral sex more often, remember that nothing provides encouragement like a good example!

COMMUNITIES AND CULTURES

SIZE ACCEPTANCE ORGANIZATIONS

Part of having a happy, healthy, functional sex life is having a happy, healthy, functional life overall. The task of creating a world in which having body fat (or a fat body) doesn't create social stress and frequent humiliation is still far from complete. As a social justice issue, the real cultural enfranchisement of all people regardless of their body size, weight, or shape lags behind the enfranchisement of other discriminated-against minorities. Civil rights based on race and religion, legal protection of the rights of gay and lesbian people, and protection of the rights of women all have long, often bloody and tremendously difficult histories, and while no one could say that true equality has been achieved in any of these realms, great progress has been made in many areas.

Comparatively speaking, the struggle to decrease discrimination in the lives of fat people is in its infancy. The National Association for the Advancement of Fat Acceptance (NAAFA) was founded in 1969 as an agency to advocate for the rights of fat people. Since then, the size acceptance movement has seen a lot of uphill battles. The fight has not been without its triumphs: the state of Michigan now includes size-acceptance as part of its civil rights legislation. Similar legislation has passed in Santa Cruz, California, and has been introduced in numerous other places, including the Commonwealth of Massachusetts and the city of

San Francisco. Fat people are becoming more and more visible in the public sphere and in the media. As manufacturers wake up to the fact that fat people have money to spend, upscale lines of clothing and accessories for fat people have been appearing.

Where size acceptance is concerned, change has been more incremental than explosive. There has been no size-rights equivalent of the (in)famous Stonewall riot that kick-started the gay rights movement, and there have been numerous problems (for a lot of often-controversial reasons – this book is, alas, not an appropriate forum for such a discussion) in terms of creating effective protest and change in regard to size-acceptance issues. Still, progress is being made, and fat people continue to become more visible as vital, vigorous, and useful elements of the human community. Some of the changes and advances that have been made in the area of size acceptance have to do more or less directly with sexuality – sexuality, after all, is one of the strongest forces in our lives, and our loves and relationships and the pursuit of sexual pleasure occupy a lot of our time and energy.

For instance, twenty years ago, it would've been nigh unto impossible to find a plus-sized wedding gown without having it custom-made. Today, many wedding gown manufacturers sell off-the-rack sizes up to 26 or even higher. For this to happen, designers and boutique owners have had to realize that women larger than a size 16 do indeed fall in love and get married – but there have undoubtedly been a large number of requests for larger-sized wedding dresses that went unsatisfied before enough manufacturers realized that the demand was big enough to be profitable. Similarly, sexy large-size lingerie is getting easier and easier to find. In just the past handful of years, Lane Bryant, arguably America's biggest plus-size women's clothing chain, has introduced a large (and apparently very successful, to judge from the size) lingerie and loungewear section to their stores which includes such delectably frilly items as lacy pushup bras, feather-trimmed sheer bedjackets, sequined camisoles, and fire-engine red lace garter belts in sizes up to 28.

Even Hollywood, the most notoriously size-unfriendly town of all, is in on it – in television and movies, we've been seeing more and more big actors and actresses, and what's more, we've been seeing them as sexual beings. Roseanne was an eye-opener for many people, as are Camryn Manheim's role in *The Practice* and Patrika Darbo's character Nancy Wesley on the long-lived soap opera *Days Of Our Lives*, an unapologetically fat major character who, on the show, is married to a

thin, successful, drop-dead gorgeous doctor. Likewise, the inclusion of the adorably chunky Mark Addy in the comedy *The Full Monty*, and the presence of big male actors like Brian Dennehy, John Goodman, Drew Carey, and the older, stouter, and still-gorgeous Sean Connery broadcasts their desirability to a large and loving audience, too.

But life, alas, isn't all lingerie and movie stars. Society has a long way to go, and size-acceptance organizations still have a lot of work to do. For many people, participating in these organizations is a valuable part of their personal development as well as their romantic and sex lives. NAAFA, the National Association for the Advancement of Fat Acceptance, has numerous chapters throughout the United States and elsewhere, as does the ISAA, or International Size Acceptance Association. These organizations aren't intended as singles' groups, but in the same way that people meet partners through other shared-interest organizations like churches, synagogues, continuing education classes, or the Parent-Teacher Association, some people also meet partners through size-acceptance groups. Chapters of these organizations often plan social events for their members, many of which are intended to give fat people a space to have social interactions where they can rest assured that they won't be judged negatively because of their size. Some size acceptance organizations, NAAFA among them, recognize that in a thin-centered society, their members often have difficulty meeting supportive partners, and therefore they may make personal ads or other dating services available to their members for an additional fee.

At social and political events that are geared toward a size-accepting population, attendees receive an invaluable gift: a place where they know they can be among people who will, by definition, accept them with the bodies they have. It can be a life-changing experience: for some people, it's the first time they've ever felt truly accepted as human beings. There are also quite a few size-diversity and fat-acceptance conferences each year in various cities around the country. The largest of these in terms of sheer numbers are usually the annual national NAAFA conventions, which took place in Los Angeles in 1998, in Boston in 1999, and will be held in San Francisco in 2000. These week-long conventions have garnered a fair amount of media attention in the past few years. They consist, as do many similar weekend-long conferences, of numerous workshops and seminars, speakers, and lecturers during the days, followed by numerous dances, pool parties, dinner parties, dinner dances, and other evening social events. NAAFA and other size-acceptance or-

ganizations also hold events throughout the year. There are also numerous purely social groups that exist to produce social events on a regular basis for non-thin people and their admirers. These may or may not have size acceptance as part of their agenda, and will be discussed in more detail later on.

These conferences and social events are wonderful places for fat people to go to meet people who are accepting of them at their size. Some of the people who attend these events attend because they are fat, some are non-fat and non-FA supporters of size acceptance, and some prefer fat partners and want to support and be around the people they love and desire. Not too surprisingly, it is a new and usually very pleasant experience for people from all three groups to be in an environment in which fatness is – maybe for the first time in their experience – not a liability or a source of social friction. Being in a place where the majority of people are fat lets you see fatness from a new perspective. Suddenly, being fat is normal, and instead of judging people by their size, you find other ways to evaluate them – their brains, beauty, fashion sense, personality or what-have-you. Just getting to be around other people who are confident about fat people's worth and attractiveness can do a great deal to increase confidence and self-worth.

It should be noted that events sponsored by size-acceptance organizations are not all intended to be places for people to meet potential partners. Some members of size-acceptance organizations become a bit irritable when people show up to size-acceptance conventions and conferences with the sole goal of finding a partner or just getting laid. This is perfectly justified. It's just not considerate, polite, or appropriate to treat an event that is intended as a political, educational, empowerment, and consciousness-raising gathering as a meat market. As one NAAFA member remarked, "Can you imagine what would've happened to someone who showed up at a Black Panthers meeting just to get laid?" The size-acceptance movement supports people of all sizes finding partners, having relationships, and having sex. Still, attending the NAAFA national convention, for instance, just to get laid would be a little like buying a car just to sit in it and listen to the stereo. Sure, you can do it. Sure, it'd be enjoyable. But both car and convention can get you much further and do you a lot more good if you use them for *all* the purposes for which they were designed.

In truth, size acceptance organizations can do a lot for your sex life even if you attend them just for the size-acceptance message and not for

the possibility that you might that you might meet someone. As your self-confidence increases, your ability to be sexually self-confident increases along with it. The more you believe that you are attractive, the more other people are going to agree, and the better you'll be able to accept romantic or sexual interest without being surprised or feeling overwhelmed. Participating in size-acceptance organizations can help give you many useful tools for negotiating everyday life, from snappy comebacks to use on people who try to harass you, to strategies for getting the best possible health care, to a network of people on whom you can call for support and the kind of confidence-building friendships that help you live life to the fullest. How does this help your sex life? Simply put, your sexuality and libido are not separable from the rest of your life. The fuller and better your life is all the way around, the better your sex life is likely to be, and the less likely you are to settle for second best when it comes to your sexual needs and pleasure.

Fat Admirers

Imagine being a teenager and knowing that you are very different from your friends and classmates. It's not that you look any different. You wear the same kinds of clothes they do, and you listen to the same music. You might be on the football team or the cheerleading squad, you might look like the ultimate All-American kid, but you know that deep down you are different. And you know, furthermore, that no one you know would even begin to understand it if you tried to explain, because it's not who you are, it's who you get crushes on that makes you different. You know that the other kids would practically crucify you if you put up a picture of the person you have a crush on in your locker at school, so you don't. When people ask you why, maybe you avoid the subject, or maybe you lie. Why? Well, judging from the conversations you have, the books you read, and the television shows you watch, you're pretty sure that no one else gets crushes on the same kinds of people you do. The people you get crushes on are fat.

The people you find the most attractive and sexy make you sigh at the thought of getting to touch and caress their beautiful, soft, pillowy rolls and folds and creases. The people you think are gorgeous have round faces, chubby cheeks, and plush tummies and hips and butts, and you'd probably fall over in a dead faint if you ever saw one of them in an ad in

a fashion magazine or in *Tiger Beat* or *Seventeen*. And you know better than to mention it, because everyone else you know thinks that fat people are disgusting, and all your female friends are on diets all the time. You don't want to be teased, so you hide your preference from your friends. Maybe you date people who are thinner than you prefer, people who may not even really appeal much to you, so that you'll fit in. Maybe you're shy or unwilling to date people who don't really interest you, so you don't date much at all. Perhaps you're not only attracted to bigger partners, but you also discover that you're gay or lesbian, and the one-two punch of being attracted to people who are the wrong size *and* the wrong gender is just too much to take, so you decide to stick to masturbation and fantasies until you grow up and leave home at the very least...

Or imagine what life would be like for such a person a little further down the road. What if you were falling for someone, but every time you tried to tell them how you felt, they laughed, because years and years of being told they were too fat to be attractive to anyone had made them unable to accept the fact that you really did find them desirable? What if you had a fabulous new lover who was everything you'd always wanted, but knew that your friends would laugh at you – and maybe even at your partner – if you introduced them? How would it feel to know that the person who you'd chosen as your life partner might be a liability to you in terms of your potential for professional advancement, just because he or she didn't fit the norm or didn't seem upwardly mobile enough in other people's eyes? What if your parents, when introduced to your fiancée, were obviously horrified by the person you were in love with and asked you if you didn't think you could "do better than a fat girl?"

Welcome to life as a fat admirer. To some readers, these dilemmas may sound pretty familiar. Many gay, lesbian, bisexual, and transsexual people deal with these kinds of issues as they grapple with ways to make their attractions and sexualities fit into a world that often doesn't understand. The discomfort, fear of exposure, difficulty in leading an open and honest life, and the fear of harassment that people who are attracted to fat partners often feel is one of the potential points of solidarity that the size-acceptance community shares with the queer community. People whose sexuality is oriented around partners who are not what society tells them they "should be," whether in terms of size, gender, or in other ways, have significant obstacles to overcome in order to be able to live and love proudly and freely with the support of an accepting community.

In the first chapter, we compared the spectrum of hetero-, bi-, and homosexual attractions as visualized through the famous Kinsey Scale to the spectrum of attraction that people can have to thinner and fatter partners. Basically, just as people can be solely attracted to people of another sex, attracted to men and women in differing proportions, attracted to men and women equally, or attracted entirely to people of their own sex, people can be attracted exclusively to fatter partners, can be attracted to both fatter and thinner partners in varying degrees, or might feel attractions only to thinner partners. Similarly, one might be attracted only to partners above – or below – a given size or weight, just as some people are attracted only to partners who are six feet tall or taller, and so forth. Just as people who like thinner partners have preferences for long legs or muscular ones, red hair or blonde, there are also fat admirers who like fat butts, fat admirers who love chubby babyfaces, fat admirers who would like nothing better than to luxuriate in a lover's big soft tummy, and any other variation you can imagine.

The range of partners and attributes that a person might find attractive is a quirky thing. No one really knows why people develop the tastes they do. What we do know is that at least to some degree, these preferences seem to be pretty hard-wired. While there are a great many people who are capable of finding fat partners attractive, not all of them self-identify as "Fat Admirers" (FAs) or "Chubby Chasers." There is no hard-and-fast rule about who identifies themselves as a FA and who does not. Generally speaking, the stronger the attraction a person feels to fatter partners, the more likely a person will be to consider their appreciation for fat bodies to be an integral part of their sexual identity, and thus to self-identify as an FA.

There are a fair number of people who do claim their attraction for fat partners as a fundamental part of their sexual identity. Statistical estimates suggest that probably about 5-10% of the average population could be considered "fat admirers," but the accuracy of these estimates is open to debate. Given that there are so many people whose range of attractions may include a fatter partner at some point in their lives but who don't identify themselves as FAs, it's really quite difficult to imagine what a real figure would be.

Looking at how people identify their sexual preference in terms of sexual orientation is again useful in understanding this. There are many people who do not identify as homosexual or bisexual who nonetheless do sometimes have sexual relationships with people of their own sex.

These people might be afraid to identify as gay or bi because of the potential social fallout, or they may simply feel that the level of their interest in or attraction to same-sex partners really does not justify their taking on that label. They may not feel that the label describes their sexuality accurately – there may be other labels, like "leather daddy" or "femme," to name two, that they feel do a better job of identifying what is most important about their sexuality. What it boils down to is this: people choose the labels with which they identify themselves; the labels don't attach themselves to people on the basis of desires or behavior. Similarly, people whose attraction to fatter partners was infrequent or not too pronounced might not feel that their sexuality was defined by their attraction to fat partners, and thus might not feel the label was a useful one for them. Or perhaps they might be worried about inviting harassment if they were to assume a label that is none too well understood by the general public, and which proclaims an attraction that is commonly thought of as "sick" or "perverted."

All this is to say that just because someone doesn't identify as gay or bisexual doesn't mean they've never had a same-sex affair (or won't in the future), and just because someone doesn't identify as a FA or Chubby Chaser certainly doesn't mean they'll never be (or never have been) attracted to a fat partner. Fortunately, getting a better understanding of FAs doesn't require that we know how many there are of them, but that we see them for who they are, discover what it is they value about fatter lovers, and find out how their attractions affects their lives.

People of size often wonder how they can tell when they're dealing with Fat Admirers, if it's not evident from context or because the person has identified themselves as such. All jokes about trying to get them to wear identificatory armbands or special propeller beanies aside, it is an issue of some importance to fat people who would like to know when they're dealing with a fat-admiring person. After all, if you don't know that a person's avoiding eye contact because they're so smitten that they're speechless, you might think they're doing so out of disgust!

For better or worse, there's no way to tell a fat admirer from anyone else you see on the street. Fat admirers can be of any gender, any sexual preference, any age, any race, and any religion. There are gay men fat admirers and straight women fat admirers, lesbian chubby chasers and straight male FAs, and there are plenty of bisexual fat admirers out there, too. Fat admirers may be fat or thin, tall or short, rich or poor, and working in any profession you care to name. Sexual preferences have an

uncanny way of cutting across borders, and the preference for fat partners is no exception.

Like other sexual preferences, the attraction to fat partners often begins very early in life. Sometimes people can trace it to a specific individual who was the source of an early crush, but other times it's just a generic preference. People who self-identify as "Fat Admirers" have often been attracted to fat people since childhood or simply "as long as they can remember."

> *"The first crush I ever had was on a woman who was very large. I was five. She was the mother of a boy I was 'dating.' I was his girlfriend because I found him extremely cute, though he got teased for being chubby. He had the most angelic cheeks and disposition. His mother, though, was the object of my affection. She would pick us up from school and I would stare at her the whole way. I dreamed of marrying her when I grew up. She remains the most attractive archetype I can imagine." – C. S.*

> *"Think Russian superheavyweight Olympic weightlifters. That shape has just always been my ideal, since puberty and sexual identity were thrust upon me. Oh, and I'm a sucker for blond hair and blue eyes and even more for red hair and blue eyes. I remember the Christmas after my first 'pubes' grew in... Santa and Frosty looked REALLY good." – FatBoy*

> *"I've never experienced the kind of gut-wrenching, overpowering, I-must-have-you-now kind of lust for a stranger who wasn't substantially overweight. It's just always been like that for me." – Sophie*

Other people learn to appreciate the beauty and sexiness of other fat people more intensely as they become more and more confident about their own.

> *"I love my body except for when society tells me it's ugly. And I love fat in other people. It seems the more I love my body, the more I find other fat bodies sexy. I know some people don't have that experience, like they have always thought it looked good on other people but not themselves, but it's mine. And I find fat really SEXY. Yum, I wanna suck on some right now..."*
> *– Erica*

This brings up the question of what it is that fat admirers find so attractive about their partners. Mainstream culture, it goes without saying, doesn't understand the attraction, and neither do many fat people. Fat people , after all, are products of mainstream culture just like everyone else, and have been taught to think of their own bodies as disgusting and unacceptable.

Sexual attraction is notoriously difficult to explain. It ultimately seems to boil down to some version of "I don't know why, but I know what I like." Still, we can make some useful generalizations about the kinds of things that many fat admirers find desirable in fat partners. The softness and generosity of fat bodies are things that many people find sensual and appealing, for instance. Other people simply like the large size of a fat partner, or like the feeling of being enveloped and held. "One man's meat is another man's poison," the saying runs, and you could as easily say that one person's "ugly flab" is another person's wet dream of sweet, soft, shapely, endlessly touchable sex appeal.

"[Fatness] is soft, giving, womanly, overflowing, exciting, given in many interesting shapes worth exploring. It is also a bit 'naughty' or 'forbidden' – that is the paradoxical good side of living in a thin-admiring society! But it is also 'excessive' in and of itself, and human sexuality always deals with excess. One could think of simpler ways to reproduce the species... and shouldn't roundness quite naturally be the basic sexual signal for men (and women)?" – Scandinavian FA

"I like big-big butches usually (or FtMs [Female to Male transsexuals]) and I like them to be a little smaller than me to waaaaay bigger, but I'm definitely not turned on by much smaller. I want someone big and warm to cuddle with, someone whose body is bigger to hold me and that can take what I have to give." – Elena

"I have always been drawn to heavier bodies. When I was younger, I had a fascination with bodybuilders and people who were highly muscular, but not so much as sexual objects. Heavyset men and women seemed to combine the strength of a bodybuilder with the softness of someone caring and loving." – Lewis

"I like the build of a well-proportioned large man and the way their bodies feel next to mine. Their very presence just feels 'manly' to me in a way thinner guys don't." – FatBoy

"I've always appreciated a well-rounded body more. Skinny just seemed... wrong. Did they not eat enough? Do they not like food? What the hell is wrong with these people? The comfort, knowing that this is a person that can share some of life's better moments... being able to eat real food and not be embarrassed to get naked for sex afterwards. To know that I could curl up in their arms and get comfortable without having a bony body part to wound me. I'm a massive snuggler. One of my favorite memories of college is a matronly mommy figure that was overly fond of hugs – particularly ones that left you smothering in cleavage. She wasn't fat, she was ultimately fluffy. A hug from her screamed feather beds and pillows and other soft sweet things. I could've lived in her bosom." – Suzeanne

"Creamy, lush, soft, warm curves and plenty of them. I like feeling like there's a lot there to play with, and I also like feeling like I'm not going to break the woman I'm with. A beautiful fat woman has it all over a skinny minnie, seriously, just built for comfort. Besides, who wants to date a woman who never eats and who gets all uptight about all that 'does this dress make me look fat' stuff? I don't ever want to have that fight again. You know, there's no right answer when a girl asks you that, because they never believe you when you tell them you think they're beautiful when they think they're fat. My last few girlfriends were big and knew they were sexy too, and nothing's more sexy than that. Gotta love it." – Mack

Despite the intensity of their attraction to fat partners, many FAs are "in the closet" about it. Just as there are often compelling reasons for queer and trans-identified people to stay closeted, there are unfortunately also reasons – often the same reasons, in fact – that fat admirers find it easier to keep their partner preferences a secret. Because fat is so heavily stigmatized in our culture, family and friends may disapprove quite vocally when presented with a partner who seems "fat and undesirable" in their eyes. A gay male chubby chaser named Sam writes that when he explains to his heterosexual friends that he is a FA, the "first reaction is

shock, thinking you can do better. But when you explain what you find attractive, they get over it. Gay friends on the other hand don't always get the attraction and still ask if I find Tom Cruise-like men they are ogling attractive. Of course, the answer is no. Give me John Candy-sized any day." Other FAs report that their families treat their fat partners poorly, and that it sometimes takes years for family members to learn to see past their partners' size and accept them as people. Some people say that their friends and family have told them that their attraction for larger partners was indicative of a "mental imbalance" or mental illness, in the very same way as gay, lesbian, bi, and transsexual people have long been told that their failure to be was similarly a "mental imbalance" or a mental illness.

Being a fat admirer can also cause problems in the business world, where having a fat partner (like having a same-sex partner) can be a terrible professional liability even if no one is usually honest enough to come out and say it in so many words. Gauging a person's power or status by judging the social value of their partner or spouse hasn't disappeared, after all. The common currency for politically and socially advantageous romantic relationships might once have been an aristocratic pedigree, but today it is the degree to which the partner conforms to a given standard of beauty and sexiness. The idea of the "trophy wife" is a familiar one to all of us, and we're all quite used to seeing aging rock stars, rich businessmen, and Hugh Hefner-types with their habitual complement of ultra-fashionable, super-slender, conventionally gorgeous arm candy whenever they appear in the media. It's not that these exotic lovelies are drawn to these men for their physical prowess or Adonis-like good looks; it's simply that money and power talk, and so does whatever the culture deems as "physical perfection." Often they talk primarily to one another.

Having a conventionally beautiful (and this means, among other things, slender) partner is often a form of conspicuous consumption – "Look what I've got!" – or a sort of plumage display. As much as many people will try to pretend that business relationships are not social, and that promotions and hirings are based on merit and experience alone, this just isn't always true. Other factors come into play. When one's co-workers and superiors gauge your taste, your ability to achieve, and your social mobility by how much your partner conforms to the mainstream ideal, having a partner who does not conform to that ideal can create

problems – even if the disapproval, as it often does in these cases, remains unspoken.

There is considerable potential for Fat Admirers of any type to face a lot of social and professional disapproval for their partner choices. For a queer-identified FA, the combination of sexual orientation and body size preference can be a real one-two punch. While it can be discouraging both to FAs themselves as well as to their partners and potential partners that they live their lives in the closet, it's also not all that hard to understand why it can seem compelling for them to do so.

Because a lot of FAs spend many years hiding their desires, they, like a lot of fat people who find themselves excluded from the teen dating scene, may not get the benefit of the usual adolescent grope-and-fumble learning curve. They may suddenly find themselves in their twenties or thirties, finally able to acknowledge their attraction to fat partners, but without the social skills or the social practice to handle flirting, dating, and forming relationships with grace, tact, and savoir-faire. The wobbly insecurity and "oh God, what do I do now?" feelings that many people go through in junior high or high school are no less scary and no less intimidating when one faces them later in life! This can result in relationships that are clumsy and not too satisfying for either partner – and that's without even considering the sexual end of things.

As a result, a lot of fat people and a lot of FAs end up going through a sort of "second adolescence" when they discover a size-accepting partner or a community in which they can show their true selves. This "second adolescence" is another one of the things that a lot of FAs share with queer-identified people, many of whom don't truly experience their sexual growing-up until they finally find themselves in a community where they are free to express their sexual attractions without fear of censure. During this coming-out process, FAs often end up cutting a wide swath, sampling relationships with different people with the same degree of delight (and about the same degree of discrimination) as a kid set loose in a candy store. This can be a wonderful experience, but it can also be problematic: it's easy to hurt people's feelings by being fly-by-night, and easy to end up with a history of unsatisfying relationships and a bad reputation as being undependable or only in it for the nookie. Also, given the current HIV/AIDS pandemic, running rampant sexually isn't terribly sensible in terms of sheer health and wellness, no matter what community you're doing it in: fat people get AIDS too. "Second adolescences,"

as deliriously delightful as they may feel, are best approached with a bit of grown-up sensibility and sound judgement.

It bears mentioning that this sort of thing isn't the experience of every FA, and neither is it the experience of every gay, lesbian, bi, or transsexual person. Many people do find ways to assert their preferences early on and lead their lives with pride, despite the fact that mainstream society doesn't necessarily approve. But there are a lot of FAs, particularly those whose attractions are predominantly or solely focused on fatter partners, who do go through this sort of thing, and these people should know that they are not alone.

Participation in size-acceptance organizations or in organizations of fat admirers often helps fat admirers feel less alone and develop better coping and relationship skills. NAAFA's membership includes a great many FAs who are often ardent champions of size acceptance in all arenas, not just sexual. However, the most far-reaching and cohesive organizations for people who are attracted to partners of size exist in the gay men's community, testament to the gay community's invaluable knack for organizing socially and politically around commonalities of sexual preference. (More about these organizations and specific listings can be found in "Chubbies and Chasers and Bears, Oh My!" and in the Resource Guide at the end of the book.) Fat admirers of other sexual orientations would probably do well to follow this model: the isolation and invisibility felt by many people who have non-mainstream sexual preferences can be alleviated quite a bit by simply finding other like-minded people to talk to. Not coincidentally, having a reasonably identifiable group of fat admirers around also makes it easier for fat people who want to find fat-admiring partners to do so – clearly a win-win situation.

After discovering that Fat Admirers exist, many people of size deliberately set out to try to meet a self-identified FA in the hopes that they'll finally meet someone who will desire them as a person of size. While this is one way to meet a fat-accepting partner, it's far from the only way. Remember, not all Fat Admirers are out of the closet about their preferences, and not all people who are attracted to fatter partners, or who have the potential to be attracted to fatter partners, feel the urge to identify as FAs or Chubby Chasers. Just because a fat person meets someone who is known to like fatter partners is not a guarantee that they will be appropriate partners for one another, or even that they'll be attracted to one another. Some fat people may feel that their own preferences don't matter as much as finding a person who will find them desir-

able, but going into a relationship where the attraction isn't mutual is a recipe for disaster. Just because you're fat doesn't mean you don't get to have preferences too.

Generally speaking, relationships based solely or primarily on physical factors have a tendency to fizzle out fast. This is particularly true if the physical attraction is one-sided. Relationships that last are sustained by similar interests, shared tendencies and beliefs, the ability to have good conversations and communications, and many other factors. This is not to say that there aren't fat person/FA couples in which all those things do happen. Far from it. There are fat person/FA relationships that are rich, full of shared joy, and that last for decades, but in most cases, the fact that one person is fat and the other is an FA is ultimately the icing on the cake, rather than the cake itself.

Seeking out an FA in the hopes that something will click is a passive-aggressive strategy for finding a relationship: there's something to be said for fishing where the fish are, but for a fat person to just go to an event where they know there will be fat admirers and waiting for someone to pick them up isn't as likely to net them the same quality of partners that they might find by doing a little active hunting of their own. Your interests and desires are just as important as your partner's, after all! When you're trying to find a partner, you shouldn't feel as though you're applying for a job where you have to prove your usefulness and worth in order to be hired, but rather approach it as a process of meeting people to see whether one of the people you meet seems to be someone with whom you can build a mutually satisfying relationship.

When a person of size chooses to present him or herself only (or primarily) to FAs, it has the undesirable side effect of considerably narrowing the pool of potential partners. As has already been noted, the community of out-and-proud Fat Admirers is rather small – much smaller than the total number of FAs, people with some FA tendencies, or those who are simply attracted to a wide range of body types. Yes, it is more likely that a person of size will find someone who is highly physically attracted to them if they seek out an FA partner, but that's not to say that won't happen at random. No person of size should feel that they have to go and present themselves to people already known to be tolerant of and/or desirous of fatter partners in order to find a partner. Fat people find partners in the same way that thin people do, by being out in the world and striking up conversations with people they find attractive

(you can even flirt a little... it doesn't hurt). One never knows when a casual chat might be the beginning of a beautiful relationship.

In the next few sections, we'll explore some of what's out there for people of size and their admirers in the heterosexual, gay male, and lesbian communities, including information on size acceptance groups, social events and gatherings, and numerous resources for people of all sexual orientations who are looking for support, camaraderie, and friendship. There are also some reflections on bisexuality and transsexuality in relation to size issues, and a brief section on sex, people of size, and the Internet (the new sexual vistas opened up by the Internet could fill several books of their own!). For more information on individual groups, services, magazines, organizations, and so forth listed throughout this chapter, consult the Resource Guide at the end of this book.

THE STRAIGHT WORLD

For men and women of size and those who admire and love them, there are a great number of opportunities to meet up with potential partners. The everyday world provides a plethora of chances, as it does for everyone, but there are also organizations like NAAFA and the ISAA, numerous groups around the country that put on socials and dances for big people, and, of course, the Internet.

Size acceptance organizations, as was noted previously, are not primarily designed to provide people with opportunities to meet partners. But as with any other organization, people do meet up under their aegis. NAAFA is widely thought of as being primarily heterosexual and as not being particularly welcoming toward the non-heterosexual community, and while NAAFA does not discriminate against anyone on the basis of sexual orientation, it is nonetheless true that the vast majority of the participants at NAAFA events do appear to be heterosexual. However, there are often non-heterosexual people at NAAFA events, most frequently bisexual and lesbian-identified women, and they are usually treated with friendly respect.

There are numerous organizations that produce social conferences and events for the size-positive community outside of politically-inclined size-acceptance organizations like NAAFA and the ISAA. Local and regional dances are found in many large metropolitan areas all over North America, including the Large and Lovely and Big Sensations dances in

Massachusetts, Big CONNnections dances in Connecticut, the God-
desses dances in New York City, and similar dances in cities as diverse
and remote as St. Louis, Los Angeles, Minneapolis, and Atlanta, to name
just a few of the cities with regular BBW/FA social functions. For the
most part, size-positive social events tend to be geared toward BBWs
and male FAs unless otherwise indicated. As of the present time, we have
been unable to find any hetero-oriented social events which focus on big
men and their heterosexual female admirers, but people of all genders
are generally welcome at size-positive social events. Listings of these
social events and organizations can be found in many places, but one of
the most reliable places to find recently-updated listings of events for
heterosexual people of size and their admirers is at the *Dimensions* maga-
zine website.

 Dimensions magazine itself is an odd hybrid of quasi-fetishistic
girlie mag and size-acceptance gazetteer which, while focused on the
desires of the heterosexual male FA (and with a healthy supply of scant-
ily-clothed models in its numerous pictorials), also contains useful size-
related news and information for people of all genders and orientations.
Dimensions also regularly runs a column by a female FA, and has regular
women-oriented columns and features on topics such as large-size fash-
ion, but overall the magazine is geared toward male FAs, many of whom
seem to be of the "bigger is better" mentality.

 This has its advantages and its drawbacks: it does indeed provide a
much-needed forum in which straight male FAs can see women who ap-
peal to them in a magazine, a clearinghouse for size-positive information
and views, and a place to run a personal ad where looking for a big part-
ner is the norm rather than the exception. However, and particularly on
a visual level, it also presents fat women primarily as sex objects, a posi-
tion which is not necessarily truly supportive of fat women as human
beings. This is at issue in *Dimensions* particularly because of its pro-feeder
stance, and the frequent inclusion of feeder erotica, a type of erotica which
has a particularly fetishistic and objectifying take on fat women's fat and
their bodies generally (for more on feeders, please see the section on
feederism in Section Six: Titillations and Tactics). Like most magazines
whose sexual content is aimed at heterosexual men, it also tends to per-
petuate an uneven power dynamic in which men are the "active" partner
(they are doing the looking, and the magazine is very obviously designed
with their visual pleasure in mind) and women are mostly passive and
present in order to give pleasure to men.

This isn't necessarily a bad thing *per se*. Fantasy and arousal are wonderful things, and so is appreciating the beauty of women whose beauty is not always appreciated in mainstream society. However, when we bear in mind that women generally, and fat women specifically, are already subject to a lot of societal pressure to be passive, silent, and perennially available to men, it is understandable that many people find it embarrassing, offensive, and socially and politically problematic when women are portrayed in ways that overtly glorify this sexually objectified, passive, and manipulable status. This is a valid and frequent objection that many people have to pornography and sexualized images as a whole, and in all fairness, it must be added that *Dimensions* is far from the only magazine on the market, or even the only fat-specific magazine on the market, in which this is a problem.

Problems and politics aside, Dimensions and related magazines – like the new British magazine *Belly* and the American periodical *Plumpers and Big Women* – are great, if one-sided, resources for heterosexual male fat admirers. *Big Butt* magazine, which is edited by a woman who goes by the fancifully lewd name of Mendi Teats and is predominantly written by women as well, tends to have a much sassier attitude. The content is still very obviously aimed at men, but the way in which the magazine is edited and put together gives the impression that the women involved in the magazine are presenting themselves to show off their bodies and sexuality for their own reasons, on their own terms, and with a very healthy sense of humor – a sensibility which makes the magazine all the more appealing.

Magazines like *Big Butt*, *Plumpers and Big Women*, *Belly*, and *Dimensions* can also be very empowering for some women. A woman of size chancing across a copy of one of these magazines at a friend's house, on a newsstand, or at a fat people's gathering may get her first exposure to the notion that there are people who consider bodies like hers to be wonderfully desirable. Many women also find out about FAs for the first time through these sorts of magazines – and given that most fat people grow up being told that no one will find them attractive because of their size, this alone can be a life-changing piece of information to absorb. Particularly for women whose sexual self-confidence is very low and who have trouble believing that anyone could find them beautiful and desirable, the knowledge that someone *might* may provide a vital glimmer of hope and rekindle a flame of self-confidence that will help them heal and blossom as human beings.

Right now, there are no sex-related publications designed for female fat admirers, but then there's very little in the way of mainstream sex-related magazines that's aimed at heterosexual women, period. Women, and particularly heterosexual women, are still "not supposed to" enjoy sex, and especially pornography, to the degree that men are "supposed to." That women do in fact often enjoy sex, erotica, and pornography accounts for the proliferation and success of women-oriented sex boutiques, erotica and pornography produced by women, but these enterprises, like the all-orientations fat sex 'zine *Zaftig! Sex for the Well Rounded*, are still on the fringes of the mainstream business and publishing worlds.

Like most other pornography, the majority of what is available in terms of video porn is designed to appeal to the men who form the bulk of the porn market. However, straight female fat admirers may find something they will enjoy in the video offerings provided by Maximum Density Videos, a company which primarily deals in gay men's videos but which does carry some videos featuring heterosexual sex. For the female fat admirer, the gay men's porn videos available from the same company are also an option – not heterosexual in content, but for all that, twice as many (or more) of the hunky big lads that many female FAs adore. Wild Bill Videos, with their focus on big breasts and butts, and videos available through the *Dimensions*-affiliated Vendredi Enterprises are some of the best sources for heterosexual-content, fat-oriented videos. Do, however, bear in mind that it is almost always only the women in fat-related sex videos who are fat, and that their size is not always treated respectfully even though they are presented as objects of sexual interest. Many fat women find it very alienating and offensive to be presented with images of other fat women which someone insists are supposed to be sexy, but which to them seem merely objectifying, disrespectful, and embarrassing.

Couples who want to watch porn together would probably do well to start with videos from woman-positive companies like Fatale Video (many of whose videos show people with a broader range of body types than the usual porn industry standard-issue skinnies) and work their way up to other types of porn that some women might not be as comfortable watching right off the bat. Good Vibrations, a woman-positive, size-friendly sex toy and bookstore based in San Francisco, boasts a wonderful catalogue of videos that have been individually reviewed and rated by their staff, including information on what tapes are best for couple view-

ing. They do not specialize in plus-sized porn, but their friendly, helpful approach to women's sexuality and pleasure makes a Good Vibes visit (they also have a website and a paper catalog) a great place to begin for couples who are interested in exploring video erotica together.

Online, there are two high-traffic and very well-known sex-positive email distribution lists, the FatSex mailing list and the Fat BDSM mailing list, both run by Yohannon, a noted Fat Admirer, size-acceptance and fat people's sexuality activist. Both have been in existence for quite a long time and are open to women and men of all sizes and orientations, though the traffic is primarily heterosexually oriented. Information on these can be found at the Rotunda website, www.rotunda.com (see Resource Guide). There are numerous other sexually-oriented email distribution lists that are geared toward people of size, but these two are among the longest-lived and most dependably moderated and maintained. More on email lists and the size-positive, sex-positive community can be found in the "Fat, Sex, and the Internet" section.

Many people also like to use personal ads. There are numerous newsletters and websites that consist primarily (or exclusively) of personal ads aimed at the size-positive community. *Loving You Large Newsletter* is a print newsletter of personal ads exclusively for big people and their admirers, and there are numerous similar resources available online, including *BBW Friendly, Large and Lovely Personals*, and *Generous.Net*. A discussion of personal ads, and how to use them to your best advantage, can be found in the section called "Making Personal Ads Work For You." For more information on the resources mentioned in this section, please see the Resource Guide at the end of this book.

CHUBBIES AND CHASERS AND BEARS, OH MY!

In the words of writer and sexuality activist Joël Barraquiel Tan, "If fat is a feminist issue, then fat or heft is a fetishized one for gay men. Gay men have a tendency to sexualize difference where lesbians have historically politicized it." This statement, while perhaps a little overly simplistic, is nonetheless very true in terms of how the gay male and lesbian communities treat issues of body size differently.

Gay male culture, like heterosexual male culture, tends to be very visually oriented and body-conscious when it comes to conceptualizing attractiveness and sexual desirability. Some of this body-consciousness

derives from gay men's porn, and perhaps specifically from the "physique" and bodybuilder magazines that were the chief sources of gay male erotica for decades before the gay rights movement gained steam. We now see a similar attention to beautiful men in the heterosexual world, as images of buffed and impossibly beautiful young men become a routine counterpart to similarly glossy fashion-magazine images of super-slender, impossibly perfect young women. As a result of intense body consciousness in the gay community, there is now a very high level of body dysphoria, eating disorders, and obsessive-compulsive diet and exercise behavior among men, analogous to the kinds of eating disorders, body-related self-hatred, and obsessive-compulsive dieting and exercise that have long plagued women who likewise want to be as beautiful as the idealized figures they see in fashion magazines, movies, and television.

The "body beautiful" image is so highly emphasized and so highly valued in gay male culture (as it is for straight women) that many fat gay men feel like they don't stand a chance of having any romantic or sexual success. Physical perfection is the coin of the realm in many gay communities, and those who fall short are often left by the wayside. Fortunately, gay men have never been shy about making even their most idiosyncratic sexual preferences perfectly clear. A subculture of fat gay men and their admirers has come into being that not only tolerates fat men, but enthusiastically embraces them with enthusiasm, rampant libidos, and sensual delight.

The world of big and fat gay men and their admirers is broken up into two general, but not mutually exclusive, groups based on physical characteristics. Chubbies and Chubby Chasers are fat gay (and/or bisexual) men and the men who admire them. Chubs may be of any size of large, and may have any combination of other physical characteristics in addition to their size – facial hair or no facial hair, androgynous gender presentation or masculine, trendy and fashionable or given to a more rugged wardrobe, or what-have you. Being a Chub or Chaser doesn't necessarily say anything about a man's sexual practices aside from his preference for other men – what kinds of sex a man enjoys, what kinds of roles he takes or doesn't take, are matters of individual preference unrelated to size.

Sometimes, a Chub is also a Bear. Bears are big/fat gay (or bi) men who tend toward an archetypally masculine appearance. Most Bears are –

no surprise – furry, wearing beards and/or moustaches, and enjoying and flaunting their body hair. The "Bear wardrobe" also tends to be distinctive, with many bears preferring jeans and t-shirts or work-shirts, leather jackets, and other traditionally "masculine" or rugged gear. The "Bear" nomenclature has become rather extensive, with a whole jargon of its own. A somewhat older Bear man with some gray in his hair might be called a "Grizzly bear," a Bear man whose hair was entirely white or gray might be a "Polar bear," whereas a younger Bear who was smaller in size or girth might refer to himself as a "Bear Cub." The Bear community is also somewhat allied with the BDSM or leather community, but it would be incorrect to say that every man who identifies as a Bear is necessarily interested in BDSM sexuality.

In general, then, we can say that most Bears are also Chubs, but not all Chubs are Bears. Partly for this reason, Chub/Chaser groups exist independently of Bear organizations, though they do share some common ground. Most Chub/Chaser groups – like the many Girth and Mirth groups which exist in numerous cities across North America – and Bear organizations are primarily social organizations, without spending much or any time on size-acceptance efforts or politics in the larger community. Affiliated Bigmen's Clubs, Inc., of San Francisco, is an umbrella organization that tries to keep Chub/Chaser and Bear groups in touch with one another, helps people start clubs, keeps a calendar of regional events, and helps put on a national Convergence (convention) each year which draws hundreds of big gay men and their admirers. Individual Chub/Chaser groups and Bear groups also sponsor numerous weekend retreats, club nights, parties, and other events for their members across the country and around the world. In many big cities with sizeable gay populations, there are also gay bars which are frequented by Chubs and Chasers, the most famous of which is San Francisco's Lone Star Saloon.

For many gay men, finding a Chub-friendly environment is an eye-opening, life-changing experience, whether they are fat themselves or attracted to fat partners. Many fat gay men go through life feeling that they will never have a chance to have the kind of sexual or romantic lives they dream of because they are fat, and they are all too aware of how harshly much of the gay world treats those who are not paragons of conventional beauty. For some men, Chub/Chaser and Bear culture provides a safe haven and an opportunity to be found desirable for the first time in their lives as fat men and as gay men. For other men, it's a chance to

openly show their love and lust for the men they find most attractive, without fear of ridicule or ostracism. Many men have rich, wonderful memories of what being in Chub/Chaser spaces has been like for them.

> *"One birthday, I treated myself to a vacation in San Francisco. I went alone, and arranged it so I'd be there for Gay Pride and the Fourth of July. I was shopping one day and went to the Lone Star Saloon approximately 4 p.m. that day for the first time. I ordered my first drink, and before I could "check out the scene," I was approached and hit on. Next thing I knew, I was the center of attention and could choose my poison. That day I learned what it's like to be attractive and desired."* – Viking Treasure

> *"[After posting an ad and picture on a gay gainers/encouragers website] I went from feeling sexually isolated to being a "pin up boy" overnight. I received hundreds of emails requesting pictures and/or casual sexual encounters. After following up on a few, I found that I wasn't getting much enjoyment out of being someone else's object of desire with no emotional/intellectual connections... I discovered just how 'old fashioned' I really am in some ways!"* – Mike G.

Chub/Chaser and Bear culture, like other segments of the gay male community, have created quite a bit of their own specialized reading material and pornography. Magazines like *Bulk Male*, *Bear*, and *American Bear* are available, as well as videos from Brush Creek Media, Maximum Density Videos, and Chubnet Productions. ChubNet, an exemplary and well-maintained website maintained by Larry Zagurski and Jim Close at *www.chubnet.com*, is an extraordinarily comprehensive resource for big gay men and their admirers that has been around for a long time and offers services from online personals to online shopping, with everything in between. ChubNet also maintains the most comprehensive listings of regional and local big men's clubs and Bear groups. Information on ChubNet and other Chub/Chaser and Bear resources can be found in the Resource Guide at the end of this book.

LESBIANS AND THE BODY POLITICAL

Lesbian culture has long been entwined with feminist culture. Although there are apolitical lesbians, much, perhaps most, of lesbian cul-

ture is informed by feminist and progressive politics. This is, and has
long been, one of the great strengths of the lesbian community as a whole.
The lesbian community's intense feminist-driven awareness of oppres-
sion and social injustice has led to a great deal of important work in terms
of identity politics, social change, and examining and understanding the
political and sociological underpinnings of prejudice and oppression on
the personal level as well as the cultural.

One of the issues of oppression that has always been a source for
discussion in the lesbian and feminist communities has been the politics
of appearance, including body size and weight issues: as the title of Susie
Orbach's popular book put it, *Fat is a Feminist Issue*. This is true, insofar
as prejudice on the basis of physical appearance and conformity to an
image that is considered desirable by men is definitely a feminist issue.
Fat itself, however, affects men just as much as women, and it is a com-
mon mistake to think that fat men's lives are not affected as deeply and
powerfully by size and weight issues as women's are.

Feminist and lesbian culture have made a valiant effort to encour-
age people to be sensitive to, but not prejudiced about, issues of physical
and cultural difference. The effort to create a world in which people are
able to appreciate and enjoy the full spectrum of humanity is an honor-
able and meaningful one, and in the feminist/lesbian community, women
of a wide range of body types, shapes, appearances, and personal styles
are often able to coexist together, appreciating one another's uniqueness
and appeal. This is not to say that the lesbian or lesbian/feminist world
is an utopia for fat women or anyone else, but the way in which lesbians
and feminists have treated difference – as a political issue that is due for
personal and cultural redress – has meant that appearance, including size
and weight, is less often a source for harassment or prejudicial treatment
in the women's community.

At the same time, fat is still a hot button for lesbians, as it is for
almost all women. Gay women are raised in the same culture as everyone
else, and so they grow up with body size and weight as sources of con-
flict and self-doubt just as straight women do. Despite the fact that the
women's community deliberately avoids demonizing fatness in the way
the straight world tends to, and leadership in the women's community is
more often derived on basis of merit and willingness to work than the
kinds of extraneous appearance-related factors that might govern similar
decisions in the straight world, biases in favor of thinner women may

nonetheless manifest in all the usual social, organizational, and hierarchical ways. It seems fair to say that the women's community has indeed lessened prejudice against fat women on the whole within its boundaries, but that despite everyone's best efforts, prejudice on the basis of size still exists at both the community level and in individual women's lives.

Fat lesbians also face the problem of fitting – to one degree or another – the outward face of the stupid and boorish straight stereotype of the "fat and ugly" woman who becomes a lesbian because she's "too fat and unattractive to get a man." This is particularly infuriating in light of the fact that many lesbians, just like gay men, bisexuals, and fat admirers, have known that they had non-mainstream sexual attractions since childhood, and body size, quite simply, doesn't necessarily have anything to do with whether or not a woman becomes a lesbian. But the hateful stereotype still lingers, and it still stings. Some women thumb their nose at the stereotype, taking the attitude that since they don't want men to find them attractive, they're all the happier to be "fat and ugly" in straight men's eyes. Many gay women enjoy a significantly better body image overall than straight women or gay men, simply because there is not the same kind of pressure put on them in the lesbian community to conform to unrealistic body images in order to be found sexually attractive.

While the fat gay women interviewed for this book all agreed that they tended to fare better as fat women in the women's community than they did in the straight world, they all also agreed that there is a certain amount of size discrimination in the lesbian community, and that, furthermore, the community isn't always honest about its own lack of size acceptance. Living in a community where progressive politics are an important part of the shared culture, and where the "party line" (not that such a thing literally exists) holds that every woman is beautiful in her own way, there can be a lot of shame associated with still having internalized prejudices, like internalized homophobia or internalized fear of fat. "If I had a dime for every dyke I know who says 'All women are beautiful' and 'Isn't it awful how many women develop eating disorders so they can conform to the beauty myth' when they wouldn't be caught dead dating someone as big as me and they're working out 7 days a week and dieting and counting fat grams and everything, I'd be rich," said one woman, who asked that her name not be used.

The truth is that looks *do* matter to lesbians just as they do to other people, and there are codes of beauty and attractiveness in dyke commu-

nities just as there are in any other. Despite the genuine gains made by
the lesbian-feminist community in realizing a more physically egalitar-
ian culture, weight and size prejudice do exist among lesbians as well as
in the wider feminist community. It's impossible, after all, to be a cul-
tural island, completely walled off from the messages and teachings of
mainstream culture, particularly when a lot of the things women learn
about size, weight, and their bodies are instilled during childhood.

The progressive politics of the feminist and lesbian-feminist com-
munities have made them the breeding ground of much size-acceptance
activism. In the 1970s, the early size-rights group called the Fat Under-
ground originally arose out of the feminist movement, and the feminist
anthology *Shadows On A Tightrope*, an early call-to-arms about size dis-
crimination, is a book that still helps to propel the size-acceptance move-
ment today. The Feminist Caucus is still a strong special interest group
(SIG) within NAAFA. There are regular conferences of fat feminists on
both the west and east coasts, with the west-coast Fall Fat Women's Gath-
ering being the most regular and visible.

On a national level, the New York-based National Organization of
Lesbians of Size held their first national conference in 1999 in Kingston,
New York, which drew women from across the country. Also in evidence
were members of several local support and social groups for fat lesbians
and bisexual women such as the New York City-based Fat is a Lesbian
Issue (also known as FLAB) and Full Bloom Women, a lesbian-friendly
fat women's group from the southern New Jersey/Philadelphia area.
Other areas of the country have similar social and support groups for fat
women and for fat lesbians, including Seattle's fabulous SeaFATtle orga-
nization (not exclusively lesbian) and the associated Sisters of Size group,
also in Seattle, a support group especially for fat lesbians.

As of this writing, there is no official network of regional and local
lesbian and/or women's community groups that deal with size and fat
issues, but many such groups can be located through the National Orga-
nization of Lesbians of Size. Another valuable resource available to fat
lesbians regardless of their location is the "fat dykes" email listserv, to
which any lesbian of size (or supporter) may subscribe. (Further infor-
mation on the resources mentioned in this section can be found in the
Resource Guide at the end of the book.)

Notwithstanding the many wonderful organizations and groups
available in the women's and lesbian communities that are size-accepting
and fat-friendly, sexuality around size issues has historically been far less

visible in the lesbian community than it has been in the heterosexual or gay male worlds. For several years, there was a fabulous, San Francisco-based 'zine called *FatGirl! A 'Zine for Fat Dykes and the Women Who Want Them*, a treasure trove of fat lesbian erotica and images. However, due to the fact that independent publishing can be a really efficient means of losing money, *FatGirl!* is sadly no longer in publication, though parts of its website are still in existence (see Resource Guide). While it existed, *FatGirl!* was sassy and sex-positive testament to the fact that there are indeed fat-admiring women in the lesbian community, as well as confident, sexy big dykes and bi women who aren't the slightest bit hesitant to strut their stuff.

For many reasons, in part the political climate in the women's community that tends to frown on using physical characteristics as a basis for judging a person's value or worth, there's no easily-identifiable fat admirer community in the lesbian world. This can be a source of frustration, both for gay women who are chubby chasers and who often feel quite alone in their preference, as well as for lesbians of size who wonder whether women who really get turned on by big women's bodies really exist. They do – there are fat admirers of all genders and orientations – but without an easy way to identify themselves and within a community which tends to discourage sexual objectification based on physical characteristics, it can be hard for dyke chubby chasers to make themselves and their preferences known, and likewise difficult for fat dykes who might want to explore a relationship with a fat-admiring partner to know they're there.

BI AND LARGE

Bisexuals come in all sizes, including large. They also come in all genders, and can have many different preferences in terms of their partners' bodies and physical characteristics. Many people who are heterosexually identified are behaviorally bisexual – meaning that they sometimes have sexual relationships with people of the same sex – and so are many people who identify as homosexuals, who may sometimes have relationships with partners of the opposite sex. There are bisexuals who are equally attracted to men and women, bisexuals who are attracted much more to one sex than the other, and some people for whom gender is not a limiting factor and who find themselves attracted to people regardless

of whether they're male, female, crossdressers, transsexuals, or differently gendered in other ways.

The bisexual community, which is nowhere near as large as the gay or lesbian community in terms of its public presence (the public presence and organized presence of a group of people does not necessarily reflect the numbers of people who could rightly be said to be members of that group), does not at present support many resources for people of size. One of the few resources that is explicitly both bisexual in orientation and size-friendly is the Bi-Fat Admirers email list, which lists its subscription information at the following website: *http://www.sub-rosa.com/lennier/*. In general, however, bisexuals have to make their way in either straight events or gay events, or create their own bi-friendly events and spaces. It should be noted here that NAAFA events have often proven very friendly to people of all orientations, including bisexuals.

TRANS, GENDER, AND SIZE

As the transgendered/transsexual community and its issues become more and more a part of public awareness, so do transgendered/transsexual people of size. Though many people presume that thinness and trans identification go hand in hand, it's worth remembering that many visible and/or successful trans persons are fat – consider the unapologetically fat and much-missed drag film star Divine (*Female Trouble, Pink Flamingos*, etc.) or the 300-pound Belgian TV personality and drag goddess Dille (né Rene Scheppers). In truth, there are many people of size who are transvestites or crossdressers, transsexuals, drag queens or kings, or who are intersexed or intergendered in various ways.

Fatness, and the physical characteristics associated with it, may be a real asset to transvestites or transsexuals when they are dressing to "pass" as a person of a different gender (not all trans persons want to pass, or try to). This is particularly true for male-to-female transpersons, who often find that being fat gives them more flesh to mold into feminine curves using a girdle or corset. In particular, men who have fat deposits in their breasts can achieve lovely realistic cleavage with a minimum of fuss. Heavy men also have the edge in terms of being able to create womanly hips out of whole cloth when they have an abundance of "cloth" with which to work – simply putting on a waist cincher to re-

shape the midsection has a far more pronounced effect when there is a more flesh for that waist cincher to push around and reshape.

However, female-to-male crossdressers or transsexuals of size often find that their female fat distribution patterns may make it doubly difficult for them to disguise their sex effectively or easily. Big-busted women, even if they go braless and let their breasts sag down toward tummy level, are often harder to take for men than women with smaller breasts who can bind them flat. However, women of size who are trans-identified aren't always at a disadvantage. Apple-shaped women, with big bellies and small breasts, have a definite edge in terms of having a body that is easily presented as androgynous or masculine, particularly if they also have broad shoulders or a large frame. The very same body shape that can be a bane to women who wish to appear classically feminine can be a real asset to F-to-M [female to male] crossdressers or transsexuals.

It bears mentioning that every transperson, fat or thin, goes through a certain amount of trouble in figuring out the best ways to make their body appear to be the gender they choose to present, or to make it not present an easily identifiable gender at all, as some trans-identified people prefer. Bodies being the quirkily individual things that they are, every person who wants to modify their outward appearance, particularly in terms of gender signifiers like breasts, hips, and so on, has to figure out tricks that work for them and their own individual body size and shape.

It's worth noting here that boutiques which cater to male crossdressers are often wonderful places for plus-sized women to shop for lingerie, fetish clothing, hosiery, and high-heeled shoes in larger sizes and wider widths. It is usually easier for big FTMs to find larger sizes in men's clothing than it is for MTFs to find similar size ranges in women's clothing. Men's clothing tends to run in a much broader size range and to be cut in less body-conscious shapes, making it easier to find clothes that not only fit, but which fit in ways that help to maintain the outward appearance of the wearer's preferred gender.

QUEER ACCEPTANCE AND SIZE ACCEPTANCE: NOT-SO-STRANGE BEDFELLOWS

At various points in this book, the issues and prejudices faced by people of size and Fat Admirers have been compared to similar issues

and prejudices faced by gay, lesbian, bisexual, and transgendered people. This may make some heterosexual readers a little uncomfortable. It can be hard to think about yourself and your life having things in common with people whom you may ordinarily think of as being fundamentally different from you, and whose difference may be a source of some social or moral difficulty for you. But prejudice is prejudice, and oppression is oppression. Being sexual as a fat person or as a fat-admiring person has a lot of parallels to being sexual as a non-heterosexual person. There are also a great many useful parallels between the size-acceptance movement and the struggle for queer liberation, parallels from which the size-acceptance movement could well benefit in terms of gathering support and formulating strategy.

The primary thing that characterizes "queer" sexuality is not the gender of the people involved in any given sexual act. After all, a heterosexual couple is physically capable of performing every sort of individual sexual act that either a gay couple or a lesbian couple could perform: queer folks have no monopoly on specific sexual activities. What makes a relationship or a sexual act "queer" is not so much what it is but who does it. "Queer" sex is sex that involves "queer" people, "weird" people, people who are "not supposed to" be sexual or deserve love and desire according to mainstream standards and expectations.

Fat people, regardless of their gender or orientation, are "not supposed to" be sexy, "not supposed to" be sexual, and are, according to the myths of mainstream culture, not really "supposed to" be whole people with whole lives, all because they are fat. Similarly, people who are attracted to fat partners are "abnormal," as odd and unsettling to many in the mainstream as men who love men, women who love women, or transsexuals who choose to live as a gender other than that with which they were born. If we think about what it really means to be "queer," any sex involving a fat person is by definition "queer," no matter what the genders of any of the partners involved.

In many people's eyes, a sexual act that involves a fat person is worthy of hatred and disgust simply because it involves someone who is not thin. When mainstream society tries to dictate who is and who is not worthy of being sexual and having sexual lives, it compromises both sexual freedom and social justice. Saying "fat people having sex is disgusting and wrong" is not fundamentally any different from saying "people over sixty having sex is disgusting and wrong," "two people of the same sex having sex is disgusting and wrong" or "two people who are not married

having sex is disgusting and wrong." Human beings are sexual. Sexuality that is consensual, pleasurable, and mutually-desired is not wrong, it's a part of our biological, emotional, and social birthright, no matter who we are or how much we weigh.

The group SeaFATtle, an organization of fat and size-accepting women of all orientations based in Seattle, Washington, vigorously supports the rights of both gay and fat people to live lives free of institutionalized social and professional harassment and oppression by trying to raise awareness of gay and fat people's shared points of struggle. The following is the text of a wonderful flyer, handed out by SeaFATtle members at the 1999 Seattle Gay Pride celebration to educate and inform people in these two possibly disparate-seeming communities about issues they have very much in common.

> So why is an organization with a name like SeaFATtle showing up at the Pride rally year after year, aside from the fact that we have bisexual and lesbian members, not to mention straight members who are definitely not narrow?
>
> The reason, other than that it's a real blast, is that fat people and lesbian, gay, bisexual, and transgendered (LGBT) people are in a similar position in the eyes of mainstream society. Pride Day is a great opportunity to educate people about this, but more importantly it's a chance to stand with our LGBT friends in solidarity against prejudice, and to demand fundamental human rights for all of us. As long as any of us are oppressed, none of us are free - and the only way to win this fight is by joining in it together.
>
> How are fat people and LGBT people similar?
>
> 1. Discrimination against both LGBT people and fat people is mostly still legal. Only in Michigan and Santa Cruz County in California is it illegal to discriminate against fat people. Only in a few areas around the country is it illegal to discriminate against LGBT people. Homophobia and fatphobia are not only institutionalized, but publicly defended and proudly proclaimed. Racists and sexists at least have to work indirectly these days.
>
> Most people believe that both being fat and being gay is a matter of personal choice. This is true in a sense – what we all choose is to have a fully human life. If you are lesbian or gay, it's possible to maintain "normality" by marrying someone of the

opposite sex and performing feats of imagination that enable you to function sexually often enough to reproduce. You'll be expected to suppress all evidence of a fundamental part of your personality, all the time. Never mind that your soul dies.

All you have to do is recognize that you are subhuman and not entitled to a sex life that fully involves you at all levels. "Ex-gay" John Paulk does it, doesn't he?

If you are fat, and no more than 30-80 pounds heavier than average, it's possible to maintain "normality" by cutting your caloric intake to approximately half of the average intake (often to levels that the UN recognizes as starvation); if you're really heavy, it will be six tablespoons of food per day, and you'll often be expected to undergo dangerous surgery to make sure of that – and in the end, you'll regain weight anyway, so you must continue to gradually wean yourself off food entirely, if possible. Of course, you must also work out a couple of hours every day, and maintain the regimen for the rest of your life. Never mind that your soul dies, nor that your body often dies, too.

All you have to do is recognize that you are subhuman, and are not entitled to spend many of your non-work and non-sleep hours on things like reading to your kids, taking courses to improve your professional status, or other such disreputable non-aerobic activities. Oprah Winfrey does it, doesn't she?

3. Neither fat children nor queer children are safe in schools. Both fat and LGBT kids are targeted for systematic abuse and constant harassment from their peers, destroying their self-esteem and, in too many cases, driven to suicide as a result. Sadly, the harassers are often aided and abetted by those in authority who have been charged with protecting all children.

Teachers tell gay students who suffer years of abuse by their classmates "They'd leave you alone if you just didn't act so swishy."

Teachers tell fat students who suffer years of abuse by their classmates "They'd leave you alone if you'd just lose weight."

4. Both LGBT people and fat people suffer disapproval stemming from American culture's Puritan roots, which have fostered a distrust of pleasure and happiness.

Homophobe: "Homosexuality is morally wrong, because it's about pleasure and not reproduction."

Fatphobe: "Fatness is morally wrong, because it implies eating for pleasure rather than subsistence."

5. Both LGBT and fat people are victims of ignorant and misguided health "information" and so-called "concern" from loved ones that often hurts more than it helps. They say, "Well, even if you aren't concerned about morals, you should be concerned about your health."

Everybody "knows" that being gay causes AIDS, that it's a "gay" disease, and that LGBT people are irresponsible about spreading the virus. Of course, informed people realize that unsafe sex (regardless of one's sexual orientation) spreads AIDS, that 90% of the people in the world with AIDS are heterosexual.

In addition, LGBT people often avoid medical care because they are unwilling to field rude statements about birth control and other personal issues, and because they worry about confidentiality. This means that breast cancer and other serious conditions may not be detected early enough for effective treatment.

Everybody "knows" that being fat causes heart disease, cancer, and diabetes. Of course, informed people realize that inactivity (in someone of any size), poor diet composition (because of dieting pressure, not choice), genetic factors, denial of health insurance and stress related to discrimination cause these health problems, regardless of weight.

In addition, fat people often avoid medical care because they are unwilling to field rude statements about their size and assumed habits, and because many doctors attribute almost every possible problem to weight instead of working on an accurate diagnosis. This means that serious conditions may not be detected early enough for effective treatment.

6. Both LGBT and fat people are subject to weird mythology, because we are so far outside the experience of many people. A couple of examples from the urban legend department:

– There was this emergency room episode in San Francisco–a gay man came in one night to have a gerbil extracted, which was inserted into his anus as a sexual experiment.

— Mama Cass choked to death on a ham sandwich.

If you believe either of these, we have a really great chocolate chip cookie recipe for you, plus the address of a terminally ill child who'd like you to send him a postcard.

7. Both LGBT and fat people are subject to resentment because we dare to live as we please, despite pressures that crush other people into conformity.

Homophobe: "I've been stuck in a 'shotgun' marriage for 20 years; sex with my spouse bores me, and the only person with whom I'm emotionally intimate is my best friend. I'm also trapped in a dead-end job to support kids I never wanted. Those gay people have fulfilling sex, love whomever they want, and spend their time enriching their lives. I hate them, especially the ones who are out and proud, because their very existence mocks my boring life and the sacrifices I make to fit everyone else's expectations."

Fatphobe: "I live on celery sticks and yogurt and spend most of my free time working out. I still don't much care for the way I look, but at least I am closer to the cultural ideal weight than the 10 or 15 pounds heavier that I would otherwise be, and there's always the possibility of cosmetic surgery if all else fails. At least I recognize my faults and keep trying over and over again. Those fat people are obviously eating what they want and spending a lot of their free time any way they please. I hate them, especially the ones who refuse to be ashamed and ugly, because their very existence mocks my boring life and the sacrifices I make to fit everyone else's expectations."

8. Both LGBT and fat people have a set of "things to strictly avoid doing in public." Some examples:

LGBT: expressing affection with a same-sex partner, wearing "funny" clothes, admiring people of the same sex, talking to children.

Fat: eating an ice cream cone, wearing sexy clothes, dancing and flirting, exercising – or NOT exercising.

Granted, the former is more likely to lead to physical danger, but the principle is the same: that total strangers have a right to interfere with your life.

9. Both LGBT and fat people are not given the benefit of current mores and enlightened thinking about social issues (such as it is). We are not considered entitled to the rights and freedoms of modern society; we are expected to live in the dark ages. In the eyes of others:

For people who prefer opposite-sex partners, it's the 20th century, in which marriage is about companionship as well as reproduction. Simply loving your partner entitles you to take advantage of many legal perks, even if one of you is sterile or past reproductive age, or if you just don't intend to have kids.

For people who prefer same-sex partners, it's the 11th century, where conventional marriage is about property and cementing clan relationships, and loving (or even liking) a partner of your choice is strictly irrelevant. If you love an "unacceptable" partner, legal rights and other doors are closed to you, and it's your responsibility to deal with it somehow.

For people who don't gain weight easily and are not visibly fat, it's the 20th century, in which sufficient food is generally available and most work is sedentary.

For people who are visibly fat, it's the 11th century, where most people did day-long physical labor on semi-starvation rations. If you are hungry, you must find a way to ignore it or trick your body, and if your sedentary job requires a lot of your time, it's your responsibility to find the extra time to work on your "weight problem" somehow.

If you still wonder why we're here, we suggest that you think of all the stereotypes you may hold about fat people. Write them all down, cross out "fat" and substitute "gay," and see how you feel about them. Now you know.

[The text of this flyer is reprinted here with the kind permission of the authors, Martha Koester and Marty Hale-Evans of SeaFATtle.]

FAT, SEX, AND THE INTERNET FAQ

What is a FAQ? A FAQ is a list of Frequently Asked Questions, as well as a term used as shorthand to cover any set of instructions, user's manual,

lists of advice and tips, or other sources of information pertinent to any given website, email list, Usenet group, or other online community. Reading the FAQ, or at least knowing when to refer to it, is one of the best ways to avoid being angrily told to RTFM (Read The Fuckin' Manual) by someone you've just irritated with your online behavior. The same is true of this one – using the advice listed here, and visiting the indicated sites that for further information on specific topics, can save you some avoidable mistakes.

What does this FAQ include? This is a bare-bones FAQ on fat, sex, and the Internet. It is not designed to be a complete manual on the Internet or even a comprehensive treatment of all the resources available in regard to sexuality and fatness online. What it will do is make you aware of some of what's out there, why it's important, and how to use it to your best advantage. It will also give you a number of jumping-off points for further exploration online.

Why would a fat person or a fat admirer want to look for sex-related information or communication via the Internet? Why does everyone else, regardless of size, seem to be doing the same thing? It's easy, more or less anonymous, and fun. When you use the Web at home (employers tend to frown on people pursuing their sex lives on company time), it is also a very private and easily accessible way to explore many aspects of your sexuality. It's also available around the clock, and it's reasonably inexpensive. Using the Internet also feels safer than going out to clubs or bars, and is often quite a bit more emotionally (and/or physically) safe than the face-to-face alternatives.

For fat people, it can be freeing to be able to be social in a space where bodies, physical appearance, and weight/size simply aren't at issue. You can be anyone you want to be online, and how much you reveal, or what you decide to tell people about yourself, is up to you. People can get to know you as a witty, intelligent, funny, enjoyable person without regard to your size or weight, and this can be very liberating to people who have had a lot of experiences of being rejected socially for their weight/size before people have even taken the time to get to know them.

It's also easy to build communities around common interests on the net. There are countless size-positive resources on the net right now, and more crop up every day. For people of size and those who are attracted to them, it makes perfect sense to be attracted to a place where

one can find people who have the same interests, concerns, problems, and life issues... to say nothing of people to whom one might be romantically or sexually attracted.

What kinds of size-accepting or size-focused sex-related resources are available on the Internet? The Internet gets bigger every day. It'd be impossible to list everything on the Internet that would be of interest to people of size – not only because the Internet is constantly expanding, but also because there are a great many net resources that are interesting to people of all sizes. Most things sexual, after all, don't appeal only to people of a single body type! Here are some brief descriptions of the generic types of resources available and what they do.

Websites can be anything from homegrown personal pages to giant corporate websites with thousands of pages and teams of authors and producers and programmers behind them. Generally speaking, sex-related websites come in two varieties: the ones you can browse through for free, and the ones you have to pay for.

Porn sites, particularly those that specialize in pornographic pictures and/or streaming video, are the ones most likely to charge admission or require that you register for a user name and password as a part of an age verification scheme. If you're concerned about not spending money, leaving a trail on your credit card bill, or just are leery of giving out personal information online, steer clear of these.

Free sexually related sites, on the other hand, range from simple affairs with a few amateur erotic stories or some sexy snapshots to slick, professional-caliber erotica sites that combine photos, stories, chat spaces, and other amenities. Some sites are informational, some are designed to be arousing, and some are a combination of both. Online catalogues or online storefronts are also usually free.

There are numerous online directories to size-positive websites and online resources, such as the Hot BBW Sites WebRing, the Chubs and Chasers Web Ring, and the BBW/FA Webring. These and other, similar resources are listed in the Resource Guide.

E-mail Lists are a little like a party line on the telephone: every e-mail you send to an email list is automatically copied to every member. Hundreds of e-mail lists exist for hundreds of topics ranging from raising Siberian hamsters to discussing Chaucer. There are also lists that are fat-specific or fat and sex-specific. Many e-mail lists develop a devoted and participatory community of people who get to know one another

quite well through continued group correspondence and discussion. As with other online communities, mailing lists breed friends and enemies, loves and hatreds, and sometimes produce offline friendships and/or romances as well.

With the advent of free web-based list hosting services like Onelist.com and Egroups.com, the number of e-mail lists has skyrocketed. Like everything else on the Net, e-mail lists can be ephemeral and their lifespans short. The Fat Sex and Fat BDSM lists, both maintained by Yohannon and the Rotunda.com server, have been in existence for a number of years, and are probably the most dependable and best-maintained and moderated sex-related email lists for fat people and their allies. There are also email lists devoted to gay male Chubs and Chasers, fat lesbians, fat bisexuals, and members of other communities, and new lists form constantly. There is a good sample list of e-mail lists of interest to fat people (not all are sex-related) located online at: www.bayarea.net/~stef/Fatfaqs/resources1.html, or you can also search the Web for information using any search engine, such as Lycos, Yahoo, or Altavista. Be aware that not all e-mail lists welcome sexual conversation or innuendo.

BBS and Web-Based BBS are Bulletin Board Systems, whether based on the Web or on other types of servers. BBS are set up to allow people to post their remarks on various topics in various categories – the original mental image that informed the creation of online BBS was a real-life bulletin board, where people could tack up notes to one another. It is interactive, but not realtime: you put up your post, then log in later on to find out whether people have responded to it and what they've had to say, and continue the dialogue. The non-sexual, but wonderful web-based BBS called Hank's Gab Café is a part of Marilyn Wann's Fat!So? website at *www.fatso.com*, and provides a warm and extremely supportive community of size-accepting men and women of all ages. Be aware that like other public online forums, not all BBS welcome sexual postings or innuendo.

Online Personals are just like the personal ads you find in a newspaper or magazine, but instead, they're on the Web. When you reply to an online personal, you do so through e-mail, and can proceed to strike up a "conversation" via e-mail that might in turn lead to other things – usually phone calls, then a real-life meeting.

There are numerous personal ad sites, such as *www.generous.net* and *www.largeandlovely.com* which may be used for free whether you are

posting a personal ad or browsing them. Other personal ads sites require you to pay a registration fee before you can use them, and some charge only the people who respond to ads. Several sources for online personal ads are listed in the Resource Guide, or you can find others by doing a web search, and advice on using personal ads as a person of size is available in the "Making The Personals Work For You" section.

Usenet is a vast and sprawling system of newsgroups to which people may post via e-mail. At one point in time, the Usenet's newsgroups were used much in the way that mailing lists are, and tightly-knit communities of friends and allies formed on many sexually related newsgroups. At this point, many of the unmoderated newsgroups on the Usenet are basically useless for real communication or finding community due to the influx of trolls and spam postings, but you're welcome to give it a whirl if you want to. A very good basic guide to the Usenet, written by Tim McLellan, is available on the web at the following address: *http://www.islandnet.com/~tmc/html/articles/usentnws.htm*.

Chatrooms are virtual "spaces" in which people can talk (type) to one another, conversation-style, in more or less real time (depending on system and net lag). IRC and ICQ are two types of chat software utilities that are commonly used in order to access various Internet chatrooms, but there are other types of chat interfaces that are entirely web-based. America Online, CompuServe, and other service providers may give users the option of using their own proprietary chatrooms. In a chatroom, you can "talk" to everyone else in the virtual room, talk privately with one other person, or negotiate to move the conversation to another venue, such as e-mail or telephone. Chatrooms are usually defined by their purpose or intent, which is usually identified in the chatroom's name. Examples are #bbw, #bbw-teens, #Big & Sexy, #fatdykes, and #gaychub. Be aware that not all chatrooms are open to sexual conversation or innuendo, particularly in "public" space (i.e., where all the people in the chatroom can read what you type).

MOOs, MUDs, and MUSHes somewhat resemble chatrooms, but are much more fully-textured online spaces where you can interact with "objects," build virtual structures and navigate them as you would physical structures in the real world, create programmable objects with preset functions, and in general, flesh out the experience of a chatroom with the kinds of texture and detail that might animate a real life experience. MOOs and similar virtual spaces are not usually intended to be prima-

rily sexual in nature or content, and they are also not specific to people of size. However, as with most virtual communities, your physical size is mostly irrelevant unless you make it relevant to the situation. For more information on MOOs and similar virtual communities, see http://wrt-rice.syr.edu/vivianstuff/moopage.html.

What is "netiquette"? How do I know how to act online? Netiquette is internet etiquette, or the manners you should use when you're online. Different communities have different standards of behavior, but there are some general principles of good online behavior that hold no matter what pocket of the net you frequent. The Netiquette Home Page, which is online at *www.albion.com/netiquette/*, provides a very well-done and comprehensive overview of Netiquette for almost every conceivable situation.

Just the same, here are some tips to help you be a social success when you're online, particularly if you're out looking for sexual intrigue.

Lurk first, talk later. Hang out in a chat room or on an e-mail list for a while before you jump in with both feet. Get a feel for what kinds of conversation are appropriate. If you're unsure, just introduce yourself and ask questions. Usually people are happy to help you out as long as you're respectful.

Don't assume that everyone who is online, even in an explicitly sexual venue, is there because they want to have sex. Even if they seem like they do want to have sex, don't assume that they necessarily want to have sex with you. Have a conversation before you proposition someone, at least enough to find out if they're open to a proposition. You probably wouldn't walk up to a person in a club and just say "Hey, baby, wanna fuck?", and you probably shouldn't do it online either. The same goes for asking someone their measurements, bra size, or the eternally annoying "What are you wearing?" question. If it comes up in conversation, great, but making that your opening gambit is probably not going to get you far.

Learn to take no for an answer. Arguing, haranguing, pestering, or asking repeatedly after someone has already expressed disinterest is disrespectful and useless. This is true whether you've asked for sex, or merely asked a question that someone doesn't want to answer.

Do not press people for private information. Many people are online precisely because they want to be able to be sexual and remain anonymous, and many more are simply (and justifiably) uncomfortable with

giving out personal information online. You are never obligated to give out your private information (real name, phone number, address, etc.) online, even if someone else does so (or appears to do so) first.

How do I deal with the weight issue in an online relationship? Basically, you deal with it however you want to. It's eminently possible to have online relationships in which your partner never knows what you look like, and in which you never know what they really look like either. Depending on your style and inclination, you can take on an alter ego whose physical description has nothing whatsoever to do with what you really look like. You can also choose to be scrupulously honest about what you look like, right down to your uncombed hair and mismatched socks, or any level of disclosure in between.

Depending on how straightforward you've been about your appearance, online relationship milestones like exchanging pictures or offline meetings can be exceptionally stressful. Of course, these kinds of events are stressful anyway, no matter what you look like – there's always the fear that the person on the other end, a person you may already feel you love, will see your picture or meet you in person and find that their actual attraction to the three-dimensional you is nowhere near as strong as the attraction they felt when they could imagine you any way they chose. That anxiety is all the stronger for people who fear they may be rejected for their looks or size, or who have had bad prior experiences with being rejected for those reasons, and the fear can be almost paralyzing.

The safest bet is to decide ahead of time whether you're going to disclose your physical information, how much, and in what manner. Honesty is the best policy if you think there's any potential that you're going to want to make closer contact in the future. Since that can be terribly difficult to determine in the early stages of a relationship, honesty and straightforwardness are usually the best policy overall.

Being strong, and presenting yourself as a proud, strong, beautiful person, rather than scared of rejection, insecure, and worried, can make an enormous difference in how you are perceived. Assuming that someone will reject you because of your size makes it all the more likely to happen – what you project often ends up coming back at you. Being honest and positive is the best route to take online as well as offline.

Do people really meet partners via the Internet? Yes. There are quite a few people who have met partners over the internet, including many

people who have found long-term partners, lifemates, and spouses that way *(Author's note: I recently celebrated my third anniversary with my partner, whom I first met via an e-mail list.)* It's not quite as easy as it might sound, though, and it's definitely not automatic. Hanging out online is no guarantee that you'll end up having an online relationship. Having an online relationship, in turn, is no guarantee that it'll turn into anything meaningful, or that it will materialize or succeed in the offline world.

The usual progression of Internet relationships goes something like this: people meet in a public forum like a chatroom or an e-mail list, and gradually move on to private communications, like e-mail, "instant messaging," or other private channels. Eventually, they may decide to chance a phone call, and usually only after that point do they set up an offline meeting. Because the Internet can bring people together over great distances, this can be an enormous event and create a huge amount of pressure. It may even involve overseas travel, all to meet someone you've never seen before.

When people meet offline, they are often surprised to discover that no matter how well they may think they know one another from their online and telephone relationships, being there in the flesh is very different. They may find that they're not as attracted to the other person as they thought they were, or they may find that there are aspects to the other person's personality that just don't sit well with them. Having "chemistry" online is no guarantee that it will be there offline, and it may not have anything at all to do with anyone's size, weight, or appearance. Sometimes, things just don't click.

On the other hand, sometimes everything falls immediately into place. Internet relationships tend to be grounded on sounder types of attraction than mere physical desire, and this can be a real asset. Many people find that when they fall in love with what a person is like on the inside – the part that shows the most online – it doesn't much matter to them what kind of package that person comes in physically. This isn't universally true, but many people have discovered it to be the case for themselves. Sometimes, the honesty that many people find easy to maintain in the relatively anonymous online environment means that people meet partners who are better suited to the kinds of deep-down emotional and psychic needs that they might not admit to having were they with that partner face-to-face. The challenge when these kinds of rela-

tionships are taken into offline life is keeping that kind of communication going – but it's not impossible. Many relationships that began online evolve into offline partnerships that last for a long, long time.

What are some of the drawbacks of trying to find a partner on the Internet? The three most frequent complaints people have about trying to find a partner on the Internet are:

Dishonesty – it's easy to be what you want to be online, rather than what you are. Many women remark that men conveniently "forget" to mention that they're married (or not quite divorced yet). Many men remark that women aren't the drop-dead beauties they claimed to be in the chat room. Men and women alike complain of disappointments when online reports of enormous penises or breasts, svelte figures, or other desirable attributes turn out not to be true in person.

Distance – often, people make profound emotional connections via the Internet despite the fact that they are thousands of miles apart. Some people can make a relationship work despite the distance, but for others it's an insurmountable obstacle.

Dishonorable Motives – sometimes, people pretend to want real relationships when all they want is sex, money, or other benefits. They may have no intention of giving their partner a real relationship at all, and may hurt them quite severely. This, fortunately, is not frequent.

What about all the Internet stalkers and psychopaths I keep hearing about? There are predators, creeps, criminals, and plain old assholes offline *and* online. Predators tend to prey on those they perceive as vulnerable. The less vulnerable you appear to be, and the more savvy and confident the image you project, the less vulnerable you are in general. Otherwise, trust your gut – if you think someone's bad news, trust your instincts. This doesn't guarantee that you can't or won't be victimized, but it does reduce your chances of having bad things happen to you via Internet contact. A little common sense goes a long way.

What is netsex? Netsex is when partners in an online relationship describe verbally and explicitly what they'd like to be doing to one another sexually. Depending on the degree of attraction between the partners (and to some degree on their talent as writers), this can be a very absorbing, satisfying, orgasmically pleasurable way of sharing fantasies and building communal fantasies. Like phone sex, netsex is among the safest forms of sex you can have. It can also be a wonderful arena in which to explore

your emotions and feelings about being sexual, an excellent way to get positive sexual attention when you're not in the mood to be physically sexual with anyone, or to work through psychological issues around sex, arousal, and desire.

Netsex additionally allows you the potential to try things you might never be able to do in physical reality. You can use it as a way to experiment with things that would be physically uncomfortable, dangerous, or impossible, like getting on top if even if you have bad knees, having a partner who can pick you up and carry you to the bed without strain, or having sex while weightless. If you can imagine it, you can do it. With cybersex, you can always find a fire-engine red leather g-string that fits, you can have sex on the moon or in the middle of Grand Central Station, you can play with notions that are too dangerous or risky to be worth trying in physical reality, and you can do it all as often, and in as much detail, as you desire. Sex is always about imagination, and always about what you bring to it, and that's never truer than when you're online.

3 MEET YOUR MATCH

Every day, all over America and around the world, fat women and men meet potential partners, fall in love, and have wonderful relationships and fabulous sex. Love, lust, and desire occur in the lives of people of all sizes, all shapes, and all weights. Fat people – from people who don't look fat at all but who think of themselves as fat to the very largest among us – meet partners in the same places that everyone else does: through friends and family, at church or synagogue services or meetings, while taking classes, at the Laundromat, over the backyard fence, out at a nightclub, standing in line at the grocery store, and anywhere else two people might strike up a conversation. On many levels, fat people have the same problems and the same delights in the whole process of dating and beginning relationships as anyone else does.

However, there are some issues in dating that tend to affect people of size more frequently than other groups of people. Some of these problems have to do with internalized feelings of unworthiness or feelings of unattractiveness, or they might be due to facing prejudice and harassment from fat-intolerant, prejudiced, bigoted onlookers. Others are logistical and tactical problems, such as how to assure that facilities like theatre seats will be comfortable and accessible for a plus-sized night on the town, what to say to people who make catty comments while you're out with someone, or how to write the perfect size-positive personal ad.

Ask, And Ye Might Just Receive

Many people, no matter what their size, let their fear of rejection stop them at least sometimes from pursuing people they find attractive In the survey conducted for this book, about 77% of the people surveyed said that this was true for them. It's not just fatter people who do this; thinner people also have thoughts like "oh, they couldn't possibly be interested in me, they're totally out of my league." However, it can be harder to break out of that kind of thinking when your self-confidence is none too high and there's a strong fear of being rejected for your size. This is particularly true for women of size, who not only face the problem of being large, but also having to overcome cultural conditioning against asking someone else for a date.

> "I am hesitant to pursue non-fat people whom I consider 'conventionally attractive' (e.g., by Hollywood standards), especially men. Because until I know such a person well, I find it hard to get over my automatic assumption that they will think I'm grotesque because I'm fat. I also think my size plays a part in my shyness and discomfort with social situations where I don't know most everybody – I guess I may have subconscious associations to being teased as a kid in social situations, so I get a little brittle. This affects my sex life because it limits the ways I can effectively pursue people I'm attracted to. (Although I do manage.)"
> -Stef

It's always scary to ask someone out, no matter what you look like or who you are. Even savvy debonair types have been known to have their palms get a little sweaty when they're asking for a date from someone they're really interested in. Even so, there's a lot to be said for the feeling of taking the pursuit of happiness, or at least the pursuit of a date, into your own hands rather than waiting around for someone else to ask you. After all, there's no guarantee that the person who asks you out will be someone you're interested in, and it can be disappointing to wait to be asked, only to be asked out by someone who does nothing for you. If you're doing the asking, you might get turned down – but if you're not, you at least end up on a date with the person you actually wanted to be out with. Once in a while, you just might discover that the person you asked was too shy to ask you first, and is darned grateful that you made the first move.

You Big Flirt!

For most fat people, flirting isn't just a way to grease the social gears when dealing with likely romantic prospects, it's a way of life. In her book *Fat!So?* Marilyn Wann points out that most fat people learn to flirt extremely effectively as a way of getting through life. Learning to make people smile and laugh, learning how to be attentive to other people's needs and egos, and learning how to dazzle with your personality can all be important assets when you're facing the possibility (or probability) that you'll have to overcome people's resistance to you on the basis that you're fat. A lot of people have incorporated flirting into their daily lives to such an extent that they don't even notice that they're flirting.

Flirting as survival technique is a double-edged sword, of course. On the one hand, there's no reason not to be smart, flirtatious, funny, attentive, and to show off the parts of your personality that you know tend to attract and put people at ease. On the other hand, it can be problematic if you've gotten to the point, as many people of size do, that you feel like there's a major discrepancy between your persona and your person, that your personality attracts people but your actual self repels them. This has its repercussions not only in one's everyday emotional life, but in one's sex life as well.

When one's public persona feels very different from one's inward personality and the type of person you are when you're not "on" and around other people, it's easy to feel like you're living two lives and easy to dissociate. When good things happen it may feel as if they aren't real or haven't been earned – the facile outward flirt-persona achieved it, but the inward, real self did not and thus doesn't deserve it. When it comes to sex, there may be the feeling that a partner is attracted to the outward projection that one issues, and not to the body or the "real person" beneath.

The irony here is, of course, that the person, the body, and the personality are part and parcel of the same entity, but it doesn't always feel that way. People of size often feel that "they" have to make up for what "their bodies" do not do or provide. Some people never quite shake the sensation of an incongruous, but very real, gap between the fat person they are and personality they present, as if the fabulous, likeable, sexy personality they have couldn't possibly really be integral to the fat body they live in.

"I always had boyfriends/male attention, but I felt internally that it was in spite of my fatness, that I was such a riot to hang out with that I had overshadowed my weight. I had succeeded in calling attention to something other than my size. I also had a talk with one of my lovers about this, and she expressed it really well when she said that there was the sense that she had somehow fooled whoever she was with." – Annette

Looked at from the outside, this seems awfully illogical. Particularly when you're in a sexual relationship with someone, it seems pretty obvious that they will indeed have a pretty good idea of what your body is like. Particularly if you've already been sexual with them, but even if you haven't, they already know that you're fat. After all, they can see you. If they've hugged you, they've felt your body. If you've already been sexual with them, they've felt and probably seen a whole lot more. If they're still sticking around, it should be pretty obvious that either they liked it or at least they didn't mind. Your personality may well have attracted your partner to begin with, but it doesn't stand a chance of blinding them to the real live touchable grabbable huggable squeezable reality of your body. After all, you notice other people's bodies when you're talking to them, hugging them, hanging out with them... doesn't it make sense that they're going to do the same with yours?

If you've ever raised a kitten, you're probably familiar with the trick where a kitten hides from you or another cat by sticking its head behind a door, under a couch, or something similar. It can't see you, so it presumes you can't see it... despite the fact that its fuzzy little butt is hanging right out for all to see. People do more or less the same thing when they think they've actually "fooled" a partner into not noticing their size by being fun, flirtatious, and exciting to be around. It's easy to get so caught up in your personality and in generating that outward, flirtatious, fun, but often also defensive persona that you forget that other people see you the same way you see them – full-bodied and three-dimensionally real – rather than in the shoulders-up way that so many of us (thin and fat) see ourselves when we look in the mirror.

This is not to underestimate the value of the flirt, or the flirtatious, fun, enjoyable personality. It is in fact quite true that having a sparkling, delightful persona can dispose a potential partner much more positively in regard to accepting your size. The more delightful you are, the more willing partners will likely be to accept your size as just another part of

the package. But this doesn't mean they've been fooled, not by a long shot. They've got hands to feel with and eyes to see with. Having someone regard your body positively doesn't mean they're disregarding it. Quite the contrary. It usually means they're accepting it and perhaps even enjoying it!

Sometimes it feels like the flirt persona is not the "real you." In all honesty, that's probably true – but only because of omission, not because you're fabricating things out of whole cloth or lying about who you are. Your flirtatious side doesn't usually include the more serious, heavily intellectual, or "down" parts of your personality, and when you spend a lot of time keeping those parts of yourself under wraps, it's easy to get to feeling imbalanced. Fortunately, it's not a liability to let those parts of your personality show when you're with people you know reasonably well, and though it may take a bit of a leap of faith to let a new partner see those parts of you, it's usually far from catastrophic when you do. No one, after all, is cheerful, flirtatious, vibrant, exciting, and funny every moment of the day – terminal perkiness can be just as off-putting as being eternally morose. Most people are a mixture of a lot of different modes and moods, ups and downs, happy and hardworking and yes, even depressed and sad sometimes.

It's well to remember that what makes your "flirt persona" attractive to people is, in fact, part of the "real you." If it weren't, you wouldn't be able to do it convincingly day in and day out under all sorts of different conditions, no matter how good an actor you might be. The charm and intelligence, sense of humor, and all the other things that draw people to you are genuine parts of who you are. There's no reason on earth not to capitalize on them – thin, conventionally gorgeous people often go to great pains to develop the very same sorts of personality traits and flirting-based "people skills" you may well have developed out of self defense.

So go ahead – flirt! Enjoy it. It takes on a whole new complexion when you do it in a romantic or potentially romantic context than it does when you do the same sort of things – putting people at ease, bantering back and forth, making people smile – in an everyday social or business context. Luxuriate in your gift of gab, your knack for putting people at ease, your keen eye for the double-entendre. You never know where it might get you once you put your flirting skills to work on behalf of your love life.

"I'm a notorious flirt. It defuses tension. As I've gotten older I've realized that it's a real art form and that I'm good at it. I've always been able to get a date with pretty much anyone I wanted to get to know better just by flirting. I even use horribly cheesy tricks like stealing lines from movies. A few weeks ago I traded numbers with a guy I was working with on a contract job. I thought he was cute, but wasn't sure if he was into me. But any-way, as I tucked his card into my datebook as I said: 'If you ever want to talk, just pick up the phone and give me a whistle... you do know how to whistle, don't you? Just put your lips together and blow...' There was a totally cute message on my voice mail by the time I got back to my office. We have had a couple of good dates already, so it worked." – Anonymous

Elbow (and Hip, and Thigh, and Butt) Room

It's always enjoyable when your date turns out to be considerate, thoughtful, and attentive to your needs. People are guaranteed to think better of their dates, and to have a better time while they're out, if they find themselves in places that are comfortable with a person who thinks enough of them to make sure the situation is amenable to their needs. Being thoughtful and considerate requires a little forethought, and per-haps a phone call or two, but it costs nothing and can make an enormous difference.

Say, for instance, that you have this vague recollection that your date mentioned being a vegetarian, but you're not sure. It doesn't take much to cancel the reservation you made at the steakhouse and phone up a good Indian or Thai place instead, where you know there'll be a variety of dishes available without meat in them. Similar accommodations are easy to make in order to ensure that people of size are comfortable and well-served while you're out on the town. Depending on your size and/or that of your date, you may want to phone ahead about seating. The issue here isn't so much whether you get a good table or whether they stick you back near the kitchen, but *Lebensraum...* enough space to live in and be comfortable.

In restaurants, ask if there are tables available instead of booths, since booths don't ordinarily offer you the chance to move the seat fur-ther away from the table if you need to. Armless chairs are preferable,

since even moderately fat people with wide hips often find that chairs with arms leave them bruised in unpleasant places (like the upper thighs). If you call ahead, you can often be shown to your table without having to fuss at all over any potentially embarrassing problems with seating. If a restaurant doesn't have non-booth seating, or aren't willing to provide armless chairs, cancel your reservation – and tell them why. If restaurant management doesn't know that people need these resources, they are much less likely to provide them.

Likewise, theatres and stadiums can be challenging where seating is concerned. Many theatre and stadium seats are narrow enough, and packed tightly enough, to be uncomfortable for a lot of adults, not just fat ones. Call the theatre ahead of time and ask them if they've got seats with armrests that fold up out of the way. Many theatres have these seats as "handicapped seating," but some have them just as a general practice in some parts of the auditorium. You might also ask if they have armless seating or bench seats available. If they don't, again, you might want to let them know why it's a problem. Presenting it in a matter-of-fact way, simply saying, "Wow, that's too bad that you don't have seats that will comfortably seat everyone who wants to go to the movies/see a show/go to the game. I bet you'd sell a lot more tickets if you did," is a good way to make them hear you, and make them realize the connection between providing amenable facilities and making good profits. It is admittedly harder for theaters, stadiums, and the like to provide special seating upon request – their chairs are usually bolted to the floor. But it is not impossible.

When you're looking for places to go that have amenable seating, it helps to ask around. Ask your fat friends whether they've found any restaurants or theatres in your area to be particularly size-friendly. If you are not fat yourself, but are interested in dating a person of size, you can ask that person what some of their favorite places are without even raising the seating issue *per se*. You'll not only get some insight into what places the person you're interested in finds comfortable to visit, but also a bit more of a clue about what she or he might enjoy. It's always considerate to ask what your companion likes to do and where they like to go.

Of course, there are also some date destinations that don't require that you worry about seating – a trip to a museum, a walk in the park, going to a greenhouse or gardens, picnicking on the grass, and so on. But you shouldn't avoid the classic "dinner and a movie" dates. It's a fine

way to spend an evening with someone you enjoy. As the two of you get to know each other a bit better, you'll have a better idea of how best to approach these issues and what sorts of things make you both most comfortable.

If you are a person of size and your partner asks you if the seating is acceptable, just take it in stride. A thoughtful partner will ask their date that no matter what their size – it's all a part of being courteous and looking out for your date's well-being. It may possibly feel like you're being singled out, or that someone is doing something out of the ordinary for you because of your size, but if you pay attention, you'll notice that courteous couples of all sizes have similar interchanges. "This table look okay to you, honey?" doesn't necessarily have anything to do with size, but with old-fashioned courtesy.

The closer you become, the easier it is to discuss accessibility problems openly. On a first date, it can be pretty mortifying to have to turn to your date and say "Geez, I'm sorry, but I'm just not going to be able to fit into that booth comfortably" or have to ask to sit somewhere else, the reason left embarrassingly unsaid but still obvious. Just the same, it's important to be able to say these things, whether to your companion or to a waiter or usher. You have the same right as anyone else to participate in life, and to do so comfortably.

A direct approach is usually best. Often, all you have to do is articulate what you need. "I'm sorry, but we're going to need to find a table, not a booth," or "Pardon me, but I think my friend and I would be much more comfortable in chairs without arms." If you're asked why the booth/armchair isn't suitable, you can simply say "I don't find them comfortable," or you can be more specific and say something like "big person, little space," or "that booth/chair is not one size fits all, and I simply won't be comfortable sitting there."

Sometimes there's a bit of concern over who should be responsible for making these kinds of interventions. Whoever asks for the date should try to ensure suitable accommodations ahead of time, but that doesn't always work out when you get there. Some people are able to handle these situations with alacrity and without embarrassment, but not everyone can. Even people who are usually able to negotiate these situations well can have their off-days. Protecting your companion from harassment or shoddy treatment is no bad thing. If he or she is also capable of

defending themselves, so much the better: you can try the tag-team approach.

Regardless of who spearheads the effort, seek a solution that causes a minimum of fuss with a maximum of good results. Use "we" statements to make it clear that you are there in solidarity with your date, and not willing to accept your companion being treated any differently than you are treated. This is important. Sometimes, thin people assume that they have carte blanche to treat fat people poorly. They need to see that there are thinner people who refuse to treat fat people poorly, and moreover refuse to *allow* them to be treated poorly. It's a very powerful example to set.

Don't be afraid to ask to speak to a manager. Restaurant managers have a vested interest in keeping their patrons happy, and that means that they will often go out of their way to do so if a patron has gone out of their way to bring a problem to their attention. If you still don't get a satisfactory response, leave. You don't need to give your money to people who run a service-based business and refuse to provide any.

Are You Serious? You Can't Be Serious!

Sometimes, you ask someone out on a date only to have your prospective date brush it off, as if he or she didn't really take you seriously. This can mean one of a couple of things – it could be their way of turning you down because they're not interested, but are afraid it'll seem rude if they say no flat out; it could mean that they're preoccupied and/or that your invitation wasn't clear enough. It could also mean that the person has become accustomed to thinking of him or herself as undesirable and unlikely to be asked out on a date, and therefore they're going to proceed to ignore the fact that you have indeed done so, or assume that you meant it as a joke.

This is a problem that crops up with some frequency for those who are attracted to fatter partners. Years of insecurity, bad experiences, and negative conditioning tend to leave people of size with the feeling that the only reason people would evince interest in them would be for ulterior motives or as a joke. When your defenses are up that high, it can be easy to interpret any invitation as a ruse.

"There was always a concern that an offer of a date was really a secret 'plot' to humiliate the 'fat-girl.' For example, while doing an intense and emotionally intimate scene in drama class with one of the popular guys, we made a connection that felt like more. Later, in a less intimate setting, he asked me out on a date. His buddies were looking on with smirks on their faces. I actually was impolite to him because I was very sure that he and his buddies were only asking me to see if they could make fun of me. I can never know if he actually meant it, or really liked me, because of the risk of humiliation. Imagine Popular Joe dating Fat-betty... wouldn't that be a hoot!" – Elizabeth

"There have been many times when a man found me attractive and asked me out because of my size. I found this situation to be extremely uncomfortable because I have a hard time believing anyone finds me physically attractive. I think its a joke because that is exactly the type of prank played on me throughout my highschool career. So, now that I have people who are sincerely attracted to me, I put up HUGE defenses, and wonder to myself, 'What's wrong with them that they're so desperate that they're asking me out?' It's a situation I know I need to correct, but it's what still goes through my mind anytime someone even flirts with me." – Tracy

So what's a person to do when they've just screwed up their courage to ask someone out, and they think that they might not have been taken seriously? The best thing to do is usually to ask again, and/or to ask for them to clarify their response. You might say "Hey, I'm not sure if you weren't interested, or maybe I didn't make myself clear enough – I'd really love to go have a cup of coffee with you sometime if you're up for it." It's important not to presume that your prospective date is blowing you off, but it's also important not to presume that they are automatically going to want to go out with you. They might simply not be attracted to you, or they might not be comfortable with dating, period. Making it clear that you know there's more than one reason that they might've responded in the way they did makes it clear that you're courteous, and that you're deliberately not reading anything into their reaction.

Another tactic is to wait a bit (a day or two is appropriate) and start smaller. If you asked the person out to dinner and a movie, or asked them explicitly for a date, you might reissue an invitation later on but make it for something that'd be a little less high-pressure, like perhaps a cup of coffee after work, or inviting them to join you for something that you might've already been planning on doing anyway. Asking someone if they'd like to join you when you go to a museum exhibit, since you'd been planning on going and thought they might be interested, puts a lot less pressure on them (and on you) than asking for a capital-D Date. The purpose of going out on a date, after all, is to get to spend some time with someone you think you might like to get to know better, to get a chance to talk and share your thoughts and see if something clicks. You don't have to have a candle-lit dinner for two in order to do that. Early dates should be more casual affairs anyhow.

> *"I would not believe that someone could possibly find fat, ugly me cute or pretty. I didn't know it was possible and he kept asking me to dinner or to play a game of pool. I'd hang out with him - as long as other people were around but I just couldn't accept any of his advances because I couldn't believe he was sincere. I turned this one guy down repeatedly until he just stopped asking. He kept hanging around though - I guess hoping I'd wake up and see how stupid I was being. This was just one of several such occasions."* – Katrina

> *"There was a guy that I thought was the coolest thing ever but I was convinced he only wanted to be friends. He asked me to a movie and I thought, OK, we are buddies hanging out. When he drove me home, he tried to kiss me but I turned my cheek to him. Even with this proof that he wanted more, I couldn't accept it."* – Gina

If the object of your affections still seems resistant to the idea of going out with you after you've tried a few times, you can either choose to ask them straight out why they've been turning you down, or you can simply decide to cease and desist. Once in a while, it takes being confronted with the fact that you're disappointed at being turned down for a person to realize that you really genuinely do want to spend time with them. It takes some courage, because you might get an answer you won't enjoy, but it is sometimes really worth taking the person aside and say-

ing "Listen, I've asked a few times if you'd be interested in going out with me sometime, and I will understand if you're not interested, but it's been kind of hard for me to tell whether you've been saying no because you're not interested in me, or not interested in going out right now, or if I'm putting too much pressure on you, or what. I don't want to be a pain in the neck, I just want to know if I have a chance here or if we should just be friends."

But, in the final analysis, "no thanks" sometimes really does mean "no, thanks, and you can stop asking now." It's unfortunate, and it stings a bit, but it's just the way it is. Taking a "no thanks" gracefully, and being able to be friendly toward the person rather than bitter or pissy, shows real grace and maturity. Sometimes it's hard to be gracious, particularly on the heels of a hard disappointment. After all, pressuring someone (directly or by guilt-tripping them by letting them see your disappointment or anger) doesn't make them want to go out with you any more than they did before, and may just reduce their opinion of you. Being able to be a gracious loser is the mark of a gentleperson.

The flip side of this equation, of course, is learning how to take the risk of assuming someone is serious when they express interest in you. You certainly don't have to accept any date with someone who doesn't appeal to you, but it's not really legitimate to manufacture reasons that you don't like them based on the fact that you don't like yourself too much. When people have bad self-image and poor self-confidence, or when they've been raised to think that no one with any sense would ever be attracted to them, they might think "Oh, I'm never going to get a date... there'd be something deeply wrong with anyone who'd ask a fat slob like me out on a date!" Talk about a self-fulfilling prophecy at work!

If someone asks you out, and you're interested at all in going, go, even if it's just as an alternative to sitting around watching reruns. Eighty percent of life is showing up, and you never know what will transpire when you do. You may not turn out to like the person all that much. Things may not click, and nothing at all may happen, and if so, you've lost nothing but a little time. Everyone has boring dates sometimes. That's just the way the cookie crumbles. But if you're not willing to go out when you're invited, you're going to miss out on the good dates as well as the boring ones, so you might as well increase your odds of having a great time!

It sometimes helps to think of it as rehearsal when you let yourself accept an invitation to go out with someone new. You get to practice

going out, making smalltalk, and all the things that go along with a first or second date, and there aren't really any strings attached. If you don't enjoy it, you don't have to go out with that person again. Sometimes, people of size get too worried about making a "success" out of each and every date they might have, on the theory that being fat, they're not as likely to get another chance. It ain't necessarily so, as the song says, and besides, who's to say that a date isn't successful just because you don't find your ultimate soulmate? Most dates are much less eventful. A successful date is one where you have a good time talking, spend some time pleasurably getting to know someone, and enjoy a more or less relaxing evening doing something that isn't part of your normal routine. Making dating goal-oriented, feeling that you have to fall in love or have someone fall in love with you or it wasn't worth it, puts an awful lot of unnecessary pressure on you and on the whole process.

In The Valley Of The Blind Dates

For a lot of people, and especially people of size, the words "blind date" often induce blind panic. The feeling of having someone look you up and down, then seeing the look of disgust or disappointment on their face, is all too familiar. No one likes being rejected before they even have a chance to introduce themselves properly. People of all sizes sometimes have this experience on blind dates, but people who are regularly discriminated against because of their looks – something that frequently happens to fat people – are more likely to have had the experience and understand what it feels like and what it means to have that happen. It hurts, even if you're somewhat prepared for it, and even if you're steeled for it, and there's simply no way anyone can know whether or not it'll happen on any given blind date.

Generally speaking, if you have the feeling that things aren't going well, it's perfectly appropriate to end the evening early, cut your losses, go home, and call up a friend for moral support. Most all of us have been there at least once, with a bad, ego-mashing, useless blind date that left us feeling like we might as well give up the whole dating thing altogether. Talking with someone who's been there – whether they're fat or thin – can really help to anchor you again. Talking with someone who shares your size issues can be particularly comforting.

"I have had a couple of blind dates where once the man met me you could see him looking me up and down and get that look of disappointment on his face when he found I was not thin. They would be nice enough during the date but I would not hear from them again." – Nancy

In some blind date situations, you really can't do anything to prevent a visual rejection. If you don't have any control over how you're presented to another person – as is the case when you have a friend who sets you up on a date – you can't have any way of knowing what they were told. You might've been described in physically non-specific terms that let the other person fill in the (thin) blanks. A lot of people erroneously assume that good characteristics come in "good" – i.e., thin – bodies, and unless they're explicitly told that someone they're about to meet is not thin, they will assume that they will be. This is compounded in blind date situations by the fact that a lot of people embarking on blind dates tend to be just a little bit unrealistic about who they're likely to meet. Suffice it to say that most blind dates aren't going to turn you up with a rich lingerie model who shares your love of NASCAR racing, or with a Mel Gibson lookalike with a Ph.D. and a summer home in the Sierras who loves sending roses for no reason at all.

In other blind date situations, such as meeting people through personal ads or the Internet, you have plenty of opportunity to tell them what you look like and what to expect when they see you for the first time. But it can be hard to know what to say and how to say it. If you tell them too much, perhaps they'll be turned off. If you don't tell them anything, on the other hand, they'll feel lied to when they meet you and see what you look like. It's a hell of a balancing act. The fact of the matter, though, is that when that person sees you, it doesn't matter how careful you've been or how delicately you've shaded your self-descriptions: they're going to see you in full. This can be bad... or good!

"It was the classic blind date. A friend of mine e-mailed me and said that a friend of his was going to be in town for a conference and would I be willing to take him out to dinner and show him around some. I figured it'd just be a night of playing tourist guide. We totally hit it off. He was really my type, smart and dark-haired and well-dressed. And I was his type too, woo woo! His eyes lit up when I introduced myself. He complimented me on my dress and my hair and he bought dinner. We ended up

going back to his hotel and necking and talking until three in the morning, and had another date the next night. He totally worshipped my body and we had two nights of amazing sex." – N. B.

Forewarned is forearmed. The pitfalls of blind dates are obvious, and it's simply not easy to find a good way to sidestep them. Even being as honest as possible in Internet or personal ads situations is not always sufficient to ward off problems, since the way you describe yourself – even when you use words like "fat" instead of euphemisms like "Rubenesque" – may conjure up one set of images for you and another for your blind date. Let's face it: there are reasons that a lot of people avoid blind dates like the plague. But blind dates and being set up for a date by friends are a little like the lottery… you can't win if you don't play.

"When I was in school I was told of a BBW girl who had 'a crush' on me by some of her friends. They asked me to take her out just as a friend because it would make her feel as though she fit in, or feel liked, or whatever. I did take her out, several times, not only for her sake but because I found her very attractive and sexy. We never went 'all the way', but we didn't miss it by much." – M.B.

DEALING WITH THE PEANUT GALLERY

As they say in football, the best defense is a good offense. Presenting a calm, confident, even slightly flamboyant exterior is a great way to deflect any potential snide remarks from onlookers or passers-by. It's the same principle that's taught in self-defense classes: if you move confidently and look like you know what you're doing, predatory types are much less likely to bother you.

But sometimes, people will still make rude comments when you're out on a date, or when you're talking about someone you're seeing or are interested in. Often, they won't make these comments to your face, but will make them when they know they're within earshot, a passive-aggressive ploy that lets them be cruel and hurtful, but which makes you look like the rude one if you give evidence of having "overheard" a com-

ment that wasn't directed at you, even if it was clearly meant to be over-
heard.

> *"Once when I was out on a date with a guy I was seeing, I
> went to the bathroom and walked past these two skinny model-
> looking types with big hair who were doing their makeup at the
> sink. I was in the stall and one of them said to the other, 'Did
> you see that woman who just came in? She's the one with that
> dark-haired guy you were looking at earlier.' The second woman
> laughed and said 'Oh, they must just be friends.' The first said,
> 'No, I think they're together.' Then the other one said, 'Oh, come
> on, no guy who looks that good is going to be handing out mercy
> fucks.' I was so mad I could hardly pee. I waited until they left
> before I flushed and went out of the stall. It was agonizing.
> I went back to my date and told him what they'd said. He went
> out of his way to make eye contact with one of them across the
> room, then took my hand across the table and kissed my hand,
> and told me I was beautiful and that the skinny bitches could
> just eat their hearts out. It still really hurt, though, and set off
> every horrible insecure thought I had ever had about him, and
> made me second-guess why he was with me when he could've
> had anyone he wanted. He was really gorgeous. Those women
> HAD to know that I could hear every word they said." – Deborah*

Whether a comment is made to your face or just within earshot,
you have to make a decision whether you're going to respond or not. A
response can take the form of a nasty glare, letting people know that you
did indeed hear them without your having to say so, or it can take the
form of a verbal response. Often, simply going up to someone and say-
ing, "Pardon me, I'm afraid I didn't catch what you just said. Would you
mind repeating yourself?" will embarrass them more than sufficiently.
Another, slightly nastier, alternative is to glare at them and say, "I'm fat,
not deaf," or "You know, when you make comments like that in public
you really should learn to keep your voice down. You don't want every-
one to know what an asshole you are."

You can pursue, or not pursue, making such confrontations depend-
ing on your inclination and stamina. Whether you decide to try to turn
the incident into an opportunity to educate, or merely look them in the
eye and zing them right back is up to you. In the "Getting A Grip" sec-

tion, you'll find a sampler of good zingers, all field-tested, to use on people who make rude comments about size issues.

With couples in which one partner is fat and the other is not, it is often a good idea for the thinner partner to come to their fat partner's defense, or at least to give visible support and affection to their partner in public, when there has been some sort of attack. Often, thin people expect that any thin person will join them in ganging up on a fat person. They need to be shown that this simply isn't the case. Also, your partner deserves to have you show your pride in being with them and your willingness to be with them in public. Standing up to the peanut gallery doesn't have to mean making a scene, and in fact, there's no need for it to. Just putting your arm around your partner's shoulders or giving a sharp glare to an offender, can send a clear, strong message.

GETTING PHYSICAL

As you've no doubt observed in the preceding sections, sometimes it's pretty difficult for people of size to believe that someone finds them attractive. This is true not just in general terms, but also in specifically physical and sexual ones. Sometimes, both partners on a date can be yearning to get physical – to touch or kiss one another – and both scared. They might be afraid that their partner isn't really attracted to them, or isn't attracted to them enough. Perhaps they're worried about coming on too strong, or maybe they think that it'd be inappropriate for them to show that much interest – a common problem for women who've been raised with the notion that women should avoid any hint of sexual aggressiveness. Ironically, sometimes both partners will be sitting there trying to grapple with their desire to take that next step, and nothing happens even though they both want it to! Other times, they may manage to overcome their fear and venture a physical overture of some sort, only to have one partner suddenly discover that they're feeling paralyzed by such an upwelling of feelings of undesirability and ugliness that they can't really accept or enjoy the affection.

It can be very frustrating to have to try, again and again in some cases, to convince your partner that your attentions are in earnest, that you really do want to be with them and be sensual and/or sexual with them. It can be even more frustrating to want to yield to the desire to be touched and desired, and to be caught up by years and years of your own

bad tape loops that tell you that you're not desirable and no one will want you. It can be just as maddening to be ready and interested and able to accept someone's desire and sexual interest, but to still feel a little unsteady on your feet, not sure where to go, and what to do with a lot of overwhelming and sometimes conflicting emotions, sensations, and desires.

The best solution to these problems of desire and ability to handle it is often deceptively simple: go slow. Take your time. If holding hands is about as much as you can handle, hold hands. If you end up going a little faster than you really wanted to, it's not too late to back up and just tell your partner that you're sorry, but whatever it was was just a little more than you felt comfortable with, and go back to doing what you were doing before. It can require a little vigilance to stay in a place where you feel comfortable, since necking and such tend to get hotter and heavier as you go, but it's not impossible to keep your boundaries and stick with activities you enjoy, find pleasurable, and feel comfortable with. Particularly if you haven't had a lot of experience, it can take a little getting used to the sensations and emotions that go along with being sexual so that you feel confident and competent to handle the situation. As you go, you'll probably feel just fine about expanding your repertoire.

Sometimes, though, you may not feel like you have the right to say no or to insist on limits. It may feel to you as if being sexual with someone has to be an all-or-nothing affair. This might be because of your own conditioning, or perhaps your date's putting a lot of pressure on you. Remind yourself that sex doesn't have to happen just because you're on a date. It can, but it doesn't necessarily have to, not even if your date bought dinner. The decision to have sex really ought to be predicated on passion, not payback. There's no "obligation" involved if you accept a date. Sometimes, people of size may also feel that they "should" go along with having sex if someone else wants it because they feel they're "going to miss their chance" if they don't, or because they should "be grateful that someone's interested."

This is just plain silly. If you want to have sex with someone, if you desire them sexually and think they're hot, if you think you can handle it emotionally and psychologically, then go right ahead and do it. But feeling like you "have to" have sex or don't have the right to say no to it is a crummy basis on which to be sexual.

"This guy I was seeing was trying to get me to all the way with him and I kept saying no. In so many words he kept putting me down - things like 'You should say yes because, honestly, how many chances are you going to have?'" – Katrina

" I remember at a party some guy hitting on me and me blowing him off then him being offended like he thought because I was fat I should be honored that he wanted to proposition me, and making some scene, really loudly, about 'fat girl thinks she's too good for me.' Another time at an all-night diner two guys sat at my friend's and my booth, uninvited, and we promptly moved and they made catcalls about my weight and how I should take what I can get. It seems men feel their manliness is somehow threatened by a fat girl's rejection. I don't feel so desperate that I need to give any man attention that gives me any." - Kirsten

Whether it comes from someone else telling you that "you should say yes because you're not going to get many chances," or from your own internalized fears that that may be the case, pressure to be sexual for non-sexual, emotionally manipulative reasons is coercive and none too healthy. No matter what size you are, you don't have to be "grateful" for anyone's sexual interest. If someone doesn't interest you, then you simply don't have to pursue it.

Sometimes, people may try to use the "you should be grateful" or "how many chances are you going to get" lines on you directly. "You should be grateful that someone's interested!" just doesn't cut it as either good treatment or hot foreplay. Predatory jerks who do this should be told to take a long walk off a short pier and take their hard-ons along for the ride. If a prospective partner can't get it together to treat you well, and put your pleasure and comfort at least on a par with their own, you can bet your last penny that the sex won't be worth the while anyhow... and why should you voluntarily put yourself in line to be used? If it's a choice between accepting that kind of treatment and not having sex, not having sex is the hands-down winner every time. Humiliation shouldn't be the price you pay for sex or any other kind of pleasure or attention. It's just not worth your self-confidence or self-respect. You deserve – and can get – much better.

MAKING PERSONAL ADS WORK FOR YOU

A lot of big folks – along with everyone else – end up giving the personal ads a whirl when they're in the market for a new partner. Personal ads, like any other form of blind dating, are notoriously hit-or-miss, but people do often meet partners that way. If nothing else, you can at least have some interesting evenings getting to know new people, practicing your dating skills, and reminding yourself of what an enormous variety of people really are out there in the world.

The advantage of a personal ad, at least in theory, is that you can tell people a bit about yourself and a bit about what you're looking for, therefore increasing your chances of getting a response from someone you'd actually be interested in dating. In reality, the brevity of personal ads in most newspapers means that they're more ads than they are personal, and after a while, they begin to sound an awful lot alike.

The majority of mainstream personal ads also tend to reflect the preferences and prejudices of the majority, and this can make them rather a daunting place for people of size (or people wanting to find a big partner): "fat" is a four-letter word, as far as personal ads are concerned. Many mainstream personal ads are overtly concerned with avoiding meeting a fat partner. Euphemisms like "height-weight proportionate," "athletic," an emphasis on things like "enjoys working out," and other phrases pop up all the time. Some people will even sometimes go so far as to indicate the weight range, or even the range of BMI [Body Mass Index] or body fat percentages they're willing to accept on anyone they'd consider as a potential date.

Though there are the occasional ads where someone makes it clear that they're actually looking for a partner of size, the overwhelming prejudices voiced in so many ads often make it seem useless for people of size to even bother reading the personals in most mainstream venues. Fiercely funny and insightful, writer and commentator Elizabeth M. Tamny's take on her experience of reading the personals as a fat woman appeared in her 'zine, *Gastrolater*. In this excerpt, we see two personal ads Tamny took verbatim from newspaper personals sections, followed by one of her own devising that sums up the attitude behind the ads:

> *Seeking European or American female for monogamous, long-term relationship. Me: SWM, no dependents, professional with time to spare, financial and emotionally stable. 49, 5'10", 168*

lbs. Not interested in spectator sports; very much into the arts, classical piano and literature. Affectionate and romantic. You: SWF, not over 43, very attractive, slender (not over 138 lbs.) 5'6" or taller, educated and refined. 49172

Seeking Goddess, DWPM, 58, 6'1", 195 lbs., brown/blue, nice-looking, trustworthy, thoughtful, athletic, into film noir, sports, art fairs, the lake, Bach, biking, swing. Seeks SWF 45-60, very pretty, compassionate, smart, kind (to animals also), feminine, slender (size 6-8 or less), nice legs, curvy figure (waist divided by hips equals 0.65 ratio or less) for long term relationship. 66026

SWM, 34, new to Chicago. Interested in seeing all the city has to offer, from blues clubs to walks by the lake. Professional, well-established in career, just looking to expand beyond the comfort zone. ISO SWF, 25-35, hopefully 5'4" or above, and not fat. Oh sweet Jesus, just don't be fat. Oh Lord Oh Lord Oh Lord just don't land me with a fat girl. Oh please oh please. Noooooooo fat girls. Oh Lord, hear my prayer: I'll do anything, just don't send me a fat girl. Race/Religion irrelevant. Can travel to city or suburbs. Call now! 75905

With this sort of attitude to contend with, how does a person of size go about making the personals work for them? There are two basic possibilities. One is to forego placing personals in mainstream-audience venues and to place them in fat-friendly places, such as the online *Generous.net* or *Large and Lovely Personals* sites, or in print venues like *Dimensions* magazine's personal ads. Such venues are far more fat-friendly than your average newspaper personals pages, but even there, you face the problem of needing to figure out what to say about yourself and how to say it.

In general, honesty is the best policy, and the more specific you can be, the better. You don't often see the word "fat" in personal ads, unless it's in the category of things people are seeking to avoid, but in a fat-friendly personal ad, it's much less of a liability. Even in mainstream ads, "fat" is much more honest and specific than "voluptuous," "curvy," or "Rubenesque," all of which show up frequently as euphemisms. Unfortunately, these well-intended euphemisms can backfire nastily: remember, we live in a culture where normal, healthy young women like Kate

Winslet, Drew Barrymore, and Janeane Garofalo are considered "on the heavy side" by people who idealize the wafer-thin Hollywood/Madison Avenue ideal. One person's "Rubenesque" is another person's size 12. "Voluptuous" might mean anything from "hey, you've got tits!" to describing the opulent curves of the always-resplendent opera diva Jessye Norman, depending on who's using it and their frame of reference.

The word "fat" is actually a perfectly legitimate word to use in a personal ad. It's accurate, descriptive, and it's a great litmus test. Some test personals placed as research for this book using the word "fat" actually received quite a number of responses, testament to the fact that there are plenty of folks out there who don't mind a fatter partner one bit – they're just not necessarily out in public about it. Because a lot of people still automatically hear "fat" as a derogatory term, keep it positive with phrases like "fat and sassy," "fat, fit, and fine," "fat around the middle, not between the ears," and in the middle of strings of other positive attributes, like "educated, fashion-forward, fat, sensitive, and kind to kids and animals." For the truly fat and sassy, however, there's also the approach taken by one lovely, adventuresome, fat, brunette Chicago woman, whose tagline is "Fat Free? I'm both! What did you have in mind?"

FAs may also want to use the word "fat" in a personal ad, and should also take care to frame it in a positive light. Not all people of size are comfortable with the word, and for many people, it still sounds like an insult, so similar cautions apply. Still, for many people browsing the personals, seeing the word "fat" in a personal ad may be like a cool drink in a hot desert. You might be pleasantly surprised by how many responses your "fat" ad generates.

At the same time, it may feel a little risky to use the word "fat" in a personal ad. If this troubles you, there are plenty of alternatives. You might compare yourself (favorably, of course) to a fat actor or performer: "Red-haired Camryn Manheim type" or "Sexy professional WM, friends say I look like John Goodman." Here's a short list of other ways you can communicate your size (or your desire for a bigger partner) with a minimum of misinterpretation.

Some phrases that work well in ad headlines: "built for comfort, not for speed," "more to hug," "round and well-rounded," "big, bad, and beautiful," "Teddy bear," "large and in charge," and "scales are for fish, not people!"

Ways to describe yourself: "large and luscious," "woman/man of size," "living large," "chunky," "bearlike," "I don't apologize for my size,"

"big," "BBW," "Big Handsome Man," "queen/king sized," or "blessed with size."

Below are the texts of four test ads that were placed as part of the research for this book (respondents were thanked for their time!) . Each of them received 8 or more responses when run in a mainstream paper or personals website (not explicitly fat-friendly) in a major metropolitan area. They were written to be charming, smart, upbeat, memorable, slightly quirky (things that are a little off the beaten path tend to be more memorable) and positive, and all of them got a fair number of responses even in what might otherwise be assumed to be a fat-hostile environment. (Author's note: All respondents to these ads were thanked for their interest, but were not informed that the ads were run for research purposes. Anyone who wants to use these ads themselves, in whole or in part, is more than welcome to give them a try!)

Roseanne seeks Tom! Smart, cute, professional, unpretentious fat gal who doesn't apologize for her size seeks a great guy who knows that more than a handful is NOT wasted. SF, 29, black/ brown, a little sporty, seeks SM, 28-40, who likes walking dogs, baseball games, road trips, cooking, reading, and necking on the couch. Teddy bear types a plus. Be solvent, interesting, and not living with your mom.

Remember Chunky Bars? Thick, chunky, sweet, but won't rot your teeth. Divorced man, 43, seeks soulmate for chocolate, conversation, laughter, bike riding, Sunday comics, cuddling, passion. I'm 5'10", large, chubby build, brown/brown, work in the financial industry. You – feminine, romantic, down-to-earth, tall a plus, not afraid of being sexy. Try a bite!

Mother Warned Me About Men Like You... so where are you? GM, 33, blue eyes, goatee, muscular, furry chest, looking for big man with talented hands, tasty smile, intriguing brain, wicked streak, for art movies, P-town weekends, passionate kisses, Harley rides. Seeking men 250 pounds +, prefer furry switch or top Daddy Bear types, race/age irrelevant.

Jack Sprat Would Eat No Fat, but I'm not that stupid. Average-looking artsy bi grrl, 30, loves to have something to hold onto. Me: blond/blue, Nordic, soccer-playing, short-haired, love

spicy food, grad student, told I have great legs. You: les/bi grrl or bi guy, 28-35, with chubby cheeks and everything else, plus an IQ to match, artistic, into alternative culture, open to adventure!

GETTING A GRIP

THEM BIG FAT HIGH SCHOOL BLUES

As the graffiti on the bathroom walls so often states: high school sucks. It's become a cliché to talk about how difficult adolescence is, how cruel kids can be to one another, and how much needless suffering is endured by kids at school simply because they're different in some way. Alas, the only reason it's become a cliché is that it keeps on being true. Being in high school can be miserable for anyone, but especially if you're fat.

In a lot of ways, high school is a four-year demolition derby in which the most attractive and desirable kids spend as much time trying to destroy any possible "competition" as they do actually enjoying the fruits of being at the top of the adolescent social heap. Being fat or otherwise visually "undesirable" makes you a very easy target for high school torture. What this means to teenagers of size is that just at the time that they're starting to worry in earnest about whether or not they're attractive enough to be desirable or whether all the threats of "you're not going to find a boyfriend if you don't lose some weight" are true, just at the time when their desires are becoming more intense, they also have to deal with some of the fiercest, most brutal negativity they'll ever face about their bodies, desirability, and looks.

It's not just the fat kids who go through this, of course. It's everyone. However, the high-school "demolition derby," and particularly the

preoccupation with being thin, beautiful, and attractive enough to land a visible and valuable boyfriend or girlfriend, is extreme and extremely upsetting when you already know (or fear) that you don't fit in.

The pressure that many teenaged girls (and some boys) feel to be thin creates record numbers of cases of bulimia and anorexia nervosa. But eating disorders are just the tip of the iceberg: depression, self-starvation, self-mutilation, anxiety disorders, and even suicide (attempted or successful) are all side effects of the desperate desire teenagers often feel to fit in and be accepted, to be found desirable and worthy.

The fatter you are in high school, the greater the odds that you'll be singled out for a variety of harassment and/or abuse: name-calling, bullying, teasing, having people avoid you or avoid being seen with you, having people play nasty practical jokes on you, having your locker vandalized, or whatever other fresh hell people manage to think up. The harassment and ostracism fat teenagers often face in school often has its sexual side. Large teens are commonly excluded from dating, dances, and the other aspects of social sexuality. Also, they're frequently considered as something close to "untouchables" in the de facto high-school caste system, so that even those who might otherwise have been interested in dating them face daunting social stigma if they express their interest.

> "...high school, the least comforting place for a girl's self image. Anyone who was over 120 pounds (for girls, or about 200 for guys) was made, by overheard comments and sometimes even overt insults, to feel like an inferior life form by the others of their gender. Which translated into fears that everyone of the opposite sex shared that opinion, and much too much fear to take the risk of asking anyone out." – Jade

> "High school was miserable. If I had believed my father's line about how high school was the best years of my life I would've had to commit suicide or something. It was a daily ordeal. I wasn't worried about a girlfriend. I was worried about surviving. I had precisely one date in high school – with someone I met while taking a class at the local college, and she was 5 years older than me. She decided I was too young but she told me that I was really handsome. I think she may have saved my life." – Rick

What this means – no news to anyone who remembers high school – is that fat kids are often sexually disenfranchised at just the time when

they've become most painfully vulnerable to being cast out and being considered "not viable" as sexual beings. It's not only the fat kids who get left out of the dating pool in high school, of course, but it is an experience that many people of size share. What this means is that, all too often, real life experiences around sexual issues may begin to solidify and reinforce the "fat and ugly" message that many people get both from their families and the culture around them. It can make it seem almost inevitable that they will always have a disappointing romantic and sexual life. Even with regular, run-of-the-mill romantic disappointments like being turned down for a date, fatness suddenly seems to play a role: everyone, even the best-looking jock on the football team, occasionally gets turned down for a date, but when you've been conditioned to believe that no one will find you romantically desirable because of your weight or size, it's easy to blame any and all disappointments on that factor alone. After all, that's what you've been trained to do.

Often, people who worry (or have been repeatedly told) that they don't really stand a chance in the high-school sexual marketplace end up just not participating at all. Instead, they end up watching from the sidelines, subsisting on a diet of dreams, crushes, frustration, and the nagging feeling that they wouldn't be allowed in the game even if they tried. These feelings often endure long into adulthood, and it may take significant effort and/or psychotherapy in order to loosen the grip that this kind of experience has on people's sense of attractiveness and self-worth. Budding FAs often have similar experiences, since they know that they will probably be teased or ridiculed if they make their attractions public.

Of course, the pendulum swings both ways. Instead of not participating at all in romantic and sexual interactions, some fat teenagers end up in unhealthy or exploitative sexual situations because of pressure they feel around desirability issues. There are always a few "misfit" teenagers in any high school – fat or not – who discover that making themselves sexually available will get them at least a part of the attention they crave. Most often this involves teenaged girls, who may try to use sex as a way to attract or "catch" (if only on a rather furtive level and for a short time) the attention of a boy they desire. The hope is that by giving him sex, they will get the boy to love them. Remember that many teenaged girls are fed the line that "if someone actually can bring himself to have sex with you, then he must really love you to see past your fat." That, combined with the cultural mythology that makes many people (especially women) conflate sexual desire and emotional love anyway, means

that a lot of girls and young women are willing to accept sexual activity they may not even really want in an attempt to barter for some of the desire, cherishing, and acceptance they so deeply crave.

Unfortunately, this often backfires. Because of the way the high school sexual economy works, boys who have sex can only raise their coolness quotient, but girls who have sex freely (particularly outside of a "going steady" type relationship) are seen as "trashy" or "tramps." What this ends up meaning is that there are a lot of teenaged boys who are more than happy to have what is to them emotion-free, no-strings sex with a willing partner who has, admittedly, offered herself up. It also means that there are a lot of teenaged girls who end up very hurt when they discover that sex is not a surefire way to "land a man," and for whom their first experiences of sex are often cold and unsatisfying – as Germaine Greer described it, "like squirting jelly into a doughnut." The high incidence of unprotected sex among teenagers, and the possibility of STD transmission (including HIV), makes this doubly dangerous.

Sadly, many teenaged – and not so teenaged – women who try hooking a boyfriend through sex are often nastily surprised when they discover that the boys they sleep with in their quest for affection and validation may not even be willing to acknowledge knowing them in public or around friends. This nasty little high school joke sums the attitude up quite well: "How are fat chicks and merry-go-rounds alike? They're both fun to ride, but don't let your friends catch you doing it!" Unfortunately, the young woman in question ends up in a Catch-22. If she tries to play the public humiliation card by exposing the fact that a given boy has had sex with her, a fat girl, she takes on the burden of being labeled a "slut" for being public about it… the old double standard rides again.

> "There was always a concern that an offer of a date was really a secret 'plot' to humiliate the 'fat-girl.' For example, while doing an intense and emotionally intimate scene in drama class with one of the popular guys, we made a connection that felt like more. Later, in a less intimate setting, he asked me out on a date. His buddies were looking on with smirks on their faces. I actually was impolite to him because I was very sure that he and his buddies were only asking me to see if they could make fun of me. I can never know if he actually meant it, or really liked me, because of the risk of humiliation." – Elizabeth

"There have been many times when a man found me attractive and asked me out because of my size. I found this situation to be extremely uncomfortable because I have a hard time believing anyone finds me physically attractive. I think it's a joke because that is exactly the type of prank played on me throughout my highschool career ." – Tracy

One of the specialties of the high-school demolition derby is the baiting of the unpopular by the popular with the intent to humiliate and shame them. Fat teenagers of both sexes are sometimes baited into humiliating positions by having one of the popular (generally thin and conventionally attractive) kids pay attention to them or ask them out, only to humiliate the fat kid by pulling a "what made you think I was serious?" sort of number in the end. This can, understandably, make a fat teenager pretty paranoid whenever anyone pays attention to them, even if the attention may seem or actually is positive. Given the amount of teasing and abuse they often endure, this level of suspicion isn't too surprising, but sometimes it does get in the way of their ability to perceive or accept genuine interest, a problem lot of fat people carry into adulthood.

However, the prognosis for teenaged fat kids' sexuality isn't entirely bleak. Common problems aside, it must be mentioned that some fat teenagers have no problems at all getting dates. Some fat teenagers are very well-liked, popular, and end up doing all the same things other teenagers do. Often the fat teens who have the fewest social problems are the ones who are well-supported by their families and who additionally have found some activities at which they can excel. Also, some people who were fat teenagers mention that being large gave them the appearance of being older than they really were, an appearance that stood them in good stead when it came to attracting admirers.

Unfortunately, there's not necessarily any way to prevent a fat teenager from having a rough go of it in high school. There's no real way to prevent *anyone* from having a rough go of life at that point in time. However, there are some things that teenagers, parents, adult friends of teenagers can do to help them develop confident and healthy personalities – and sexualities – no matter what their size.

It can be a great experience for teenagers of all sizes just to get away from the whole high school scene once in a while. It's a good reality check for teens to get to interact with adults on a peer level, and to

find out that life isn't always going to be like high school. Volunteering is a great way to meet a wide variety of people and to get a chance to explore areas of interest and expertise. Many museums have special programs for high-school aged volunteers, for instance. The confidence one gets from doing work that is fulfilling helps make people more attractive, both to themselves and to other people. As a bonus, non-high-school activities let teenagers meet people outside of their usual circles, opening new doors for friendships and possibly for romantic relationships as well.

Because of the ways the laws run, and because of some legitimate concerns about protecting kids and teenagers from unwanted sexual attention, it's pretty difficult to find venues for teenagers to deal directly with their sex-related issues. However, some avenues do exist for teenagers to get to know more about sexuality, to get comfortable with talking about sexual issues, and in general, to interact with their sexuality in ways that are not about engaging in sexual activity. Working in peer counseling and teen resource hotlines often offers opportunities to learn about and teach sexual and safer-sex information. Of particular interest to gay, lesbian, bisexual, or transgendered teenagers (particularly in urban areas) there are groups like P-FLAG (Parents and Friends of Lesbians and Gays), which has chapters all over the country, or local groups like Boston's BAGLY (Boston Area Gay and Lesbian Youth) or A Slice Of Rice (GLBT group for Asian youth). You can often find out about such local and regional groups from meeting listings in alternative or GLBT community newspapers.

The Internet, despite all the hype about porn and so on, also presents many constructive and fun options for teenagers to learn, read, and write about both sex-related and size-related issues. One of the best and least preachy sex education websites designed for teenagers is Pink Slip, which bills itself as "Sex Ed without the lame movies" and can be found at *scarletletters.com/pink*. Pink Slip is intentionally size-inclusive and welcomes teenaged readers of all sizes. Other useful and interesting websites for teenagers about sexuality are Planned Parenthood's Teenwire site (*www.teenwire.com*) and the Coalition for Positive Sexuality (*www.positive.org/cps/*). On the size issues front, the website for *Radiance, The Magazine For Large Women*, has a large and impressive section just for kids and teenagers of size (*www.radiancemagazine.com*), and *Fat!So?*'s web-based bulletin board, Hank's Gab Café, is often welcoming to teenagers as well (*www.fatso.com*).

Parents and adult friends of teenagers can really help the teenagers in their lives have a positive sense of themselves as sexual beings as they go through the often difficult years of junior high and high school. Even though it might not seem like teenagers pay much attention to grownups, they really do. Encouragement and support are important, even if the teenager in question may not seem to notice it specifically. They may be too embarrassed to say anything, but the likelihood is good that they will notice, and will appreciate, your supportiveness.

Don't tell teenagers or anyone else things like "you won't find a boy/girlfriend unless you lose weight" or "you'll have an easier time getting dates if you lose weight." It's not necessarily true, it's not helpful, and it just makes the person feel worse about themselves and their attractiveness. Likewise, don't say things like "you've got such a pretty face, if only you'd lose some weight." People can be attractive in a wide range of sizes. The less pressure teenagers get about their size, the more likely they are to see themselves as worthwhile and attractive people.

Avoid repeating the tired "these are the best years of your life" line in regard to high school. Given the way a lot of fat high schoolers are treated in high school's often ruthless hallways, they may be some of the worst years of their lives, not the best. If they feel that what they're experiencing in high school is the best they can expect in life, they might well become despondent... and with good reason. This is particularly important in regard to sexual and romantic issues. If a fat teenager isn't having much success with high school dating and romance, imagine how they'll feel being told that their current vulnerability and unhappiness is "the best" life has to offer them! It's better to be honest and admit that high school can be difficult and painful, but that there are a lot of things to look forward to.

Praise teenagers whenever it seems appropriate. If they're looking good or have done something well, tell them so. Don't qualify praise with weight-related taglines like "...and you'll look even better after you lose a little of that weight." If they've done something worth praising, it's worth praising, period. Every time you qualify praise with a weight-related comment, you intensify the hold of the mental equation between size and self-worth, making it very hard for the recipient to trust or accept your praise at face value.

Within your budget, try to help your teenager dress in style, even if it means goofy clothes or clunky shoes that you don't particularly like.

Sometimes just having one or two items of clothing that are trendy can help a kid feel much better about him/herself. It feels better, when you're a teenager, to be able to "pass," at least a little, in the styles that your friends wear. If your teenager is going to a dance or formal, go a little out of your way to help them find something appropriate. Prom dresses in plus sizes are hard to find, but it's not impossible. They probably won't be marketed as "prom dresses," but you can find some splendid dresses if you hunt around a bit. Some of the clothing catalogs in the Resource Guide are great places to find special-occasion clothing in larger sizes, particularly for women.

If a teenager you know mentions someone whom they find attractive or have a crush on, don't try to give them what you might think of as a "realistic" (i.e., usually pessimistic) idea of what you think their chances are for romantic success. Squelching someone's fantasies and dreams can really crush their spirit. If disappointment is in the cards, it will happen of their own accord, and in any case, you might not have a very accurate assessment of the situation. Even if you think it would be falsely encouraging to be overly positive, you can still smile and listen. Similarly, don't pooh-pooh their choice of crush object, unless you genuinely think that person might prove hurtful. This is particularly important if the person in question is perhaps not someone you personally find attractive, whether because of size or weight or for other reasons. Your teenaged pal's tastes don't have to be the same as yours: other people have a right to their own attractions.

Keep in mind that there are many people who find partners of size very attractive indeed, and that includes finding them sexually attractive. Occasionally, parents of fat teenagers assume that if their child is fat, he or she is less likely to be sexually active. One woman who responded to the survey conducted for this book said that her mother actually encouraged her to gain weight as a teenager on the grounds that if she was fat, she would not be having sex. In actuality, almost all teenagers are at least curious about sex, whether they become sexually active or not. No one can tell which teenagers are going to be sexually active and which are not by weighing them on a scale. All teenagers need to have sound, unbiased information about sex so that they are better able to make informed decisions about their own sex lives. The best any parent can do is to help their child be aware, supported, and well-educated enough to be confident with making their own good decisions about sex.

When you talk with your kids about sex, avoid linking sexual behavior to weight or size. It causes a lot of unnecessary angst and is often erroneous anyhow. For instance, some people report having had their parents say things like "Well, if you end up having sex, the person will really have to love you to see past your weight" as part of parent-child "birds and bees" talks. This may be the ideal, but as we all know, sexual interest doesn't necessarily mean that there's a corresponding emotional commitment. Believing that an emotional bond will exist just because sexual activity takes place is a dangerous trap for a teenager to fall into, particularly for a fat teenager who may feel that being sexually available presents them with an opportunity to get the emotional attention they crave. Teenagers are equipped, more often than many people think, to make sensible decisions about their sexuality. But for them to be able to make good decisions, they need good information, not judgmental or false generalizations.

FRIENDLY FIRE: COPING WITH FAMILY AND FRIENDS

It's not exactly a news flash, but families are rarely, if ever, perfect. Even fabulously supportive families have their quirks and problems. No matter whether your family is the type that put the "fun" in "dysfunction" or the type of clan that makes *Whatever Happened To Baby Jane* look like *A Walton Family Christmas*, it's more than likely that you have, at one point or another, had some issues come up in regard to the way your family and/or close friends have treated you in regard to your weight or size.

People of size may find it illuminating to know that familial pressure and harassment about size issues is not at all limited to people who are fat as children. Girls of all sizes grow up being warned "not to get too fat" or to "watch what they eat," boys of all sizes often get pressure to be more athletic or physically strong. Unfortunately, the people who are closest to us – family, particularly parents, and close friends – are often the source of a lot of harassment and even outright abuse on the basis of (perceived or actual) fatness or physical condition.

It can be hard to fight being ground down by this treatment. The people who are closest to us often have the greatest ability to hurt us. Proximity and long-standing bonds offer the opportunity for a great deal of love and support, friendship and solidarity, but they also offer the

chance to learn how to push people's buttons very effectively and to know precisely what parts of someone's psyche are most volatile and vulnerable to attack. This is true in regard to size-related issues, and with almost every other type of human vulnerability you can imagine, emphatically including the vulnerability we all feel about our sexuality and desirability. When negativity and harassment about body size and weight combine with negativity about sexuality, as they so often do, it can set the stage for an awful lot of deeply painful familial interactions that leave lasting scars.

It's important to mention here that while family abusiveness in regard to weight and size isn't limited to fat people, people of size are likely to suffer from this sort of family damage than people who grow up and remain "average" or on the thin side. People of all sizes grow up having been taught at their parents' knee that they constantly run the danger of being undesirable, unlovable, and unacceptable if their bodies deviate too much from the ideal (whatever that "ideal" may be). This tends to affect women more than men, because more emphasis is put on women's looks than men's, but it definitely does not exclude boys and men, who often do get left out of these kinds of discussions on the grounds that discrimination based on looks and physical issues doesn't affect them. Everyone, regardless of their gender, has to deal with being judged visually – and while male beauty or the lack thereof has not historically been as large an issue in Western culture as female beauty, it would be shortsighted to dismiss the fact that many men do go through very similar, and similarly excruciating, pain in regard to these issues.

Families, and particularly parents, often try to use sexual or romantic undesirability as a goad to prod children and teenagers into dieting or losing weight. Whether in the classic "no one's going to want to marry you if you don't lose weight" formula, or any of the many variations such as "you're going to have a much easier time finding a date for the prom if you just lose fifteen pounds," the link between desirability and thinness often gets reinforced through the use of scare tactics – the threat of not being wanted or found desirable. This often goes hand-in-hand with other size-related disapproval, sometimes including expressions of outright disgust at a person's size, looks, or weight.

This sort of criticism doesn't exist in a vacuum, of course. People hear it on a daily basis, from the culture at large (newspapers, magazines, television, conversations around them, etc.) as well as from parents, sib-

lings, grandparents, and friends. It is hard to resist such overwhelming negativity, and difficult not to end up internalizing it. Even in the face of positive real-world experience, many people still have grave difficulties shaking the baggage of years and years of size-related oppression and being told that they are, and will continue to be, undesirable and unloved.

> *"My father keeps telling me that not only am I ruining my health, but no one will ever find me sexy, desirable, attractive, or want to be near me because I am so huge, including platonic friends. Apparently in his eyes I am a huge ball of lard who radiates unattractiveness. All of my friends have laughed when I told this story, and touched me. Oh boy. My father, as mentioned many times, thinks that I am a large fat blob and every time I talk with him for more than five minutes my weight comes up.... That was certainly meaningful to my sexual development; you can only get told so many times that you're not as pretty or that no one will love you before you start to believe it..." – K.E.*

As the saying goes, "children learn what they live," and when children live with constant parental disapproval, they learn that they aren't (and perhaps cannot be) valued as they are, that they are irreparably flawed. They may feel that their parents don't really love them – it's not hard to question a parent's love when they are always trying to tell you how unlovable you are and how no one else will want to be around you when you're fat. Children don't have to be young for this to be a problem, either. No matter how old you are, you are still your parents' child, and for most people, parental treatment and opinions continue to influence self-image and self-esteem for as long as the person's parents live and even beyond. All this is to say that for many people of size, treatment they receive at the hands of parents, family, and close friends presents a serious challenge to the ability to live a happy, healthy, active sexual life.

> *"I was married for several years before it dawned on me that my mother had been wrong that I'd never find a boyfriend if I didn't lose weight. It took a while for that one to sink in." – Deborah*

Fortunately, many people do manage to shake loose the unpleasant mantle of parental disapproval and the threats of being found undesirable. Sometimes, all it takes is having one or two good experiences that make it obvious that they can be desirable and loveable just as they are to help people wake up to the fact that just because their parents (or the culture they live in) said something doesn't make it so.

> *"When I was 15 (I looked and acted much older) I was approached by two guys that were a few years older than me. He and his friend came up to me, asked for my phone number, called, etc. They were fighting over me. It was amazing! I was (and am) 5'4" and weigh about 250, and I was walking with a very thin and beautiful friend, but they didn't want her number! It was one of the most important things that brought me out of my desperate need to be on a diet and begin the acceptance process."*
> *– Amanda*

> *"When I discovered the Fat Acceptance Movement, NAAFA, and* Dimensions *Magazine, my entire self image changed – and this was about six or seven years ago. Too bad it took so long to feel as though I wasn't being done a favor, huh?" – C. M.*

Discovering your own attractiveness and desirability, and your potential as a vital, sexual, fully physical human being is just one part of overcoming the damage that many people carry around with them as a result of the "friendly fire" they endure from the people who are closest to them. Becoming more and more self-aware and self-confident goes a long way toward helping you "unpack your baggage," but it doesn't always solve the problem of having to face your parents/relatives on an ongoing basis, and having to come into repeated contact with the self-same negativity that generated all that baggage in the first place.

Sometimes, parental negativity about size issues lessens the stronger and more self-confident one becomes. But other times, the people closest to us will keep up their old tricks come hell or high water. It can take the wind out of even the most positive, self-assured person's sails to face that sort of long-honed and well-practiced opposition. People describe their confidence, feelings of sexiness and worth "just evaporating" when they have to deal with the negativity and harassment of relatives, and particularly their parents. The damage can linger for weeks or more.

Confronting parents with their damaging negativity, particularly where your sexuality is concerned, can be a daunting prospect. Many people (parents or otherwise) don't seem to be able to see their behavior as being in any way inappropriate or problematic. After all, they are simply reacting to fatness and body size/weight issues in the way that they have learned is correct according to the culture, and this body of opinion is additionally entrenched by the support of many professionals such as doctors and psychologists. It's damned hard to try to combat this kind of deeply entrenched prejudice no matter how profoundly your own experience of yourself and the world may contradict it. It's particularly hard when it's your parent, or sibling, or a close friend – people you trust and count on – who is telling you that your experience doesn't count, only the fact that you're not thin matters at all.

Keeping your self-confidence, your sense of self worth, and remaining able to assert your positivity and sexuality in the face of this sort of thing is very hard work. Some people will respond well to a straightforward educational tack. Simply explaining to them that their fears and projections about fat people's sexuality (and your sexuality in particular) are not necessarily accurate or fair, or telling them that their negativity hurts you and doesn't help your situation at all, may get them to rethink the way they behave toward you. Other times, people will respond more favorably to an educational, explanatory stance if the message is delivered by a more neutral-seeming authority. Give your favorite naysayer a copy of this book, or of a book like Ken Mayer's *Real Women Don't Diet* or Charles Schroeder's *Fat Is Not A Four-Letter Word* (see Resource Guide). For those who persist, as many "concerned family members" will, in bringing up what they conceive of as the serious health issues around fatness, the best resource is *Big Fat Lies*, by Dr. Glenn Gaesser. Prejudice thrives on ignorance, and education can sometimes cure it. Having controversial information presented by an outside source often lends it credence that it isn't given when it comes from the mouth of someone who might be presumed to be "just being defensive."

This is a useful tactic, but it isn't always successful. People can be remarkably resistant to changing their opinions even a tiny bit when it comes to issues as volatile and personal as fatness and weight. After all, if someone relents and acknowledges that people can live good lives and be sexual and happy without having to be thin to do it, what does that say about their own years of dieting, fretting, and self-enforced misery

in relation to their weight? Remember, too, that the culture we live in makes it hard for people to conceive of alternatives to a world in which fat equals bad and undesirable. Some people also have a vested interest in these beliefs in terms of personal gratification, control, or a sense of superiority. When someone to whom you're very close is persistent in these beliefs, and shows no signs of being willing to entertain any other viewpoint, it's time to try other ways of protecting yourself from the damage their attitudes can cause you.

Depending on how sympathetic you think your family/friends are likely to be to your happiness and well-being, you may wish to point out to them that when they criticize you for your size or tell you that you're not going to find a partner because of it, they're not doing you any good and are hurting your feelings and offending you. It can be effective, particularly with parents, to tell them that it is very hard for you to feel like they love you and care for you or your company when they are constantly putting you down or making their praise contingent upon some size-related remark. You might point out to them that since you both already know that you are not thin, and it is pretty obvious that their comments won't magically make you thinner, that their persistence in making them it demonstrates that they are evidently willing to go out of their way to say hurtful things to you.

When confronted with the pain their comments cause, parents and other family members often get defensive. They may claim that they say these things "for your own good" or because they don't want you to have to put up with the harassment and negative fallout that fat people have to experience in our society. Point out to them that perpetuating the same harassment and negative fallout themselves is hardly a means of solving the problem. They might never have thought of it that way.

Unfortunately, they may not be able to think of it that way, either. Often, confrontations with parents and family about size-related harassment just end up in an emotional, unpleasant, bitter stalemate. You may know, on the basis of previous interactions, that your family members aren't likely to change their stripes anytime soon in regard to weight issues, and that knowing that they're hurting you isn't going to help. You may simply be tired out from fighting the same fight over and over again with resistant people. You may, in short, be fully justified in not wanting to try to argue the point, but still want to have a way to refuse to take the abuse.

Refusing to accept size-related abuse from people who are close to you, whether it's "if I had been as fat as you are when I met your mother, you never would've been born" from a parent or other sorts of attacks from other people – boyfriends/girlfriends, spouses, and lovers are also notorious for dishing out weight-related abuse and emotional blackmail, ranging from "you used to be so sexy before you gained all that weight" to "if you cared about this relationship, you'd lose weight" and beyond – can sometimes require drastic measures. Some people find it necessary to cut off contact with people in their lives whose abusiveness has been particularly persistent and nasty. This is a high price to pay, but in some cases, it's genuinely worth it – not having a relationship with a given person is sometimes a perfectly reasonable alternative to having a relationship with someone that continually causes you damage and pain and which compromises your ability to be a healthy, functional, happy human being. Sometimes, eliminating these kinds of relationships paves the way for much better, far more supportive, life-affirming, and worthwhile relationships down the line.

> "A man that I was in an on and off sexual relationship with said he would not marry me unless I lost weight, but apparently I was good enough for sex. Looking back, that was when I realized that there are plenty of men that would want to marry me and I needed to dump this idiot. When I realized that there were men that wanted me BECAUSE of my size, I milked it for all it was worth. My husband and I are together because he prefers large women and we are EXTREMELY happy in bed, out of bed, on the floor... wherever we are." – Anonymous

Other times, leaving the relationship altogether doesn't really feel like the right thing to do. In such cases, it's helpful to find out whether there are pockets of support among your family and friends, people who know you and who know your situation well and who are willing to support you and perhaps even empathize with your problems and issues. Other relatives of size may or may not be the best places to look, since they may still be operating under the same damaging ideas you are trying to work through. You may find that a thin relative or friend who is aware of size prejudice and weight-related pressures is equally able to be someone to whom you can turn for friendship and mutual support.

"I think I've always been conscious of the fact that my parents believed that I'd never 'find anyone' because my size would make it impossible for anyone to find me attractive. That's been counterbalanced on some levels by my sister (a beautiful womyn well within 'normal', conventionally attractive size range) who shares many of these size issues with me – discussing it with her has helped me to understand that, at least on some levels, these issues are not a result of my size but merely of my existence in a society which focuses so intensely on a restricted and restrictive 'body beautiful'." – Demeter

It might also be helpful to work on setting boundaries with the people in your life whom you know to be the most prone to say things that are hurtful. There's no rule that states that you must share every last little detail of your life, or be open to discussion on every imaginable topic with someone, even if that someone happens to be your mother, your sister, or your spouse. It's perfectly reasonable to put your foot down and simply decide not to discuss your sexuality – or your weight – with anyone who you don't trust to be reasonably supportive of you. If someone brings it up, you can simply say that you're not willing to discuss it. If they challenge you about why, you can legitimately say that that, too, is not something you're going to discuss. You may choose to try to explain why you don't want to discuss these issues, but be forewarned that it's very hard to keep from having the discussion turn that way even as you're trying to establish that you're not willing to discuss those topics.

Parents, particularly, will sometimes act very hurt and put out when a child (even an adult child) tells them that some parts of their life are simply off limits for discussion. Remember that you have a right to privacy, and that your parents no more have the right to barrage you with negative and derogatory comments about your attractiveness and desirability than they do to know every intimate detail of your sex life. Sometimes it helps to think of it this way: you're not out to attract your parents, date them, or make them desire you sexually. Ergo, their opinion of your attractiveness and desirability is really quite immaterial.

You might understandably have the desire or hope of being able to solicit their opinion on things that matter to you – such as whether or not they think you are attractive to other people, etc., – but if you already know what their opinion is, and you know that their opinion is not

going to change unless you change yourself first, what's the point in asking only to be disappointed and hurt when you get the negative reaction you could've predicted in the first place? Sure, there's a possibility that even the most recalcitrant and steadfastly negative parent, sibling, or partner will suddenly come around and become supportive and positive, but don't hold your breath waiting for it to happen. Just do your best to be positive, confident, and let your family and friends see that you know yourself to be an attractive, sexy, worthwhile person, and let them abide by the principle so wonderfully articulated by Thumper the Rabbit in *Bambi*: "If you can't say anything nice, don't say nothin' at all."

Lest it sound as if people of size inevitably have bad experiences with their close family members and friends, it should be noted that there are a large number of fortunate fat folks who don't, whose mothers, fathers, and other relatives are supportive of them and encouraging of their attractiveness and desirability. Sometimes family members have had similar issues in their own lives in regard to weight, size, and sex, similar conflicts about desirability and attractiveness, or they may simply be supportive and compassionate people who are well-equipped to recognize the beauty in the people they love no matter what their size.

> *"My mom has always told me how 'incredibly beautiful' I am and that the younger a man is the more stupid they are. She has always told me that because of most men not maturing as fast as women, it will be when I am in my late 20s to 30s before I realize how desirable I am. I think about that sometimes and ponder if she is right... like if it will get better than it already is.." –* Amanda

> *"My mother is fat, and she told me a lot about her past sex life. I never got the impression that her sex life suffered at all due to her weight. In my mind fatness might get in the way of getting people to like you, but I never considered it a problem with sex. In fact my mom told me that when she was skinny and had sex, it hurt her hipbones." –* C. Q.

In the final analysis, though, one of the best and most lasting cures for repairing the damage that the disapproval and negativity of friends and family can cause is simply learning how to live a good, positive, sexually-confident life. Cultivating good relationships with people who treat you well, treating yourself well, doing things to enhance your feelings of

self-esteem and sexiness, and protecting your right not to be harassed and abused are all things which will make you feel, act, and be more centered, more in control of your own life, and thus more appealing and confident. Be as sexy, sassy, bold, and alluring as you like. Wear the kinds of clothes that make you feel good and look good – even if your mother wouldn't approve of them. Seek out the kinds of relationships you want in your life, and remember that not only do you deserve pleasure no matter what your size, there are people in the world who will agree with you wholeheartedly. Dare to prove the nay-sayers wrong!

> *"Fourteen months ago, after I left my husband, I suffered a serious depression. My skinny sister came from Colorado to be with me for a few days. She said to me one night (in an effort to make me feel better?), 'if you don't lose weight you'll never get another man.' I cried so hard one of my contacts washed out. Two weeks later I was seduced by the 29 year old ex-boyfriend of my ex-roommate. Living well really IS the best revenge." – BJ*

Fear, Opportunism, and the Case of the Closeted FA

> *"I'm having a problem with this friend of mine. We're JUST friends, with an occasional fuck on the side. We have a deal that nobody will find out about it. I'm fine with the situation as it allows me to get laid between relationships, only the next time this idiot sees me he acts like I've been mean to him or something, avoiding me when there's people around. Of course this starts tongues wagging and he's been asked about 'us.' His excessive energy in denying it only makes it worse. Is he afraid of a real relationship or of people finding out he likes sex with a fat girl?? It's driving me up the wall. I'd get serious if he wanted to, but this is impossible. I have half a mind to turn him down next time he wants it with ME. Pity, because he's my all-time favorite stud." – Mitzi*

Many women of size – and yes, alas, it is mostly women of size, in relationships with thinner men – have had the experience of starting a relationship with a man who seems very attracted to and interested in

them only to discover somewhat belatedly that he isn't interested in having anything to do with them in public. These men (and there may well also be women who do this sort of thing) may not be willing to be seen with their fat partners in public, may be averse to introducing them to his friends or family, or, more insidiously, he may revel in her big bountiful body when they're being sexual, but refuse to acknowledge her if they're anywhere that someone else might catch on. These are typical symptoms of a relationship with an in-the-closet Fat Admirer.

It can be a cruel awakening indeed to realize that you've been seeing a person who may profess any amount of love and lust in private, but refuses to be seen with you in public. This sort of treatment makes many fat people feel that they've been had when they realize that the person in whom they've been becoming emotionally and sexually invested was either only really in it for the sex alone, or is in any event not man enough to own up to his attractions and sexual preferences. It may make people of size doubt whether they will ever find a partner who will love both their personality and their physique. The experience of being wanted so intensely for one's physical attributes, and yet apparently not be considered "good enough" to introduce to friends or go out in public, may make a person feel like a whore, a sideshow exhibit, or like someone's fetish sex toy. None of these are very comfortable things to feel. Moreover, it usually makes people very confused, not just about their partners' motives, but about the motives of any subsequent partners they may have. It's hard not to take this kind of treatment as an insult. It's also hard not to constantly be suspicious that it'll happen again.

Requests and pleas for better treatment generally don't work. Often, it only gives a manipulative in-the-closet FA an edge to have concrete evidence of how dependent a partner is on his approval and attention. It's altogether too easy to set a manipulative and vicious cycle in motion – pleading and promising, unfulfilled promises leading to more pleading, desperation and dependency increasing along the way – if the wronged partner doesn't put their foot down. Closeted FAs have a much harder time not acknowledging their partners if their partners make it plain to them that no public acknowledgement of a relationship means no more relationship, period.

In-the-closet FAs tend to come in two flavors, the frightened and the opportunist. Frightened closeted FAs are not unlike frightened closeted gay, lesbian, bisexual, or transgendered people: they know that they have an non-mainstream sexual orientation or sexual preference, and they

are concerned about being ridiculed, having it reflect badly on them, or being harassed if their preference becomes public knowledge. This is understandable, but not really forgivable. It's one thing to keep your preference a closely guarded secret if it doesn't involve anyone else. It's quite another to compromise someone else's dignity and treat them with disrespect because you're not capable of pulling together the necessary intestinal fortitude to withstand the possible fallout of admitting that your preferences are somewhat different than the mainstream.

This may seem a little harsh. It isn't easy to face the prospect of being teased or harassed, of having co-workers, friends, and family possibly question your relationship choices or give you a hard time about the people you choose to date, love, or marry. Of course, fat people have to face the prospect of this sort of harassment on a daily basis whether they want to or not. They don't have the choice of hiding their fatness the way an FA can hide his or her attractions to fatter partners, and thus aren't likely to have all that much sympathy or empathy for a fallout-fearing admirer. For a person of size, adopting a "love me, accept my size" policy is not only justifiable but completely sane.

The truth of the matter is that coming out as a partner of a person of size probably isn't going to be as bad as you think. Attitude has a great deal to do with it. As Eleanor Roosevelt said, "No one can make you feel inferior without your consent." The more an FA presents their attraction or their partner(s) confidently, as something or someone they are proud of and enjoy, the more likely it is that the people around them will accept this. The more furtive and insecure they are, the more likely it is that people will pick up on their insecurity and worry.

In truth, "coming out" as a Fat Admirer, or simply as someone who has chosen a partner of size, is one of the times in life when social taboos against public tactlessness work in your favor. It's simply not polite to make nasty comments about someone's lover, partner, or spouse, at least not to their face. The stronger and more confident you are, the more proudly and lovingly you can present your fat partner, and the more confident both of you are in social situations, the smaller the chance that anyone will even say anything behind your back. Once people get used to the situation, they're often quite accepting even if they can't empathize with Fat Admirer preferences or desires. This "coming out" process doesn't have to be a big deal. You don't have to make an announcement or take out a billboard. You simply have to lead your life with your

partner without apologizing for your choice, your partner, or your attraction to your partner. In short, you just have to behave with a partner of size as you would with any other partner.

Then there's the opportunistic closeted FA, the one for whom a fat partner is quite welcome in the sheets – but won't be acknowledged anywhere else, no matter what. In the case of the opportunistic closeted FA, it's often not so much that they fear being found out as an egotistical unwillingness to let other people know that they'd "stoop to sleeping with a fat chick." Sometimes, people with this mindset feel that they can get away with using fat partners for sex because their partners will be grateful for the attention. Sometimes they're right, though this says more about how badly damaged many fat people are by being told they're undesirable and unlovable than it does about anything else. Basically, the opportunistic closeted FA is willing to take what they can get sexually, but isn't prepared to give much or anything in return. Such sexual opportunism, it goes without saying, can play hell with partners who are expecting something more involved or who have been led to expect a more serious emotional and personal investment.

However, as long as both partners are more or less clear on the fact that they're both there just for the sexual attraction and that neither of them are expecting more than hot sex, there's really nothing wrong with a purely physical, flagrantly opportunistic sexual relationship. This is true both for women and men. Some people of size find that they're actually fine with not being acknowledged in public in some cases – the lover in question might not be up to their usual standards or be someone they're interested in acknowledging in public, either. Opportunism can work both ways, after all.

> "The only time I had a problem with a lover not wanting to admit that he was seeing me it was someone I wouldn't have wanted any of my friends to know I was sleeping with either. He was a real loser, but man was he fun in bed. So when I noticed that he had no intentions of making me his girlfriend in public I was actually quite relieved. Total wash-up as a person. But in bed...whoo! I had a hot affair with him where we fucked a few times a week until I got bored." – Sasha

If you suspect that you're dealing with a closet-case FA in your relationship and you don't like not being acknowledged, the best thing

for you to do is to address it. Confront your partner with what's going on from your perspective. See what your partner has to say about it. It's not worth pleading to get the acknowledgement and respect you deserve, so make it clear that you're not about to beg. Simply tell a partner whom you think or know to be playing the "in the sheets but not in the streets" game that you find their behavior hypocritical and unacceptable.

It takes a lot of courage to face a lover and confront them with the fact that they're treating you shoddily, but it shows great strength to be able to tell them that you know you deserve better than you're getting. Let's face it: either you're good enough for him or you're not, and if you're good enough for him to want to be sexual with you but not good enough for him to acknowledge you in public, then he needs to rethink the way he treats the people with whom he has sex, get a reality check on his own honesty and self-honesty, and recognize that the kind of treatment he's dishing out is hurtful and disrespectful.

Confrontations like this are rarely uneventful. It's humiliating for anyone to be confronted with their own two-facedness. Anger and humiliated defeat are both likely responses. This is particularly true if you go to the length of looking your partner in the eye and telling them that they have to tell you, up front and without hedging, whether or not they think you're good enough for them. If they say that you are, then you can feel free to read them the remainder of the riot act in terms of what sort of respectful acknowledgement and real partnership you expect from them if they want to keep you as a lover. You have every right to be respected, acknowledged, paid attention to, and treated just like anyone else would expect to be treated in an intimate relationship. Your size has nothing to do with it, the fact that the relationship has come to exist does.

If they say that you aren't, tell them they can have it their way, and not to let the door hit them on the ass on the way out. Retain your dignity, and rest assured that despite the fact that you may not have wanted the relationship to end, it is a serious slap in the face to your partner have their lover dump them because they weren't capable or willing to be honest. No one has the right to run roughshod over a person they profess to be attracted to or even love, especially if it's because they can't face up to their own attractions. Perhaps they'll learn a lesson for the next time, and in the meantime, there are bigger, better, and more respectful fish in the sea.

Arousal, Desire, and Self-Confidence

Many people of all sizes have problems, at one point or another, with their levels of arousal or arousability, the amount of desire they feel for sex, and their feelings of sexual self-confidence. Sexuality is one of those things that makes us exceptionally vulnerable – it has less to do with looks or one's sexual track record than it does with the simple fact that sex is powerful and volatile and it affects us very strongly. Stress, worry, fear, self-hatred, or simple distractedness can all easily create serious obstacles to our ability to have the best and most pleasurable sex lives we can.

For people of size, problems with arousal and desire are often intertwined very closely with issues of self-confidence and self-acceptance. Plainly put, if you aren't confident that you and your body are attractive and desirable, if it is difficult for you to accept the idea that you can be sexy and lovely and luscious, it's going to be more difficult for you to accept yourself as a sexually vital being who is desired by other people and has perfectly legitimate sexual desires, needs, and pleasures. Accepting and perhaps even coming to enjoy and revere your sexual, sensual, and physical self is a major part of being a fully integrated human being who owns sexuality and sexual pleasure as part and parcel of their life. The more that integration takes place, the more fully one can enter into sexuality and sensuality, enjoying it and celebrating it to the fullest.

There are a number of different things that go into making this integration, this generation of an organic, deeply felt sexual self-confidence, happen. Some of the most directly sexual ones involve the relationship you have with your body. Many people of size come into adulthood already pretty much alienated from their bodies, a situation which stems both from the Western tendency to be a bit alienated from the body and also from the fact that people who are fat often learn to dissociate "themselves" from "their bodies" as a way of coping with the often intense abuse, harrassment, teasing, and negativity that is leveled against them from an early age.

It's common enough for even thin people to have negative thoughts when they really take notice of a part of their body that they don't happen to find physically attractive – who hasn't heard someone say "Ugh, my thighs!" or "I look so fat!" when they catch a glimpse of themselves unexpectedly in a mirror or window? For people of size, this reaction

often happens every time they actually focus attention on any part of their bodies, because they've been so often subjected to messages that their bodies overall are flawed, ugly, unwanted, and often, completely disgusting. It's a difficult task to learn to accept your body when so much of the world around you is constantly telling you – in conversation, in ads that promise to melt away "ugly flab" or get rid of "unwanted pounds," in magazines that show extremely uncommon body types as the paragon of beauty, in the advice you're given by family and friends – that your body, and therefore you, are unacceptable. The upshot of all this is that fat people often have needlessly but violently antagonistic, hateful, resentful relationships toward their own bodies.

Not too surprisingly, it's pretty difficult to enjoy your body, be relaxed when other people touch you, or appreciate and enjoy anyone else's enjoyment of your body and its parts, if you can't help feeling that you're really unacceptable and horrible the way you are. Some people resist being sexual altogether, or are comfortable being sexual only in circumstances where they feel they can hide: doing it only with the lights out, doing it only in certain positions so that "the fat won't show," doing it while wearing some articles of clothing to "mask" the offending body part(s), never getting on top, and so on. Some people, particularly women, are too worried about being seen to really enjoy the sex they do have. Even women who are well within the "normal and attractive" range of conventional body beauty sometimes go from aroused to appalled at the mere thought that their partner might have felt or seen their belly or thigh. Many people of size speak of a feeling of "waiting for the other shoe to drop" when they are in a sexual relationship, or feeling like their lovers couldn't possibly be seeing the "real them," or a feeling that they keep waiting for their lovers to wake up and realize what they really look like and reject them.

Is it any wonder that people sometimes have a hard time getting aroused, staying aroused, feeling desire, and feeling confident about their ability to have fully pleasurable sex lives when thoughts like these are going through their heads? In the surveys conducted for this book, it was quite common for people of size to report that they believe that they were sexy but that their bodies were not. Even if you feel like you are a sexy and sensual person on the inside, it can really wreck your mood and throw you into a pit of self-doubt and anguish about sexuality if you feel like your outside is bound to disappoint. If that's what you're thinking,

your body is indeed bound to disappoint someone: that someone is you. You end up paying the price in the form of angst-ridden sex that isn't really all that much fun... or as enjoyable or as absorbing as you'd like it to be.

Part of the solution, at least, is the ongoing process of self-acceptance and learning to accept your body, no matter what size you are. One good exercise to try is self-massage. Touching yourself all over in the way a masseuse might touch you, in sweeping, soothing gestures, is excellent for giving yourself positive sensations and getting to know your own body and how you like being touched. Stroke your thighs and arms first, your calves, your hands, your head. Do a little kneading and massaging, whatever feels good. Spend time lightly rubbing your joints – they do a lot of work for you, so be kind to them. As you go along, try your shoulders and upper chest, then move down to your tummy and hips. Try to concentrate on touching yourself in ways that feel good sensually, and at least at first, pay more attention to how your touches feel to you than how your skin and flesh feel under your hands.

If you start having negative thoughts about your body or the way your body feels under your hands, pause for a moment and go slower and press a little harder. Really feel your body, both the way the touches feel to the body part you're touching and the way your body feels under your hands. You will find that your body has a lot of different textures and consistencies. Not all muscle feels the same, and not all fat feels the same, either. Some places on your body will be softer and more pillowy, and others will be firmer and more springy. As you get more comfortable with all the different sorts of ways your body feels, go ahead and play around a little with your body. Gently jiggling or swaying, letting your fat undulate under your hands as you experiment with pressure or light kneading, can really feel very good and be a lot of fun. Do it as long as you enjoy it, and stop if you start feeling self-conscious enough that you begin having negative thoughts about that touchable, sensual, wonderful body of yours.

Masturbating is also a great way to get more comfortable with your own body and with the sensations you can experience and enjoy. If you already masturbate regularly, try varying your self-loving by touching yourself all over during masturbating, and especially by touching parts of your body that you'd like to feel as more erotically sensitive. If you've always wanted to be able to enjoy being touched on the thighs or hips

when you're getting aroused, for instance, touch them yourself as you're gearing up for solo sex or take a moment away from more direct genital stimulation to touch them as well.

Being comfortable with touching your own genitalia, and knowing what kind of stimulation feels best for you and is most likely to lead directly to an orgasm, is great. But so is being able to be sexually aroused by touching that isn't directly genital. After all, our genitals are smaller, in terms of the amount of our bodies they compose, than our heads are. Being sexual only with your genitals is a little like living only in your head – you miss out on a lot of other possible input and experience. Ideally, being erotic and acting sexually should encompass your entire body, including your genitals, and your mind and "head space" as well.

Another way to work toward feeling more accepting and loving of your own body and your own sexiness and sexuality is to move your body in ways that feel good. Dancing, even if it's something you do all alone with the shades drawn, is a fabulous, fun activity. Moving your body to music that makes you want to move is phenomenally freeing. Especially if no one's watching, you can shake your groove thing until it damn near falls off and enjoy every minute of it. It doesn't have to be traditional "dance moves," and you don't have to "dance" in standardized ways. Move however you want to – roll on the floor, bounce on the bed, do high-kicks in the breakfast nook, sway back and forth and wriggle as you sit in your chair, belly-dance in the shower, or pretend you're Martha Graham in your living room.

Like any other form of movement, dancing is good for you, and gets your blood pumping and your muscles moving and the oxygen flowing to your brain just like having sex does. Unlike a lot of forms of exercise that many people do specifically to try to lose weight like running, calisthenics, or aerobics, dancing isn't formulaic or repetitive unless you want it to be. Like sex, dancing and moving around to music is about expressing yourself, about channeling your feelings into and through your body, and about feeling both sensation and emotion through your entire body and many senses simultaneously.

Other types of movement can work this way, too. Swimming is a wonderful way to move your body, particularly if you can splash and sport around any way you choose rather than just swimming laps. Water is very sensuous and also very kind to bigger bodies. The trick is to find a place where you feel comfortable swimming. In some areas, size-acceptance groups hold regular swims for people of size, and they, like the

pool parties at size-acceptance conventions, are extremely popular, positive, and great fun. If there's no size-accepting swim in the area where you live, get together a handful of fat friends and find out how much it costs to rent out the pool at the local YMCA or community center for a couple of hours. If you get 10-20 people together to split the cost, it can be very affordable and a lot of fun, a fabulous way to form community, feel better about your body, and enjoy not only moving your own body, but being around other people of size as they enjoy being physical too.

This is actually a pretty important point. A lot of the isolation that people of size feel within their own bodies – the feeling of being estranged from your body – is akin to the isolation that is often felt just being a fat person, estranged from the rest of the "normal" world. Being able to be around other people of size, particularly those who are size-accepting and who share your goals of living fully in your body in all ways, including sexually, is an excellent way to gain comfort and support. Being around other people of size, and particularly, if it should happen, having romantic or sexual relationships with other people of size, can really change the way you interact with your own body. Finding yourself sexually attracted to another person of size can suddenly clear up that whole mysterious problem of how anyone could be attracted to someone (like you) who isn't slender!

Get more involved with your body, no matter what size it is. Pamper it. Give it long baths, nice lotions, sensual and good-feeling rubs and massages, whether self-administered or given by someone else. Wriggle around and move and enjoy the sensations of movement. Touch yourself sexually and sensually and revel in the delicious feelings your body is capable of having. Take the time to spend a bit of your day living somewhere other than just in your head, and enjoying the wonderful body you have. It may not be perfect, whatever your conception of "perfect" may be, but it is yours, and it is capable of wonderful things. For better or worse, for fatter or thinner, it's also the one you've got – you might as well enjoy it.

Learning to enjoy your body and accept yourself as you are is an ongoing process. Self-acceptance doesn't mean stagnation. It doesn't mean that you accept yourself as you are, and therefore you don't ever try to better yourself or change things that you want to change. It just means that you accept yourself in that moment in time, and don't put off giving yourself credit for being a sexy, desirable, worthwhile person until you

lose weight. It means that you don't put off asking that sexy person you've been eyeing out for a date until you've lost ten pounds. It means that if you want to wear a g-string or a tuxedo or a corset or high heels because it makes you feel sexy, because it feels good to feel sexy, and because you deserve to feel good and feel sexy. And it means that when someone else finds you attractive or desirable and expresses an interest in you sexually or romantically, you don't immediately think to yourself, "Jeez, what kind of weirdo is this gonna turn out to be? If s/he's interested in me, there must be something wrong!"

Self-acceptance also means that when a lover begins to undress you and the lights are still on, that you might make a little extra effort to let them see you naked. Self-acceptance means that you at least allow yourself the notion that they might want to... and that they might even be enjoying the hell out of it. Self-acceptance means accepting your own needs and desires enough to tell your partner that you want them to touch you this way, and that way, and that you tell them what you want to do where they're concerned. It also means not putting up with bad sex, or unwanted sex, or sex that you aren't really too sure about, because you know you don't have to settle for sex that's not what you want and need it to be. Self-acceptance, as a sexual person and a person of size, means acknowledging that you have appetites and making a good-faith effort to trust them. Self-acceptance means letting yourself be touched because you deserve the pleasure of being touched. And maybe most of all, self-acceptance means trusting the pleasure that your body and mind can give you, remembering that not everyone derives pleasure in the same ways from the same things. If it brings you pleasure, brings your partner(s) pleasure, is consensual, and harms no one, trust your gut and enjoy.

These things aren't immediate, and they're not necessarily easy. It's enough to just take baby steps. It becomes easier as you get more practice, and you don't have to do everything all at once. Some things you may never do at all. But each step you take toward self-acceptance, both in terms of being a sexual being with desires and needs, and in terms of being able to enjoy and trust your body's capacity for sexuality and pleasure, will enhance your sex life and your life as a whole.

Unfortunately, there's no simple answer to overcoming the feelings of estrangement from the body or estrangement from being sexual that deeply affect many people's sex lives. There's no piece of lingerie, no psychotherapeutic technique, no pill or potion, no CD of mood mu-

sic, and no ideal lover whose presence will magically make it possible. Even being thin doesn't automatically make it possible – just as many thin people as fat people have these kinds of problems. Fortunately, it is possible to make progress anyway, with or without the help of an understanding, attentive, and supportive lover, by doing things that support your physical and mental health, your ability to enjoy your body, your ability to enjoy your sensuality, and your ability to accept yourself for who and what you are. Not only do you deserve to have a vital, full, integrated, physically sexual life no matter what your weight or size, but, very simply put, you *can*.

How To Say Yes, But Not To Everything

"For the longest time, I almost always accepted propositions for sex - on some level, I think I believed that I might never get another chance, that I should be grateful that someone would deign to sleep with me and should go along with it. Of course, that led to a lot of conflicted feelings about sex and some not very positive feelings about myself. In the past few years, that's really changed – I've been celibate for almost four years now, having realized that I needed to take some time, feel good about me before getting back into sex. On a couple of occasions since, I've fooled around with people but been (a) totally upfront about my limits and (b) comfortable stopping things when they reached a level beyond which I was not comfortable. It's been incredibly empowering to realize that (a) people still want to be with me even if I won't fuck them and (b) that I can say no, or stop or walk away." – Demeter

Sometimes, the issue isn't so much whether or not you want to be sexual but how sexual you want to be, when, and with whom. Perhaps you're the type who likes to take it slow to really be sure that a sexual situation is the right one for you before you go all the way. Perhaps you're the type who likes to take it slow just because you enjoy the anticipation and the build-up to actually having genitally-focused, capital-S Sex. Maybe your own feelings about sexuality and sexual ethics mean that for you, it's not really right to have certain kinds of sexual activity happening unless you're in a committed relationship like marriage. Or it might be

that you simply aren't comfortable with certain activities unless you really feel like you can trust your partner. The problem, in each case, is to know how to set your boundaries so that you can enjoy yourself and enjoy being sensual and sexual without feeling overwhelmed or in over your head.

It can be very difficult to know how to set boundaries when you've grown up, or spent your adolescence, in an environment in which you had to (or at least felt like you had to) hew to everyone else's line in order to be accepted. Fat people face not just the usual (and usually relatively reasonable) run of having to conform to parental standards about curfews, grades, and which of their friends their parents find unacceptable, but from childhood on, they also face a great deal of parental, familial, peer-level, and outside pressure about their bodies, their weight, their appearance, and their appetites. Repeated dieting, particularly when enforced by someone else (like a parent), tells a person (of whatever age) that they aren't competent to choose their own food, that they don't know how to control themselves, that their appetite is not to be trusted, and that pleasure for pleasure's sake is a bad thing, at least where enjoying your food is concerned. This tends to make people mistrust their physical appetites and responses. When you're accustomed to ignoring physical hunger even to the point of pain, it can disrupt the ways in which you respond to other types of bodily triggers. You may not trust the signals that your body is sending you, or figure that they're just not important enough to worry about – after all, you know that hunger pangs can be ignored, so it becomes easy to ignore other kinds of desires as well.

Perhaps the most significant damage that many people suffer as a result of growing up fat is feeling that no matter what they do, they're not worthy of being loved, wanted, or truly accepted and desired as long as they are fat. When people feel like this, they often become very obsessed with pleasing everyone but themselves just so they'll be accepted and included. Sexually, this can mean that a person feels unable, unqualified, or undeserving to draw boundaries that have to do with their own desires, limits, fears, and needs. After all, many fat people live much of their lives squelching their own desires in order to be extra-good, extra-helpful, and extra-forthcoming so that the people in their lives will love them and accept them in spite of their fat. Being inclined toward putting other people's desires far ahead of your own, however, can be a good way

to end up being taken advantage of in a very serious and potentially unpleasant way when it comes to being sexually active.

For example, a lot of people of all sizes end up getting into sexual relationships when what they really want is to be wanted, loved, and accepted. These things can, and often do, coexist with sexual relationships, but they don't always, and there's no guarantee that they will in any individual case. It can be really painful to think you'll be getting the love and acceptance you crave in exchange for being sexual with someone and then not get it – even if you also genuinely wanted to be sexual, it hurts not to get the other things you wanted and which you thought would come along with the sex.

Regardless of whether you want loving, sweet, cuddly affection, a slam-bang no-7strings hot fuck, or anything in between, the trick to getting what you want without having to do a lot of things you don't want to do is learning how to set your boundaries. We live in a culture in which relationships can go from "Hi, nice to meet you" to "Wow, that was great, want a cigarette?" with sometimes alarming rapidity, and many people tend to assume that a romantic liaison is necessarily going to be sexual as well. When you're interested in taking the scenic route rather than the fast lane to the bedroom, tell the other person(s) involved so that everyone knows what to expect and doesn't feel too manipulated or frustrated.

One of the big issues in setting boundaries is being able to explain why you want them. You don't have to justify your boundaries, but you should give a partner some reasonable idea of why you are putting limitations on your sexual activity with them. Just saying "I know from past experience that I don't tend to enjoy it as much if I rush things," or "It takes me a while to get comfortable enough with a new partner that I can really let loose and let go of all my inhibitions, and since I'm very attracted to you, I'm really invested in taking the time to get totally comfortable with you so I can do that" is more than sufficient.

A lot of people emphasize learning how to say no as an important limit-setting technique, but it's just as important to learn how to say yes. In sexual situations, it can be more powerful, and more effective, to know how to say yes, but not say yes to everything, than to simply say "no." The difference is not in what you do or do not actually do in terms of sexual behavior, but the psychology of how you verbalize and maintain your limits. Giving yourself or your partner a laundry list of things that are off-limits can seem very off-putting. Giving yourself and your part-

ner a list of things you can do, that you know you enjoy, seems like it offers much more possibility. This is particularly true if you are responsive and communicative when they do the things that you enjoy: showing your pleasure is a form of positive feedback.

Be aware that sexual situations have a tendency to snowball, and that when things feel good and you're getting aroused, it can be easy for you or your partner(s) to slip up and forget about a boundary or three. Sometimes this is really okay, and you may genuinely not feel like you want to stop the action, but at other times it's problematic and puts you in a position where you just don't feel comfortable, or know you won't feel comfortable with it later on. When this happens, it's okay to call a time out, to say "I'm sorry, things are getting a little beyond my comfort zone... I need a time out." Relax, breathe deeply, regroup, and take a minute or two to think about where you want to go with things. Sometimes it can take a bit of discussion and comforting to reduce the frustration level – no one likes being cut off cold when things are getting hot – no matter what gender your partner(s) may be, being left with the achy unfulfilled sensation of "blue balls" isn't much fun. But, on the other hand, it's also not even close to fatal and will, at most, just be a little achy and frustrating and unfulfilling.

Although your partner may agree to your boundaries, it isn't their responsibility to enforce them. The person who establishes the boundaries has the responsibility to maintain them. Once in a while a partner will try to push boundaries, and sometimes you have to push back to maintain the limits that you need. Repeated resistance from a partner is another problem, but don't assume that it has anything to do with your weight or size. Sometimes it can be easy to blame any failing in the sexual arena on your weight or size. In truth, some people will push boundaries just because they're there to be pushed, and it doesn't matter who sets them or what they look like.

You're more than entitled to push back. It's difficult to set sexual boundaries, and challenging to maintain them, particularly when you feel like you're keeping someone from having something they really want to have and they're frustrated or possibly irritated about not being able to have it. Most people don't have much practice at doing this. No one likes making unpopular decisions. People of size in particular are often accustomed to making concessions in terms of their own comfort or boundaries in order to placate other people and to assure themselves of being well-liked as a compensatory gesture: feelings of having to do more or

give more in order to make up for being fat are very common. But they're also largely erroneous. People in general usually try to be kind and forthcoming in regard to people they care for and people whom they wish to have a good opinion of them, but there are limits to everything.

For people of size, the need for boundaries and the type of boundaries that feel appropriate can change dramatically as self-acceptance and self-confidence increase. Interestingly, people often find themselves wanting more boundaries as they become more confident and self-aware. When you're used to taking a lot of crap from people and just putting up with it or letting it roll off your back, your boundaries can get pushed back to survival levels, and your warning bells and defense mechanisms don't go into action until you're threatened pretty seriously. The more self-accepting and self-confident you become, the more you find that your boundaries become important to you, and the more you find out what it is that you can and cannot comfortably tolerate in your relationships (sexual and otherwise) with other people. You learn to negotiate social relationships more adroitly, and learn to put your foot down with the people who make a practice of overstepping your boundaries... not because you enjoy having to put your foot down, not because you enjoy having conflicts, but because you value and respect yourself.

Anyone who enters into a romantic or sexual relationship has a right to their own standards for how they want to be treated, how they want to be able to interact with their partner, what kinds of closeness and intimacy they need in a relationship, and what levels of respect they need. Fat people are no different than thin people in this regard. Boundaries, in this way, are a sort of responsible selfishness. They're self-protective (hopefully not in a reactionary way) and self-supportive (hopefully not in an arrogant way). Boundaries also come as a real shocker to people who don't expect that you'll have any – many people who have a low opinion of fat people and who think that fatness automatically equals irresponsible, stupid, and having low standards won't expect that of a fat person. Surprise!

Don't be afraid to spring this kind of "surprise" on a potential sexual partner. If they're worth your time, they'll be able to roll with your desire to negotiate boundaries, and they'll probably even have a few of their own to add to the mix. For instance, if you say that you're interested in getting physical with them after a date but that you don't want it to go below the waist, they may respond with another boundary, such as "Sure,

but if we're not going to get that heavy, please don't play with my nipples, because that's just about as intense for me as directly touching my clit." Or they might have a question about whether or not something specific is okay – if there are to be no hands below the waist, would it be totally out of the question if some bumping and grinding went on, or not? Setting boundaries is almost always a process of negotiation – you know what your limits are, but within those parameters, a little give-and-take is always appropriate.

If, on the other hand, they should happen completely drop their beads and stomp off in a huff because you've dared to set any limits at all on their behavior, well, good riddance. Some people just can't handle not getting their own way. That's their problem, not yours. Sure, sometimes it can hurt to see someone walk away, particularly if they're someone to whom you're attracted and with whom you had really wanted to be sexual, but it's not necessarily worth your sanity, comfort, dignity, and self-worth to do what it would take to make them stay. The truth of the matter is that even though it may feel like they're rejecting you, it's the other way around: you make your standards clear, and if they decide that they can't work with you or negotiate with you at the very least, they know that their other option is to take their business elsewhere.

Sometimes it may feel as if setting boundaries means forfeiting the opportunity to have sex, and that saying "No, I don't want to go all the way right now" means giving it up altogether. If a partner isn't willing to accept your boundaries, that may sometimes prove to be the case. But there are just as many (and probably more) people who will be willing to work with you. You don't have to be thin to have the right to say no. You don't have to be thin to have the right to walk away from a situation that isn't to your liking. You don't have to "settle for what you can get" just because you're not slender. And perhaps most importantly, you don't have to be thin to decide, consciously and with your own best interests at heart, when, where, and to what you say yes.

On Being A Sex Object

Some of you are probably wondering what the hell a chapter about being a sex object, the object of a physically-rooted sexual desire, is doing in a book about fat people and sex. Fat people, after all, aren't usually the ones we see plastered all over movies and magazines as sexual icons.

But one doesn't have to be a movie star or a model to be a sex object on a smaller, more personal scale. All that has to happen for someone to become a sex object is having someone else view them in a way that is primarily sexual or sexualized. This happens to people all the time, no billboards, magazine coverage, or Hollywood stardom necessary. What's more, it happens to people of all sizes, including large, extra-large, and supersized.

When you become aware that you are the object of someone's desire, it leaves you with the task of figuring out how to handle it emotionally as well as how or whether to respond. People of size are often raised with the expectation that no one would ever sexually objectify them, or even express sexual enthusiasm for them or their bodies. Therefore, people of size often find that when they end up facing situations where they are being regarded as sex objects (not necessarily negatively or exploitatively) or simply desired on a profoundly physical level, they just don't know what to do. That's not uncommon. Finding yourself standing full in the face of someone else's sexual interest or desire, particularly when that person is not someone you know, makes most people – fat, thin, or otherwise – feel a bit like a deer caught in the headlights of an oncoming truck.

> [Interviewer: How do you react when you can tell someone's attracted to you?] "Panic. It's a very strange feeling, since it has only occurred at the NAAFA convention last year, for the first time in about 15 years. It was a very strange feeling because the attraction was solely physical – I thought the guys were creeps."
> – Anonymous

Part of the problem with any form of sexual objectification is that being looked at as the object of sexual desire is an extremely different experience from being the one doing the looking. The dynamics of the situation often mean that the person on one end of the sexualization/objectification equation is completely blind to the feelings and experience of the person on the other. For the person on the receiving end, being regarded in an intensely sexualized way can be incredibly uncomfortable and alienating. It can feel like someone only wants you for your body or wants you as a fetish object, that they really don't care about who you are, what you might want or need, or even whether or not you're

comfortable, since their objectification makes you uncomfortable in the first place and they're doing it anyway.

For the person doing the objectifying, it usually feels quite different. When we're attracted with that degree of sexual intensity, we often don't see what we're doing as sexual objectification. It may in fact feel like you're a helpless victim of your own desire. You'd prefer not to stare, but you just can't help yourself because the attraction is so strong that you're sitting there flushed and totally unable to think. It may seem difficult to comprehend how a person to whom you're so viscerally attracted could interpret your attention as anything other than flattering, since you know how intensely and positively attracted you feel.

Ironically, even though many people talk about wanting to feel like they're absolutely irresistible and that people are intensely attracted to them, it can be pretty uncomfortable to actually feel that intensity of attraction, particularly from someone you don't know. For some people of size, it's pretty uncomfortable to feel any level of physical or sexual attraction from anyone, having been conditioned all their lives that they weren't going to. People don't go out of their way to create responses to situations that don't exist, or which they believe aren't going to. The result in this case is that people of size often find they have no coping skills when they're faced with a situation in which they suddenly realize that they are indeed the object of someone else's intense sexual desire.

The first reaction many people of size have to being the object of another person's intense desire is shock and disbelief. This is understandably a bit frustrating for FAs and others who are attracted to partners of size, because it creates a wall that makes it quite difficult to convince someone that your attractions are genuine.

> *"I've met a number of people who completely believe society's conditioning that anorexic models are the height of beauty, and therefore heavyset people are supposedly 'unattractive.' I've met a number of people who were completely shocked when they discovered I was really interested in them. Sometimes when I meet people for the first time, and they see me staring at them, they've had the impression that I was looking at them negatively (despite the fact I'd be smiling, or whatever). Since many of them automatically assume they're unattractive, they project other reasons onto me for my attention, such as ideas that 1) I want something from them other than friendship or sexual intimacy,*

2) maybe I'm teasing them, 3) maybe I'm thinking bad thoughts about them. Some have been so surprised when I told them I was attracted to them, and they were completely and literally speechless." – Lewis

"Either big men don't seem to believe me, or they seem cautious, or they have NO IDEA that I'm cruising them, even though every other gay man in a mile radius can tell that I'm just salivating over them." – Romeo

This sometimes combines with a deep-seated suspicion that fat people often have of anyone else who acknowledges an attraction to partners of size, the old "If they're attracted to something no one in their right mind is supposed to be attracted to, there must be something very wrong with them." Sometimes, a person of size will be able to acknowledge that an admirer is very attracted to their body, but this may be an uncomfortable prospect for them if it seems it's only their body that is being found so attractive and their admirer really doesn't care about them as a person.

It's amusingly ironic in light of our larger cultural expectations about size and desirability to note that many fat people, when confronted with an admirer whose interest is first and foremost physical and/or sexual, have the stereotypical reaction ordinarily expected from models and other paragons of conventional physical beauty: "Oh, but s/he's only attracted to me for my body…"

This may be true. It happens, and it's not necessarily a bad thing. But then again, it may not be true at all. After all, we all have our physical preferences in terms of our attractions, and it doesn't mean we're not attracted to the inside of a person just because we're also attracted to the outside.

"Some think chasers only love them for their bodies. They question why. They think you are a one-night stand taking advantage of them. They even ask me if I'm sleeping with my skinny roommates. I try to tell them a chaser's liking for fat bodies is equivalent to their liking of muscular men. Doesn't mean we don't care about the person inside, we just like a thick cover to go with it." – Sam

It's a little presumptuous – to say nothing of insecure! – to assume that someone who's obviously attracted to you is only going to be at-

tracted to you for your body or your looks. If you don't talk to them and give them a chance to get to know you, that's all they *can* possibly find attractive since they have nothing else to go on. Without question there are those who will simply stand there with wolfish looks on their faces, and that wolfishness sometimes is all that's going on: sheer animal attraction. But if someone is staring at you and seems hesitant to approach you, try to remember that they might well be nervous as hell. It's very risky to try to talk to someone to whom you feel an intense attraction, and feeling that strongly attracted to anyone draws out insecurities and fears of rejection. It's a friendly gesture to suspend judgment if you think someone's just tongue-tied and scared.

No matter on which side of the desirer/desired equation you may fall in any particular instance, it behooves one to learn to deal graciously with both expressing and accepting interest. It may not be comfortable or appropriate to directly acknowledge someone else's sexual interest, but it is always possible to acknowledge their presence as a person. A friendly smile, an instant of eye contact, or a bit of small talk don't obligate you to anything, and can take a lot of angst out of the situation for both of you. If the attraction is mutual, and chatting proves fruitful, then by all means proceed on to bigger and better things. If not, don't bother.

Those who are trying to communicate their physical attraction should be aware that expressing interest too strongly is likely to be offputting, and that what may seem like a compliment to you may seem gauche, insulting, or just extremely forward to the object of your affections. In particular, remarks about specific body parts – breasts, belly, butt, hips, etc. – may be taken exceedingly poorly. Remember that people of size often have very conflicted, and possibly very negative, feelings about the very parts of their bodies that you find so arousing. Tread gently. It's almost always acceptable to just say "Wow, you really look amazing tonight" or use other similarly general compliments, but "God, you have the biggest, roundest, sexiest tummy!" may very well not be taken in the spirit in which it was intended.

For those who find themselves the objects of someone else's desire, it's well to try to suspend disbelief for a moment and give the person who is approaching you the benefit of the doubt. That doesn't necessarily mean doing anything more than being friendly. Sometimes, another person's desire can feel very much like a demand. The knowledge that someone desires you may feel as though it carries an expectation

along with it that you will offer them the chance to fulfil that desire, but it isn't. It's just desire, and you actually aren't under any obligation even to acknowledge the other person's desire unless you happen to want to do so. In fact, you're actually quite within your bounds to just enjoy being desired and do nothing about it whatsoever if the attraction isn't mutual or if your life circumstances preclude your doing so.

You are ultimately the only person who really has the right or the ability to decide what to do with someone else's desire for you. You can accept it but not reciprocate, accept it and reciprocate with desire of your own, turn it down graciously, or even reject it outright with every drama-queen temper tantrum you want to throw if that's what you really want to do. It can actually be quite enjoyable to know that you're desired and not feel any compulsion to do anything because of it. If you handle your admirers and your own emotions graciously, you can have a fabulous time flirting and chatting and no one's feelings will be hurt at the end of the evening when you both go your own ways. In order to do any of these things, though, you have to be willing to admit that these powerful physical attractions can happen, and you have to be aware of them and ready to respond with graceful awareness when they do. Be alert for "the look that says 'yum'," and dare to believe that it's exactly what it looks like... the likelihood is that you're right.

CONFRONTATIONS & COMEBACKS

Who hasn't had the experience of having someone make a nasty comment or say something insulting, only to be unable to think of anything to say in response? Inevitably, most of us think of our snappy comebacks later on, when it's too late to use them. What better remedy than a good stock of preselected comebacks, ready to be applied whenever the situation warrants it! Ranging from saucy to thoughtful, sarcastic to straight-up, here's a sampler of retorts – all field-tested – to many of the rude comments that people often make about people of size, focusing on sexualized situations.

If someone uses "fat" as an insult, such as looking you up and down and saying "Damn, you're fat!", you can:

- "Thank you, how kind of you to notice!" (this confuses the hell out of people)

- look down at yourself, look up at them while holding up a random number of fingers on one hand, and say, "Very good! Now, how many fingers am I holding up?" (Alternately, you can do this holding up your middle finger, giving them a hearty fuck-you in the process.)
- "Yes, yes, I know, you just want to know my secret, don't you?"
- "Jealous? You sure are acting like it."
- "No shit. Alert the press."
- "Yes, I am. And clearly you're a rocket scientist!"
- "Yes, you're right. And you're an ass. I'd rather be fat."

If someone uses some variant on "Oh, but you have such a pretty face, if you'd only lose some weight…"

- "Yes, I do have a pretty face, and the rest of me is pretty damned fine, too."
- "You know, you do too. It's a pity the inside isn't nearly as lovely as the outside."
- "I'm so glad you brought it up! I was just thinking the same thing about you!" (this works particularly well on very thin people who seem like they're neurotic about their weight)
- "Thank you. Did you know that fat people like me get fewer wrinkles than thin people? I'm going to enjoy looking this good for a long, long time."
- "Yes, isn't it wonderful? Just the other day someone told me I looked just like a Rubens/Renoir/Titian/Botero/etc. (pick one) painting!"

If you're ever the recipient of "You know, I'd be willing to go out with you (sleep with you, marry you) if you'd just lose some weight…"

- "I'm sorry, but I don't believe I indicated any interest. Don't flatter yourself."
- "Sorry, I believe in unconditional love."
- "If I were willing to do that much work just for a date (or a fuck), believe me, I wouldn't be wasting it on you."
- "And here I was just thinking, 'You know, I'd be willing to go out with you if you weren't such a sizeist, prejudiced creep.'"

- "I'm shocked. I never thought you'd be the type to want people to belittle themselves for your pleasure."

- "Geez. And I just recently lost over a hundred pounds, too." When they look at you and go, "Oh, really?", smile and say, "Yeah, I just dumped the last butthead who said something like that to me, and boy, do I feel great!"

- "Honey, don't flatter yourself. I'm twice the man you'll ever be and ten times the woman you'll ever be able to get."

People who try to tell you that you should lose weight or you won't find a partner (boyfriend/girlfriend/husband/wife) can be dealt with as follows:

- "Well, thank goodness! I couldn't possibly fit any more dates into my schedule right now."

- "Maybe so, but with the harem I've got right now, who has time?"

- "I'm sorry, but if that's your way of trying to scare off the competition, it's not working."

- "Really? Wow, that'll be news to my boyfriend/girlfriend/husband/wife/partner..."

- "Yeah? Tell that to the guy/woman I dumped last week. S/He won't stop calling."

- "Wouldn't it be convenient for you if you were right? Then you could tell me that it was all my fault. I think that's pretty cold-blooded."

- To a parent: Give a great big puppy-dog-eyed soulful smile and say, "Yep, you're right. I guess I'll just move back in with you for the rest of my life and tag along with you everywhere you go as long as we both shall live. Won't it be nice to have so much quality time together?"

- If you are in a relationship: "I'm in a relationship right now. Amazingly enough, I didn't have to lose an ounce."

- If you are married: "Oh, that's right, this ring on my wedding finger means that I've got to lose weight to find a partner!"

- If you are gay or lesbian, you could also say "Eeeew, a girlfriend?" (or boyfriend, depending on your orientation) or "Well, thank God for that! My girlfriend/boyfriend will be so glad to hear it!"

If someone tells you that you're too "fat and ugly" for anyone to be interested in having sex with you, you can come back with:

- "Oh, I wouldn't be too sure about that if I were you." (accompanied by a big Cheshire-cat grin)

- "That wasn't what your husband said last night..."

- "Wow, you're right, you bigoted windbag. I sure am glad you're so tactless and ill-mannered, or I never would've known how repulsive I truly am."

- "Oh, stop, you scoundrel! Flattery will get you nowhere with me!"

- "Given a choice between being fat and not getting laid and being a self-righteous twit like you, I'd still choose to be fat. "

- "Really? Boy, good thing nobody told my lover(s) that!"

- "Funny, that's not the way my boyfriend/girlfriend/lover/partner feels about it."

- "I'm sorry you're feeling so insecure and unlovable. Chronic projection onto other people is a classic symptom of bad self-image!"

- "A thousand pardons, o, Your Self-Righteousness! I am obviously not worthy of being in the presence of one so discerning and aesthetically perfect as yourself!"

- "Gee, I'm sorry it's so miserable for you to be in my presence. Please, don't put yourself out on my account."

To respond to comments that in order for someone to want to be sexual with you, they'd have to really love you to be able to get beyond your size:

- "Doesn't it embarrass you when you expose your own limited sexual imagination like that?"

- "Thank goodness! Sex is much too important to me for me to waste it on all the people who just want me for my body."

- "Oh, that explains the people who keep chasing me because they think I'm sexy! Thanks for clearing that up."

- "No, some people want to be sexual with me because of my size. And some people just realize I'm sexy as hell and it doesn't matter what size I am."

- "I don' t know about that. I've had a lot of hot one-night stands."

- "Oh, but I don't want them to get past my size! How can my sex slaves worship my every jiggle if they get past my size?"

- "I'm really disappointed in you for telling me lies like that. Or maybe you're just ignorant. Haven't you ever heard of Fat Admirers?"

- "What a coincidence! I have a very similar problem being around you – it's only because I really love you that I can get beyond your incredible bigotry and intolerance and the way you always harass and patronize me."

If someone implies or says that anyone who is interested in fatter partners is "sick" or a fetishist, try these:

- "You seem really preoccupied with my/other people's sex life/lives. Have you talked to a psychiatrist about that? Most healthy people aren't quite so obsessive about other people's sex lives."

- "The only thing sick about fat people and sex is that people are so damn terrified of the idea that fat people can be sexy and have great sex lives just like I do. Being terrified of someone else's sex life when it has nothing to do with you – now that's sick!"

- "You know, you really don't know what you're talking about, but hey, I admire people who aren't afraid to show their ignorance in public."

- "Yes, and fetish sex is all the rage these days! I've never had such a busy social calendar!"

- "Oh, heck, that's nothing compared to my fetishes! The more, the merrier!"

- "Many men are attracted only to women who weigh between 105 and 120 pounds. I, on the other hand, am attracted to women who weigh between 150 and 500 pounds. Now you tell me who has a 'fetish'!" – From the FAQ about size acceptance at *www.bayarea.net/ ~stef/Fatfaqs/size.html*

- "No, wanting to dress a fat person in a gorilla suit, sitting naked in front of them, trying to dice potatoes with your genitals while re-

citing the Pledge of Allegiance in a Cockney accent... THAT'S a fetish!" – From the FAQ about size acceptance at *www.bayarea.net/ ~stef/Fatfaqs/size.html*

And of course, if anyone ever gives you the "Ugh, why would anyone want to have sex with someone as fat as you?" routine, you have a variety of zesty mouthfuls at your disposal:

- "Because people like you ask too many obnoxious rhetorical questions."
- "Well, you know how it is. The wider the hip, the tighter the grip."
- " 'Cause I'm built for comfort, baby."
- "Three words: incredible gripping action." (thanks to Marilyn Wann for this one!)
- "Why choose quality over quantity when you can have both?"
- "Because good things do not always come in small packages."
- "I'm not sure, but I suspect it could be simple good taste."
- "Well, there are those who believe that too much of a good thing is just about perfect."
- "Sheesh, I don't know, really, but they say it's all about that tongue thing..."
- "You mean other than my intelligence, my fantastic body, my brilliant conversation, and my self-confident appeal? Maybe they just like having mind-bending sex. Yes, I guess that could be it."

5
TO YOUR HEALTH!

Good health is a crucial part of sexual well-being, no matter what your size or shape. If you don't feel well, you're not going to feel very sexy. You certainly won't feel as good about being sexual if you're feeling droopy, having pain or discomfort, or worried about whether or not you're going to end up pregnant as you would if you were full of vim and vigor and secure about your safety and contraceptive options. Whenever your physical or mental health is at stake, your sexual health is, too. To have the kind of happy, healthy, horny, wonderful sex life you want, you need to take care of yourself – and that includes taking care of your health.

Safer sex, sexually transmitted diseases, fertility (and infertility), birth control, sexual abuse, and sexual violence are all issues that sharply affect physical and mental health. These issues can come up at any point in a person's sexual life, whether you're in your teens or your eighties, whether you're 150 pounds or 510.

It's important to find good health care for your entire body and mind, including good gynecologists, midwives, obstetricians, urologists, proctologists, internists, family practice physicians, primary care physicians, psychotherapists, endocrinologists, and sex therapists who can help you with any sex-related problems you might have. But compassionate, skilled, no-nonsense health care can be hard to find. When you're a person of size, it can be even more difficult to find health care practitioners who don't treat fat people as fat first and foremost and very much secondarily as people.

And of course, no matter how good your doctor is, there are some issues that are often difficult to bring up. Very few people feel completely at ease bringing up questions about sex, sexually transmitted diseases, genital and reproductive anatomy, sexual violence, or just routine sexual problems like impotence or being inorgasmic.

Even when you are able to talk to your health care provider about sexual issues, sometimes it can be very hard to find out what medical information is and isn't relevant to you as a fat person. Likewise, it can be difficult for your doctor to know how (or if) to talk to you about weight and nutrition issues. Nobody wants to be lectured every time they go to the doctor, but sometimes a change in your eating or exercise patterns can help you feel better, and the doctor must decide – with some guidance from you – how much information is appropriate.

Also, a doctor may not always have the best information, or end up only being prepared to give an educated guess rather than actual facts when s/he has to deal with a patient who is larger than average: there has actually been very little research done on the medical issues of fat patients. Doctors and nurses are only human, and they can make mistakes, make assumptions, be prejudiced, or just not be as well-educated as they might be on certain topics, just like anyone else. If you have done your homework, chances are that you can have a more meaningful dialogue with your health care providers and take better control of your sexual health and your health overall. You may even be able to help your health care providers do their homework a little better when it comes to sexual issues and people of size. Your sex life is too important not to educate yourself about potential problems – forewarned is forearmed!

The information in the following chapter is not designed to replace seeing your doctor or other health care practitioner, but it will help you to enhance your knowledge of your own sexual health and well being. If you think or know that you have any of the medical conditions listed in this chapter, or have been the victim of sexual violence, do not rely solely on this book. Instead, seek medical attention immediately. You might try the online Fat-Friendly Health Care Providers List *(http:// www.bayarea.net/~stef/Fat/ffp.html)* to help you find a doctor who is known to be size-friendly.

Being well-informed about your sexual health helps you know what questions to ask of your doctor, and what warning signs to look out for that might mean you need to see one in the first place. No matter what your

size, you can – and deserve to — stay safe, control your fertility, protect yourself, get good care for yourself when things go wrong, and have loads of fun enjoying your exhilaratingly healthy and sexy body and mind.

PLAYING SAFE

AIDS (Acquired Immune Deficiency Syndrome) is a deadly disease and a legitimately big deal. There is no cure for AIDS. AIDS gradually ravages your body's ability to protect itself against infections. Even with excellent medical care and the admittedly fabulous medications and therapies now available, AIDS is a truly awful disease. Many people living with AIDS stay relatively healthy for a very long time. However, AIDS is a deadly disease. While many forms of cancer can be cured, AIDS cannot. That, unfortunately, is what "deadly disease" means.

HIV (Human Immunodeficiency Virus), the virus that causes AIDS, is transmitted via the sharing of infected body fluids. Most commonly, this happens due to the sharing of infected blood products or semen (male ejaculate); sharing of vaginal secretions is a possible but less common route. HIV is a virus. *Any human being can potentially carry the HIV virus,* no matter whether they are male, female, transgendered, gay, straight, bisexual, old, young, sexually active, not sexually active, thin, fat, short, tall, or whatever else. Viruses do not discriminate. Disease organisms don't care who you are. *Any unprotected sexual contact you have in which bodily fluids are involved could expose you to HIV.*

HIV / AIDS is only one of many sexually transmitted diseases (STDs). Like the HIV virus, the disease organisms that cause other STDs are equal-opportunity organisms. They don't know or care whom they infect or how much he or she might weigh. Due to advances in medical technology and research, many STDs are now curable, including the formerly incurable diseases gonorrhea and syphilis. However, just because some STDs are curable doesn't mean that you should be cavalier about the possibility of becoming infected. Even curable STDs can cause significant health problems, and many can leave you infertile. Also, if you are infected, you are not the only person whose health is at risk, because you run the risk of infecting other people.

Overview: Sexually Transmitted Diseases

This list describes common sexually transmitted diseases, their major symptoms, and their treatment and/or curability status. All of these

can be transmitted through unprotected sexual contact and the sharing of infected bodily fluids. Some of them are easily curable, and others are not.

- *Chancroid Lesions* – bacterial lesions accompanied by lymph node swelling in the groin area. Women may have no lesions, only the lymph node symptoms. Curable with antibiotics.

- *Chlamydia* – microscopic parasite infection that can cause sterility, Pelvic Inflammatory Disease, and other types of related infections. The "invisible STD," because many who contract it display no symptoms at all, so it is easy to have and transmit without knowing it. Common symptoms include vaginal/penile discharge, pain during intercourse or during/after urinating. Curable with antibiotics.

- *Gonorrhea* – bacterial infection whose symptoms include a discharge from the urethra or vagina, pain during urination. A large percentage of infected women show no symptoms, so it is very easy to have and transmit the infection without knowing it. Can cause sterility, eye infections, heart problems. Curable with antibiotics.

- *Hepatitis A and B Viruses* – viral infection. Can be prevented through vaccination. Post-infection vaccination will not get rid of an existing infection. If you are sexually active, consider getting these vaccines. Symptoms include jaundice, fever, flu-like symptoms, extreme fatigue. Most people who contract the virus recover from the active disease and their bodies kill off the active virus, but chronic infection is possible and very serious. These viruses are highly contagious and can be easily spread by even non-intimate sexual contact like open-mouth kissing. If a hepatitis sufferer's body does not kill off the active virus, there is no medical way to eradicate it, so the infection itself is considered incurable.

- *Herpes Simplex Virus I & II* – two forms of the same virus, both of which can be transmitted sexually. Classic symptom is the herpes lesion or sore, a painful "cold sore" type lesion. Lesions show up on genitals, cervix, anus, mouth area, or other places on the body. Infection can be transmitted by any contact between a herpes lesion and another person's body, no matter where on the body that contact occurs. Like other viral infections, it cannot be cured, but symptoms can be managed with proper care and medication.

- *HIV* – Human Immunodeficiency Virus, the virus which causes AIDS. There may be no symptoms of illness for up to 10 years (or even longer) following infection. Classic symptoms include: flulike feelings, night sweats, fever, chronic diarrhea, unexplained weight loss, purplish skin lesions. Transmitted in blood, semen, breast milk, and vaginal secretions. Symptoms can often be managed to a certain extent. However, neither HIV nor AIDS can be cured.

- *Human Papilloma Virus (HPV)* – the cause of warts, including genital warts. There are many different forms of this virus. Some types of genital warts are associated with genital/cervical cancer and rectal cancer. Genital warts are considered highly treatable, though they are viral and thus may recur.

- *Pelvic Inflammatory Disease* – chronic, progressive pelvic and uterine infection in women, most often caused by chlamydia and/or gonorrhea. Can cause extensive damage to internal organs due to inflammation and heavy scarring. Can cause infertility or ectopic pregnancy. Symptoms include unusually long/painful periods, lower back/abdominal pain, nausea/vomiting. The underlying infections can be cured with antibiotics. PID-related scarring may require surgical repair.

- *Pubic Lice or Crabs* – small parasitic insects that infect the pubic area. Primary symptom is intense itching. Lice may be visible to the naked eye. Can sometimes be cured with over-the-counter pesticidal shampoos and soaps, but some bugs are resistant to OTC cures and require prescription cures.

- *Scabies* – small parasitic mites that burrow under the skin. Can infect the groin, underarms, and other areas of the body. Primary symptom is intense itching. Scabies are not usually visible to the naked eye. Can sometimes be cured with over-the-counter pesticidal shampoos and soaps, but some bugs are resistant to OTC cures and require prescription cures.

- *Syphilis* – spirochete infection. If left untreated, can lead to disfiguring lesions, brain damage, mental impairment, and death. Common early symptoms include a painless lesion (called a chancre) on the genitals or anus, in the vagina/cervix, or in the mouth/throat, as well as a distinctive rash that tends to affect the palms of the hands and soles of the feet. Curable with antibiotics.

- *Trichomoniasis* – protozoan infection. Causes a frothy vaginal discharge, itching, and burning during urination in women. Men can contract it but rarely have symptoms, making it easy for a man to give trichomoniasis to a woman without knowing he has it. Can be cured with medication.

- *Urinary Tract Infections (UTIs)* – bacterial infections, can be caused by bacteria getting into the urethra and/or bladder. A UTI may be sexually transmitted, or may occur independently of any sexual contact. Common symptoms are fever, frequent urination, difficulty holding your urine, painful or burning urination, feeling like you have to urinate even if your bladder is empty, lower back/abdominal pain. Severe infections may infect kidneys as well. Keeping urine acidic (many women prone to UTIs drink cranberry juice as a preventative) helps to cut down on the risk of UTI. Curable with antibiotics.

- *Yeast Infections* – fungal overgrowth in the vagina, in the male urethra, or on the skin. Symptoms include burning or itching and a whitish or yellowy thick vaginal discharge. Men often exhibit no symptoms, so it can be easy for men to harbor yeast infections and transmit them to women without knowing it. Can be easily cured with antifungal medications.

Planned Parenthood estimates that one out of every four people currently between the ages of 15 and 55 will contract a sexually transmitted disease. That's 25% of the population... and pretty significant odds. However, there are very easy, effective ways to decrease your risk of infection, maintain your health, and avoid getting infected or infecting anyone else.

Knowing how STDs are transmitted can help you avoid contracting one. Most STDs, including HIV, are transmitted through the exchange of infected bodily fluids like semen, vaginal secretions, blood, saliva, or breast milk. There are some STDs which can be transmitted without bodily fluids being exchanged – herpes, scabies, and pubic lice – but most of them require some sort of contact with infected body fluids.

When performed without a barrier that prevents body fluids from coming into contact with skin, genitals, or mucous membranes, many common sexual activities expose one or both participants to a partner's body fluids, most often semen, saliva, and vaginal secretions. Most disease transmission takes place because of fluid contact. This happens most

easily when there is any opportunity for an infectious agent to spend a long time inside an uninfected person's body or any chance for it to enter the bloodstream directly.

Both of these things can happen when body fluids enter the body via the vagina, rectum, or mouth. When infected bodily fluids are held within a person's body, as is often the case when semen is ejaculated into the vagina or rectum, there is a bigger window of opportunity for disease organisms in those fluids to find a way to get into the body and bloodstream.

Infection is still more likely when body fluids come into contact with broken skin of any sort, even microscopic cuts, abrasions, or lacerations in skin or mucous membranes. While it's generally pretty safe to get someone else's bodily fluids on a part of your body that isn't likely to have cuts or abrasions – the back or chest, for instance – it can be risky to just assume that your skin is unbroken, particularly inside orifices like the vagina or anus where you can't easily see. It's easy to get tiny cuts and abrasions during sex or just during daily life. Even something as minor as a paper cut, cat scratch, or hangnail constitutes broken skin. The delicate mucous membranes and skin of your mouth, genitals, and anus/rectum are even more vulnerable (how many times have you noticed some blood from your gums when you brush your teeth really thoroughly?) than the relatively tough skin on your hands.

The rule of thumb to follow in regard to other people's bodily fluids during sex is "on me, not in me." You are far more likely to become infected if there are infected fluids inside your body, or in contact with a cut or abrasion, than you are if they are on unbroken skin. You do not have to avoid contact with your own bodily fluids, only with other people's.

Barriers and Spermicides

The best way to prevent STD infection – including HIV – is to avoid contact with anyone else's bodily fluids. To do this, you need to use barriers. Barriers such as condoms, gloves, and dental dams keep sexual partners from coming into contact with one another's body fluids, thus keeping everyone safe from infection. As a bonus, using barriers for safer sex is a good form of birth control (where applicable).

An underappreciated benefit of safer sex is that it makes cleaning up after sex much easier and more pleasant. Simply strip off the used safer sex barriers (gloves, condoms, dental dams), dispose of them prop-

erly, and, if needed, wash up a bit. Many people who dislike the sensation of having ejaculate oozing from their bodies after sex find that safer sex actually makes them more eager to have sex, since this is no longer an issue when condoms are used.

Barriers for safer sex are usually made out of latex, but may be available in other materials as well, which is helpful for people with latex allergies. When you use latex or other barriers for safer sex, always put the barrier in place before there's any potentially risky contact. Using plenty of water-based lubricant can make the use of barriers much more pleasant for everyone concerned. Never use oil-based lubricants with condoms or any other latex barrier. These include hand lotion, massage oil, cold cream, Vaseline, butter, Crisco, cooking oils, and so on. Oil disintegrates latex and destroys the effectiveness of the barrier. Water-based lubricants like Astroglide, KY Jelly, Wet, ID Lube, and so on are formulated for use with condoms and are fine for use in safer sex.

Always use a new barrier, whether it is a condom, glove, or dental dam, every time you have sex. This is one time when recycling is not a good idea! Types of barriers for safer sex are:

Condoms – a tight-fitting sheath that covers the penis and catches the semen at ejaculation. Condoms work by keeping semen out of the receiving partner's body, and also keep the receiving partner's bodily fluids from making contact with the penis, particularly the mucous membranes lining the urethra. Condoms should be used for all penetrative sex, whether it's vaginal or anal. Condoms can also be used for oral sex (fellatio) on men.

Always put a condom on after the penis has become hard, and always remove it before the penis becomes soft again to avoid having the condom slip off or leak. Pre-ejaculatory fluid or "precum" can contain disease organisms as well as sperm, so put the condom on before any penetration occurs. Putting a few drops of a water-based lubricant onto the tip of the penis before putting on the condom makes for greatly improved sensation for the wearer. Use a new condom every time you have sex, or if you go from anal to vaginal penetration in a single session (to avoid getting bacteria from the rectum in the vagina). If you have sex for a long time, consider changing condoms midway through to help prevent breakage.

So-called "skin" condoms (actually made from sheep intestines) do not protect against HIV. If you want to be protected from HIV and

other STD organisms, do not use "skin" condoms. Polyurethane condoms protect against viruses and other orgasms, but some studies show higher breakage rates for polyurethane condoms.

The effectiveness of condoms for safer sex may be enhanced by the use of lubricants containing the detergent nonoxynol-9, which has been proven to kill sperm as well as HIV (in the test tube). Many condoms are lubricated with a compound that contains nonoxynol-9, and many water-based lubricants contain it. However, many people have an allergic reaction to this chemical and find that it gives them a painful, sometimes very itchy, contact dermatitis or rash. If you are one of these people, read the ingredients on condom and lube packages carefully in order to avoid it.

Condoms can also be used on sex toys. Use a condom on your dildos, insertable vibrators, butt plugs, etc., for easier cleanup, whether you use them on yourself or someone else. Always use a condom on your sex toys if you're going to share them with someone else – simply remove the old condom and put on a new one between users. As with penises and fingers, sex toys shouldn't go from anus to vagina without getting a new condom in between to avoid getting fecal bacteria in the vagina.

Latex Gloves – the "exam gloves" or "surgical gloves" used by doctors and dentists. Surgical gloves are now available in non-latex varieties for those who have latex allergies. Most chain drugstores carry some variety of medical exam gloves in their Home Health or First Aid sections.

Gloves should be used any time you're going to put your fingers or hand into anyone's vagina or anus, or any time you think you might come into contact with another person's blood. Use plenty of water-based lube with gloves for best results. When you take gloves off, peel them off so that they're inside-out, keeping the lube/fluids on the inside and away from you and your partner(s). Like condoms, gloves are intended for one-time use. Use a new one every time you are going to penetrate someone with your fingers or hand.

Dental Dams – Small, stretchable squares of latex originally manufactured for dentists to use in patients' mouths, but in this case, used as a barrier between the tongue and mouth of the licker and the vulva/clit or anus of the lickee during cunnilingus (eating pussy) or anilingus (rimming). Spread water-based lube on the side that will touch the lickee's body to help transmit sensation.

Glyde Lollyes are thinner, larger dental dams made specifically for use during cunnilingus. Plastic wrap can also be used, though a double thickness is usually safest since it tears fairly easily. As with other barriers, do not use oil-based lubes with dental dams of any kind, and use dams only once. Use a new dam every time you have oral sex.

Relative Risk and "Reasonable Risk"

It's possible for a person of any gender or sexual orientation to transmit an STD (including HIV) to any other person of any gender or sexual orientation. STDs and AIDS are not limited to gay men, people who have a lot of partners, or people who have kinky sex. Viruses and bacteria aren't smart enough to know the difference. They'll infect you no matter who you are, who you sleep with, or what you look like. The amount of protection you need from viruses depends on your amount of potential exposure. Not every type of sexual activity holds the same degree of risk of infection. Thus, the types of safer sex techniques that are appropriate to the situation will depend upon the activities in which you choose to engage.

Statistically, unprotected anal and vaginal intercourse have the highest rates of transmitting infection, including HIV. Obviously, anal and vaginal intercourse are not (by many people's standards) "kinky sex," and are not at all limited to people of any one sexual orientation. Still, any activity in which infected fluids (semen in this case) will be held within the body for any period of time increases the chance that infection will be transmitted, and this is why unprotected vaginal and anal sex are the activities with the highest statistical risk of transmitting an STD or HIV. Here's a list of types of sexual activities ranked in order of their approximate risk level from highest risk to lowest risk. Sharing needles for IV drug use is also an extremely high-risk activity, but is not included the list because it isn't sexual.

Highest Risk

Lowest Risk
No Infection Risk

Unprotected anal intercourse

Sharing implements used to draw blood (razor blades, tools used for piercing, any BDSM toy or whip that could draw blood, etc.)

Unprotected vaginal intercourse

Unprotected oral sex on a woman who is menstruating

Unprotected oral sex on a man including ejaculation

Unprotected oral-anal contact

Getting someone else's urine or feces in any orifice

Unprotected finger fucking or fisting

Unprotected oral sex on a man without ejaculation

Unprotected oral sex on a woman who is not menstruating

Sharing uncovered sex toys

Protected anal intercourse (with a condom)

Protected vaginal intercourse (with a condom)

Oral sex on a man using a condom

Oral sex on a woman using a barrier

Oral-anal contact using a barrier

Finger fucking or fisting wearing glove(s)

Touching someone's genitals

Open-mouth or tongue/French kissing

Bondage

Hugging, touching

Massage

Masturbation (alone or with partner)

Spanking, whipping that does not break the skin

Talking dirty, role play, phone or net sex, fantasy

There are other factors which are also important to consider when assessing risk. Many doctors feel that risk of previous STD exposure is one of the biggest factors you should consider when deciding how safe you need to play with any given partner. Talking frankly and honestly about past partners, any past STD diagnoses (particularly ones that cannot be cured, like herpes and HIV), and your sexual habits is an important part of assessing risk. Although having had sex with many partners does not necessarily constitute substantially increased risk, having had unprotected sex with many partners definitely does. This is an area in which many people are less than honest, so you will have to decide how much you trust your partner's truthfulness about past STD exposure.

"Reasonable risk" is a term that is used to refer to the level of STD and HIV transmission risk that an individual finds reasonable to assume for themselves in their own sex life. Obviously, this is going to vary a great deal from person to person. For instance, one person may consider unprotected oral sex to be a reasonable risk, since it does have a fairly low known transmission rate for HIV and other STDs. For another person, that level of infection risk may be too high for comfort. This can require negotiation within relationships. For example, if the two hypothetical people just mentioned were to be in a relationship with one another, they'd have to negotiate about what would be an acceptable level of safety for both of them to use during sex. It's better to be safer rather than less safe – to use the greater level of protection rather than the lesser level – so whomever's safer sex standard is higher is the person whose standards should probably be followed.

If your partner is unwilling to use safer sex techniques, or is unwilling to come up to your standard of reasonable risk, you are totally within your bounds to refuse to have any sex that might be unsafe. It's better to be safe than sorry. As they say, "no glove, no love."

Fluid Bonding

"Fluid bonded" is a phrase that refers to the condition of sexual partners who have made a deliberate, explicit decision to have unprotected sex, and thus to be exposed to each other's bodily fluids. This phrase is more accurate than "monogamous," since monogamous relationships don't necessarily include being fluid bonded (a monogamous couple may still choose not to exchange fluids), and since more than two people may be involved in a fluid bonding agreement. "Fluid bonded" talks about the status of a particular relationship in terms of safer sex

behavior, rather than characterizing the relationship in terms of the sexual behavior, sexuality, or relationship status of the participants in the relationship.

Strictly monogamous sexual activity with an STD-free partner is the best way to minimize your risk of infection short of abstinence. If you have only one partner, and they have only one partner (you), and you are both free of any STD or HIV infection, then the likelihood of extraneous infectious agents entering that closed loop is very low indeed (but not zero, since it is possible to contract some STDs non-sexually).

However, many relationships are monogamous in theory but not in practice. Affairs are far more common than most people want to admit, as are casual sexual contacts outside of "monogamous" relationships, such as one-night stands or patronizing prostitutes. If appropriate safer sex measures are used, casual sexual encounters do not necessarily have to present a significant health risk. However, many people throw caution to the winds in more than one way when they're trespassing the boundaries of a monogamous relationship, and may end up bringing STDs and even HIV infection home with them only to transmit those diseases to their partners. Needless to say, partners who believe themselves to be in monogamous relationships who subsequently find themselves infected with an STD are usually justifiably upset at finding out, in this extremely unpleasant way, that their partner has violated the terms of their monogamous relationship.

Hence the concept of "fluid bonding." When one is fluid bonded with one or more partners, the issue is physical safety and health, rather than a moralistic prohibition against being sexual with more than one partner. In a fluid bonded relationship, there is an agreement that any sex that happens outside of that relationship will be non-fluid-exchanging sex. People use the concept of fluid bonded relationships for many reasons. A couple in a monogamous relationship might use it as a way of saying "Not only are we monogamous but I expect you to go out of your way to protect our mutual health from the risk of STD or HIV infection in case anything should happen." A couple in a polyamorous relationship, an open marriage, or other sexually non-exclusive relationship might use fluid bonding as a way of prioritizing safer sex and affirming a primary relationship: "We acknowledge that we may both have other partners, but we only share fluids with one another. Because we are fluid bonded, we expect one another to protect our mutual health from the risk of STD or HIV infection that could arise from any other sexual rela-

tionship." A three-, four- or more-person family may use fluid bonding as a way to express who is "inside" and "outside" the family boundaries as they protect their health.

Fluid bonding is dependent on trust, as is monogamy. Unlike monogamy, which is often assumed, the decision of sexual partners to be fluid bonded usually entails some explicit negotiation having to do not only with their own sexual behavior and STD risk and/or status, but explicit ground rules about what behaviors are and are not permissible without barriers.

If something happens to disrupt the fluid bonding agreement, such as a broken condom or a partner's disregard for an agreement, everybody involved will have to decide together whether to assume the risk of continued unprotected sexual contact, or to use protection for the six-month period required for HIV antibody testing.

Fluid bonding, like monogamy, only works if both partners are both compliant with the terms of the relationship and completely forthcoming about their actual behavior. There may be times when you feel insecure about having unprotected sex with a partner with whom you are fluid bonded and/or monogamous. You may have had an outside sexual encounter, or one that exceeded your safer sex boundaries, and want to protect your partner from any potential risk until you know for certain that you are not infected with anything. Or you may suspect that your partner hasn't been forthcoming about his or her own activities.

If you are concerned, safe is much better than sorry. It is much better to risk having to explain why you want to have safer sex with a partner with whom you don't normally do so than it is to risk infecting someone with HIV or an STD. Your emotional discomfort at having to confront your fears and perhaps deal with some uncomfortable subjects or difficult confessions is small potatoes compared to the potential risk of infecting your partner with a potentially fatal or lifelong disease.

Myths About Sexually Transmitted Diseases

As with other realms of sexuality, there are a lot of myths and old wives' tales that circulate in regard to sexually transmitted diseases in general and HIV/ AIDS in particular. Knowing the truth can keep you from a nasty surprise.

- **Fat people and ugly people are at lower risk for STDs and HIV –** this usually stems from the mistaken belief that people of size and people who aren't conventionally attractive don't have sex, or don't

"get around enough" to have possibly been exposed to STDs or HIV. This just isn't so. Anyone who is at all sexually active is at risk for STDs and HIV and should be using safer sex where applicable, regardless of their looks or size.

- **Only sluts or people who sleep around a lot get STDs** – anyone can contract a STD or HIV. All you have to do is have unprotected sex with an infected partner. This could happen with your five hundredth sexual partner – or with your very first.

- **Heterosexual people don't get HIV/AIDS** – while HIV and AIDS are still more common among gay men than others, that situation is changing fast. The virus doesn't care what your sexual identity is or what your partner's gender may be. HIV is transmitted through certain sexual activities, regardless of the gender or identity of the participants.

- **AIDS is a "gay disease"** – No. HIV is a virus. Viruses can't tell whether you're gay, straight, male, female, or something else entirely. The common cold is also caused by a family of viruses (rhinovirii). Anyone who can catch a cold is also capable of being infected by other viruses if they are exposed to them, including the virus (HIV) that causes AIDS.

- **You can tell who's going to be high risk for STDs by how they look and act** – You really can't. Anyone who is sexually active can contract an STD or HIV. Planned Parenthood estimates that one in four people between the ages of 15 and 55 will contract an STD in their lifetime. There's no way that you can tell who might be infected and who might not be by how they look or act. Many STDs can also be transmitted by other means than sexual contact.

- **There's no need to use safer sex if it's your first time** – only if your partner is also a virgin, and you have a) absolute faith that there's no way s/he could've been exposed to any STD and b) an alternate means of birth control (if applicable). Being a virgin doesn't protect you from getting pregnant, getting infected with a disease, or anything else. The same is true if you're a "born again virgin" reentering the dating scene after a long monogamous relationship.

- **If you really love and trust your partner, you shouldn't need to practice safer sex** – Love and trust are wonderful things, but they don't prevent the transmission of STDs or HIV. Love does not make

you immune. Trust does not make you invulnerable. Unless you and your partner know for certain that you are both disease-free, and you are making a decision to become fluid-bonded, it is a good idea to practice safer sex.

- **I know I'm disease-free, I don't need to practice safer sex** – That's great, but you're not in danger of giving yourself anything anyway! It's other people you have to worry about. Protect yourself from them even if you're not worried about protecting them from you.

Fat People and Sexually Transmitted Diseases

"On several occasions I was perceived as 'safe' or 'safer' because I was fat. One person said that fat people don't get AIDS, and I actually had a doctor tell me that in his experience that fat people have a much lower incidence of AIDS. He didn't know why but speculated that what made us fat protected us somehow or maybe that we 'just don't get around as much'." – Mike

For a number of reasons, people of size are often thought to be at lower risk for STDs, and particularly for HIV infection. Extreme thinness has become associated with the tragic wasting and emaciation that frequently accompanies AIDS-related illnesses. When extreme thinness signifies extreme illness, it makes sense that plumper partners will look more healthy by contrast, even though it's not necessarily the case.

The truth of the matter is that gay or not, fat people are at risk for AIDS and other STDs just like anyone else. As has been repeatedly mentioned in this section, if viruses and bacteria and other disease organisms can't tell whether you're gay or straight, male or female, they certainly can't tell how much you weigh.

Despite the rather serious risks it poses, people don't always bring up the subject of safer sex, or they may not insist on it because they are worried that bringing up using condoms, gloves, dams, or the "bother" of safer sex might be the "straw that broke the camel's back" and send a prospective sexual partner running. This question is particularly relevant to people of size, who are often extremely insecure about their desirability and the reasons why their partners are sexually interested in them in the first place.

"For the longest time, I didn't have safe sex at all – related, I suspect, to the whole idea that I was lucky that anyone would

want to have sex with me and shouldn't ask for anything more. Of late, as I struggle to come to terms with my body and take control of my sexuality, I've also struggled to recognize (and demand) that I'm entitled to be safe in sex..." – Demeter

"I am a fat woman living with HIV. Ironically, being fat is a good sign now. It means I'm not getting sick yet, and that's a good thing. For years I never ever asked anyone to use safer sex when I had sex because I figured I should be grateful that they were interested at all. I knew that most men didn't like to wear condoms, and I was on the Pill so I wasn't going to get pregnant. Besides I figured that any man who was desperate enough to fuck me was probably not having any luck anywhere else, or they wouldn't have come to me for sex, right? And I was grateful that there were people who wanted to fuck me. I was that low down. It took my finding out that I had HIV to start to learn to accept who I was. I wish I had known then what I know now."
– Anonymous

Sometimes, people will – rather unethically – prey on those with a low self-image to talk a partner out of his or her insistence on safer sex. They may insinuate that if you're fat, you should be grateful for what you can get, and not to get on your high horse and insist that you have the right to protect your health by asking them to play safe with you. Or they may just use the usual tired complaints – hating condoms, not being able to feel anything, or some variant on the "but don't you trust me?" line. Sometimes, people will try combination arguments that might run something like this: "Well, I know you can't possibly pose a risk because you're fat and you don't get much action, and, well, you trust me, don't you?"

The only appropriate response to people who try to talk you out of using whatever safer sex measures you need to feel safe is to tell them that they can either wrap it... or forget it. No glove, no love. You don't have to apologize for your size, and you don't have to run the risk of compromising your health because of it, either. No sex is so good that it's worth getting sick for, particularly when some of the diseases that you could catch as a result are incurable and fatal. Yes, it's possible to have unprotected sex and not have any repercussions – like Scarlet O'Hara's maid said, "Lordy, Miss Scarlet, hundreds and hundreds of times

don't nothin' happen at all!" – but, particularly considering that some of the possible repercussions are life-threatening, it only takes the fact that something could to make taking reasonable precautions well worth the while.

Sexual Abuse, Sexual Harassment, and Rape

Sadly, sexual abuse, sexual harassment, and rape are a part of the sexual landscape, although they have almost nothing in common with the kinds of joyful, positive, sharing, pleasurable sexuality that are what this book is all about. Tragically, men and women of all ages, races, shapes, and sizes become the victims of sexual violence every day in North America and around the world. This emphatically includes men and women of size.

It is important to say this, and to say it bluntly. Fat women, men, teenagers, and children can be sexually abused, harassed, and raped. Fat people of any age or size or gender, of any sexual orientation or appearance, can be abused, harassed, raped, and violated personally and sexually.

Sometimes, people think that only women, or only women who fit a certain profile – young, conventionally attractive, perhaps provocatively dressed – are the victims of sexual harassment or sexual violence. This is not true. Sexual violence happens to children and to little old ladies and men. It happens to people who are physically defenseless, living in nursing homes and other institutions. It happens to professionals at work, to housewives, to college students and grandmothers. Sexual abusers can sometimes be strangers whose attacks come out of the blue, but most of the time, attackers are known to their victims. Married people can be raped or sexually abused – even by their spouses. Gay, lesbian, bisexual, and transsexual people can be raped or sexually abused. Prostitutes and other sex workers can be raped or sexually abused. No matter who you are, what you do for a living, what you look like, what you're wearing, or where you live, you could become – or may have been – the victim of sexual violence.

Sexual violence is a very unpleasant prospect. It is uncomfortable to think about. It is very easy to start to think "oh, that could never happen to me." It may be even easier for people who don't think that they are sexually attractive to think that they couldn't possibly be "attractive enough to provoke that kind of thing." Rape and sexual assault

rarely have anything to do with sexual attraction or normal sexual desires. Sexual assaults are violent crimes that have to do with power and the urge to violate and destroy someone else's person, personal rights, and dignity.

The National Victim Center and the Center for Crime Victims Treatment and Research published a study in 1992 that indicated that approximately 683,000 American women were forcibly raped in the calendar year 1990. The National Coalition Against Sexual Assault estimates that this number would have been doubled if the number of children and men who were sexually assaulted during the same period were added. Many crime prevention organizations and women's health organizations cite the statistic that one in four women will be sexually assaulted during her lifetime.

Sex crimes are far more common than most people realize. There are far more victims of sex crimes and sexual assault than most people acknowledge. Some of those victims are people of size.

> "I was raped a few years ago. I went to the only gynecologist in my very small hometown. He was very reluctant to do most of the STD tests because he didn't really believe that I was forced into it. He told me that if someone was going to rape anyone it would have been someone much 'different'." – Amanda

Nonetheless, the same stupidity and prejudice that leads to other types of harassment and abuse in regard to size issues and sexuality also often means that a person of size who attempts to report sexual abuse, harassment, or rape will not be believed. (This can, of course, also happen to thin people, but fat people seem particularly vulnerable.) Sometimes, people of size are told that they are lying about an assault or harassment situation, that these things "don't happen to people like you." This is a horrible and negligent way to treat anyone who has been in a trauma situation, but particularly where sexual violence is concerned. You have a right to be heard. You have a right to be believed. Your weight and size should not be an issue. Police, doctors, and law enforcement workers should be aware that, according to the FBI, less than 2% of reported rapes are false claims. If someone reports sexual violence, take them seriously, no matter what they look like or who they are.

People of size who have been victims of sexual violence may believe that the abuse would not have taken place if they had not been fat,

even though they may know that thin people also become victims of sexual abuse. They may feel that because they were fat, they might somehow have "deserved it." *No one deserves to be abused, harassed, or raped.*

Sometimes thin people who are victims of sexual crimes think that if they had only been fat, they would not have been as sexually attractive and thus they would not have become victims. The truth of the matter, again, is that sexual violence isn't about being attracted to someone sexually in any normal, healthy, sane, consensual manner. It has to do with power, anger, insecurity, and the desire to do damage to other people's bodies and lives.

There is a nationwide hotline that anyone in the US may call if they are, or think they might have been, the victim of sexual violence or domestic violence. Counselors are available to talk to callers, recommend local resources and rape crisis centers, help victims find someone to assist them with reporting their situations, and in general, to help victims negotiate what has happened to them and what their options are following the abuse or attack. If you have been sexually abused, sexually harassed, or raped, no matter what gender you are, what size you are, or when the abuse took place, you can call these numbers for sympathetic, responsive, useful help and referrals, 24 hours a day, seven days a week. You can even call these numbers if you think you *may* have been sexually harassed or abused and aren't sure, but want to talk to someone about what happened. *The National Domestic Violence/Abuse Hotlines can be reached at any of the following telephone numbers, anywhere in the USA: 1-800-799-SAFE, 1-800-799-7233, or, with a TDD, 1-800-787-3224.*

HOUSTON, WE HAVE A PROBLEM: ERECTILE DYSFUNCTION AND THE BIG SEXY MAN

All too often, big men who deal with erection difficulties (sometimes called "impotence," but more accurately characterized as "erectile dysfunction" or ED) do so in complete silence, worried (or perhaps convinced) that they will simply be told that they can't expect any better or any different because they're fat. As has been mentioned before in this book, Alex Comfort, in *The Joy Of Sex*, cited fatness as "a physical cause of impotence," and he's not the only authority figure to presume that this is the case.

Even if one doesn't assume that simply being a man of size is likely to be a physical cause of erectile dysfunction, people may presume that fatness causes erection problems due to psychological factors: classical Freudians might attribute them to a castration complex, pop psychology might cite "performance anxiety," and someone psychologizing a fat person might presume that worries about being "fat and unattractive" are automatically to blame (and indeed it's possible, but it's not a conclusion one should jump to). Very simply put, it's often easy — although not always correct — to put the blame for erection problems on weight, and for fat men to feel very alone, guilt-ridden, and inadequate about such problems.

In reality, erectile dysfunction is neither uncommon, an individual failing, or as medically cut-and-dried as some people think. While psychological factors may be a cause of or contributor to erectile dysfunction, there are also numerous physical factors which can also compromise a man's ability to achieve or maintain a sufficient erection for enjoyable sex and/or achieving orgasm. Many times, a combination of these factors contributes to occurrences of ED, making it complex to understand and treat.

This physical and psychological complexity is understandable. The mind's role in arousal and sexual response is at least as important as the body's. For this reason, men whose ED may be physiologically due to either neurological or cardiovascular problems (which may in turn be due to other things), may also have a psychological component to their problem as well: having had problems with erection for physiological reasons, the fear of a repeat experience can sometimes cause a recurrence for non-physical reasons. Sometimes men may also feel that if they were just thinner, more handsome, a better lover, or in some way "better" or "more of a man," they wouldn't ever have problems with erection. This isn't true. There is no personality type, or personality flaw, that makes a man particularly prone to erection problems: men of all types can have ED episodes, whether they're fat or thin, macho jocks or sensitive new-age guys.

One important thing for men who have problems with ED to bear in mind is that they are definitely not alone. In the 1994 book *Sex In America*, researchers announced that more than 10 million American men suffer from erection impairment of some sort at least sometimes, and part of the *Massachusetts Male Aging Survey* conducted from 1987-1989

reported that anywhere between 33 and 67 percent of men over 40 experience some periodic erection difficulties. Statistically, the older a man gets, the more likely he is to have suffered some episodes of erectile dysfunction. ED is neither uncommon nor limited to men of any particular size, shape, or color.

However, men of size are at higher risk for several conditions that can strongly influence the probability of erectile dysfunction problems, particularly diabetes, hypertension (high blood pressure), and heart disease. Studies of fat men's sexual response have indicated that in general, fat men's ability to get and maintain erections is no different from thinner men's ability to do those things, but that they are at a significantly higher risk for cardiovascular problems which may cause ED.

Erections are made possible by blood flow into the spongy tissues of the penis, which swell as they become engorged with blood, making the penis hard. Anything which compromises strong, healthy blood flow and good cardiovascular health, like coronary artery disease, atherosclerosis, or high cholesterol, may compromise this, too. If there has been damage to the blood vessels in the penis or leading to it, or damage to the nerve structure of the penis, this may also cause ED. Diabetics particularly face a high risk of ED that may become worse with time, particularly in insulin-dependent diabetics (Type I diabetics). When other factors like heart disease are also present in men with diabetes, this can compound the probability of ED occurring.

Fortunately for the men (and women) who have these types of health problems, there are many medications which can be very helpful for managing these conditions, lowering blood pressure, reducing the risk of heart attack, regulating insulin levels, and so forth. However, some of the drugs that do this can be a double-edged sword where ED is concerned. It's not always clear whether a condition like hypertension or heart disease, or the medicines used to treat it, are causing or contributing to ED.

Sometimes, people who find that their medications seem to be making their ED worse than it was (or people who find themselves having ED as an apparent result of taking medication) will stop taking their medication because of it. This is tempting, but it's really a bad idea. Not only can it mean that your overall health will become worse, but since one of the best ways for men with ED to manage their ED is to have tight control over the any contributing medical condition(s), you might actually end up making your sexual dysfunction worse over the long haul.

If you think that your medications may be causing problems in terms of ED, discuss it with your doctor. S/he should be able to discuss the problem with you and to help advise you in regard to therapies for ED that won't compromise your health.

When you do discuss ED with your doctor, don't be surprised if he or she mentions weight loss to you as something that might be helpful. It is true that weight loss can help to stabilize many of the conditions that contribute to ED. However, you don't have to feel like this means that you have to lose an enormous amount of weight in order for it to have a salubrious effect on your overall health or your sexual health: small weight losses, like 10-20 pounds, may help to stabilize things and/or prevent them from becoming more severe. There are no guarantees that losing weight, whether a little or a lot, will definitely help with any erectile dysfunction problem, but it may help, may help the situation from becoming any worse, and it's unlikely to do you any harm.

Whether or not you lose weight, regular exercise helps a great many men with their overall health and feelings of being connected to their bodies. The cardiovascular benefits of exercising may also be helpful in cases of ED that have a cardiovascular component. This doesn't mean that you have to run marathons — just that moving your body in ways that are fun and feel good is good for your body and for your mind-body interaction, two of the things that can help you have better sex no matter what your weight or size. As a bonus, regular exercise means that actually having sex is less likely to feel strenuous when you do it, and can improve your stamina, too.

Other therapies for ED run the gamut, from psychotherapy and sex therapy to drugs like the famous little blue pill Viagra to (in extreme cases) surgical interventions. There is some controversy in the medical community as far as what the best and most appropriate treatments are for erectile dysfunction, but there are also some extremely low-tech things that you can do in terms of the way you make love which can help to increase your ability to enjoy sex even if your penis doesn't happen to be at its most cooperative.

Using a cock ring (a strap or ring that fits around the base of the penis, fitting tightly enough that it helps keep blood in the erect penis, thus prolonging erection) can be a good adjunct for men with ED, particularly if they're prone to getting an erection only to have it recede inopportunely. Some men also have good results with vacuum pumps designed to be used on the penis, essentially drawing blood into the pe-

nis by creating a vacuum around it, whereupon they would then use a cock ring to help maintain the erection for sex. These are available from many specialty sex stores and boutiques. As an herbal extract, Gingko biloba taken as a dietary supplement is reported to help some men with ED. If you're using any of these methods – or any others — on your own, be sure to let your physician know what you're up to so that he or she can better help you help yourself.

There's also a lot of potential in learning to make love a little differently. Learning to feel more sexually attuned to your whole body is a win-win process: when you enhance your sexuality by learning to appreciate the sensuality and pleasure that you can have from non-genital and perhaps non-traditional forms of stimulation, you open yourself up to a whole range of pleasures that are just as accessible to you whether you are having erection difficulties or not. Sometimes men in particular need to take some time to become acquainted (or reacquainted) with their non-genital erogenous zones: nipples, lips, thighs (particularly inner thighs), bellies, butts, and even fingers and toes can be powerful sources of sexual sensations. Men's sexuality so often seems dependent on their erections that it may feel like their sex life has been dealt a death blow if they happen to have a problems with ED, but this is emphatically not the case. Occasionally men discover whole new sides to their sexuality when they learn to appreciate and connect with the parts of their sexual selves that are not dependent upon their penises, a process that can be exciting, freeing, and can mean that they are able to have consistently good sex regardless of episodes of ED.

BIRTH CONTROL AND CONTRACEPTION

When it comes to birth control, men have few choices. If you want to make sure that you're not going to get someone pregnant, you can either choose to have a vasectomy or use condoms faithfully, or simply choose to have types of sex that don't result in you getting your penis near anyone's vagina. While the recent research indicates that there may be a workable hormonally based male birth control pill in existence as early as 2015 or so, that's still a long way off.

For women, and particularly women of size, there are more options. You can choose a partner with a vasectomy, insist on faithful condom use, or engage in sexual acts that do not involve getting a penis near

your vagina. In addition, there are many other chemical and physical birth control methods. Most of them (with the exception of condoms and spermicidal foams and/or inserts) require a doctor's examination and prescription.

This issue alone is sometimes enough to make good birth control inaccessible. Medical prejudice against fat people is legendary. It can be difficult to get good medical care of any sort when you doctor is more interested in telling you that you're fat than s/he is in treating whatever might actually be wrong with you.

When women of size seek gynecological care, they often get the double whammy of being confronted with a doctor who not only wants to treat their fatness rather than their gynecological concerns, but who may also hold a lot of ignorant prejudices in regard to fat people and sexuality. Regardless of what any medical professional thinks of the health risks of fatness, this should no more get in the way of their treating you for the reasons for which you made an appointment to see them than it would if you were a member of any other known risk group – a cigarette smoker, a drinker, or a person who regularly participated in extremely risky sports like rock climbing or bungee jumping. These kinds of factors (including fatness) may be relevant to your medical treatment in some cases, depending on what's being treated and how, but doctors have an obligation to treat you for the reasons you request treatment rather than trying to treat you for a condition (fatness) which may have nothing to do with why you are in their office. Health care providers also have an obligation to know when fatness – or smoking, or bungee-jumping, or whatever risk factor may be pertinent – is or isn't relevant to any specific disorder or treatment.

An example of a time when fatness might be relevant to treating a gynecological condition would be if a patient complains of extremely irregular periods. The coexistence of fatness and irregular periods should signal a gynecologist to check for hormonal imbalances and/or Polycystic Ovarian Syndrome (Stein-Leventhal Syndrome). An example of a time when fatness is completely irrelevant to gynecological treatment would be if a patient with regular menstrual periods comes in to see a doctor about being fitted for a diaphragm. A reasonable and competent doctor would examine her, look over her medical history, and, if s/he felt that a diaphragm was in fact that patient's best birth control option, fit her for a diaphragm just as s/he would with any other patient.

Being fat has nothing to do with the need for birth control. Fat women can and do get pregnant. Fat women can and do have sex lives that are enjoyable, happy, exciting – and, if they are having sex with men, potentially also fertile. Many gynecologists are aware of this, and treat all their patients, fat or thin, in much the same way regardless of their size. But others are biased and may even be openly hostile toward their fat patients. They may treat their fat patients very badly, humiliating them, verbally denying the existence of fat patients' sex lives, or may even use access to birth control as a way to attempt to blackmail patients into losing weight.

> *"I have had terrible luck with the medical profession. Especially with regard to birth control. The doctor actually had the attitude, 'But you'd need to have sex to need birth control and who would have sex with you?'" – Katrina*

> *"My doctor recently told me that if I gained any more weight that she would no longer give me my birth control. I saw a second doctor about this and he said that there was no medical reason for her decision. He even further went on to say that he believed that she was prejudiced because I was not an 'average' size." – Sally*

If your doctor is not willing to treat your gynecological (or any other) concerns in a competent, professional manner that takes your weight into account only when it is actually medically relevant, switch doctors. There is no reason for you to accept inappropriate, incomplete, or humiliatingly delivered medical attention from any health care professional. NAAFA, the National Association for the Advancement of Fat Acceptance, publishes a brochure on the rights of fat patients to competent, adequate, nondiscriminatory medical care. It can be a good idea to give your doctors a copy of this brochure and talk to them about it. This is particularly important if you are trying out a new doctor. If they're not willing to at least discuss the notion of providing appropriate and unbiased health care to you as a person of size, it's time to look elsewhere for care.

The truth of the matter is that being fat does not affect your potential need for birth control, and it is not an excuse for any health care provider to fail to help you get reasonable and appropriate birth control prescriptions or devices. If you're a premenopausal woman having het-

erosexual sex (even occasionally), there is a possibility that you could get pregnant.

Fatness also has very little to do with what types of birth control are appropriate and useful for most women. Unless there are other gynecological problems or irregularities present, fatness itself generally does not affect the effectiveness of normal birth control methods. Barrier methods, like condoms, diaphragms, and cervical caps, function by preventing sperm from reaching the egg. As long as a person is capable of using a barrier device correctly, there should be no problem with using it for effective, safe birth control. A diaphragm may need to be refitted if you gain or lose more than ten pounds.

The IUD (IntraUterine Device), which acts by preventing any fertilized egg from implanting in the uterine lining – the necessary second step, after the egg has been fertilized, which must take place for that fertilized egg to develop into a fetus – is also a good choice for women who choose it and can tolerate it physically (although this choice has become less popular in recent years due to some safety questions).

Tubal ligation, though it is a surgical sterilization and may, as a surgery, hold some increased risks for some women of size, is another great option for women who are sure they don't want to bear children, or who don't want any more than they already have.

Most women whose hormone profile is within normal ranges can successfully use hormone-based birth control like the Pill, Depo-Provera, and Norplant. Occasionally, these forms of birth control will not be appropriate for women of size (or other women). Most often, this is due to some variety of hormone imbalance.

Hormone imbalances can usually be treated medically. Sometimes doctors will advise weight loss as a means of treating a hormone imbalance, but this is not always appropriate or helpful. Women sometimes go through a lot of trouble to lose weight only to discover that they still have a significant hormone imbalance that apparently was not, in fact, related to their weight at all. In general, even when fatness may be a legitimate issue in a hormone-level problem, it can be a reasonable decision to request that your doctor treat your hormone level issues with medication rather than putting your faith in something as notoriously unpredictable – both in terms of how unpredictable losing weight itself can be, as well as the unpredictability of its efficacy as a treatment for hormone level problems – as weight loss.

Healthy fat cells normally produce estrogen. In women of size, this can sometimes lead to an overabundance of estrogen, although it does not always do so. Too much estrogen can cause your body to react in much the same way that it would if you were on the Pill, and lead to infertility due to lack of ovulation. While this infertility could work to your advantage if you don't want to become pregnant, it is also notoriously erratic and unreliable. There are many, many mothers running around who once assumed, or may even have been told by a doctor, that they were infertile. Unless you are controlling your fertility with some contraceptive method that you know is in place, you're still taking your chances. (Even then, all contraceptive measures have some failure rate.)

Fatness is also correlated with, and possibly in part caused by, a medical syndrome called Polycystic Ovarian Sydnrome (PCOS), also sometimes known as Polycystic Ovarian Disease or Stein-Leventhal Syndrome, which is discussed in depth on p. 180.

KEEPING YOUR HEAD WHEN YOUR FEET ARE IN THE STIRRUPS

It's difficult to feel like you're in a position of power, or have much control over what is going on, when you're at the gynecologist's. Flat on your back, usually naked except for a poorly-fitting hospital gown, trying to be nonchalant with your feet in those uncomfortable metal stirrups and your butt hanging off the end of the examining table, is just not a position in which most of us are at our best. Being poked and prodded, examined and scrutinized in the most intimate areas of your body when you're essentially completely immobilized and completely vulnerable is not too much fun.

Men sometimes feel similarly when dealing with a urologist or proctologist, but on the whole, men have to go through similarly intrusive medical exams far less frequently than women do. For men who do have frequent dealings with urologists or proctologists, trying modified versions of the questions given at the end of this section can help you to find a good, unbiased practitioner.

For women of size, the experience is often made even less pleasant by the fact that it can be physically uncomfortable to be on the table, which may feel like it isn't wide or sturdy enough to really hold them

properly. The arms may not have anywhere to rest, and it is uncomfortable to have to let them dangle over the sides of the table. The angle and placement of the stirrups can also be uncomfortable, depending on how flexible your hips might be and the size of your belly or thighs. Standard-issue hospital gowns are too small to fit many "average" people, and women of size are usually left with the option of having to choose whether they want to be uncovered in back or in front. Add a rude, condescending, abusive, or humiliating attitude on the part of the practitioner, particularly if they are ignorant or lack the compassion to learn how to examine you competently and gently, and it can leave almost anyone feeling victimized and dismissed as a human being.

There are many women of size who avoid going to the gynecologist on principle because they've had too many bad experiences with the medical profession. This is a potentially dangerous thing to do, since early diagnosis and treatment of illnesses like breast cancer, cervical cancer, and STDs can save your life, prevent pain, and keep you fertile. Still, given how brutally unpleasant some fat women's experiences with gynecological care have been, it's not surprising that many avoid it like the plague. No one wants to volunteer for that kind of treatment.

The good news is that going to the gynecologist doesn't have to be a nightmare. Forewarned is forearmed. Knowing what a gynecologist should be doing, what a competent examiner will do for you regardless of your weight, and what to look for when you are looking for a gynecological care provider can go a long way toward letting you keep your dignity even when you're flat on your back with someone peering at your cervix.

The gyn exam usually begins with a standard diagnostic interview. Your examiner will ask you questions about your reproductive health, such as whether your periods are regular, when your last period ended, and whether or not you might be pregnant. They will probably ask you if you are sexually active. If you are, they may also ask you what form of birth control you're using. If you're not heterosexual or not sexually active, it's perfectly okay to tell your practitioner. The examiner may offer you the opportunity to ask any questions you might have about safer sex and STDs. Your examiner will probably want to check your vital signs, too, like blood pressure, pulse, and so on.

A breast exam, in which the practitioner will feel your breasts and underarms, usually takes place either before or after the pelvic exam. This

is done to check for any lumps which might indicate breast cancer or cystic breasts. If you don't already know how to do a breast self-exam, ask your examiner to teach you how.

The centerpiece of the classic gynecology experience is the pelvic exam. There are three parts to this. There's usually an external exam, which is mostly visual. The examiner looks at your entire vulva, including the labia majora and minora, clitoris, urethra, and the surrounding area including the perineum (the strip of skin between your vagina and your anus). What they're looking for is anything out of the ordinary that might indicate a skin disease, an infection, an injury, or an STD. Many STDs, including syphilis, herpes, and chancroid lesions exhibit themselves as lesions or sores on the genitals. Other STDs produce characteristic types of vaginal discharge which can sometimes be spotted in the external part of a pelvic exam. Your examiner may spread your labia or touch your labia or vulva in order to get a better look at things.

After the external exam, it's time for the internal exam. The second part of the pelvic exam uses the speculum, a duck-bill-shaped device designed to hold the walls of the vagina open so that the examiner can look inside. The examiner will take a sample for a PAP Smear test, which involves scraping some cells from the cervix to be tested for any cell malformations that might herald cervical/uterine cancer. This can hurt a bit, but it's usually not too bad and is, at any rate, over with quickly.

The most common complaint that women of all sizes have about this part of the pelvic exam is that the examiner uses a speculum that is too large, or that s/he opens the speculum so widely that it causes actual pain. With larger patients, practitioners sometimes mistakenly assume that a bigger body necessitates a bigger speculum, but this is not necessarily true. A medium-sized speculum is adequate for use on most women, though sometimes a smaller or larger speculum will be necessary. As for the degree to which the speculum is opened, it is of course most comfortable for the patient if the examiner opens it only as far as is necessary to do the exam. If the speculum exam hurts, tell your doctor; s/he can often switch to a smaller speculum, or adjust it to a less uncomfortable setting.

Due to the variation in the way that women's bodies are built and their comfort with having their vaginas dilated, what is perfectly comfortable for one woman may be very uncomfortable or downright painful for the next. Tell your practitioner if something s/he is doing is caus-

ing you pain. Sometimes there's just no other way to accomplish the exam, but it really shouldn't have to seriously hurt. An unusual amount of pain on having a speculum (sometimes even a finger) inserted into the vagina may be an indicator of an underlying health problem and should be taken seriously.

The final part of the exam involves the practitioner inserting a finger or two into your vagina. This is the bi-manual exam, which lets the examiner palpate, or feel, your cervix, uterus, and ovaries. S/He does this by inserting surgical-glove-covered, lubricated fingers into your vagina, then pressing with her other hand on your abdomen in order to help move the internal organs into range so that they can be easily felt. This is how your examiner can check for any lumps, bumps, tumors, cysts, or other abnormalities on internal organs that s/he can't actually see.

Occasionally, a practitioner who is inexperienced with examining fatter patients will complain that they "can't feel anything" because of a patient's fat. This is usually indicative of their inexperience in working with fat patients. Women's reproductive organs are located in more or less the same places no matter how big or small the woman is, and what's more, they're generally more or less the same general size no matter whether the woman is big or small, fat or thin. In short, unless your internal geography is substantially unusual (and this is rare), there should be no reason that a practitioner would be unable to palpate your uterus, cervix, and ovaries in a standard exam. It may take a little bit of practice for them to figure out how best to press on your abdomen to optimize their ability to feel your organs, but it certainly isn't impossible. It also certainly isn't your fault if they don't have the necessary education or experience to perform an adequate examination on a person of size, and it is *definitely* not your fault if they don't have the tact and compassion to try to do so humanely, gently, and without being condescending or hurtful to you.

After a pelvic exam, your examiner should offer you a chance to get cleaned up – they use water-based lubricants, usually KY Jelly, when they insert fingers or a speculum into you during the exam, and should offer you some tissues and/or a chance to use the bathroom – and to get dressed again. Then there may be some follow-up questions or just a discussion of what your examiner found during the exam, including whether or not you need to have any follow-up visits for any reason.

Those are the basics. There is really no reason that any competent and well-practiced examiner should not be able to perform a compas-

sionate, thorough, reasonably comfortable, gentle gynecological exam on any patient no matter what her age or size.

When you are looking for a new primary care physician, gynecologist or obstetrician, you can ask questions to help make sure that your new doctor is ready, willing, and able to deal with you as a patient. This is particularly helpful if you're looking to address a specific health issue – pregnancy, PCOS, menstrual irregularity, etc. – and you know that you'll be seeing a lot of this particular practitioner in the process. There's no sense subjecting yourself repeatedly to someone who makes the whole experience a miserable one. Here are some important questions which can help you decide whether a gynecologist or obstetrician is the right one for you.

Patient Diagnostics – Questions to Ask A Primary Care Physician, Gynecologist or Obstetrician

- **Do you welcome patients of size into your practice? If so, what percentage of your patients are fat?**

 If the practitioner has no fat patients, it could be that s/he has scared them off. There are enough people of size in the world that you should be a little suspicious if a practitioner claims not to have any fat patients at all.

- **Have you ever examined/treated a patient of my weight? (tell them your weight... and be honest)**

 Just because a practitioner may not have treated a patient of your specific weight or size doesn't mean they won't be competent to do so. However, it's a great litmus test, and you can tell a lot about a practitioner by how they react to this kind of question and what they have to say about their experiences in treating patients of size.

- **Do you think it is more difficult to examine a fat patient? If so, why or how? Do you have experience doing pelvic exams on fat patients?**

 As above, this is a good litmus test. It also offers you the opportunity to ask whether or not they have had any trouble doing so, and/or what sorts of methods they might use to maximize their ability to do a good pelvic exam on a woman of size.

- **Are you willing to adjust your stirrups for me if I am not comfortable in them as they are set?**

A practitioner may never have given this issue much thought. It can make a lot of difference in how comfortable you feel while you're being examined to have the stirrups adjusted to better suit your body, flexibility, and size.

- **Do you have exam gowns available in extended sizes that will fit me?**

If the answer is "no" (extended-size gowns can be difficult to obtain, since most physicians have switched to paper gowns which are not available in larger sizes) you are at least forewarned. Many people of size choose to take their own plus-sized hospital gowns to medical appointments. These are available from Ample Stuff (see Resource Guide).

- **Should I need it, do you have access to transvaginal ultrasound equipment?**

Occasionally, abdominal fat can make it difficult to perform some types of diagnostic exams, such as palpating the uterus in early pregnancy to determine approximate fetal size and age, or doing diagnostic uterine or ovarian ultrasounds. Ultrasounds can now be done through the vaginal wall, as well as being done through the abdominal wall. Your practitioner should be aware of this option, and should be prepared to make arrangements for you to get this kind of exam if need be.

- **What is your experience with diagnosing and treating Polycystic Ovarian Syndrome (Stein-Leventhal Syndrome)?**

PCOS can be a difficult syndrome to diagnose correctly, because the diagnosis is based entirely on symptoms and the symptoms can be very different from woman to woman. It also has a strong correlation with fatness – about 40% of PCOS sufferers are obese, and there is evidence to suggest that PCOS can cause weight gain that is extremely hard to lose for metabolic reasons. Particularly if you suspect you may have PCOS, it is important to try to find a doctor with some experience in working with this particular syndrome.

- **Are your examining tables accessible to larger women? (If you have any mobility impairments, ask in regard to those as well.)**

You may wish to ask your practitioner to make sure there is a sturdy step-stool to help you to get up on the table. It may also be appropriate to ask how wide the exam table is.

• **I have a patient advocate who comes with me to medical appointments. What are your policies in regard to permitting patient advocates in the examining room?**

If you are concerned about how you might be treated by a health care provider, or if you would just like to have someone with you for support, you can take a friend with you as a patient advocate. Often, a practitioner who might not have been supportive or compassionate if it were just you in the room will be on his or her best behavior if there's a third party around. This is also a good thing to do if you have to go back to a practitioner with whom you have had problems in the past. Providers should be willing to allow you to have a patient advocate with you under most normal office-visit or lab situations.

MENSTRUAL IRREGULARITIES AND POLYCYSTIC OVARIAN SYNDROME

Menstrual irregularities are among the most common gynecological problems, along with vaginal or urinary tract infections. Irregularities can include anything from very painful, heavy or long menstrual periods to a complete absence of them – and anything in between, including any sudden or odd-seeming changes in menstrual cycle or pattern.

As with other health problems, some practitioners will attempt to blame any menstrual irregularity or problem on a fat patient's weight. Sometimes weight is a relevant factor in a menstrual problem, but this is not always true. Nor is it always true that weight loss is a functional cure for these problems. In any case, your practitioner should be able to treat you medically, just as s/he would anyone else, and not put the blame for your condition on your shoulders by saying "oh, it's just because you're fat. Lose weight and it will go away."

One of the more common fatness-related menstrual irregularities is amenorrhea (lack of menstrual periods) due to an oversupply of estrogen. Healthy fat cells produce estrogen as part of their normal function. Some women's bodies accommodate this without a problem, but others

do not, and end up with significantly elevated estrogen levels. The problem with having too much estrogen in your body is that your body may react more or less as if you were on birth control pills, by either ceasing to ovulate or having erratic ovulations. This, in turn, can either suppress your periods or make them erratic too. Too-high estrogen levels can sometimes be normalized through weight loss, but not always. In any event, hormone levels can still be normalized with pharmaceuticals, and this may be the preferable treatment.

Another frequently occurring reason for menstrual irregularity among women of size is a syndrome called Polycystic Ovarian Syndrome (PCOS), sometimes also known as Polycistic Ovarian Disease or Stein-Leventhal Syndrome. The classic symptoms of the syndrome are amenorrhea (sporadic or absent menstrual periods), infertility, high androgen or testosterone levels, hirsutism or male-pattern hair growth, enlarged and polycystic ovaries, and, in about 40% of cases across the board, "clinical obesity." When they do menstruate, PCOS sufferers may have long and heavy or exceptionally cramp-ridden and painful periods, and may also have pain at ovulation, if it occurs.

There is a strong correlation between insulin hyperproduction, insulin resistance, and PCOS. This probably has something to do with why women with PCOS often have a very easy time gaining weight and a very difficult time losing it, as well as with the increased risk of adult onset (type II) diabetes. PCOS, particularly the aspects having to do with insulin resistance, diabetes, and weight gain, is not yet completely understood.

Women with PCOS who are fat are more likely also to have hirsutism as a symptom, though genetics also seem to have a great deal to do with whether or not hirsutism is present. Other symptoms can include resistant post-teenaged acne and a non-painful, benign, velvet-like, greyish-brown hyperpigmentation of the skin known as *acanthosis nigricans* which can sometimes be found on the neck, underarms, and groin, and which may be more closely related to insulin-resistant diabetes than to PCOS per se. *Acanthosis nigricans* in a thin person is a red flag that a serious problem may be present.

No one knows what causes PCOS. A tendency to develop PCOS can apparently be inherited from either or both parent(s). It is important to emphasize that women do not develop PCOS because they are fat. The cause-effect relationship between weight and PCOS is complex, and fatness may exacerbate some PCOS symptoms, but fatness or weight

gain does not cause PCOS. About 40-50% of PCOS sufferers are fat, which shows a high correlation of fatness and PCOS. However, the only causal relationship that has been established thus far is that PCOS may contribute to fatness due to insulin-related issues. Therefore, while even a minor weight loss has been known to have a beneficial effect on some aspects of PCOS such as insulin resistance, weight loss is not necessarily the most useful therapy for PCOS. Depending on metabolic issues created by insulin resistance/overproduction, weight loss may also be extremely difficult or impossible to achieve anyhow. Depending on the woman, weight loss may improve hormone levels or induce menstruation, but that doesn't mean that the syndrome has been cured.

For PCOS sufferers, there are many possible treatments. Menstrual periods are usually regulated with birth control pills, and hirsutism can be controlled with a drug called spironolactone. Clomid is often prescribed for women with PCOS who are trying to get pregnant. There are also drugs which may be prescribed to help address insulin resistance and/or overproduction. Occasionally, surgery is recommended on the ovaries themselves, but this is not usually very effective.

Fertility, Pregnancy, and Childbirth

Although there isn't a lot of comprehensive research available on the subject, anecdotal evidence tends to suggest that men and women of size have the same range of experiences with fertility, pregnancy, and childbirth as other people. There is little available information on the fertility of fat men as a separate issue.

Women's fertility often has a strong genetic component: if your mother, maternal grandmother, and sisters conceived easily, chances are that you will probably conceive easily too (although factors such as STD history and hormonal status can alter that likelihood). Stress, nutrition, and general health level can also affect a woman's ability to conceive and carry a child to term. Fatness alone doesn't compromise fertility in most cases. Estimates in regard to causes of infertility in women of size suggest that weight is a relevant factor only about 10 percent of the time.

Despite this fact, many gynecologists and obstetricians will try to tell prospective mothers that they have to lose weight in order to become pregnant, or to avoid nightmarish health risks to themselves and their potential or actual fetuses. It is true that there are some cases where

body weight can be a component in infertility (as with menstrual irregularities, see above), but this is far from uniform. Usually, having a health practitioner say "You're too fat to get pregnant" is not a diagnosis at all, but a handy code phrase that means "You'd have to have sex to get pregnant, and who would have sex with you?!?" There is no way for any doctor to make a "visual diagnosis" of infertility just by looking at someone. At the very least, telling someone that they are "too fat to get pregnant" is an empty phrase and should be ignored. Fatness itself is not necessarily a barrier to being fertile. Suffice it to say that there is a perfectly good reason that fertility goddesses are so often depicted as being fat!

As with menstrual irregularity, there are many reasons that women may have problems with infertility. Some of them do have legitimate correlations with fatness. Three of the major fatness-related causes of infertility are lack of ovulation caused by a hyperabundance of estrogen, hormone-level related Luteal Phase Defect (problems with what goes on in the luteal phase of the menstrual cycle, the part between ovulation and menstruation and the time when a fertilized egg would implant in the uterine lining), and PCOS. In general, extremely thin women and extremely fat women tend to have lower conception rates than women whose body sizes and weights are less far out toward the extremes of the human spectrum. However, women of a very wide range of body sizes are able to become pregnant and carry healthy babies to term without any problems at all, including women who are thin as well as women who are fat.

For women of size (and their partners) who are facing difficulties with infertility, the scene can sometimes seem bleak. However, there are a lot of good doctors out there who have success in helping women of all sizes to get pregnant and have healthy pregnancies and healthy babies. Use the "Questions to ask your gynecologist" list on p. 178 as a guide to helping you interview prospective doctors. A doctor who is sympathetic to your needs will be a doctor with a much better attitude toward helping you have the baby of your dreams. Finding support (the online Plus Size Pregnancy website at *www.teleport.com/~rvireday/plus* has links to some online discussion groups) from other women of size who are going through the same things can also be a great asset in terms of information and friendship while you go through the process of trying to become pregnant. Women often benefit enormously from the knowledge that they can share amongst themselves.

Some women try to lose weight before they try to get pregnant, on the grounds that they will have an easier pregnancy if they are not (as) fat. This may or may not be true. The important thing to remember is this: weight-loss dieting can cause its own fertility problems, including lack of ovulation, problems with hormone levels, and loss of libido. Also, given that most people who lose weight gain it back (the National Institutes of Health estimate that about 95% of people who lose weight with dieting gain it back – the body is very reluctant to give up reserves of fat), losing weight before a pregnancy may lead to a lot of weight gain rebound during or just after a pregnancy. Women of size who want to bear children should consider this issue carefully, particularly if their gynecologist recommends that they lose weight before they try to become pregnant. They may decide that it's better for their physical and mental health to not put themselves through the physical and mental stress of losing weight pre-pregnancy, only to face the prospect of weight regain during and after pregnancy. If your obstetrician suggests that you lose weight, ask for his or her reasons and references, and do not accept "In my experience..." answers.

During pregnancy, there are three potentially severe complications which doctors will keep a special watch out for when the mother is a woman of size. One is gestational diabetes, which is usually very controllable with nutrition and medication. The other potential complication for which bigger moms are at a somewhat higher risk is pre-eclampsia, a hypertensive disorder which can have disastrous consequences for both mother and fetus if it is not diagnosed and controlled. Neural tube defects, a family of birth defects which includes spina bifida and anencephaly, are also considered higher-risk in plus-sized pregnancies, but the risk is still quite small and can be lessened if the mother-to-be takes folic acid supplements. Note that none of these conditions are specific to women of size, but may pose problems for pregnant women of any weight. Also, remember that "higher risk" does not mean something will necessarily happen. All "higher risk" really means is that you and your doctor should be particularly alert for the warning signs of certain conditions. For more information on plus-sized pregnancy and fertility issues, please consult the references listed in the Resource Guide.

One of the biggest obstacles to a good plus-sized pregnancy, as with finding good medical care of any sort, is finding health care practitioners who treat you competently and respectfully, and who involve you

in the decision-making process. Being proactive and interviewing doctors, looking over medical facilities, asking questions, and discussing size-friendly treatment protocols with potential health care providers is your best way to insure a good experience during pregnancy and childbirth. Use the list of questions in the "Keeping Your Head When Your Feet Are In The Stirrups" section as a basis for asking questions of your fertility and pregnancy-related health care providers, and remember that you deserve competent, nonjudgmental, supportive fertility and pregnancy-related care no matter what size you are. It can take some hunting to find the one that is right for you, but there are competent, compassionate providers out there. The wonderful web-based Fat-Friendly Health Care Providers List *(http://www.bayarea.net/~stef/Fat/ffp.html)* not only lists many health care providers, but allows you to list providers with whom you have had good experiences so that other people of size can find out about them, too.

"When I was pregnant with my daughter I paid a visit to the Childbirth Center in my local community to see if it was a group I'd want to have a baby with. The one skinny midwife showed me around, and then sniffed, 'of course, you'd be high risk because of your weight.' Stunned, I said, 'what's the relationship?' She said, 'oh, I don't think there is one, but people will tell you that you'll be in labor longer, you'll have trouble starting labor, etc.'. I was so pissed when I left I decided not to use them. A few days later the founding head midwife called me to see if I had any questions. I told her exactly what the other midwife had said, and she said, and I quote, 'oh, bullshit. I weighed 227 last time I checked, I've had three babies myself, I've delivered hundreds, you'll be just fine. Come have a baby with me.' I did. My first was born in the hospital, but for my second, born five years ago, I gave birth at the Childbirth Center itself. One more story – during that first pregnancy I went to one appointment with their consulting obstetrician. I was about seven months pregnant, give or take a few days. I asked him if the baby was head up or head down, and he sneered, 'with all that fat in the way, how am I supposed to tell?' Next day I called my pal the head midwife, told her the story, and she apologized. Then she checked into it, called me back, and apologized again. I don't expect that I was the reason for it, but she terminated the schmuck's contract a

month later and replaced him with a fabulous OB/GYN who never batted an eye at my weight." – An Anonymous, But Happy, Big Mama

ASSUME THE POSITION

TITILLATIONS AND TACTICS: PRACTICAL SEX FOR PEOPLE OF ALL SIZES

One of the most frequent complaints that fat people and their partners have about their sex lives – often one of the only complaints – is that some of the standard sexual positions for masturbation, penetrative sex, and oral sex just don't work well for them. This can happen to anyone, regardless of their orientation, sex, or size, but fat can present its own range of sexual challenges. The missionary position for vaginal or anal penetration is likely to be difficult for a couple who both have prominent bellies, for instance, while for a person who has a bodaciously round rear end, it might be difficult to achieve penetration from the rear. There's no getting around it – there are simply some times where having a fat belly, butt, thighs, or whatever other body part(s) can make it difficult to attain the classic positions in their "textbook" forms.

But who says that that "textbook," regardless of whether it's *The Joy of Sex* or *The Kama Sutra*, necessarily teaches all the best and most workable sexual positions even for thinner people? The truth of the matter is that fat people aren't the only ones who find that the old standbys don't always work so well. People of all size ranges find that, for many different reasons, the traditional poses for sex may not always be just what the doctor ordered. Couples who have a significant height difference to accommodate, for instance, are also likely to find many of the standard positions awkward in their "standard" forms. People with various types of physical limitations – say a trick knee, a bad back, or a mo-

bility impairment of some kind – also have to learn to work around their various abilities and disabilities in the sexual arena.

Anatomical differences, disabilities, and injuries aren't the only considerations that demand a more detail-oriented or experimental approach to choosing sexual positions. For instance, some women find it painful to have their cervixes bumped during intercourse, so positions that encourage deep penetration have to be managed carefully or excluded altogether. Some people just don't care much for a given position: they may associate it with a negative experience, it may seem unaesthetic to them, or it just might not feel good. Pregnancy, too, creates its own variables. Anyone who's ever tried to have sex after about the sixth month knows that some things just have to change according to the circumstances and the shape of the body as the baby grows.

In short, there are any number of reasons that a position might not be the best position for a particular person or at a particular time. If some position just isn't working out for you for whatever reason, there's no need to be embarrassed... rest assured that you're far from the only person in the world who ever ran into that particular problem. The trick is to find the positions that *do* work for you and that offer the greatest degree of versatility and variety for your sex life.

Bodies come in an almost infinite variety of sizes and shapes, and there's an even greater variety in possible shapes and topographies among fat bodies than there is among thin ones. Your body size and contour can also change over your lifespan due to pregnancies, illnesses, exercise, weight gain or loss, and the simple and natural processes of aging. As your body changes, it only makes sense that sometimes your approach to how you have sex and in what positions may need to change along with it. With the right mindset, making these changes can be an opportunity for invigorating sensual renewal rather than a source of frustration for you and your partner(s).

Finding positions that work wonderfully for you always requires some individual experimentation. Experimenting, it hardly needs to be said, can be an awful lot of fun, but guidelines are also helpful. In this chapter, a number of positions will be described in detail, but these are meant as suggestions more than they are blueprints. There are many variations on the positions listed that *aren't* described here. You can "roll your own" when it comes to sexual positions simply by lifting (or having a partner lift) a leg in the air or swinging it in a different direction, by

putting a pillow or two under your butt, by standing instead of kneeling, or what-have-you. Use your imagination! A dirty mind is a terrible thing to waste. Also, remember that while these positions are often useful for people of size, they are not limited to people of size. Any position listed in this book should work for thin people as well.

When you're trying new things, keep an open mind and a sense of humor. You wouldn't necessarily expect to have a new recipe come out absolutely perfectly the very first time you try it, and a new sexual "recipe" is no different: it may take a little rehearsal in the kitchen, but with a bit of practice you can waltz right in and whip up a *pièce de résistance*.

MASTURBATION

People always seem to forget about positions for masturbation when the topic of conversation is sexual positions. This is probably partly because we masturbate alone most of the time, and therefore we don't have to think about where our bodies are in relation to another person's. It's also partly because most people learn how to masturbate sometime in childhood or puberty, when we're unlikely to be thinking about what kind of position we use when we do it. We do it more or less on instinct, and we then usually bring our youthful masturbation methods with us into adulthood. Sometimes this works out just fine, but sometimes the techniques and positions we learned for solo sex when we were kids just don't work as well once we've gotten bigger and heavier.

This is true for everyone, not just fatter people. Many women learn to masturbate lying on their stomachs with one hand beneath them rubbing their clit. Adults who try this position for very long may well discover that they're cutting off circulation to their hand by lying on it – and a hand that's gone to sleep is a hand that's pretty useless for getting you off! People get frustrated when they find that their weight, size, or body shape have changed so that they can't masturbate the way they've been accustomed to doing it.

It's actually not so unusual to have to learn new masturbation techniques as an adult. However, because masturbation is so primary and is usually learned so early, it's an activity where we're not as likely to have learned how to really articulate what we like or how we do it. This can make it hard to know what to change.

Sometimes all that's needed is a shift in position. If you usually lie on your stomach, try lying on your side or back. If you're not comfortable lying flat, prop yourself up on pillows to raise your upper back and effectively lengthen your arms a bit, while still letting you be relaxed and able to concentrate on being aroused and feeling good. Masturbating while sitting up is also an option for a lot of people. You may find, as some people do, that you can masturbate very happily in a number of different positions – a far more versatile state of affairs than being locked into doing it the same way you've been doing it since you were thirteen and thinking it's the only possible way to go!

People with large bellies often find that lying on their sides makes masturbation easier. For a lot of people, lying on their sides helps shift the belly to one side a bit, giving them an easier and more direct route to get to the goods. Never be afraid to let gravity help you with a reach problem! So if particularly thick thighs make it harder to get your legs spread as wide as you'd like, try bending your legs at the knees, then letting your knees fall gently toward the floor while you lie on your back. Putting a pillow or two under each knee with your legs spread can also make a lot of difference in terms of giving you more room between your thighs. Some people also find that propping just one leg up, for instance on the back of the couch while you're lying on it, is a nearly effortless way of making it easier to touch, play with, and enjoy your own genitals.

Some very large-breasted women report that their breasts get in the way of their being able to masturbate comfortably. Again, lying on one side is often helpful. Another position that works for some women is to raise the hips by putting some firm pillows underneath the buttocks and the small of the back. Several large-busted women report that regardless of whatever else they may do, they find that wearing a supportive bra during sex and masturbation helps keep the breasts from getting in the way when they're reaching for other things. While effective, this may not be the most erotic solution. People who want a more classically sexy look might try a bustier or corset as a more erotically appealing way to keep abundant cleavage under control.

Sex toys are a part of many people's masturbation. For more information on vibrators, dildos, butt plugs, and the numerous other types of toys and gadgets that can help enhance your sex life (solo or with a partner), including advice on which types work best for bigger people, please see the section on Sex Toys (page 203).

Positions for Penetration

There are probably as many different ways to achieve either vaginal or anal penetration with a partner using fingers, a dildo, or a penis as there are people who have penetrative sex. Penetration with the fingers is the least likely to cause any problem in terms of finding a workable sexual position, since arms are fairly long and bendable and it is usually easy enough for a partner to position him or herself in such a way as to be able to easily reach a partner with at least one hand. This is also true when you penetrate your partner with any hand-held dildo or other object – our hands and arms make it easy to do. Penetration with a penis or with a dildo in a harness, both of which are substantially more limited than arms and hands in terms of dexterity, can be a whole 'nother story.

After all, penises, and dildos when worn in standard dildo harnesses, protrude from a part of the torso that isn't all that maneuverable. Also, while dildos can be bought in varying lengths, the one you have in your harness at a given moment (not so unlike a penis) is only as long as it is. When a partner's belly, thighs, or butt are well-padded, length can be an issue in how easy it is to insert the penis or dildo into the vagina or anus. This depends on a number of things, such as where both partners' fat occurs on their bodies and how they fit together. (For more on dildos and harnesses, see the "Sex Toys" section, page 209.)

Particularly if both partners are large, it may take some work to find consistently good positions for penetrative sex. There is a grain of truth to the old fat-negative cartoons that show two naked fat people bumping their very protruding bellies together, genitals ludicrously far apart, with a caption that reads something like "mission impossible." Yes, it's true: bellies can get in the way. And yes, if you tried to go about penetrative sex in precisely the way it's shown in the cartoon, and your bodies were shaped like the ones in the cartoon, it wouldn't be too easy to achieve penetration. But in the real world, this only creates a problem if you happen to believe it's only sex if your belly buttons are touching. There are actually quite a number of positions in which fat people and their lovers, no matter what size they are, can achieve wonderfully enjoyable penetration.

Often, people who don't have success with the "old standby" positions feel like they're either sexually inept, or else that they're just too fat to be able to have good sex. It ain't necessarily so. Most of us haven't

been educated too well about the range of possibilities of our own sexuality as human beings. Because of the way we're taught to think about life in general, we often end up believing that there are "right" and "wrong" ways to have sex, "right" and "wrong" positions in which to do it, and so forth. The truth of the matter is that the "right" way to have sex is whatever way works best and gets you off the most. Conversely, the "wrong" way to have sex is any way that makes you uncomfortable, unhappy, or that hurts or degrades you or your partner. The French Olympic gymnastics judge is not lurking in the closet, waiting to leap out and rate you on your style, accuracy, and athleticism. You don't get extra points for being able to do it standing on your head, on one foot, or if you can make yourselves look just like the airbrushed couple in the glossy sex-positions book you got from some catalogue. Happy, horny, wonderful sex – penetrative or otherwise – is as possible for fat lovers as it is for anyone. It may require a little creativity and a willingness to try new things to find the positions that work like dynamite for you individually, but that's true for everyone no matter what their size. Generally speaking, where there's a will there's a way.

Because these positions generally work as well for anal sex as they do for vaginal sex – the anus and vagina in women, after all, are just an inch or two away from one another – and because sexual positions, like sexual activities, aren't limited to partners of just one orientation or gender, this section deals simply with penetrative sex rather than being broken up into "vaginal" and "anal" intercourse. You can try any of the positions described in this section for either vaginal or anal penetration. Rest assured that they've all been field-tested and are effective for both! That said, let me also remind you that while it's okay for a penis, dildo, or finger to go from vagina to anus, it's not okay to go from anus to vagina without a thorough washing and/or taking off the old condom and putting on a new one. Normally occurring bacteria that live in the intestinal tract can cause infections if introduced into the vagina. For those choosing to have only vaginal or only anal penetration, this is obviously not an issue.

Face To Face

The classic "missionary" position, in which the person being penetrated lies on their back on the bottom and the person doing the penetrating lies on top, hip to hip and belly to belly, may be unwieldy or uncomfortable if one or both lovers has a big belly. Mind you that this

isn't always the case: sometimes the luck of the draw means that two big partners will have tummies that fit well together, allowing them an easy close fit for this kind of fucking. But if standard missionary is less than satisfactory, there are a lot of face-to-face alternatives.

You can begin by putting some pillows under the hips and butt of the person on the bottom to raise them up above the bed or other surface. Often, this will present a better angle for penetration, as well as letting gravity help pull the belly away from the pubic bone a bit. Raising the knees helps to spread the thighs wider, or, alternately, the penetrating partner can help hold their lover's legs up and apart. Generally, the more the person being penetrated can angle their pelvis upward, whether with the help of pillows, raised legs, or a simple pelvic tilt, the easier penetration becomes. If you imagine pushing the tip of your tailbone toward the ceiling, sort of curling the small of your back and your butt upward, you're doing a pelvic tilt. Is it any wonder that this is precisely the sort of motion we make instinctively when we're fucking and we're really caught up in the sensations of sex, pushing toward a partner?

One variant on the missionary position which works for a lot of people (and additionally allows for particularly deep penetration) is for the penetrating partner to let their lover's ankles rest on their shoulders, the thighs and calves against their belly and chest. This can be done while the penetrating partner is in a kneeling position, or, if the person being penetrated is lying on a surface that puts them at the right height (some people's kitchen tables could tell some very juicy stories!), while standing. The standing variation can be a good option for lovers whose knees are not able to bear a lot of weight for a long time. This is a gem of a position for women who like clitoral stimulation while being penetrated, since it's very easy for their lovers to reach their clits this way, and men being penetrated in this position can also easily stroke themselves or be stroked by their lovers.

Depending on how flexible the bottom's hips are, the penetrating partner may be able to lean down over them to some extent or another when in this position, the bottom's legs still against the top's belly and chest. This can create a nice feeling of tautness and pressure. The further the knees go toward the shoulders, the closer the position gets to the legendary "Viennese Oyster," a position in which a woman hooks her ankles behind her neck while she is being fucked. Don't fret if your hips aren't too flexible, though – this position does an admirable job of ex-

posing the genitals and asshole for adoration and attention no matter how much or how little you bend.

One of the drawbacks of this position, as with many of the positions which make it possible for fatter folks to have nice juicy penetrative sex, is that can be difficult to kiss or nuzzle at the same time. Unfortunately that's just the way the cookie crumbles sometimes: you can't get both ends of a playground see-saw to touch the ground at the same time, and there are situations in which one or both partner's bellies present enough of a speed bump that it just isn't possible for both genitals and mouths to meet simultaneously on either side.

Not being able to kiss while you're having penetrative sex doesn't have to mean that you have to lose intimacy, tenderness, or excitement, however. One of the great benefits of face-to-face positions is that you can maintain eye contact with your partner, which many people find to be more emotionally intimate than kissing. Deliberately maintaining eye contact as the pleasure and intensity build can be revelatory! Gazing into one another's eyes as the sexual energy builds is taught as a technique in Tantric sex to enhance emotional and sexual intimacy and the circulation of sexual energy between partners. Some people who do this regularly claim to sometimes have orgasms just from deep and prolonged eye-gazing alone.

Naturally, there are many other parts of the body to pay attention to while you're in face-to-face positions. It may not be possible to kiss your partner's lips, but it might be very easy to suck or pinch their nipples, stroke their hips, play with their cock, balls, or clit, or run your fingers through their hair. Many people find it extremely erotic to have their fingers sucked... and don't forget about sucking your partner's toes, particularly if those lovely tootsies are propped up on your shoulders to begin with. These sorts of things are excellent foreplay, and also build sexual intensity during penetrative sex. Just let your fingers.... and tongue... and lips... and hands... do the walking.

Rear Entry or "Doggie Style"

Most mammals, aside from human beings, habitually use a rear entry position for penetration. They're built for it, and in fact, so are we. What is often called "doggie style" is in reality "mammal style," used by all fur-bearing creatures from hamsters to horses to humans, and is an excellent basic position for both vaginal and anal penetration no matter what size you are. However, if the person doing the penetrating has a

particularly large or hanging belly, and/or the person being penetrated has a particularly padded butt, this position can also be problematic, and can be enhanced and made easier with some simple modifications.

In the event that a large or hanging belly makes penetration from behind difficult, the simplest solution – and therefore sometimes the least obvious one – is to lift the belly a bit and let it rest on your partner's butt and tailbone. It might seem a little embarrassing to feel like you have to lift a part of your body and move it out of the way to achieve penetration, but really, using your hands to lift your belly in this way is not so different from using your hands to move your penis or dildo so that it's in the right spot for penetration. Some parts of the body, like your hands, have great motor control, and can be manipulated with great finesse. Others, like your tummy and your penis (if you have one – dildos aren't body parts) have to be shown where to go. Believe it or not, it can be a very sexy and even comforting sensation for the person being penetrated to have your belly resting on them like this. It's like having your lover embrace you with an extra set of hands, firmly, encompassingly, and gently, but with an appendage that is much more form-fitting than a hand could ever hope to be.

A strategy that's often helpful when a partner's rear end is particularly large is to do rear entry with the person being penetrated lying on their stomach, rather than taking the standard hands-and-knees stance. Placing a few pillows under the chest and another couple under the hips raises the pelvis above the legs, improving access and making it easier for them to spread their thighs while still being comfortable. Bending the knees slightly, or drawing them up towards the hips or sides, exposes the genitals and/or ass nicely. In this position, the penetrating partner can lean forward more, or even lie on top of their partner, since the belly is a bit more easily accommodated and the buttocks are somewhat less prominent.

Prone rear-entry positions are also very nice for what is called femoral or interfemoral intercourse, or thrusting the penis in and out between a partner's closed thighs (the long bone of the thigh is the femur, which lends its name to the sexual technique). Fans of this kind of friction sex (see "Fat Frottage and Rubbing") also may like to have their partners close their legs around the shaft of their penis after they've inserted it, for a combination of penetration and frottage in which the thighs, the cleft of the ass, and/or the labia are closed tightly around the penis. The

penetrating partner then straddles the backs of their partner's thighs rather than being between them. Fatter partners have a definite advantage in this type of sex: the presence of plump, juicy, fat labia, upper inner thighs, buttocks, and the backs of the upper thighs makes for this delicious, incredible "gripping action" around a lover's shaft. Thinner people can do it too, but the sensations tend to be more intense when the "grip" of the flesh is enhanced by the resilient springiness of considerable fat beneath the skin.

One of the biggest drawbacks of rear-entry positions is that they can be rather hard on the knees if done on all fours in the archetypal "doggie" pose. For many people of size, this can present a real problem, since knees (and wrists) are delicate and easily strained. Fat people aren't alone in having joint strain problems, however. Thinner folks who develop housemaid's knee from sex don't like it any better! Kneeling on a soft surface such as a bed doesn't necessarily help much, since it is the weight your knees are bearing more than the surface upon which you kneel that does the damage. However, there are ways for rear-entry positions to work without putting undue strain on your knees.

Ways to do this include bending the person to be penetrated over the side of the bed, or over the (sturdy, padded) arm or back of a couch or armchair. Alternately he or she can stand, bent at the waist, and hang on to some suitably sturdy piece of furniture or household fixture (the rim of a bathtub, for instance, or a kitchen counter) while they are penetrated from behind. Choose the position and/or the piece of furniture over which you drape yourself based on the penetrating partner's height. The idea is to get your genitals at approximately the same height as theirs. If you go in for hard thrusting, make sure there's something sturdy underneath the chest and shoulders of the person being penetrated so that they won't be slammed into anything too hard or get knocked over.

Spooning or Sideways Sex

Spooning is a variation on rear entry that is done with both partners lying on their sides, one partner's butt pressed into the other partner's crotch, for an effect like spoons nestled together in a drawer. As with other rear-entry positions, belly and/or butt size may make this unwieldy for some people, but this can often be compensated for by having the partner being penetrated bend forward at the waist, thus making more room for the other partner's tum and thrusting the rear end backward toward the penetrating partner's dildo or penis.

A fun variation on spooning is the "X position." In this position, the partner being penetrated lies on their back, with the leg closest to their partner's hip draped over the penetrating partner's hip. The penetrated partner's other leg goes between the penetrating partner's thighs. The penetrating partner lies on their side, one leg between and one leg below their lover's legs, the two bodies forming a rough "X" shape together. This is an excellent way to get very full genital contact, particularly if the penetrating partner lifts their partner's topmost leg, bending the knee a bit. This is a great position if both partners like to move around a lot during intercourse, since it tends to keep everything "in the groove" and cuts down on the possible need for reinsertion. It also gives great access to the penetrated partner's genitals for further stimulation by either partner, a real asset for the many women who love clitoral stimulation during penetration.

Getting On Top

For a number of reasons, getting on top in a position in which the penetrated partner – the "bottom" – is above the person doing the penetrating intimidates the hell out of a lot of people. You don't even have to be fat for it to be an issue. These positions generate more angst for more people, and for fewer good reasons, than any other.

Why does getting on top create so much tension? Well, for one thing, getting on top carries overtones of sexual aggressiveness, particularly for women, who are not "supposed to" want sex. Many women are taught that it's inappropriate for a woman to display sexual appetite, and it's almost impossible to avoid giving the impression of wanting to have sex when you get on top. Lest this sound like a woman-only problem, rest assured that there are also men who are not very comfortable thinking of themselves in the "aggressive" role, or who may feel that it is inappropriate to their conception of how they should be sexual with a given partner.

Particularly when you are fat, it may feel very exposed to be on top, knowing that your entire body can be easily touched and seen. And then there are the hoary old urban legends and old wives' tales about fat people who crush, smother, or suffocate their partners by getting on top that one has to overcome before getting on top will be enjoyable. Getting on top is scary because sex makes us vulnerable. No one wants to be rejected. No one wants to have a partner see us from a different angle than normal and suddenly find the sight less than attractive (not that

this is very likely, but it's a very real fear). Fortunately for all of us, few of the things we're conditioned to believe about getting on top are actually true.

Getting on top is not necessarily aggressive or dominant, though it is true that it does generally display a certain amount of sexual appetite. It can be a vulnerable position to take from the standpoint of being visually exposed, but in all honesty, chances are that someone who already finds you sexually appealing isn't going to mind having a better view. As for crushing, smothering, and suffocation, suffice it to say that if a 250-pound football player isn't going to crush his 110-pound cheerleader girlfriend, a 250-pound woman isn't going to crush anyone, either. If it's possible (and it is) for submissive men in fetish "crushing" videos to have 500-pound women stand, sit, and even walk on them without doing any serious damage, your chances of doing any harm to your partner during an average sexual encounter are – pardon the pun – extremely slim.

The biggest hurdle, in terms of a person's ability to get on top, is usually their own emotional baggage about their looks, desirability, worth, and sexiness, rather than physical inability or displeasure on the part of their partner. If you think you might want to get on top, go ahead and give it a whirl. Try it a few times to get used to the sensations. The worst thing that can happen is that it might not be your cup of tea, in which case you've lost nothing but a bit of time. You just might find out that it's not so scary as it seems. You might even like it!

As many people discover when they give getting on top the old college try, it's actually a really good position for penetrative sex for most people of size. Not only does it often make penetration very easy, but the person being penetrated is very much in control of how fast, how much, and how deeply they are penetrated. This is worth remembering if you're a fan of anal penetration, and especially if you're curious about anal penetration but never tried it because you were afraid it might hurt. If you control the penetration, your chances of having a great experience with anal penetration are much better.

The most typical way to approach getting on top for whatever kind of penetration is to straddle your partner's hips, facing them as they lie on their back. Supporting yourself on your knees alone or on hands and knees, you can then sink down onto the cock or dildo at a pace of your choosing. Leaning forward and supporting yourself on your hands as well

as your knees increases your ability to have excellent control over both speed and depth of penetration. Once you find a comfortable pace and position, you're all set to ride like a cowboy (or a cowgirl!) for as long as you like.

If your partner has particularly wide hips, you might have more success in straddling them while facing their feet, since most people's knees are narrower than their hips. This way, your legs only have to spread far enough to straddle the knees and thighs, but you get the same amount of control over penetration as you would facing the other way. As a bonus, your partner gets an amazingly hot view of what's going on.

The paradox of getting on top is that depending on the attitude and physicality you bring to it, it can either be very tender and mutual, or it can be a very easy, versatile way to play with sexual dominance and power. After all, the partner on the bottom can thrust upward just as easily as you can thrust downward, and sexual energy is always a two-way street. On the other hand, depending on how much of your weight you let your partner take and how you move, you can communicate varying degrees of dominance or aggressiveness very easily when you're on top. If you support part of your weight with your hands as well as your knees, you can move above your partner while hardly putting any weight on them at all. But if you only use your legs to support you, your partner will take more of your weight across their hips, putting you more in control of the movement. Depending on whether you move up and down, or simply grind down against them (a favorite of many women who like deep penetration and/or G-spot stimulation), you can allow them greater or lesser freedom of movement.

Likewise, whenever you're on top of a partner, you have numerous interesting options at your disposal: you can pin their shoulders down, grab their wrists or pin them to the bed, or you can simply reach down to tease nipples, stroke the side of your partner's face, or play with their hair. Being on top can be tender or torrid, aggressive or very equally-balanced. It's got very little to do with the position *per se*, and a great deal to do with how you go about it.

Seated Positions

A variation on the "bottom on top" theme that invariably arouses a great deal of interest is seated penetration, in which the person being penetrated sits on or straddles their partner's lap. This can be done either face-to-face or facing away from your partner. It sounds like a ro-

mantic and exciting position, and it is – when it works. But this position is notoriously inconsistent, not just for fatter partners but thinner ones as well, and there just aren't any guarantees whether it will work for you and your partner. A lot depends on the angle and, yes, length of the erect penis or dildo – i.e., how much actually sticks up above the level of the tops of the thighs and can thus possibly be inserted. Most standard dildo harnesses don't place the dildo at a really good angle for this position, and many men's penises aren't at a particularly good angle for this, either. This is particularly true if both partners are fat: the combination of thick thighs, a well-padded tush, and an average-length penis may well mean that there's just not much possibility for a connection in this position. In this case, it may be helpful to have the penetrating partner lean back in a semi-reclined seated position. This will usually make more of the penis/dildo accessible.

For dildo users, the thigh harness is the perfect accessory, and makes seated sex a scrumptious piece of cake. These harnesses strap the dildo against the thigh (back or front) instead of holding it against the pubic bone or belly. They are fabulous for seated penetration because you can put the dildo precisely where it's most easily accessible (on top of your thigh) rather than trapped partly between them.

The biggest drawback to seated positions for heavy partners is that they put a fair amount of strain on the knees. It's not really possible to support much of your body weight on your arms in seated positions, though depending on what you have on hand, it might be possible to use something higher up – a bed headboard, the back of the couch or chair you're using, or something similarly sturdy – to help you raise and lower yourself.

Please don't let the fact that you might not actually manage seated penetration stop you from straddling your partner's lap! It's a delectable and intense tease to straddle a partner while facing them, rubbing your nipples on their chest, lips, or cheeks. You can grind against them, let them lick and suck your nipples or play with your breasts, and revel in some truly Academy-Award-caliber necking. Sometimes, positions that don't work out for actual penetration are just as hot and torrid without it, and this one is a case in point. There's something about sitting on or straddling a partner's lap, that conjures up visions of back seats, drive-in movies, and fervent bumping and grinding. Even if you never did those kinds of things in high school, there's no time like the present!

Standing Positions

Having sex face to face while standing up seems to be one of the top items on many people's sexual wish lists. Correspondingly, it's often one of the positions people feel most frustrated about not being able to accomplish in their own sex lives. Would that there were an easy way to make standing sex feasible or even easy for every fat person who ever wanted to try it. There isn't. But the reason why isn't due to fat – face-to-face standing sex isn't a particularly easy position for anyone!

Modern humans *(Homo sapiens)* may have descended from *Homo erectus* – "standing-up man" – but that sure doesn't mean we're built optimally for fucking while standing up. At best, face to face standing penetration is a rather athletic maneuver even when both partners' heights, the length of their legs, the relative positions of their genitals, and their ability to maintain their balance with their legs spread are well-matched. A few inches one way or the other can make it uncomfortable, awkward, or impossible to have penetrative sex this way no matter how flat two people's bellies are. Not too many people successfully have penetrative sex this way, no matter how glamorous and exciting it may seem or how many hot smut stories you've read in which some couple ends up doing the wild thing up against some alley wall. It's just a difficult position to negotiate. If it were a ski slope, it'd be a black diamond run. Being fat does, admittedly, make face-to-face standing penetration yet more difficult – but it's just not worth getting too frustrated over it if you're one of the many for whom it just doesn't work.

A lot of women have another and even more impractical fantasy about standing face-to-face penetration – the notion of having a partner lift them onto their cock or dildo and hold them there while fucking. It's a great and very romantic fantasy, but it's pretty unlikely that it occurs with any regularity in anyone's actual sex life, even if they're very skinny. This has less to do than you might think with size or weight, and a lot more to do with issues of upper body strength, physics, and plain old endurance. Even a hundred pounds – which would be a rather small person – is an awful lot for anyone to be expected to deadlift, position with the amount of accuracy it would take to lower a woman onto her partner's penis without injuring either one of them, and hold through the force and shifting weight of fucking. It'd take an extremely strong man with a lot of upper body strength and endurance, and an extremely tiny and lightweight woman, for this to be possible at all – imagine an Olympic-

caliber weightlifter with some teeny-tiny gymnast type, and even then it's somewhat unlikely. It's a great fantasy (there's a great bit in the original *Emmanuelle* novel where such a scene is described), but it's enormously impractical. It's no more a failing to have never had a partner lift you onto his penis than it is to have never won the lottery.

Before you get the feeling that sex while standing up is completely out of the picture for big folks, it should be mentioned again that rear-entry standing sex, particularly if the person being penetrated is bent over to some degree, is a pretty reliable bet. This was discussed to some extent in the "Rear Entry" section, previously, but it bears a little elaboration here. Be sure that the person being penetrated has a stable, sturdy place to stand, first, and something to hang on to for safety's sake. Falling on your face or on your knees is not a fun way of expressing your sexuality. Neither is restorative dentistry or orthopedic surgery, so err on the side of caution. Door frames, sofas and large easy chairs, kitchen tables and counters, desks, and other large, basically immobile things are good choices for support when you're having standing-up sex. So is leaning forward against a wall – the classic "quickie in the alley" scenario can be played out against the brick wall of your very own garage, if you so desire – but make sure there's something to help support you. Spread your legs as widely as you can while staying stable on your feet, stick your butt out as you lean forward a bit, and you're in position for a steamy bout of standing rear-entry penetration. For you femmes out there, remember that doing it in high heels can help mitigate a slight height difference if you're shorter than your partner or simply have shorter legs, but don't forget to have something sturdy to hang on to for balance.

ORAL SEX

In general, people tend not to be quite as concerned with positions for oral sex as they are with positions for penetrative sex. Most of the positions that people use for oral sex – some variation on the theme of lying or kneeling between a partner's legs – work perfectly well no matter what size you are. If your partner has a hard time spreading his or her legs wide enough for you to have easy access to all those delectable nooks and crannies, having him or her raise the knees and letting the legs fall open naturally, knees-first, will often help.

As with missionary position penetration, it can also be helpful to raise your partner's hips up off the bed with some pillows or a few folded blankets. This can really help to alleviate neck strain, which can ruin an otherwise lovely evening. Giving blowjobs is often more comfortable if the person doing the giving lies alongside the recipient, perhaps with one hand under his butt or thighs, rather than lying or being on their knees between their partner's legs. These two tricks can be combined if your partner has a hanging belly, which might otherwise make it more difficult for you to get all the access you want.

A good alternative position for cunnilingus or rimming is with the recipient on all fours, legs spread wide, with their partner kneeling or standing behind them. This pose works particularly well for many people if the lucky recipient of the oral attention kneels on a couch or, depending on the height of both bed and partner, the edge of a bed. The view when your partner is open to you in this position can be downright awe-inspiring!

As with penetrative sex, a lot of people are leery of getting on top for oral sex. The oft-imagined *bête noire* of sex with fat partners, the fear of crushing, suffocating, or smothering one's partner, looms larger when you're actually partly covering their mouth and nose. Women in particular may worry that if they lose control and begin to grind against their lover's mouth and tongue, their lover could be suffocated under their weight and the fleshy folds of their pussy.

This is all very highly unlikely. As long as your partner's hands are free, he or she will be able to make sure there's a reasonably clear airway just by sticking a few fingers between your pussy and their face, for one thing. Also, if a partner indicates distress, you can simply move. Even if your knees or legs won't allow you to rise easily and quickly, you still have the option of letting yourself fall to one side (bend at the waist a little and you'll take the fall as a hip roll, which is much more comfortable) if there's any chance that you might need to get out of the way in a hurry.

When you get on top for oral sex, you will probably find it most comfortable and secure to support yourself on both hands and knees. As with getting on top for penetrative sex, this gives you more control over where and how you move, how much weight your partner takes, and, of particular importance if you have a hanging belly, makes it easier for your partner to get close to your genitals. Lowering yourself to your waiting

partner's face can be an enormous turn-on for them, and additionally gives you a wonderful opportunity to tease your partner.

Do be aware of how much bucking, grinding, and thrusting you're doing as you ride your partner's face this way. While it is in fact very unlikely that you'll do any harm, it can be uncomfortable even with very lightweight partners to have someone thrust full force against your jaw or nose. Pay attention to how your partner seems to be reacting. After all, paying attention to your partner's pleasure and reactions is the best way to have excellent sex no matter what position you're using or in which specific activities you indulge.

Some people particularly enjoy the sensation of being engulfed in a woman's pussy and/or ass, or between a man's thighs. They may ask their partners to get on top for oral sex precisely for this reason. If you are (or your partner is) uncomfortable with this, you can achieve the same sense of being engulfed or surrounded while lying on your sides. With your head between your partner's thighs, you still get to enjoy the weight and sensuality of having a thigh on either side of your face, and your head will still be pretty well engulfed. In the event that impending orgasm makes your partner clutch your head too hard, push down, toward the backs of your partner's legs, with your head. This is a much more effective way to break free of a too-tight grip than trying to push backwards and up towards your shoulders and/or the tops of your partner's thighs.

LUBRICANTS AND SEX TOYS

A Few Words On A Slippery Subject

No collection of practical sex advice would be complete without a little side trip into the realm of lubricants. Next to your libido, a good lubricant can be one of the most important tools you have for a great sex life. Contrary to popular belief, arousal alone is no guarantee that a woman's vagina will produce enough lubrication to make for comfortable sex, particularly penetration. Hormones, stress, illness, pregnancy, and nutrition all have a role to play in whether and how much a woman's vagina lubricates during arousal. Plainly put, no matter how hot and bothered a girl may be feeling, sometimes she's just not going to get as slippery as she might like. So lube is a good thing to have on hand. Even when there is a fair amount of naturally occurring vaginal lubrication

going on, some women really do like it even slicker, particularly if there's going to be heavy penetration. In general, as Susie Bright says, "There's no such thing as too much lube." You can always keep a towel handy if there is.

Lube is even more of a necessity for anal sex and anal intercourse. The anus and rectum produce no lubrication of their own, no matter how aroused you get. Anal penetration without lubricant is a scarily good way to produce rips and tears in the rectal and anal tissues – which are not nearly as sturdy as the vaginal walls – an open invitation to all sorts of unpleasant side effects, like infections and increased possibility of transmitting STDs and viruses like HIV. Besides which, unlubricated anal penetration tends to hurt, and not in that "hurts so good" way, either.

As if the foregoing weren't good enough reasons to use lube, it should also be added that lube makes safer sex a whole lot more fun. Men who don't like to use condoms are often amazed at the difference in sensation that they can get when they put a few drops of lube into the tip of their condom before rolling it on. It permits a small but significant amount of "slip" between the condom and the penis which helps trans-mit a lot more sensation, a feature that makes using condoms a lot more appealing. Likewise, lube on the outside of a condom feels great for the person on the receiving end. For fingering someone's genitals or ass, you can't beat the combination of a latex or nitrile surgical glove and a good water-based lube for plain old slippery, smooth, sexy sensation. If you are using a dental dam for cunnilingus or rimming (anilingus), using lube on the side of the dam that lies against the other person's skin transmits sensation much better than just using a plain dry barrier does. All in all, lube and latex (or nitrile or polyurethane, especially for those with a la-tex allergy) is a fabulous combination. Lube is also an excellent sexual accessory for non-penetrative sex. Masturbation, mutual masturbation, using vibrators and other sex toys, and genital massage can all be en-hanced with a good lubricant.

So the question isn't whether to use lube, but what kind of lube you should be using. All the compounds you'll find marketed specifi-cally as sexual lubricants these days are water-based. These have two wonderful advantages over oil-based lubricants: first, you can wash them off/out of your body very easily and thoroughly with nothing more than soap and water, and second, unlike oils, water-based lubes don't weaken or break down latex and other barriers vital for safer sex. Some people

do use saliva or existing vaginal lubrication as lube for other things, but both dry very quickly and their consistency doesn't make them appropriate for all uses. All the way around, a good water-based lube is the best way to go.

What makes water-based lubes slippery isn't the water they contain, but rather their active ingredient. Depending on the type of lube you buy, this will either be glycerin or silicone in a food-grade, odorless, tasteless variety that is used for its slick texture and long-lasting lubricating qualities. Glycerin and silicone each have their advantages and disadvantages. You may want to experiment with lubes of both types to find out which ones you prefer for various types of sexual activities. Here's a brief rundown on what each type is like, what some of the available brands are, and what it's like to use them.

Glycerin lubes use glycerin, a long-chain sugar molecule, for slipperiness. This is the reason that they have a slightly sweetish taste. Among their advantages are the facts that they may be used with any kind of sex toy, including silicone ones, and the fact that they're cheap and easy to find. Wet, Astroglide, Probe, and ID Lube are among the major brands of glycerin lubes, and can be found in quite a few drugstore chains. On the downside, glycerin lubes tend to get sticky or tacky as they dry out, and while they can be "reactivated" with a few drops of water (or just apply a little more lube), this stickiness can make it a bit unpleasant when you end up smeared with sticky, drying lube after a round of sex and you might prefer to cuddle without it. Glycerin lubes can also be a contributing factor in vaginal yeast infections in women who are prone to them, although they're not a problem for most women. Some people find the texture of glycerin lubes "too gloppy" or "too gooey," but this is more a matter of brand than anything. The texture of glycerin lubes ranges from the thick hand-lotion-like feel of one variety called Elbow Grease, whose clingy thickness makes it excellent for anal penetration, to the light, almost waterlike consistency of ID Lube. Test out several different ones to find out which ones you like.

Silicone lubes use silicone instead of glycerin. Because silicone is an inorganic substance, it doesn't share glycerin's tendency to encourage yeast infections, and because it isn't a sugar molecule, it doesn't get sticky when it dries. However, silicone lubes tend to be significantly more expensive than glycerin lubes, they're harder to find, and you can't use them with silicone sex toys (such as many dildos). Like glycerin lubes,

silicone lubes vary in consistency and texture. Eros Lube, a very light, almost watery-feeling lube, stays slippery for a very long time but is not thick enough to be really suitable for heavy penetration or for anal intercourse (it does make a fine massage "oil," however, and is also helpful if you're trying to slither into a latex or rubber garment). Manufactured in the UK, Liquid Silk is an opaque, white, medium-thick lube that many people love for its versatility and long-lasting slipperiness, but which some people find off-putting because it visually resembles semen. The thicker (and clear) counterpart to Liquid Silk is Maximus, which is ideal for anal play and vaginal fisting. There are also concentrated silicone lubes, such as Wet Platinum, which contain very little water. These concentrated lubes stay slippery for almost forever (because they don't dry out) and take a fair amount of washing to remove, which can be a liability if you have a spill or if you want to keep a firm grip on anything once you've gotten it on your hands.

There are many more brands of lube on the market than the ones I've mentioned. Some come in flavored varieties for novelty's sake, but this generally doesn't change the formulation. Many sex toy boutiques sell "trial size" single use packets of lubricants. This is an excellent way to make a sampler of various kinds of lube, so that you can try them out without ever ending up with an almost-full bottle of something you never want to use again.

Sex Toys

Sex toys come in a wide variety of shapes, sizes, materials, and functions. While the majority of them can be used by anyone, there are a few which are really only useful for people of one sex or the other. The major categories of sex toys are vibrators, dildos, anal toys, and what can loosely be termed "boy toys," toys made specifically to accommodate penises. Most sex toys are truly "one size fits all" and can be used by anyone, since they're not designed to be worn but rather to be inserted, pressed against the body, or to have the penis inserted into them. However, there are some sex toy tips and tricks which can make toys more enjoyable and useful for people of size. These special hints, as well as a brief overview of what each "family" of toy is like, are contained in this section.

For those wishing to purchase sex toys, please consult the "Sex Toy and Bookstore" section of the Resource Guide, where there are listings

for numerous size-accepting vendors who do retail business in their stores, via mail catalogs, and over the World Wide Web.

Vibrators

Vibrators are motorized devices designed to transmit vibrations to the body. They can be used on any part of the body, but sexually speaking, they're usually used on the genitals. There are two basic types of vibrators: "massager" style vibrators designed for general massage that are used mostly for clitoral stimulation (these usually run on normal household current and plug into the wall), and phallic-shaped "dildo" style vibrators that are designed for vaginal or anal penetration as well as clitoral stimulation (these usually run on batteries). A subgroup of the dildo style vibrators are the "egg" or "bullet" vibrators, very small vibrators which may be part of a larger insertable toy. Vibrators are used primarily, but not exclusively, by women, who may use them either for clitoral or vaginal stimulation.

The good news for people of size is that many of the most popular vibrators for sexual use are massager-style vibrators with handles, which makes them more versatile and a good choice for those who have reach issues. The Hitachi Magic Wand, perhaps the most famous vibrator of all, has a foot-long handle that houses its powerful motor (note to penetration fans: there are penetrating attachments available for the Magic Wand, including a great G-spotter attachment). Many of the coil-type vibrators, such as the Wahl or Sunbeam Coil vibrators, also have handles. Another option is the Flex-O-Pleaser, an utterly ingenious and extremely versatile vibrator which has a vibrating, egg-shaped head attached to a flexible stem that's approximately a foot long. The stem ends in the handle, which houses the controls. With this vibrator, you can not only adjust your angle of attack with the greatest of ease, but the slender "stem" also means that you can easily slip the vibrating head in between your body and a partner's. Sharing can be fun!

Dildo-style vibrators are another issue. Most of the dildo-shaped vibrators on the market are not built with handles, and reach can be a problem. The best bet to increase your reach is to give yourself a few extra inches of vibrator to work with. All you have to do is buy a longer as opposed to a shorter toy. A few extra inches might be just the thing to let you feel like you can keep a good grip on your toy and use it to your best advantage. Just because it's 10 inches long and you prefer 7 inches

of penetration doesn't mean you shouldn't buy it. After all, there's no law saying that you have to use the entire length of any toy!

Egg and bullet-style vibrators are generally fairly small. For people with significant reach issues, these would not be the best choice. However, there are many silicone and jelly dildos which are made with pockets into which bullet vibes may be inserted, turning the dildo into a vibrating dildo. Depending on the dimensions of the dildo and the extent of the reach problem, this is a way that people with reach problems can enjoy using "bullet" vibrators.

Dildos

A dildo is any roughly phallic-shaped solid object that is used to pleasurably penetrate the vagina or anus. They come in lengths and girths from pinkie finger-sized all the way up to party-sized monsters whose dimensions challenge credibility, to say nothing of the human anatomy. Dildos are the oldest sex toy known to historians, having been used as far back as the ancient Greeks and Romans. They can be made out of almost any reasonably hard and smooth substance, but the most common ones available today are made of some sort of plastic or rubber. Some dildos are made to look as much like penises as possible, but just as many are made to be "non-representational," that is, not to resemble penises much or at all. The highest-quality dildos commonly available are made of molded silicone.

Dildos, by the way, are not penises. They're not necessarily "penis substitutes," either. To paraphrase Gertrude Stein, a dildo is a dildo is a dildo. I mention this because some men become offended when their partners choose or use dildos that are bigger or longer than their penises are. While dildos have a lot to recommend them, and one of those things is indeed that you can buy them in any size you want, a dildo is only as good, and only as useful, as you make it. Without human effort behind it, a dildo might as well be a paperweight.

Dildos come in many configurations and varieties. There are dildos with handles attached, but these handles are just a continuation of the shaft of the dildo rather than being angled for use in masturbation. These can be useful for play with a partner. Most dildos, though not all, have a slightly flared base to help hold them in a harness and to make them safe for anal play. Some of the more penis-like, realistic models have "balls" attached at the appropriate end that serve the same purposes. Although some people don't care for such realistic dildos, the "balls" often make a

good handle at a good angle for use during masturbation (don't worry – your dildo will never complain that you're squeezing its balls too hard!). If you don't like the balls, cut them off with a sharp knife: no muss, no fuss, no legal charges. As with dildo-shaped vibrators, you can increase your reach by using longer dildos. Flexible and softer dildos are more comfortable than rigid ones. This is important, since the angle that many big women end up using for dildo penetration can sometimes irritate the urethra, a problem that will be compounded if the dildo material is hard and unforgiving.

The flexible and lengthy "double dong" dildos (double-ended dildos) are fun to play with for these reasons, and are great if you want to experiment with either simultaneous anal and vaginal penetration or with having a partner use the other end of the dildo at the same time. Be sure to get one that is long enough to give you something to hang on to and/or a few extra inches to span the distance between bodies. Since double-ended dildos can be found in twenty-four inch lengths and even longer, this should be no problem.

Ben-Wa Balls should be mentioned here, since they are small insertable metal balls made for vaginal use. Many women report no real effects from Ben-Wa Balls, though some women enjoy the sensation. In either case, they are best used either with a partner, or by women who have no reach problems. Sometimes, Ben-Wa Balls can be difficult to re-move from the vagina. Don't worry, they can't get "lost" – there's no-where for them to go, since there's no way they can fit through the os, the pencil-lead thin opening to the uterus. Just reach, or have a partner reach, into your vagina with two or three fingers, and you should be able to remove them fairly easily.

Dildo Harnesses
Dildo harnesses are made to hold a dildo in place against the wearer's body so it can be used for hands-free penetration. Dildo harnesses come in several different styles, two of which are useful for larger people. The cheapest dildo harnesses are latex or rubber underwear-like garments, usually in the oxymoronic "one size fits all," and are thus basically use-less to most people of size. They're not all that great even for those whom they do fit – they aren't easily adjustable and they are reportedly uncom-fortable for many users.

Generally, strap-style dildo harnesses are a much better bet. These generally consist of a belt around the waist, a front strip of leather, vinyl,

or cloth which has an O-ring, cock ring, or an opening for the dildo, and a strap or straps which go back between the legs and come up behind to attach to the waistband. Some harnesses have anchoring straps around the upper thighs instead. Most harnesses position the dildo over or just above the pubic bone, but there is a model designed for bigger users (Stormy Leather's "Crown" harness) which positions the dildo higher up, more or less even with the tops of the hipbones, providing better control and more penetration depth for those with bigger bellies.

Strap model harnesses are usually made either with leather or leather-like straps, or with straps made of nylon webbing of the sort you often find in adjustable backpack or book bag straps. The straps are most often fastened with buckles, plastic squeeze clasps or paired D-rings (both often found on backpacks/book bags), or sometimes with metal snaps or Velcro. All harnesses are somewhat adjustable in size, but most are not created with the larger user in mind. If you have any doubt about whether a harness will fit you based on its cited size or measurement range, try it on. Again, the Crown model harness from Stormy Leather is the biggest readily available model, but since people come in different sizes of large, the Crown may be too big for some and not big enough for others.

It is possible to "size up" your dildo harness with homemade strap extenders. This is easiest to do with nylon webbing, which can be purchased by the foot or yard at camping stores. If your dildo harness is made of nylon webbing or uses clasps or buckles which are designed to be used with this kind of webbing, it should be a simple matter to go to your friendly neighborhood camping goods store and match clasp sizes, webbing widths, and create a "seat belt extender" for whatever strap(s) need to be lengthened. If you have a leather dildo harness, or one which uses metal buckles, you can still make extender straps, but it may require some sewing or reworking of your original harness.

An alternative to the standard dildo harness is the thigh harness, usually a wide band of neoprene (the same material wetsuits are made of) that straps around the thigh and has a hole in it to put the dildo through. These permit enormous flexibility in terms of the positions you use for penetration, particularly since, with a thigh harness, you can choose to have the dildo pointing out from the top, side, or back of your thigh. As with standard harnesses, though, one size does not fit all, and extenders can be made along the lines given above for standard harnesses.

An alternative to using a dildo harness that works for some people is tucking the base of the dildo into the fly of a tight-fitting pair of jeans (particularly button-fly jeans). This can be an attractive and sexy option particularly for women and transsexuals who "pack" (wear a dildo under their everyday clothes).

Anal Toys

Loosely defined, anal toys are any sex toys specifically made for anal penetration. Dildos can be anal toys, but are not limited to anal use. All anal toys, with the exception of anal balls or beads, should have flared bases. It is possible to push a cylindrical or spherical object entirely into the rectum, which could result in an embarrassing trip to the emergency room. You can avoid this fate pretty much entirely by sticking to toys made specifically for anal use and not pushing them past the narrow "neck" of their flared bases.

Butt plugs, a type of dildo made specifically for anal insertion, may be a little difficult to negotiate for people with reach issues. Somewhat conical, with a flared base, butt plugs are designed to be inserted and left in place during masturbation or other play. You may find that a "bloop stick" dildo, which looks like a series of graduated spheres stacked one on top of the other, is a longer and thus more reach-friendly butt toy. These can still be held more or less in place by the anal sphincter, which can tighten around the narrower space between "bloops" in the same way that it would around the narrow part of the flared base of a butt plug, but give the additional length necessary to insert and remove them easily.

Anal beads, which are plastic, rubber, or metal beads on a string, are designed to be inserted into the anus and then pulled out (slowly or quickly) when the user is close to orgasm. For people without reach problems, or who use anal beads with a partner, they are fine toys. However, for those with reach problems, anal beads are an impractical choice.

Boy Toys

Men and women both can use almost all the varieties of sex toys mentioned so far. Boy toys, on the other hand, are sex toys designed specifically to accommodate penises. These include various types of sheath-like devices meant to imitate the vagina, mouth, or anus, vibrator attachments that fit around the penis (usually either the base or the head), cock rings, penis pumps and/or enlargers, and of course, the ever-popular and perennially lurid "inflate-a-date" or blow-up "love doll." Gener-

ally speaking, boy toys are one-size-fits all, although cock rings come in a selection of sizes so that you can choose the one that most closely approximates your genital dimensions. All boy toys presume that the user is able to reach his own penis, and/or is able to insert it successfully into an orifice (artificial or flesh-and-blood) without assistance.

The only boy toy with any particular potential for helping to address reach problems is the Fleshlight, a ten-inch tube of a fabulous, relatively new polymer known as "Cyberskin." Cyberskin has a marvelous skin-like texture, holds and transmits heat exceptionally well, and reputedly gets about as close as any boy toy comes to actually simulating the sensation of fucking an actual person. (There are also cyberskin dildos available, incidentally.) The tube has a simulated orifice at one end (your choice of lips or labia) and is encased in a rigid plastic housing from which it can be removed for cleaning. Because of the length of the Fleshlight and the rigidity of its casing, it may be helpful for masturbation for men who have reach problems.

OTHER SEXUAL ACTIVITIES

Penetration, masturbation, and oral sex aren't the only ways to have sex – far from it. The following section deals with various other sexual activities. Some are genitally focused and others are not. Some of these ways of being sexual appeal to just about everyone, while others appeal to specialized audiences. Similarly, some have more specifically to do with fatness or an attraction to fatter partners, and some are things that apply equally to people regardless of size. All of them can be part of healthy, whole, wonderful sex lives for the people who enjoy them, regardless of orientation, gender, or size.

BODY LOVE / BODY WORSHIP

There's nothing new or in any way unusual about wanting to touch, caress, massage, stroke, kiss, knead, lick, gaze at, contemplate, and verbally praise your lover's body, particularly the parts you happen to find arousing, adorable, and desirable. This, loosely defined, is what constitutes body love or worship, which can be part of foreplay, a separate sexual activity of its own, a part of penetrative or oral sex, or, with a slightly different twist, part of a fetish or BDSM scene. Adoring, venerating, ad-

miring, loving, and enjoying a lover's body is a fundamental part of being sexual with a partner.

Culturally, we tend to engage in large-scale body worship on a daily basis, but only of certain types of bodies. These currently fashionable body types are emblazoned by the dozens all over billboards, magazines, television shows, movies, advertisements, and mainstream commercial pornography. No one, consequently, would think it odd for a lover to engage in more up-close and personal body worship with a partner who was considered physically beautiful by mainstream standards. In fact, we tend to find it odd if someone doesn't find conventional body ideals sexually appealing. But fatter bodies, at least at this point in the sociocultural history of the West, are generically excluded from the "body beautiful" ideal.

As a result, body love or worship involving a fat person's body as the object of veneration is seen (when people are capable of imagining it at all) as unusual, even abnormal. This is why body worship involving fat partners is noteworthy as a sexual practice. That the admiration of fatter people's bodies is seen as unusual or odd by most people (and even most fat people) says a lot about the power of culture to define what is perceived as "normal" and "abnormal," "desirable" and "undesirable." When the same actions involving the same body parts can be seen so differently depending on the size or weight of the people performing them, one has to wonder a little bit about why basically identical acts might be perceived so differently.

On some levels, of course, body size and weight make no difference at all in body worship and body love. Beauty, as the phrase goes, is in the eye of the beholder. Different people are attracted by different things. A person's size, shape, and amount of fat padding really have nothing to do with the nature of attraction and desire, but they do have a great deal with how people feel about body worship, admiration, and praise.

Fat people, like almost everyone else, often internalize from childhood that fat is ugly, bad, and undesirable, and that as long as they are fat, they are too. People are so indoctrinated in and sensitized toward the presumed ugliness and repellent qualities of fat that many women (and some men) who are well within the "conventionally attractive" size range still think that they are fat and therefore hideously unacceptable. As ludicrous as looks in the cold light of the printed page, there are plenty

of 130-pound people who believe they're far too obese to wear shorts, go swimming, or, Heaven forfend, show off their bodies in any sexual way. Actual size is no barrier to poor self-image, poor body image, lousy sexual self-esteem and confidence. People of all sizes may well be horrified and confused when a partner seems attracted by a part of their bodies they themselves think of as unacceptable, unworthy, or undesirable.

This is just to say that fat people are by no means alone in having feelings that they and their bodies are not worthy of praise or positive sexual and sensual attention. People often avoid letting partners see or touch certain parts of their bodies because the contact is too threatening and scary. The upper arms, upper inner thighs, lower curve of the belly, and "love handles" at the hips or waist are places where a lot of people don't particularly like to be touched, because it is too fraught with tension for them to be touched in places where they know they carry fat. It can be a powerfully emotional experience to have a partner touch a part of your body with which you yourself have so many negative associations! Sometimes people get angry or burst into tears when a partner touches a vulnerable part of the body and the person being touched actually lets themselves really fully feel that touch.

> "My partner and I had had an enormous fight about sex where he kept saying that he was getting tired of constantly having to try to get me to believe that he really did find me sexy and that he really did like my body. I just couldn't see it, couldn't accept it for the life of me. I was lying there crying and he started to try to comfort me. I was distracted, so it took a couple of minutes to notice that he was gently rubbing my tummy. All of a sudden it hit me that he was rubbing my fat stomach and he was worried about me and that he still loved me and wanted me, and I burst into tears all over again because it was so emotionally touching and so honest. It wasn't until I stopped crying that I had the sudden realization that I was also extremely sexually aroused by being touched so tenderly and meaningfully. I realized that I really needed to learn how to accept people touching me like that. And meaning it." – Deborah

What this means is that for many fat people, body worship and praise, even on the simplest levels, can have special significance and be fraught with special fears and apprehensions. Often when a partner praises

a part of a fat partner's body, the reaction is disbelief and stunned in-comprehension. They may think that their partner is playing a cruel joke on them, trying to deceive them or set them up for a fall. It can take a lot of work toward self-acceptance, to say nothing of perseverance, patience, and gentleness on a partner's part, to get past these defensive reactions to a point where a fat person can accept and even believe that they are worthy of admiration and desire.

Sometimes body love or worship forms the basis for revelations. At times, being on the receiving end of this kind of physical attention can bring powerful issues to the fore:

> *"Early into a relationship with one former partner, we were lying in bed and he started stroking my stomach. I withdrew immediately – I was so disgusted by my body and didn't want him to touch my fat for fear he'd be repulsed too. Instead, he was upset about my withdrawal. When we finally talked about it, he explained that he 'loved all of me because it was me.' [This was] The beginning of my recognition that my own body image and hang-ups needed to change and weren't necessarily how other people felt about me..."* – Demeter

If you are working toward being able to accept (or toward helping a partner accept) attention and admiration on a physical level, it helps to go slow. Negative self-image or body image doesn't accumulate in a few hours, and a few hours of loving attention isn't necessarily going to get it to go away. Persistence, care, and respect, plus a willingness to at least try to accept a partner's interest as genuine, are the only things that make a lasting impact.

> *"My partner is always telling me I am beautiful and yummy. She's the one who calls me her Viking Warrior Goddess. When I look in her eyes, I see she believes every word she says, and so I have been forced to trust and believe in her vision that I am beautiful and sexy. Every once in a while now, I just wake up feeling beautiful."* – Dev

Bellies as Erogenous Zones

One variety of body worship or body love that is particularly em-blematic of many fat admirers' sexuality is the desire to caress, stroke, touch, and make love to a fat partner's belly. Unlike many of the other

parts of the body that are typically capable of developing large fat reserves – the butt, thighs, and breasts – the belly is not ordinarily thought of as being an erogenous zone, and while being touched on the belly is intimate, it's not usually presumed to be a sexual act.

For people who find big bellies extremely attractive, however, they can be just as sexy and as sexually significant as breasts, hips, thighs, or genitals. It can be extremely arousing for some people just to rub and caress a partner's belly. Belly-focused attentions can form an entire sexual act in themselves or be combined with a variety of other sexual activities from necking to fucking.

Some belly fans have very strong preferences about the types and shapes of fat tummies they prefer. Different people find different things attractive; for instance, the absence or presence of clearly delineated rolls or folds, firm "beach ball"-like tummies or soft pillowy ones, and so on and so forth. This isn't too surprising. People have preferences about things like red hair versus strawberry blonde, green eyes versus hazel, facial hair or no facial hair, and degrees of breast size, so why shouldn't different folks have different tastes in bellies? It merely goes to prove that just because someone is attracted to fat partners doesn't mean they're in any way indiscriminate about their attractions on the physical level or that any old fat body will do to appeal to a fat admirer. Fat bodies are just as varied, and their admirers just as discerning, as any others.

The other major point to be made about the belly as an erogenous zone is that it is not merely an erotic object for other people to enjoy, but that many people find it highly arousing to have their bellies caressed, massaged, and otherwise stimulated. More men than women report feeling strong sexual stimulation from having their bellies fondled and stroked, but the tummy and abdomen are generally very sensitive to touch, so this is not at all illogical. In some non-Western systems of thought, erotic energy is seen as flowing from and/or through the belly and solar plexus, suggesting that engaging and touching those areas may help to stimulate sexual energy.

Mike G. is one of the many fat men who likens the intensity of sensation from having his belly stroked to the kind he feels from his other sex organs: "I will say that for me, my belly is another sexual organ. Rub it the right way, and I'm putty in your hands." A few men, not all of them fat, also report enjoying rubbing their bellies during masturbation.

One reason that more men than women say that they are aroused by belly stimulation may be that it is to some degree more acceptable for men to have big bellies. A big belly is the physical symbol of a certain "Diamond Jim" type of successful old-money tycoon, and can carry with it some connotations of aristocracy, power, and pleasure. Desirable and/or successful women in the twentieth century, on the other hand, are rarely depicted as having protruding bellies, or indeed any detectable fat at all. Women also generally endure harsher and more systematic sexually-related body criticism than men do. This tends to make it less likely that they will eroticize their bellies, which, if they are at all fat, are systematically labeled as unacceptable and sexually undesirable.

FAT FROTTAGE OR RUBBING

Frottage or rubbing refers to rubbing the penis or clitoris against some non-genital part of a partner's body. While this can be done anywhere on any partner's body regardless of their size, there are some types of frottage sex that are archetypally "fat" frottage. Interfemoral intercourse, or fucking in between a partner's thighs (see "Rear Entry," p. 190), is one such type of frottage, and while interfemoral intercourse can be done with thinner partners, the firm yet yielding, soft yet gripping quality of a plump partner's flesh makes this type of stimulation particularly pleasurable with fatter partners.

Men tend to participate in frottage sex more often than women, mostly because frottage is easier to do with a sex organ which protrudes out from the body. However, women also often find that a partner's round, fleshy thigh or arm provides a delightful surface against which to bump and grind. Together, women also may rub their mons and/or vulvas against one another, a type of frottage sex sometimes called tribadism. This tends to be more difficult for fat women, particularly if they have large bellies. Because women's genitals are innies instead of outies, it can be pretty difficult to find positions which make this possible for big women.

The classic form of fat frottage takes the form of a man putting his penis into a fold or crease of a fat part of the partner's body and rubbing against/into or "fucking" that fold or crease. The crease or fold under the "apron" or abdominal fat of a person with a hanging or drooping belly (between the fat layer and the mons) is a favored site, but depending on a person's body shape, there are often other possibilities. Both men and women can develop the belly fold, incidentally, and one of the

things that may make it exciting and attractive to frotteurs (people who engage in rubbing sex) is its proximity to the genitals.

Some people might wonder how a roll of fat could be sexually attractive. We're not taught to think of it this way, but fat actually has many sexually and sensually enticing qualities. There's an old joke that runs "How do you make a ten pound lump of fat irresistible? Stick a nipple on it." Crass, yes, but it wouldn't be funny if it weren't partly true. Women's breasts are mostly made of fat, the very same kind of fat that a lot of people have been conditioned to find sexually unattractive if it occurs anywhere else on a woman's body. This is the reason that fatter women often have bigger breasts and very thin women often have very small breasts – and why many thin women who want to have big breasts have resorted to surgical augmentation. It should come as no surprise that the same pleasantly soft, pillowy, jiggly, warm, dense roundness that people love about women's breasts also exists in other places where there is a significant quantity of fat below the skin. Soft, warm, yielding flesh is reassuring, sensual to touch and lie against, and just feels very, very sexy. When you remember the breast connection, it's not so difficult to see how fat frottage might very well be arousing and satisfying.

But what about the person being rubbed against? Do they find it arousing too? Sometimes yes, sometimes no. Some fat people, especially people who have a major erotic investment in their own fatness, can be aroused by having a partner rub against their rolls and folds. Some people are indifferent to it. Others may permit a partner to engage in fat frottage because while they themselves are not fond of it, they like being able to give their partner that particular sort of sexual pleasure.

Many fat people, however, find this type of frottage sex demeaning, humiliating, or even quite disgusting. The desire for fat frottage may seem fetishistic in nature, and sometimes it may in fact be so. It is not necessarily comfortable, flattering, or fun to be (or to feel as if you are) someone's fetish object. Moreover, fat frottage tends to be a fairly one-sided sexual act in terms of direct sexual pleasure.

Fat frottage also holds unfortunate echoes of the boorish "pick a fold and fuck it" attitude that is sometimes expressed about sex with a fat partner, as if it were truly impossible to tell the difference between a person's (especially a woman's) genitals and any other crease or fold of flesh. To metaphorically turn a fat person's body into one all-encompassing and permanently receptive sexual organ by regarding the folds

and creases of a fat body as just another type of orifice to be used for one's sexual gratification is an unpleasantly predatory and dehumanizing way to objectify another human being. It implies that fat people are (at least to the people who take the "pick a fold and fuck it" mentality) always passive, without sexual expression or needs of their own, and always receptive to being fucked – no matter how, when, or in what manner. This is a dehumanizing and fundamentally abusive way to view any person or group of people.

For all of these reasons and more, fat people often find the notion of fat frottage upsetting. Fat people, like everyone else, generally want to be loved and desired for more than just their physical attributes. There is a great deal of apprehension and complex emotion involved for many fat people if it becomes apparent that they are sexually desired for their fatness, even if fat frottage is not involved at all. It can be a powerful, confusing, and sometimes upsetting thing to be desired for a physical attribute which, for most people, has so many associations with of undesirability, ugliness, sexual and/or romantic rejection, and so forth.

The general public is also unlikely to understand or empathize with the desire for fat frottage sex for many of the same reasons that fat people have a hard time understanding it. Fatness is so often regarded as sexually unattractive that it is unthinkable to many people that anyone could be sexually aroused by a fat partner, much less enjoy a form of sex that involved a partner's rolls and folds. Furthermore, in our culture, having a non-genital sexual object is often seen as deviant and strange, and additionally, anyone who is greatly aroused by a body type or body part that is seen as "abnormal" will likely be viewed as "abnormal" themselves.

Fat frotteurs, however, aren't necessarily perverts, fetishists, or exploiters. Despite the way that fat frottage may be perceived, people who enjoy this form of frottage are not necessarily out to objectify, dehumanize, or in any way cause harm, embarrassment, or discomfort to their partners. Some people simply find fat frottage an arousing, sexy, sensuous type of sexual stimulation that they want to share with people they love. A predilection for a certain type of sex, even if it's not one that mainstream society sees as "normal," does not necessarily mean that someone is incapable of forming whole, rewarding, loving, healthy sexual and emotional relationships.

People who enjoy, or think they would like to try, frottage with fat partners are well advised to remember that their partners may not be willing even to experiment with this type of sex. Even broaching the topic

may well open up an enormous can of worms. Discussion is essential, and "no" should always be respected.

If you do practice fat frottage, remember that as with any sexual practice that is likely to make a partner feel particularly emotionally vulnerable, you need to take care to make sure your partner feels cared for and respected before, during, and after the sex act(s). The partner being rubbed against in frottage may find it more enjoyable if they are also directly sexually stimulated at the same time. Water-based lube is also helpful for frottage sex, since folds or creases anywhere on the body often have delicate and sensitive skin. Lube can be applied directly to the skin to help avoid any discomfort, tugging at the skin, or potential friction burns.

Breast Frottage or Tit Sex

Another variation on the frottage theme, much more culturally prevalent and acceptable to many people, is frottage, rubbing, or fucking between the breasts. Contrary to what many people think, women aren't the only ones with fuckable breasts. Many fat men have fairly large breasts too, since fat deposition in the breasts is not limited to women. A great many gay male chubby chasers enjoy their partners' breasts, and may engage in male-male breast frottage if the breasts are large enough to do it comfortably.

However, the archetypal form of between-the-breasts frottage is heterosexual, with the woman's ample breasts sandwiching the man's penis. While this is obviously possible with any woman whose breasts are large enough to do it comfortably, fatter women often have larger breasts than thinner women, and thus this also has ramifications specifically for fat people's sexuality.

As with rubbing between a partner's thighs or against/between any other pleasingly plump bits of flesh, it is the firm yet yielding, soft yet resilient texture of the fat beneath the skin that creates a pleasurable tightness and pressure around the penis. While her partner's penis is between her breasts, a woman may also suck or lick the head of the penis when it pokes out toward her chin, but the friction provided by the breasts themselves is the primary source of stimulation.

Some women feel as negatively about having a man fuck between their breasts as they might about having him do the same to any other fleshy fold or valley, but some women enjoy and welcome this kind of

frottage. As with any other sexual activity, it's always respectful to ask a partner whether or not it is acceptable to them before you go ahead and do it, and as with any other sexual activity, it's always respectful (and far more mature) not to wheedle, whine, or pester if they give you an unequivocal "no" as an answer. Some people just don't enjoy it.

When you are straddling a partner's chest, remember that they'll be more comfortable if you don't put your full weight on their diaphragm or solar plexus. Keep the bulk of your weight on your knees, or try lying on your sides if your partner finds it uncomfortable to be straddled. Another possible position for titfucking is for the partner whose penis is being stimulated to lie on his back with the other partner lying between his spread legs, breasts surrounding the penis. Either partner can use their hands to hold the breasts in the desired position and at the desired degree of pressure around the penis.

The Truth About Crushing, Suffocation, and Smothering

We've all heard the snide jokes and remarks along the lines of "sleeping with so-and-so would be like getting run over by a steamroller" or stories about some "man who slept with a really fat woman and was found crushed to death the next morning by the police." Urban legends, myths, and old wives' tales abound wherever you find something that is perceived as being out of the mainstream, and fatness is just one of the many human variations that is routine grist for the rumor mill. The truth of the matter is that sex with a fat person won't crush you, suffocate you, or smother you any more than eating watermelon seeds will make watermelons grow inside your stomach.

Suffocation, crushing, and smothering fears are all engendered by the awareness of physical difference, and by the awareness that a bigger, heavier person is indeed more of a physical threat than a smaller, lighter person would be. Some people suggest that a fear of being smothered or suffocated by a sexual partner is related to the fear of being consumed or destroyed by the mythical toothed vagina, or *vagina dentata*, essentially a fear of the power of female sexuality. Other people link the fear of crushing or smothering to the child's experience of the all-powerful, encompassing mother, whose body is so much bigger than the infant's as to be terrifying. No matter how you psychoanalyze people's fears of smothering, crushing, or suffocation by fat partners, actual crushing, smothering, and suffocation are equally unlikely things to actually have take place.

It seems odd that no one thinks twice about the guy on the bottom in some of the double penetration scenes in porn flicks, where there are two people lying on top of him and the one on top is adding to the pressure by banging away, but they'll automatically assume that having one even moderately fat person on top during sex will flatten a thin partner like a steamroller. Likewise, no one bats an eyelash at the thought of a 280-pound football player having sex with a tiny hundred-pound cheerleader type, but somehow people are capable of believing that a 280 pound woman could somehow manage to crush a male partner (of whatever size/weight) inadvertently during sex and not even know it. This is patently ludicrous. First, it's just not all that probable that a fat person will do any damage to a sexual partner unless, God forbid, they are actually trying to do them harm. Second, fat people are just as capable as anyone else of moving out of the way if a partner expresses distress or displeasure (and their partners are just as capable of doing their best to signal their distress and to move out of harm's way if the need arises). Lastly, fat people are fat, not insensate. Skin is sensitive to pressure and touch whether it covers bone, muscle, or fat. Human beings do not simply sit on or roll over on top of large objects – especially something as large as another human being – and not notice.

Yes, fat people weigh more than thin people, and yes, this means that having a fat person on top of you during sex will produce more intense and encompassing sensations of pressure than having a thin person on top of you during sex. Depending on your individual tolerance for pressure and the way in which that pressure is put on your body, you might find the sensation of another person's weight on your body to be anything from erotic to reassuring, comfortable to possibly painful.

This has more to do with how and where pressure or weight is put on the body than on how much pressure or weight there is. If someone knees you in the nose or in the crotch, elbows you in the ribs, or accidentally gouges their chin into your belly, it hardly matters whether that person weighs 150 pounds or 350 pounds: it's going to hurt. Swift hard pressure exerted with a single body part generally does. Think of the difference between dropping a brick on your toe and laying that same brick gently over the entire surface of the top of your foot.

Likewise, concentrated weight that is allowed to impact a small area of someone's body will also cause discomfort, pain, and possibly injury. Caution should be taken when concentrating one's full body weight on

any specific part of another person's body, regardless of your weight or theirs. Specific areas to avoid subjecting to concentrated weight or pressure are the belly and abdomen, the diaphragm region or solar plexus (located at the bottom of the ribcage), the kidneys, the throat and neck, the pelvic region, the face and throat, and the genitals. These areas of the body are not protected by bone and are particularly vulnerable to pressure-related injury.

Generally speaking, however, you'd have to go out of your way to put your entire body weight on another person's body. In most of the positions in which people fear putting too much weight on their partners, they are in reality supporting most of the weight themselves. For example, many people worry that if they straddle a partner's hips, they'll be putting too much weight on their partner's pelvis or belly. In fact, they are supporting the lion's share of their weight on their knees and shins, and if they lean forward and support themselves on their hands as well, they are likely to be putting only a small fraction of their body weight on their partners. Furthermore, what body weight they do put on their partners in that position will be spread over a large part of their partner's body.

Lying on top of a partner in the missionary position, for instance, might effectively immobilize them. This could be either pleasurable or somewhat uncomfortable depending on their tolerance for that sensation, but unless you were to prop yourself up on their chest on your elbows, you'd be highly unlikely to actually hurt them. The human body is a pretty sturdy thing, and when someone lies on top of you or straddles you, the weight generally gets distributed pretty comfortably, especially if the person on the bottom relaxes and lets their body adjust to it. At worst, it might feel like a heavy blanket or perhaps one of those lead-filled aprons they sometimes give you when you're having an X-ray. Many people find the sensation of having another person's body weight on them quite reassuring, if not downright erotic.

When you put your body weight on your partner, always solicit feedback and listen to what your partner has to say. Communication is key. The person on the bottom should tell the person on top how they're doing(and the person on top should listen. Likewise, the person on top should feel free to let their partner know if they're feeling uneasy or need to stop. It can be a little scary to let a lover take your body weight, no matter how much or how little you weigh, but if your lover is enjoy-

ing it and says so, it's okay to go ahead and do it. Relaxation is important, particularly for the person on the bottom. Sometimes, muscle tension or other factors may make taking a partner's weight uncomfortable even for people who normally enjoy it. If it's not working, don't worry about it. Tomorrow is another day. Switch positions and try something else.

If you're going to be putting weight on a partner and you're worried about your balance, find something to hang on to, like the wall or headboard, or just lean forward and support yourself on your hands as well as your knees. Settling into place gently and evenly means no one gets hurt, whereas kneeing your lover in the nose or crotch is a good way to do damage whether you weigh 120 pounds or 250. Lying half on top of and halfway alongside of a partner is a good compromise measure if you're not sure you're ready to let a partner take your full body weight.

As a person of size, you can safely straddle, lie on top of, lean against, and thrust against or into your partners without harming them in the slightest. Pay attention to where your weight is going, be aware of how much of your weight you are supporting yourself, and you should have no problems whatsoever. In the event that a partner is very sensitive to pressure and finds it unpleasant (or if they have medical conditions that preclude your putting weight on them), there are always alternatives.

However, some people actually have strong sexual desires to be crushed, smothered, suffocated, or trampled, particularly by fat partners. Ironically, this is one of the best illustrations that can be provided of just how unlikely it is for a fat person to cause physical damage to a sexual partner. For people with trampling, crushing, suffocation, and smothering fetishes, videos and magazines are available which show very large women (up to 600 pounds in some cases) doing all of these things to willing and usually male "victims." Several women, including the 300-pound, six-foot-plus Queen Adrena, have made a handsome living as dominatrixes who specialize in smothering, trampling, face-sitting, and other heavy pressure techniques. The market for this, while admittedly not as large as the market for run-of-the-mill heterosexual porn videos, is still big enough to make it profitable.

For people of size, the clear lesson of videos like "Women In Black – 1,050 Pound Trample Attack," in which a single man of average build gets quite seriously squished by a full 1050 pounds of feminine pulchri-

tude (and loves every minute of it) is this: you'd have to try pretty hard to actually crush, smother, or suffocate someone. Likewise, if you happen to be the partner of a person of size, the odds are vanishingly small that he or she will accidentally injure you, so there's no reason to avoid any sexual position which you both find arousing, enticing, and physically feasible given your body topologies, comfort level, and any physiological limitations you may have.

Bigger BDSM

BDSM is not a single sexual practice but an entire universe of sexuality and sexual practices that all share the fundamental principle of erotic power difference or erotic power exchange. A portmanteau acronym, "BDSM" is an acronymphomaniac's delight that elides the abbreviations for three different flavors of sexual practice into one catch-all that covers everything from a light spanking to latex-encased breath-deprivation scenes: B/D stands for bondage and discipline, D/s for Dominance and submission, and S/M for sadism and masochism. It isn't in the scope of this book to provide a detailed discussion of BDSM sexuality. If you are interested in finding out more about BDSM, and particularly if you want or need an "entry level" text, please consult the Resource Guide, which lists several suitable books. The discussion that follows deals with size and weight issues as they pertain to BDSM, written primarily for those who are already moderately familiar with BDSM practices, techniques, and terminology.

Safe, Sane, and Consensual

"Safe, sane, and consensual" are the watchwords of BDSM sexuality, and for good reason. BDSM sexuality often deals in volatile and sometimes potentially hurtful or dangerous activities which may include the use of pain, humiliation, bondage, servitude, or other types of interactions or stimulation that would be undesirable in other contexts. Responsible BDSM practitioners, whether they are dominant or submissive, engage in BDSM play that is:
- physically and emotionally safe
- psychologically and emotionally sane
- consensual and agreed-to between all parties

What this means in practical terms is that people who engage in BDSM sexuality talk as peers – often at great length, and always prior to engaging in any BDSM activity – about desires, needs, limitations, what they want from a particular scenario or relationship, what roles they are willing to take, what actions they are willing to perform, what kinds of stimulation (physical or mental) they enjoy, and so forth. This helps to ensure the safety and enjoyment of everyone involved.

Part of safe, sane, consensual BDSM play for people of size is making sure that all participants have an understanding of what special techniques, allowances, and methods may be necessary to adapt particular BDSM practices so that they can be done safely at their size and weight with everyone's pleasure and enjoyment in mind. It can be difficult or embarrassing to ask that concessions be made for you because of your weight or size, but it is part of every BDSM player's responsibility to let their partner(s) know about factors which could possibly make play emotionally or physically unsafe.

Sexual, physiological, and psychological limits are all pertinent to BDSM play. Fat-related limits go well beyond the kinds of physical limits we normally associate with weight – say, making sure that an attachment point for bondage is sufficiently well-anchored to a sufficiently sturdy structure to withstand a greater amount of tension or torque – but may also include limits about what it's okay to say, parts of the body that are okay to touch or handle (and how), roles that you are comfortable assuming, and so forth.

> *"I'm a submissive and I tend to like verbal humiliation. I like being called a slut, a whore, a tramp, a sleaze, a cunt, whatever. I like being told just how much of a slut I'm being while my top works me over with a flogger, which always gets me really hot. But I can't take it if someone puts the word 'fat' in there. 'Fat slut' or 'fat whore' just makes me shut down, I don't know. It's really upsetting to me to have anyone use words like fat, pig, cow, or things like that when I'm in sub space even though they could call me a skanky cum-whore and I'd love it. My top now knows what is okay and what isn't. There are just some things I can't take, and I learned the hard way." – Ashe*

People of all sizes can have issues and limitations in BDSM which may stem from past trauma, injury, disabilities, bad experiences, or body

image/acceptance issues. This is as true for tops (dominant partners) as it is for bottoms (submissive partners). A savvy bottom keeps tabs on their top's preferences and predilections and informs the top of their own, just as a good top remembers and respects the bottom's limitations.

Limits Around Fat-Related Issues: Tips for Tops

Danger Zones in Verbal Humiliation: Make sure you know what words and phrases are safe to use. Ask whether specific words and phrases are okay, particularly words like "fat," "obese," "cow," "pig," "elephant," "whale," "fatty," "fatso," and other terms that are often used as insults toward fat people. Some people get off on humiliation that hits as close to home as these words can, but not everyone does.

A lot of fat people are accustomed, insofar as one ever really becomes accustomed to such things, to being verbally humiliated in their daily lives. For this reason, it may be difficult for a bottom to say that they don't want fat-derogatory terms and words used toward them in a BDSM context – they simply may not imagine that it would be possible to opt out of being called these things. If you are in any doubt about whether or not verbal humiliation involving fat-negative words is okay, err on the side of caution and steer clear of them.

Danger Zones in Physical Play: Like some incest and rape survivors, people of size may have physical "danger zones" where specific kinds of touch or sensation (or any touch or sensation at all) are extremely unpleasant and frightening. Tops should recognize that a sensation or touch that may seem innocuous or erotic to them can be terrifying or humiliating in a bad way to a bottom who has severe body-image or self-acceptance issues. If there are specific things you would like to do to your bottom physically that you think could possibly be problematic, ask. You may want to demonstrate how you might touch them, or show them what some of the things you might do may feel like, so that they can have an accurate basis from which to make their decisions about what they think will be okay for them.

Generally speaking, it's good to ask whether it is okay to touch the fatter parts of a bottom's body, and how it is okay to touch and/or manipulate those body parts. It may be okay to do skin sensation play on a person's stomach or abdomen with ice or fingernail scratching, for instance, but placing restraints or ropes around or across it or "jiggling"

their fat with your hands might elicit very much the wrong sort of reaction. When in doubt, use a "green/yellow/red" safeword system so that your bottom can signal you when you're getting close to an uncomfortable boundary.

Know When Not To Push Boundaries: There's a time and a place for everything. Some boundaries are okay to push, and some are not. Generally speaking, it is not okay to push people's boundaries when you run a risk of causing real emotional, physical, or psychic damage. If a bottom has stated a limit that has to do with their fatness, size, weight, or related body and self-image issues, a good top should respect how significant these issues can be by not trying to push. There are plenty of limits you can push that will be a lot more pleasurable for all concerned.

Nonconsensual emotional or physical sadism is not BDSM; it's abuse. If you find that you can't respect bottoms of size as human beings because of their fatness, you have no business topping them. If you think you may not be able to respect anyone's limits for any reason, the wise solution is to opt out of the scene.

BDSM is Not a Diet Aid: Regardless of your size or your bottom's size, resist any temptations you might have to try to make BDSM into an exercise in weight loss or a way to convince someone to lose weight. Dieting might be masochistic, but it isn't BDSM; BDSM isn't a weight loss technique, it's a form of sexual expression.

Some submissives of size have reported having tops use weight either as a form of leverage ("I'll scene with you/buy you a new collar/take you to the BDSM club/whatever once you lose weight") or as an excuse for intrusive, inappropriate behavior. One submissive woman reports that a top she met at a play party offered to "help her lose weight" by engaging her in a full-time power exchange relationship in which he would force her to exercise and keep her on a diet consisting solely of water and his semen. It hardly needs to be said that this sort of thing is inappropriate, tactless, a violation of personal boundaries, and is in exceptionally poor taste besides.

It can be easy for some dominants to assume that they have the right to pass personal judgements in regard to submissives. A person's weight is their own business, as is the decision whether or not to lose or gain. Besides which, you're a top, not Richard Simmons. Don't you have

better things to be doing with a willing bottom than haranguing them about their weight?

Limits Around Fat-Related Issues: Tips for Bottoms

Find the Strength in Your Vulnerability: Remember that you do not make yourself invulnerable to abuse by refusing to admit that you can be hurt. You're better off taking the vulnerable-feeling step of talking openly with your top about your fat-related limitations than you are being caught off-guard when one of your boundaries gets crossed during a scene. It can be difficult to admit that there are touches, sensations, and comments you just can't take – it can be hard even to say the words. It may feel like you're admitting a shortcoming. But tops are tops, not mindreaders, and they can only operate on the information you give them. Good bottoms don't make their tops guess about limits any more than absolutely necessary.

Ask For and Use Appropriate Safewords: You should always use a safeword when you play. Particularly if you are interested in playing with things which are new to you or which are particularly volatile, it's wise to request and use safewords on the "green/yellow/red" scheme. The "green" safeword means "go ahead, keep doing what you're doing," the "yellow" means "be careful, slow down, you're getting close to a limit," and the "red" one means "stop everything immediately." Don't be afraid to use your safewords. That's what they're there for.

Take A Self-Inventory: It's a useful exercise to go through as many possible scenarios in your head as you possibly can, and evaluate how you think you might feel about having various things done or said to you in a scene. Pick a part of your body – say your stomach, butt, or thighs – and try to imagine all of the various things that a top might do with those body parts: skin sensation play, spanking, flogging, caning, using clips or clamps, fondling you, jiggling or kneading, binding, rope winding or tight rope bondage, and so on. What seems most exciting and appealing? What seems least exciting? Are there any things that you think would probably be unpleasant? These are things to keep on your list of limits, and things to tell your top about when you play. If you're not sure about something, that's okay too. At least your top will have a better idea where the gray areas lie.

You Don't Have to Compensate For Being Fat: Many people who are fat have a lot of problems believing that they are desirable, lovable, and worthy of attention from other people. Often, people who feel this way about themselves subsume their own boundaries for the sake of pleasing a partner. This can happen in and out of BDSM contexts, whenever people feel they have to compensate for their size by giving a partner whatever he or she wants or feel that they shouldn't express (or aren't really entitled to have) preferences, desires, or limits of their own. A submissive of size may fear that they are not attractive enough to hold a top's interest if they also insist on maintaining limits. This can all be compounded by the pressure submissives sometimes feel to prove how much they can/will take for a top, or competitive pressure to be more submissive than other bottoms in the scene.

This is not only dangerous psychologically, but can potentially be dangerous physically as well. In the best of all possible worlds, all tops would always have their bottoms' best interests at heart, and would take care not to push their bottoms in ways that might be hurtful even if the bottom didn't specify limits of their own. But in the real world, unfortunately, there are always predatory jerks around who will take advantage of anyone who seems like an easy mark. If you can't claim your own limits, you're going to have a much harder time protecting yourself when you need to. Yes, it's good to trust your top... but only when the top has earned your trust. You also have to remember to trust yourself, and remember that your best line of defense against being treated poorly is to know where your limits lie and to insist on having them respected.

It is okay to have limits. Most healthy people do. It is okay to insist on your limits. It is okay to safeword. No one should be allowed to make you feel inferior because you are protecting yourself and keeping yourself sane, happy and healthy by establishing your own limits... not even you.

BONDAGE FOR BIGGER BODIES

Bondage is rarely made significantly more difficult or dangerous by a bottom's size. There can be difficulties in finding suitable bondage equipment that is sturdy enough or large enough to be suitable for a larger person (See "Equipment") but the actual act of bondage is not usually all that different with bigger partners.

When engaging in bondage with big partners, all of the usual caveats apply: don't make bonds too tight, don't tie up a bottom in such a way as to put hazardous strain on their joints (knees are particularly vulnerable with bigger people), and don't tie people to things that are unlikely to be able to take the weight or strain. When you are binding, strapping, or tying a part of your sub's body that is well-padded with fat, you should be binding them securely but not too tightly. Don't be afraid to compress the fat areas somewhat, but crushing any part of the body (fat or thin) too hard will produce discomfort and bruising. Some bigger bottoms are not comfortable with having bondage straps or ropes cut into the fatter parts of their bodies at all, but some enjoy the sensation of having their bellies, butts, thighs, etc., compressed or tightly bound. It can be exciting and effective to begin with the bondage fairly loose, then gradually tighten as you go, so that the tightness of the bondage becomes a part of sensation play

It's worth noting that rope bondage, and particularly Japanese rope bondage techniques, can be very effective on bigger bottoms. Because rope is so flexible, infinitely adjustable, and available in lengths quite sufficient to circumnavigate bigger bodies, it can be a satisfying alternative to having leather gear custom-made.

When you are binding a bottom to an anchor point or anchoring structure, whether it be furniture, bondage furniture, a wall, or whatever, bear in mind that the amount of stress, torque, or tension a bottom puts on a piece of equipment or an anchor point has as much to do with how much they move around and/or struggle as it does with their weight or size. A very large bottom who is fairly passive while bound may not require bonds as extensive or anchors of the same sturdiness as a very small bottom who likes to fight. Regardless of whether a bottom is passive or a struggler, care should be taken to make sure that bondage feels and is secure for them at whatever size or weight they may be. Eyebolts should be sunk deep into surfaces where they're not likely to give. If a bottom is tied down to a piece of furniture, make sure it is substantial enough to support them easily without wobbling or breaking – and yes, it is possible to break bed frames, given the right combination of torque on the legs, weight, and angle of pressure. Bondage furniture, like benches, chairs, racks, cages, pillories, and so forth, should be built fairly heavily in the first place to bear the strain of being used for bondage, but it would not

be inappropriate to reinforce bondage furniture with metal braces if it has become wobbly or you have any suspicion that it might not hold up.

The issue of adequate support is particularly important with regard to suspension bondage. Suspended slings, cages, spreader bars, and so forth need to be suspended from beams or structures that will hold a good deal more weight than you ever intend to put on them: the force and torque exerted on an anchor or mounting by a suspended fixture (even when there's no other weight on it at all) can be dramatic! For the same reason, if you use motorized winches or hoists for suspension, make sure that they are rated to weights well above that of anyone you might ever need to lift.

It is generally a bad idea to attempt suspension bondage on a person of size using either two-point (wrists or ankles) or four-point suspension (wrists plus ankles). It's not always a great idea to do this with thinner people either, as joints are delicate and it's easy to hyperextend and/or dislocate them when the entire weight of the body is hanging from the arms and/or legs. The best way to suspend a bigger partner is to either use a sling or use five-point (or more) suspension to suspend them by wrists, ankles, and at least one attachment point on a heavy-duty body harness that supports the midsection.

The safety you gain by following these principles, and the bottom's sense of security at feeling that they are bound sturdily enough that they can relax into the bondage rather than having to be tense about whether or not their bonds will really hold them, are both priceless.

Other Forms of BDSM Play

As with bondage, most of the usual forms of impact and sensation play need no modification to be used on bigger bottoms. In fact, being big can be an asset for a submissive – there's that much more skin to feel with, and it makes a bigger "canvas" for the top to work with. Remember that the "padding" that fat provides doesn't lessen sensation in any way. The nerves responsible for making sensation play and impact play so thrilling are right there on the surface, so you don't need to hit or press harder or in any way play rougher with a fat submissive than you would with anyone else.

It's wise to bear in mind that fat bottoms may be at higher risk for certain conditions like diabetes, certain circulatory problems, and certain types of serious (potentially fatal) systemic infections like cellulitis.

Particularly if you participate in very tight bondage, blood sports, or con-
striction of various body parts with corsets or other devices, be extra-
careful to monitor yourself (or your submissive) closely for damage dur-
ing and after play. If there is any question of infection, whether due to a
surface wound, abrasion, skin puncture, internal bleeding, or even bruis-
ing (which is a form of internal bleeding), see a doctor immediately. Be
particularly aware of any part of the body that becomes painful and hot
to the touch – this can be a warning sign of cellulitis, a type of tissue
infection which can rapidly become so serious that it can cause the loss
of a limb or even death.

The BBW Domme Goddess Mystique

*"I have had NUMEROUS men approach me online that don't
really care what I look like. They're interested in my size, and
more often than not, are very submissive men looking for a
Domme. I am not into D/s and I find this a bit bizarre and
discouraging." – Sekhmet*

While Sekhmet is clearly none too thrilled by the intense interest
that many submissive heterosexual men have for BBW dommes, this is
one of the most prominent, and often most desirable, fat-related BDSM
archetypes. Big top women, and particularly big femme tops, hold a spe-
cial place in the hearts and imaginations of many switches and submis-
sives – particularly submissive heterosexual men.

The appeal of a big top is partly the implication of power that a
woman of size possesses, and also the maternal quality that a big, juicy
body often projects. With tall, strapping BBW dommes, there is also an
"Amazon" or warrior-goddess image that goes along with their height
and sizeable frames, a quality capitalized upon by 6'1", 300-pound former
professional wrestler and professional dominatrix Queen Adrena, who
has carved herself a profitable niche in the fetish video pornography
market.

Goddesses are often asked to be significantly more bodily in their
domination than are smaller domme women. Because of their size and
weight, they are ideally built for making certain punishments, such as
over-the-knee spankings, crushing or trampling, face-sitting, and breast
smothering into voluptuary, excessive delights. A big domme, more physi-
cally substantial than a thin dominatrix and often considerably stronger
as well, can really put some power behind the strokes she delivers, and

the simple fact of a large and domineering female physical presence is a powerful turn-on to many submissives.

BBW tops are additionally attractive for all the same reasons that dominant personalities tend to be attractive in general – a dominant streak, socially speaking, is often perceived as self-confidence, and many tops are indeed self-confident people. This, in combination with a bigger body, can really make an impact on people, particularly in a culture in which big or fat people are often expected to be shuffling and apologetic because of their weight. But big and confident and female does not necessarily equal a sexual dominant. Just as many confident men are submissives (or are altogether uninterested in BDSM) the same is true of confident women. Those seeking a domme (online or off) should bear that in mind and avoid being presumptuous or rude.

It should be noted that there are plus-sized professional dominatrices. Unfortunately, it isn't within the scope of this book to provide contact information for these women and their services. Check local or regional BDSM/sex-related publications such as newspapers, swingers' guides, and the Domination Directory International, an international index of professional BDSM practitioners. However, the best way to find a dominatrix whose size and style will suit you is often via word of mouth. This provides you with a chance to ask questions about style and other issues before contacting the Domme directly. You should be aware that dominatrix services are not inexpensive, and should additionally be aware that providers of some specialty services do charge extra for them. However, with a skilled dominatrix whose style matches your tastes, it can be worth every penny.

Crushing and Trampling, Face-Sitting, and Smothering

It's not impossible for thinner tops to do crushing, trampling, face-sitting, and smothering, but these four activities are qualitatively different when performed by big dommes. The reasons why are pretty obvious: a heavy top's size intensifies the sensations of these activities and additionally enhances the eroticism of taboos and fears about crushing and/or smothering.

There are those who see the desire for being crushed/trampled/smothered as part of a continuum with the same urges that produce a desire for forced infantilism. There can be a powerful sensation of being in a child-like position vis-a-vis a woman whose proportions are, to an adult, reminiscent of what the vast fecund hills and valleys of the mother's

body must have been like to them as infants or small children. It'd be a bit facile to assume that this were at the root of every submissive's desires, but it's not out of the realm of possibility. A safer assumption is that there are people, and particularly heterosexual men, who desire the feeling of having a larger woman's body weight on them in focused and specific ways that deliberately play upon danger and taboos specific to sex with fat women. These taboos are part of what makes this kind of play so exciting, and are also what can make this kind of play seem so bizarre to those who don't share the desire – a group of people which includes, not too surprisingly, many fat dommes.

When people think of the challenges of BDSM, or of limit-pushing, they usually think about these things as they pertain to submissives. In the case of crushing and smothering play, most people see the challenges from the bottom's perspective: a "normal" man, dwarfed by the woman he is with, forced to trust in her mercy as she crushes, tramples, or smothers him. This is admittedly no mere smack on the fanny. But the emotional and psychological challenge of crushing/smothering play is not one-sided. When a domme is asked to crush, trample, smother, or suffocate a bottom with her own body, she is forced to confront many potentially upsetting images and aspects of her own sexual self.

The notion of dominants being insecure about methods of domination seems a little incongruous. It's not the dominatrix image. But tops are only human, and as fat women, big dommes have the same sorts of emotional baggage other people have about weight and body size. Being sexually dominant doesn't magically make someone immune from the fear of inadvertently injuring a partner during sex. It's not unexpected to have these fears come to the fore when a woman is asked to do certain things, like sit on a partner's face, walk on them, or sit on their body, activities where it may seem almost inevitable that they will crush/suffocate/smother their partners.

Because, of course, that's precisely what happens. The crushing/suffocation/smothering is definitely desired by the bottom and the application of weight and/or smothering is done in a controlled fashion, but just the same, there you have it: a fat woman crushing and/or suffocating a sexual partner. The idea of doing these things, things that most fat women are desperate to avoid doing, can be daunting and perhaps even humiliating.

For women who are comfortable enough with their size to use their weight as a tool in sexual subjugation, however, it can be a thrill to get to throw your weight around a bit. As with other BDSM techniques, it's wise to follow some common-sense precautions.

First and foremost, always be sure that you can support some of your own weight. You should never end up putting your weight on a partner without the option of supporting at least some of it yourself. Also, bear in mind that while a great deal of force concentrated on a small surface area can easily cause damage, a great deal of force spread evenly over a large surface area is much more likely to be pleasurable. (Remember the difference between dropping a brick on your toe, as opposed to laying it across the top of your entire foot – this is the difference between putting your body weight on someone quickly and with a small part of your body, and putting your body weight on someone more slowly, and with a bigger body part or section of your body.)

Crushing can be done most easily by simply lying or sitting on partner who is in turn lying or sitting on a firm, supportive surface. The surface must be firm and resilient – no waterbeds!– so that you can easily lift yourself off of your partner, and so that you can more easily control your own motion and balance. If you're going to lie on your partner, first straddle them, then lean forward and support your weight on all fours. Gradually lower yourself on top of your partner's body. Once you're there, you can wriggle around a bit to provide additional sensation to your bottom. Lying down and sitting both distribute body weight over a fairly wide surface area, so it's not necessary to actually avoid any particular part of the body. However, some parts of the body take the weight more easily than others: the back, the bony part of the chest, the pelvis, and the legs are all generally safe.

For sitting and face-sitting, your submissive should lie on a surface that is both high enough and firm enough to permit you to sit down and get up easily. The edge of a bed with a firm mattress is a good choice, as is having your partner lie on a weightlifter's bench or something similar. If the bench is not wide enough for you grip the edge and lean on it while your submissive is lying on it, you should also arrange to have another means of support nearby so that you can support some of your weight with your arms when you need to. Chairs, kitchen stools, barstools, and step-ladders are all good choices.

For trampling, keep that chair, stool, or stepladder handy. You not only need a way to help support your weight, but to steady your footing. Human beings are notoriously uneven and squishy! Losing your balance could mean injuring your submissive or yourself, and explaining that you twisted your ankle falling off of a human doormat will get you some curious stares in the emergency room.

In trampling, there are very specific body parts to avoid. Standing on someone concentrates a lot of weight on a small surface area, so avoid the soft parts of your sub's body. Do not step on the stomach or abdomen below the ribs, on the pelvis or genitals, the face, throat, or kidneys. Good places to put your weight, for many people, are over the coccyx (tailbone) and butt, between the shoulderblades, on the sternum (breastbone), and on the thighs.

With face-sitting and breast-smothering, as long as you follow the principles given above (i.e., putting large amounts of weight or pressure over large surface area, gently, and supporting/being able to support part of your weight yourself at all times), you should have no problem physically. Face-sitting is usually done straddling the bottom's head, rather than sitting sidesaddle, since part of the point of face-sitting is that the bottom's face be completely engulfed by the top's butt, thighs, and/or vulva.

Any time you engage in play which restricts a bottom's ability to breathe, you have to be careful of how much you restrict their air and for how long. Monitor your submissive constantly during any suffocation or breath-restriction play. Some people are able to withstand a great deal more than others and still find it pleasurable. You should give your bottom a non-verbal way to safeword, since at least some of the time, their mouth will be blocked. You can give your bottom a small bell to hold, for instance, or a toy that will make a noticeable noise when dropped. Be aware that during breath-restriction play, people sometimes hit the panic threshold suddenly. Be prepared to move quickly and release bondage immediately. Just keep these common-sense precautions in mind, and you should be able to throw your weight around in the BDSM arena to great effect.

Equipment and Supplies

Most BDSM equipment aside from clothing items is genuinely "one size fits all." Floggers, crops, canes, paddles, nipple clamps, tawses, switches, flails, Wartenburg wheels, electrostimulation equipment, suc-

tion cups, cock and ball torture toys, and so forth can be used by pretty much anyone. Likewise, much bondage equipment works well for bodies of any size. Rope and chain come in lengths that are truly one size fits all. However, other types of bondage gear may not be quite so forgiving.

Some bondage gear, like blindfolds, hoods, gags, gag harnesses, and basic collars, are usually fairly easy to find in appropriate sizes. Wide, flexible, and well-padded wrist and ankle restraints (leather, rubber, or cloth) are the least likely to put harmful strain on delicate joints, and providing the option of handgrips as well as wrist cuffs is a good way to help bottoms of all sizes reduce the strain bondage can place on the wrists (look for cuff/handgrip combinations available as single units, which simplify this considerably). Stores that have a large male clientele are often good places to look for wrist and ankle restraints in longer lengths, as men tend to be built larger than women.

Body harnesses, chastity belts, posture collars, and restraint belts can be much more difficult to find in larger sizes. As with many bondage items, if you can't find what you want in the size or style that you need, it is often best and easiest simply to have something custom-made, make it yourself, or adapt a similar item that wasn't originally intended for BDSM use. BDSM players often find that necessity is the mother of invention, and there are quite a few books on the market which offer advice to the kinky do-it-yourselfer.

For body harnesses, bigger people should try looking through catalogs from industrial safety supply houses. Many of these sell body harnesses that can run to fairly large sizes. They tend to be made of heavy-duty nylon or other webbing rather than the classic black leather, but they still serve their purpose. Marine supply, camping and mountaineering stores, and rock climbing gear shops frequently carry similar body harnesses, although they may not come in as wide a size range as the ones made for construction workers and miners.

Many craftspersons who make BDSM-related equipment and clothing are willing to work with clients to produce furniture, bondage straps and restraints, corsets, collars, harnesses, and other clothing and equipment to measure. In general, if you find a manufacturer (particularly an individual craftsperson or a small shop) whose goods you particularly like, ask them whether they do custom work, and whether they are willing to work with larger clients. For fetishwear specifically, please see the Leather and Fetishwear section of the Resource Guide for names and

contact information for some vendors who carry leather and fetish clothing in larger size ranges.

FEEDERISM

Broadly defined, feederism can be characterized as being aroused by or deriving sexual gratification from eating, watching a partner eat, or feeding a partner. More specifically, a person who identifies as a "feeder" generally finds it arousing to watch a partner eating, and often also finds the "side effects" of eating, specifically weight gain, to be arousing as well. A person who identified as a "feedee" would, correspondingly, derive sexual satisfaction from eating, being fed, and/or gaining weight. People who are specifically interested in the weight-gain aspect of feederism sometimes refer to themselves as "encouragers" (for a person who enjoys other people's weight gain) or "gainers" (for people trying to gain weight themselves).

The archetypal feeder/feedee relationship is one in which one partner derives erotic satisfaction from feeding his or her partner, whether feeding by hand or simply providing food, with the goal of having the partner gain weight and become fatter. The weight gain may be large or small. Sometimes, after a gaining period, the feedee will then lose the weight by dieting before deliberately regaining it in a conceptually reversed form of yo-yo dieting where the gain, not the loss, of weight is the more desirable part of the cycle. More often, those who pursue the weight gain side of feederism pursue significant weight gain, either to a predetermined goal weight or simply until the feedee's metabolism refuses to permit him or her to gain any more weight. This point varies from individual to individual.

Some feeders (not all, and it's impossible to give any accurate statistics given the covert nature of the practice) want their feedees to become immobilized by their fat, so that they have to be worshipped and served, and are completely physically passive, always available for erotic contemplation and/or sexual activity. Other feeders have more worldly goals in mind, such as that their partner reach a world record or merely gain enough to join one of the exclusive groups in the weight-gain fetish world, such as the so-called "500 Club," whose members are composed of women who weigh 500 pounds or more.

It is to be presumed that in a wholly consensual feeder/feedee relationship, the weight-gaining partner would also derive sexual or erotic pleasure from being fed and from gaining weight. Since so little information is available on feeder/feedee relationships generally, and so little of what is there discusses the feeder/feedee relationship from the feedee point of view (almost all the written information available, most of which is on the Internet, seems to be from the feeder perspective), it is very difficult to say how often this is the case in real-life feeder/feedee relationships.

Because of the high social, personal, and professional liabilities that go along with being fat to any degree, and the even more fundamental liabilities to health and mobility associated with the kinds of extreme weight gain some feeders seek, feeder/feedee relationships are often extraordinarily risky. Not only is there the basic risk that all practitioners of kink share, that of being ostracized or shut out from one's family and community because one engages in non-mainstream sexual practices, but a feedee may also be isolated and made dangerously dependent because of becoming fatter.

The more extreme a feedee's fatness becomes, particularly as he or she gains enough to become physically less mobile or in fact immobilized, the higher the risk that he or she will lose social, professional, and personal contacts. Family members may decide that the person is "too far gone" or may simply be too repulsed by the feedee's fatness to be able to provide friendship or, in the event that things go bad in the relationship, support and aid. As a feedee becomes larger and larger, it may become harder and harder for him or her to hold down a job. In some cases, feedees have become virtual prisoners of their feeder partners, cut off from their social network, unable to find work (whether for social reasons of nonacceptance, because of physical difficulties, or both), and ended up in truly and negatively compromised positions, unable to leave if and when they might have desired to do so.

Other risks of feederism are physical and health-related. Extreme weight gain, particularly if the person isn't getting much or any exercise, can cause some serious problems. Muscle atrophy combined with weight gain is not a promising combination. Add that to the increased risk of problems like cellulitis (a type of deep tissue infection that can become fatal), Type II diabetes, pulmonary problems, and other ailments like bedsores, circulatory problems, or infections caused by difficulty in main-

taining adequate hygiene, and you have a fairly considerable potential for a feedee to suffer from compromised health. In some cases, due to complications from these and similar conditions, feedees have, in fact, died.

Long-term physical and emotional damage, disabling illness, social isolation, and/or death are simply not reasonable prices to pay for anybody's turn-on. Opponents of feederism often point to these health risks as their primary reasons for rejecting the practice, but there are many other issues that make this sort of feederism troublesome. The plain truth is that often, feeders have been quite predatory in finding (or "acquiring," since a part of much hard-core feederism is the objectification of the fat person as a fetish object) people who become their feedees.

It's no news to anyone that fat people, particularly fat women, are routinely oppressed in our society. It should also come as no surprise that one of the most prevalent and psychologically painful ways in which fat people are oppressed is by being told that they will never find love or have anyone be attracted to them because of our size or weight. The vast majority of research survey respondents for this book who identified themselves as fat reported having had parents or immediate family use the threat of romantic or sexual undesirability as a means to try to goad them into losing weight. When even parents tell their fat children that unless they become thinner, they will be doomed to a life of loneliness, rejection, and celibacy, it can be easy for fat people to become dangerously desperate to be accepted and wanted. When you consider this, and remember how those messages are reinforced daily in hundreds of ways throughout Western popular culture, it sheds some light on why a fat person might be so grateful to be accepted and loved by a partner that they might not think to question it when a partner who accepted their size encouraged them to gain more weight.

To be loved, to get or keep what one has been told one would never have or deserve to have since she or he was fat, a fat person might indeed be willing to gain weight. Being a feedee might well become acceptable to a vulnerable fat person, if the alternative seemed to be rejection or loneliness. It's well known that people (of all sizes) sometimes cling to unhealthy relationships in order not to lose a partner, especially if they have a poor self-image, think themselves unlovable, and despair of ever finding another relationship.

A fat person who has been taught all his or her life that he or she was disgusting and physically undesirable might even find a feeder's erotic interest so gratifying that he or she becomes a willing feedee simply in order to enjoy the unaccustomed, almost forbidden pleasure of having someone find him or her overtly sexy. The sad truth is that there are a lot of people – some very fat, some moderately fat, and some not really fat at all – who are emotional walking-wounded because of the severity of the psychological damage they've sustained about their desirability and worth in relation to their appearance. People whose self-confidence is so deeply damaged are easy prey for abusers and exploiters of many different stripes.

What this means in practical terms is that it is extremely difficult to determine meaningful consent on the part of the feedee in a feeder relationship. As the articulate underground fat porn star Teighlor states in an editorial on the subject, "Feederism is a practice that, more often than not, relies heavily on the feedee's emotional dependence on the feeder to gain their cooperation." Even if a feedee consents to gaining weight for a partner, the question remains whether that genuinely wishes to gain the weight for his or her own reasons (erotic or otherwise), or whether he or she is doing it in order to be accepted, to be loved, not to lose a lover, or because he or she has been bullied into doing it in a "prove your love" or "if you loved me you would" scenario. People are emotionally blackmailed into losing weight – sometimes to the point of developing full-blown bulimia or anorexia – by the same sorts of mechanisms. A feeder who proceeds to feed a partner or encourage him or her to gain weight without obtaining full and meaningful consent is engaging in fundamentally abusive behavior.

If you find the foregoing alarming, good. Feederism is so little-known, and the dynamics and potential risks of these relationships so well hidden, that a bit of reasonable alarm is fully justified. This is particularly true in light of the fact that, historically, many feeders have not been open and honest about their interests, have not identified themselves as feeders to their partners, or explained what feederism is and what it means to the very people they were engaging in feeder relationships. Hopefully, as the Internet offers and encourages more and more communication amongst feeders/feedees and the community at large, this will change to the point where everyone will know what feederism is, at least to the point of being able to have an informed opinion of its poten-

tials and risks. In the meantime, self-preservatory wariness is not an inappropriate reaction.

Given the dominant/submissive dynamics inherent in the feeder/feedee relationship, as well as the nontraditional, non-genital, fetishized focus of its eroticism, it seems logical to think of feeder/feedee relationships as a type of BDSM. In including feederism under the rubric of BDSM, the eroticism of the fetish – which is obviously very powerful to those who feel it – can be recognized while also acknowledging that it is a non-mainstream sexual practice which includes both an implicit dominant/submissive dynamic as well as some potentially harmful risks. By bringing feederism out of the closet and into the broader world of kink, more and more people will be aware both of feederism's existence and its potential pitfalls.

Many feeders dislike this idea, feeling that calling feeding part of BDSM implies a type of sexuality – prototypical "leather" or "bondage-oriented" sexuality – that they don't feel they practice. However, it would seem that only people who practice feederism in a less-than-upfront manner, capitalizing on the fact that most potential feedees will be ignorant of the practice and what it may mean to them, have anything to lose by acknowledging feederism's dominant/submissive dynamics. Feeders who maintain their relationships in a totally consensual and honest way, who don't and never have resorted to using emotional dependency to engineer their sexual satisfaction, don't stand to lose out if their partners are well-informed since they would've informed their partners anyhow.

There are some people who use the BDSM dynamic as a way of creating agreed-upon, mutually desired weight gain. There are also people who use it as a way of creating mutually-desired, negotiated weight loss. In some lifestyle BDSM relationships, the partners use their roles to help one another achieve goals they both desire, whether the goal is to stop smoking, to use money more responsibly, to gain or lose weight, or any number of other things. The two main features of the BDSM context that help keeps this kind of lifestyle modification from becoming coercive are first that the partner is loved and desired regardless of whether or not the change is successful, so that there is no emotional blackmail tied to weight gain or weight loss, and second, that both partners fully understand and consent to what they are doing.

It's patently impossible for anyone to give meaningful consent in ignorance of the facts. This is true of any sexual relationship, but is even

more important in any relationship in which the type of sexuality in which partners engage has a real potential for causing serious and long-term damage. Simply put, just as it's ethically indefensible to force sex on someone who doesn't want it or who is unable to resist it (for reasons of youth, disability, etc.), it is ethically indefensible to push anybody to engage in any potentially harmful sexual practice (even as one as non-genitally focused and thus as seemingly nonsexual to many as encouraging weight gain) without securing explicit awareness and consent.

Given the fact that being even moderately fat exposes one to so much institutionalized prejudice and so many individual attacks, to induce a person to become fatter when it isn't their idea to do so is a truly abusive thing to do. Doing so to a person who is fat to begin with and who therefore is fairly likely to have a damaged sexual self-esteem (and thus be more likely to agree to suggestions in order to be accepted, desired, or loved) is predatory, exploitative and morally and ethically indefensible. It's tempting but foolish to assume that anyone with whom one becomes romantically involved automatically always has one's best interests at heart. In the pursuit of relationships as with so many other potentially risky situations, *caveat emptor*.

This is by no means to say that all feeders behave this way. Many, perhaps most of them, do not. Also, just as not all fat people are (or should be) feedees, not all Fat Admirers are feeders. Feeders are generally also Fat Admirers, but the converse is not true – a point which is well-understood by the feeder subculture, as is the fact that most people who are already fat are not interested in becoming fatter:

> "The Gainer/Encourager group is more intense, more focused on fat and gaining weight rather than the person as a whole. The FAs and Chubs/Chasers seem to be more into acceptance and it seems to be a light preference rather than a fetish type thing. I seriously doubt that many Chubs or BBWs would be interested in becoming even bigger." – from a gainer/encourager website

It must also be said that not all feeders are out to push their partners to gain weight. Many feeders realize that their weight-gain fantasies were probably best left in the realm of fantasy for their partners' sake, but they still really enjoy the sensuality and eroticism of being with fat partners, eating with them, and watching them eat. On his website, one self-identified weight-gain/feeder fetishist writes:

"My woman will always have control of her body. I would never force her to do anything. If she wants to lose some weight, so be it. The idea of her getting softer doesn't imply that she has to gain 100+ pounds. However, it would be cool to watch her get too big for some of her clothes—and like it! I'd love to see her flaunt it, and enjoy watching my reaction.

"Am I looking to start such a relationship with a woman who is already supersized? No. Am I out to fatten up a presently skinny woman? No. It's just a fantasy. Would I object if it actually happened? No. [You can't see it, but I have a silly smile on my face at this point.]

"Since the process of intentionally eating to become fat is a purely fantastical pleasure, my woman wouldn't have to gorge herself until she was near bursting. All she'd have to do is enjoy a large dessert, taunting and teasing me while she enjoys every bite. All she'd have to do is eat several bites very sensuously, saying 'Mmmm, honey, I'm getting fatter because of all this luscious dessert. Do you want me to get fatter? I do, so I'm eating all of this. Then I'm going to want some more. Every bite is going right to my thighs. I want the next plateful to go my ass. Ooo, I can feel my boobs getting fuller. Want to get me another piece of dessert, honey?' I'd be putty in her hands if she did that..."

As is the case with most interpersonal relationships, the degree to which feederism is pursued ethically and humanely is dependent upon the individual. Just as there are bad tops and unpleasant bottoms to be found in any local BDSM scene, there are more and less ethical practitioners of feederism. Only being aware of the potential for harm offers any meaningful protection from its risks – or the ability to partake sanely and sensibly of any form of sexuality which you find appealing.

Neither food, eating, sex, or the combination of the three is problematic in and of itself. Eating can be tremendously sensual, and well it should be: food tastes and feels good as well as being nourishing. If it weren't, eating wouldn't play such an important role in our cultural, social, sensual, and sexual lives. The everyday eroticism of food is routinely made explicit in movies like *Tampopo*, *Like Water For Chocolate*, and even the most mainstream of Hollywood comedies like *Austin Powers: International Man of Mystery*. Playing with food during sex, or eroticizing food and/or eating, can be scintillating and satisfying parts of re-

spectful, healthy, hot sex play. Eating can be very erotic all by itself, and this brings up an intriguing and ironic fact: while there are many feeders who would love to have feedees, there are also people who get aroused by eating who have no interest in being in a feeder/feedee relationship. Feedees can be feedees without the presence of a feeder, but without a feedee, a feeder's ability to express those desires is very limited.

> *"I wouldn't say that I'm a feedee exactly, but I do have some feedee tendencies. I have no interest in gaining weight in the real world. I do find it to be a powerful fantasy. I enjoy eating beyond the point of satiation, and find it sexually arousing, but do not do so for the purpose of gaining weight. I do sometimes gain some weight as a result of this activity, but I consider it to be more of a side effect than a goal." – Sophie*

This points up the fact that the problem with feederism isn't food. It isn't food, or sex, or the eroticism of food or eating, or even fatness or weight gain. The problem with feederism is control and power, and the need for sexual desire to be handled honestly, ethically, and humanely. It's silly to argue that feeder/feedee relationships cannot possibly be consensual, a stance sometimes taken by anti-feederism zealots. Experience and research prove that no matter what your turn-on, there's likely to be someone somewhere who shares it who agrees. However, in order for feederism to be truly consensual, both partners need to be informed and aware of the problems that this form of sexuality may cause.

FAT AS FETISH

The exact definition of a sexual fetish is open to debate. While a psychologist might use the term "fetishism" to mean something along the lines of "a condition in which a particular object or body part must be present in order for an individual to obtain sexual satisfaction," most people use it far more loosely, to mean that someone has a notably strong sexual preference for a particular body part, object, substance or image. Often, "fetish" carries with it overtones of "pervert" or "deviant," which, while not necessarily true, underscores the fact that the fetishist's degree of interest in his or her object of choice is perceptibly more intense than a non-fetishist's, and furthermore that the specific object of desire is not generally one of the "conventional" ones. Commonly fetishized

things include feet and shoes, particular garments like underpants or corsets, leather, and rubber or latex.

There's some debate as to whether or not body parts can be truly considered fetish objects, since they are parts of human sexual partners. In the colloquial sense at least, though, they can. People can fetishize all manner of body parts, from feet to a bald head, and fat is one more thing that can become an object of extremely focused sexual interest. For some people, fat is a turn-on in any degree, while for others, the guiding principle seems to be "the more, the merrier." Some people like fat bellies, others fat butts or thighs, enormous breasts, or may be very attracted to fat deposits in other places, such as the upper arms, back, or hips. The degree of fatness which is considered attractive, and the degree to which it is considered desirable – from a mild preference to a desire so strong that a person can't achieve sexual arousal with a thin partner – varies with the individual.

A fetish, *per se,* does not necessarily compromise or damage a person's ability to have good relationships and a varied and interesting sexual life. However, some people can indeed get so caught up in their fetish interests that they end up not handling their relationships well. People with very strong fetishes (and, it must be said, not a lot of emotional maturity) may be prone to use people as nothing more than sexual objects, without caring much for them as human beings. This can happen not just in the case of fat fetishists and fat people, but with other sorts of fetishes (and the people whose bodies are the fetish objects) as well. Understandably, this sort of sexual objectification and even commodification is uncomfortable and upsetting to the people who find themselves on the receiving end. Should you suspect that you are being treated primarily or exclusively as a fetish object by a partner, or discover that this is the case, and you are uncomfortable with it, you have every right to leave the relationship.

Not all people who are interested in fatter partners are fetishists. Most are not. Because fat is generally viewed as unacceptable and unattractive, anyone who is even mildly attracted to it is more likely to be labeled with the "fetishist" (in the sense of "deviant") stamp than someone with, for instance, a pronounced attraction to flat-chested women. This is neither necessarily accurate nor fair. Just as some people have a preference for redheads and some a passion for celebrity lookalikes, some people take great joy in fatter, rounder, and/or heavier partners without

it being a fixation, a pathological obsession, or a sign that anything at all is wrong with them.

Fat people who are uncomfortable with their own bodies also sometimes wrongly assume that anyone who is interested in them for their bodies must perforce be a fat fetishist. Because people of size are generally taught that their bodies are ugly and undesirable to just about everyone, they may feel that anyone who pays any attention to their fat, or to the fat parts of their bodies, is fetishizing their fat. This perception, in most cases, is nothing more than hypersensitivity at work, because the simple truth is that most of the people who are interested in fatter partners are in no ways fat fetishists. But in the same way that a tiny pimple on your nose seems like it's the size of Mount Rainier when you have a date, someone paying attention to or touching a fat area of your body is going to seem like a big deal if you're hyper-aware and worried about whether they're going to be disgusted by your body and your fat. Because of this kind of hypersensitivity, fat-admiring partners' physical attentions can be misperceived. As people learn to accept their bodies, they generally learn to better accept other people's attention to their bodies, and it's less likely that run-of-the-mill sexual interest will be misinterpreted as fetishistic and can be enjoyed for what it is.

SIZE AND SEXUAL PLEASURE

Almost everyone, no matter what size they are, wonders at some point or another if they're really getting as much pleasure out of sex as they're "supposed to." After all, not very many of us actually get the chance to see other people having sex outside of (possibly) porn movies, and it can be hard to know what is really a reasonable level of expectation in regard to sex. By the time we're sexually active, most of us have developed an idea of what is "supposed to" happen when we have sex. We pick this up from a variety of places – stories, romance novels, newspaper articles, movies, television shows, locker-room (or ladies' room) discussions, sex ed classes in school, and so on. But the information we acquire that way isn't always the best information, and doesn't always reflect either our sexual reality or the realm of sexual possibility.

Culturally, we've developed a very genitally focused and orgasm-oriented approach to sex. People who enjoy non-genitally focused forms of sexuality, who choose not to focus on orgasm as their primary sexual

goal, or who may have difficulty having orgasms may be thought of, or think of themselves as, odd or flawed. If a person doesn't orgasm easily, and from the types of stimulation they think are "supposed to" give them orgasms, they may assume that there's something wrong with them – even though, much of the time, there isn't anything wrong with them at all.

Sexual response is a very individual and variable thing. Not all people enjoy the same things. Not all people orgasm from the same things, with the same frequency, or from the same kinds of stimulation. But the unfortunate tendency many fat people share when they don't feel that their sexual response measures up to the way they think it's "supposed to be," is to assume that they are sexually abnormal because they are fat. We're taught to believe, after all, that if negative things happen to us in the sexual arena, it's because we're fat: Have trouble getting a date? Its because you're fat. Partner have an affair behind your back? Well, if you weren't so fat, they wouldn't have wanted to look elsewhere. Irregular menstrual periods? Impotence problems? Having trouble getting pregnant? Doctors often blame infertility on fat. And so on and so forth, ad nauseam, with the same old non-answer. "X happened because you're fat" is simply not necessarily the case. Weight, size, and people's attitudes toward it (our own as well as other people's) may have something to do with these and other situations. It's possible that weight and weight-related attitudes might have a determining role in a given situation, but a person's weight or size is rarely the only or even the primary reason that things happen to them, be those things good or bad.

The presence or absence of body fat does not change the human ability to be sexual. There's nothing about being fat that makes it any more or less difficult to feel sexual pleasure or to have orgasms. As long as there are no physiological problems such as nerve damage or injury, there should be no physical obstacles between any fat person and a full, pleasurable, wonderful sex life. Fat people have the same equipment as anyone else – it's in the same places, it does the same things, and it looks remarkably the same. The labia majora and mons can carry extra fat (the area just above and around the base of the penis is the analogous spot in males), but if you were to look at close-up photos, you'd see no appreciable differences between a fat woman's clitoris or vagina and a thin woman's clitoris or vagina, a fat man's penis and scrotum and a thin man's penis and scrotum. There'd be no difference in their neurology, no dif-

ference in their physiology, and no difference in their function. In fact, it might be argued that on some level, fatter people have a greater capacity to feel pleasure, since we have more square inches of skin surface with which to feel the delicious sensations of being caressed, stroked, and embraced!

Logically speaking, therefore, there's no real reason for fatter folks to have any less sexual pleasure than thinner ones: we have the same range of response as anyone else. In fact, while there's no physiological reason for it, there is some evidence that suggests that on the whole, fatter women are more likely than their thinner sisters to have orgasms – this was the conclusion drawn by a 1996 survey done by *Weight Watchers* magazine, which suggested that not only were fatter women more likely to be orgasmic, but that they were more likely than their thinner sisters to be in happy relationships. Why? It's anyone's guess, really, but various people have suggested that fatter women may have better sex lives because they are more in touch with their physical appetites, and/or because they are less uptight about how their bodies might look during sex. Perhaps people who eat more are less likely to suffer nutritional deficiencies or dieting-related depression. Maybe people who are more comfortable with their bodies in terms of their weight and appearance are likely to be more comfortable with themselves as sexual beings! Certainly one survey by no means indicates that all fat women have amazing sex lives, but it is heartening to think that there's some proof that it is possible for fat people's sex lives to be every bit as good as anyone else's.

But still, people often attribute any lack or perceived lack in their sexual response to their weight or size. One woman writes: "I have trouble achieving orgasm when we are having intercourse. I believe that the biggest reason is that I am too large to 'feel' the manipulations that would bring me to orgasm. I often use a vibrating egg by my clitoris while we make love so that I can achieve orgasm with my husband." You can almost hear her thinking "if only I were thinner, I'd be able to orgasm easily from penetration," but the simple fact is that it's quite common for women not to orgasm easily from penetration alone. Many women require clitoral stimulation to orgasm, and as a result, many women adopt the eminently reasonable strategy of making sure they get adequate clitoral stimulation during penetrative sex, just as this woman has done. Because she is fat, this woman feels that her sexual "failure" is due to her corresponding "failure" to be thinner, when all that's really going on is

that she's one of the millions of women who orgasm most dependably from clitoral stimulation.

Ria, 35, writes about her own difficulties achieving orgasm in a much more realistic, proactive and positive way: "I've never had an orgasm during intercourse, and have never had a real cunnilingus attempt, but I don't attribute that to fat, just physiology and/or inattentive lovers. I orgasm quite well on my own, yay! My last, current lover tried to masturbate me but ended up hurting and numbing me out. He's younger, doesn't have fine control of his hands, and is even more inexperienced than I am, but I can't beat down the thought that it was because I was too fat for him to find my clitoris." Ria's on the right track – she knows that her lack of orgasms during partnered sex has to do with her partners, not with her body, but it's an indicator of how deeply ingrained the equation of fat and perceived sexual "failure" can be that Ria still sometimes worries whether her fat is to blame.

It's often very difficult for people to ask for what they want sexually. It may feel greedy, or people may be concerned about being too demanding or having someone else think they are "slutty" because they know what they want and how they want it. Because of years of conditioning that tell us that fat people don't deserve to have fun, don't deserve to be paid attention to, and certainly don't deserve to be sexual, it can be especially difficult for fatter people to make these kinds of requests. But it's worth bucking up the courage to ask. A partner can't learn how to please you better if they don't get any feedback. They can't read your mind to find out what your fantasies are, how you like to be fucked, or whether you want to get on top. It's much easier to work together with your partner(s) to have really wonderful sex when there's good communication between you.

Experimentation and good communication are your best tools for improving your sex life. If you are having trouble talking with your partner about sex, it can be worthwhile to see a counselor or therapist (either alone or jointly) in order to help facilitate things. Phrasing things carefully can be a good adjunct to any attempts to improve the flow of sexual communication – "I just love such-and-such a position, you get into me so deep that way" is likely to be better received than "Geez, you don't have a very big penis, so we'd better use another position" and "Oooh, why don't you roll over so I can knead your gorgeous butt while I'm inside you" is going to go over a lot better than "Let's do it doggy-style. Your big stomach keeps getting in the way."

Learning more about sex is another crucial ingredient in having better sex. As you learn, you become better able to articulate what it is that you want and need. Learning, talking, and experimenting will all help you have a more realistic idea of what is possible for you and your body, what to ask for and how to ask for it. You may even find some new and exciting options you never knew existed.

As a sexual human being, you deserve to have a sex life that is pleasurable, enjoyable, and satisfying. You don't have to "settle" for a crummy sex life because "it's all you can get" – because it isn't. You especially don't have to put up with sex that is non-consensual, exploitative, degrading, humiliating, or painful. You have the right to say no, as many times as you want. You have the right to say yes as many times as you want, too. You have the right to ask for what you want, and you have the same potential to get what you want sexually as anyone else does. You have, in short, exactly the same birthright to sexual pleasure and satisfaction that any thinner person does. If you want to be sexual, or more sexual than you are right now, go right on ahead and do it! Your size has nothing to do with it.

Here are the words of some of the people who answered the research survey for this book, each of whom was given the opportunity to share their own thoughts on size, sex, and satisfaction. Some of these people are fat, some are not – all of them know that life and sex aren't determined by how much you weigh or what size clothes you wear. The words of survey respondents have peppered this book, and their input was formative in its creation. It seems only fitting to let them have the last words about what they've learned about size, sexuality, and themselves.

"Being fat is the same as having large feet or a bald head. Don't be ashamed to be different. Use this difference to your advantage. Know that there are people out there that find you sexy just the way you are. There's always someone out there for you, just be patient enough to wait for them. They might be lost finding you!" – Sam

"There are a lot more people who find fat attractive than you think. What is most important, many of them don't even KNOW that yet – the possibility of liking plump, stocky, or fat persons

hasn't even occurred to them. Go out and show them what they really like." – Scandinavian FA

"If a man tells you to lose weight or he'll dump you, lose him. You can do better. Recognize your sexiness and build on it. Be comfortable with your body. Society believes that thin is beautiful, but society doesn't know what it's missing out on. It's their loss. Love yourself. Screw society." – 23-year-old woman

"Be aware of your own preconceptions and assumptions and try to (where necessary) disrupt them. Not doing so can rob you of any chance to make peace with (and finally celebrate) your own body. It's not size that prevents others from being attracted to you – it's your own insistence that nobody could or would find you attractive that convinces them you're right about it." – Demeter

"Don't settle for a romantic partner you aren't totally into just because they're willing to have you. There are lots of folks out there who either don't really care what size you are, or will find you more attractive the way you are than they would if they were skinny. If you happen to encounter someone who really digs your body, consider seriously at least listening to them talk about how attractive they find you. Being desired for your body can be a heady experience!" – Sophie

"As the poet Martin Espada writes: 'Rebellion is in the circle of a lover's arms.' It's essential to stop worrying about what people 'might' think, and get down to the business of learning to give and receive pleasure. Feel erotic and others will feel that from you. Guaranteed." – Lucha

THE SURVEY

Part of the research done for this book consisted of a lengthy survey that was posted on the World Wide Web. Calls for participation were issued online on several fat-related e-mail lists. The survey was quite lengthy, and as a result, many of the surveys submitted were unusable because they were left incomplete. However, a total of 109 complete surveys were tabulated and used as part of the information in this book. While this survey was not a scientific one, and the population that answered it was obviously self-selected, it nonetheless gives some useful ideas about what sexuality is like for fat people and fat admirers. It represents the first effort made to survey fat people and fat admirers as a general group of people (without regard to sexual preference, gender, weight limits, etc.) about their sexual realities, without proceeding from a biased viewpoint that fat people must, by definition, have problems in their sex lives.

Of the 109 surveys analyzed, 74 respondents were female, 33 were male, and 2 identified as transgendered or intergendered. The median age was 32 years, though there were respondents as old as 72 years and as young as 19 years of age. 45 respondents identified themselves as heterosexual, 39 as bisexual, 19 as homosexual, and 4 as pansexual (a term which means that a person is attracted to all genders, including transsexual or intergendered persons).

Physically, the respondents described themselves most frequently as "fat" (71 responses). Other terms that respondents used to describe

themselves are listed in order of frequency with the number of responses for each term given in parentheses (multiple reponses were acceptable):

Voluptuous (51)

Round (36)

Other terms not given in the list (33)

Chubby (32)

Obese (25)

Thick (18)

Bear (17)

Muscular or Stocky (10 responses each)

Normal (8)

Thin (1)

The respondents used a variety of terms to refer to themselves or identify themselves. In order of frequency (again, multiple responses were acceptable), respondents referred to themselves thusly:

BBW – Big Beautiful Woman (48)

Chub (16)

Fat Admirer or FA (14)

Bear (12)

Chubby Chaser (9)

BHM – Big Handsome Man (8)

Bear Cub (7)

Gainer or Encourager (3 each)

Feedee (2)

Feeder (1)

The overwhelming majority of the respondents – 76 of them — were in sexual relationships at the time that they completed the survey. Respondents first became sexually active (no definition of "sex" was given, permitting respondents to decide for themselves what constituted sexual activity in their own lives) at a median age of 16.5 years. 30 of the respondents had children at the time that they completed the survey.

In regard to how survey respondents preferred to maintain their relationships, 63 preferred monogamy, 8 preferred serial monogamy, 26 preferred either polyfidelity or polyamory, 7 preferred casual sex or swinging, and one person preferred polygamy. The median number of sexual partners the respondents had had in their lifetimes was 13, though the range went from respondents reporting only one sexual partner to respondents claiming over 500 sexual partners. The median length of the

longest-lasting relationships the respondents had been in was 60 months (5 years).

Respondents were asked to rank the sexual activities they engaged in most frequently from a list. Below are the activities, listed in order of frequency, with the number of respondents reporting a given activity in parenthesis.

Vaginal Sex – with penis, fingers, dildo, etc. (78)

Masturbation (76)

Oral Sex – giving or receiving (71)

Breast or Nipple Play (25)

Mutual Masturbation (21)

Anal Sex – with penis, fingers, dildo, etc. (16)

Group Sex (4)

Frottage or Rubbing (3)

Teasing (2)

Other forms of sex not listed (2)

BDSM Play (1)

Food Play (1)

Foot Fetish or Foot Play (1)

Body Worship or Body Fetishism (1)

Respondents were asked whether they had sex more often than they wanted to, as often as they wanted to, most of the time that they wanted it, or nowhere near as often as they wanted to have sex. Only one respondent reported having sex more often than desired, 13 said that they had sexual activity as often as they wanted to, 34 listed themselves as having sex most of the time they desired it, and 58 said that they did not get to have sex anywhere near as often as they wanted to.

In terms of sexual pleasure and satisfaction, 25 of the people surveyed said that sex for them was always satisfying or pleasurable, 41 said that it was almost always so, and 25 said that most of the time that they had sex, it was satisfying or pleasurable. Only 7 said that it was "sometimes satisfying/pleasurable," 4 reported that it was "not very" satisfying or pleasurable, and 1 replied that it was almost never satisfying or pleasurable for them.

In terms of their relationships with partners, 59 respondents said that they had had sexual relationships mostly with partners thinner than they were. 13 reported having had sexual relationships mostly with partners fatter than they were. 25 respondents said that most of their partners had been in the same size range as theirs.

66 of the 109 survey respondents reported that they had been asked out or propositioned for sex because of their size or weight, but only 38 of them said that they had ever asked anyone else out or propositioned them for sex for similar reasons. 79 respondents said that they had been rejected for a date or for sex because of their size or weight, but only 28 of them had ever rejected another person for sex or a date on the basis of size or weight issues. 84 respondents said that their size or weight had been a factor in whether or not they had pursued a partner whom they found desirable or attractive.

58 respondents say that they think they are sexy, another 34 said that they sometimes think they are sexy, and only 15 said that they feel they are not sexy. Body image was a slightly different story: 36 respondents said they thought their bodies were sexy, 33 said they sometimes thought their bodies sexy, and 37 said that they did not feel their bodies were sexy. However, 95 of the respondents reported that they felt that other people found them sexy or sexually desirable.

In terms of sexual dysfunction, only 33 reported any history of sexual problems, and 20 of those attributed that dysfunction either to their weight or a partner's. 60 people said that there are things they'd like to do or try sexually that they had never done or felt able to attempt because of their size or weight.

Among fat admirers, 19 said that their attraction to fat partners had begun in childhood, 8 of them realized their attractions as teenagers, and 14 came to the realization that they desired fatter lovers as adults. 7 fat admirers were themselves attracted to the idea of becoming fatter, though only 5 of them said that they felt they would be more attractive if they were fatter.

41 respondents had had difficulty obtaining good sexually-related advice, information, or medical care from health care providers, and 34 of these felt that this difficulty was due to their weight or size or to their medical providers' attitudes about their weight or size. 86 of the respondents say that they practice safer sex, 45 of the respondents say that safer sex is "extremely important to them," 43 say that safer sex is "pretty important but I don't (by choice) have safer sex 100% of the time," and only 14 say that safer sex is either not very important or unimportant to them. 45 respondents say that they have been pressured or asked not to use safer sex methods in the past, but only 4 of them said that they felt that pressure had anything to do with their weight or size. 76 respon-

dents reported that they have been HIV tested. 36 reported that they have been diagnosed with or treated for an STD.

76 of the respondents reported that they had been fat as children and 83 of them said they'd been fat as teenagers (ages 13-20). Only 19 of the respondents reported that neither of their parents were fat. When respondents were growing up, 72 of them reported having had sexual desirability or the threat of being found sexually undesirable ("you'll never have a boyfriend if you don't lose weight," etc.) used as a means to try to make them lose weight. Only 41 of them said that they believed as children that fat people could have happy, healthy, enjoyable romantic lives.

RESOURCE GUIDE

This list of resources is representative but not exhaustive. Every effort has been made to assure you of up-to-date, useful information on as many relevant topics as possible. However, some information may have become outdated in the time between the compilation of this list and your use of its resources.

GENERAL INTEREST

Print Magazines

BBW Magazine
www.bbwmagazine.com
One Year US Subscriptions: $15 / year
BBW Magazine, P.O. Box 1297, Elk Grove, CA 95759

Bella Magazine (New Zealand)
www.bella.co.nz
One Year Subscription: NZ$24 / US $20
Bella Magazine, PO Box 37 421, Parnell , Auckland, New Zealand
Phone: +64 9 309 8416 Fax: +64 9 308 9134
Note: Bella maintains a strong online presence as well as its print version.

Canada Wyde
www.interlog.com/~cdawyde
One Year Subscription: $21.40 Canada / $25 US
P.O.Box 511, 99 Dalhousie Street, Toronto, Ontario M5B 2N2 CANADA

or people who don't apologize for their size!

r a single copy.

423464 San Francisco CA 94142

maintains a strong web presence, including a high-traffic d̶i̶s̶c̶ board.

Mode
www.modemag.com
22 East 49th Street, New York, NY 10017
Phone: 1-888-610-MODE
US $18 for a one year subscription or $2.50 for a single copy

Radiance: The Magazine for Large Women
www.radiancemagazine.com
Single Year US Subscription $20 / Canada $26
P.O. Box 30246, Oakland, CA 94604
Phone: (510) 482-0680 Fax: (510) 482-1576
Note: Radiance maintains an extremely strong web presence, including its highly-acclaimed Kids Project pages (see Resources for Teenagers). Of special interest to the fat-and-sexy reader is its yearly Swimsuit Issue, which appears each summer.

Webzines

Abundance Magazine
abundancemagazine.com

BBW Today
www.dakodadesigns.com/bbw/

Thick
216.55.27.148/thick/

Books

Bovey, Shelley. *The Forbidden Body: Why Being Fat Is Not A Sin* (Pandora Press, 1994)

Brown, Laura S. and Rothblum, Esther. *Overcoming Fear of Fat* (Harrington Park Press, 1989)

Bruno, Barbara Altman. *Worth Your Weight: What You Can Do About A Weight Problem* (Rutledge, 1996)

Donley, Carol C. and Buckley, Sheryl. *The Tyranny of the Normal: An Anthology* (Kent State University Press, 1996)

Erdman, Cheri. *Nothing To Lose: A Guide to Sane Living in a Larger Body* (Harper Collins, 1995)

Erdman, Cheri. *Live Large!* (HarperCollins, 1996)

Fraser, Laura. *Losing It: America's Obsession with Weight and the Industry that Feeds It* (Dutton, 1997)

Gaesser, Glenn, Ph.D. *Big Fat Lies: The Truth About Your Weight And Your Health* (Fawcett Columbine, 1996)

Garison, Terry Nicholetti, and David Levitsky, Ph.D. *Fed Up! Liberating Ourselves from the Diet/Weight Prison* (Carroll & Graf, 1993)

Goodman, Charisse. *The Invisble Woman: Confronting Weight Prejudice in America* (Carlsbad, CA: Gurze Books, 1995)

Hillman, Carolyn. *Love Your Looks: How to Stop Criticizing and Start Appreciating Your Appearance* (Simon & Schuster, 1996)

Hutchinson, Marcia Germaine. *Transforming Body Image: Learning to Love the Body You Have* (Crossing Press, 1985)

Johnson, Carol. *Self-Esteem Comes In All Sizes* (Doubleday, 1995)

Louderback, Llewellyn. *Fat Power: Thin May Be In, But Fat's Where It's At!* (Hawthorn Books, 1970)

Manheim, Camryn. *Wake Up, I'm Fat!* (Broadway Books, 1999)

Mayer, Ken. *Real Women Don't Diet! One Man's Praise of Large Women* (Bartleby Press, 1993)

Millman, Marcia. *Such a Pretty Face: Being Fat In America* (New York: Norton, 1980)

Schoenfielder, Lisa, and Wieser, Barb, eds. *Shadow On A Tightrope: Writings by Women on Fat Oppression* (Aunt Lute, 1983).

Schroeder, Charles Roy, Ph.D. *Fat is Not a Four-Letter Word* (ChronMed, 1992)

Schwartz, Hillel. *Never Satisfied: A Cultural History of Diets, Fantasies, and Fat* (Anchor Books, 1990)

Thone, Ruth Raymond. *Fat – A Fate Worse Than Death: Women, Weight, and Appearance* (The Haworth Press, 1997)

Wann, Marilyn. *Fat! So? Because You Don't Have To Apologize For Your Size* (Ten Speed Press, 1999)

Wolf, Naomi. *The Beauty Myth: How Images of Beauty are Used Against Women* (Anchor Books, 1992)

SEXUALITY RESOURCES

General

Web Resources

BiNet USA – www.binetusa.org

International Foundation for Gender Education – www.ifge.org

International Sex Workers' Foundation for Art, Culture, and Education –www.iswface.org

The Kinsey Institute – www.indiana.edu/~kinsey

Queer Resources Directory – www.qrd.org/qrd/

San Francisco Sex Information – www.sfsi.org

Safer Sex – www.safersex.org

Sexual Health Network – www.sexualhealth.com

The Society for Human Sexuality – www.sexuality.org

Books

Anand, Margo. *Art of Sexual Magic: Cultivating Sexual Energy to Transform your Life* (Putnam/Tarcher, 1991)

Blank, Joani, ed. *First Person Sexual: Women & Men Write About Self-Pleasuring* (Down There Press, 1996)

Blank, Joani. *Good Vibrations: The Complete Guide to Vibrators* (Down There Press, 1990)

Blank, Joani, ed. *I Am My Lover: Women Pleasure Themselves* (Down There Press, 1998)

Boston Women's Health Collective. *Our Bodies, Ourselves For The New Century: A Book By And For Women* (Touchstone Books, 1998)

Brent, Bill. *The Black Book*, 5th Edition (Black Books, 1999)

Castleman, Michael. *Sexual Solutions: For Men and the Women Who Love Them* (Touchstone, 1989)

Dodson, Betty. *Sex for One: The Joy of Selfloving* (Crown Publications, 1996)

Easton, Dossie and Catherine A. Liszt. *The Ethical Slut: A Guide to Infinite Sexual Possibilities* (Greenery Press, 1998)

Haines, Staci. *The Survivor's Guide to Sex : How to Have a Great Sex Life After Child Sexual Abuse* (Cleis Press, 1999)

Heart, Mikaya. *When the Earth Moves: Women and Orgasm* (Celestial Arts, 1998)

Hutton, Julia. *Good Sex: Real Stories from Real People* (Cleis Press, 1995)

Joannides, Paul. *The Guide to Getting It On!* (Goofy Foot Press, 1998)

Kasl, Charlotte, Ph.D. *If the Buddha Dated : A Handbook for Finding Love on a Spiritual Path* (Penguin USA)

Litten, Dr. Harold. *The Joy of Solo Sex* (Factor Press, 1994)

Dr. Patricia Love and Jo Robinson. *Hot Monogamy: Essential Steps to More Passionate, Intimate Lovemaking* (Plume, 1995)

McIlvena, Ted. *The Complete Guide to Safer Sex* (Barricade Books, 1999)

Morin, Jack, Ph.D. *Anal Pleasure and Health: A Guide for Men and Women* (Down There Press, 1998)

Morin, Jack. *The Erotic Mind : Unlocking the Inner Sources of Sexual Passion and Fulfillment* (Harperperennial Library)

Moser, Charles, Ph.D., M.D. *Health Care Without Shame: A Handbook for the Sexually Diverse and Their Caregivers* (Greenery Press, 1999)

Queen, Carol. *Exhibitionism for the Shy* (Down There Press, 1995)

Rosenthal, Saul. *Sex Over 40* (Tarcher, 1989)

Semans, Anne and Cathy Winks. *The Woman's Guide to Sex on the Web* (Harper Edge, 1999)

Steinberg, David, ed. *The Erotic Impulse: Honoring the Sexual Self* (Tarcher/Putnam, 1992)

Taormino, Tristan. *The Ultimate Guide to Anal Sex for Women* (Cleis Press, 1997)

Winks, Cathy. *The Good Vibrations Guide: Adult Videos* (Down There Press, 1998)

Winks, Cathy and Anne Semans. *The New Good Vibrations Guide to Sex* (Down There Press, 1997)

Zilbergeld, Bernie, Ph.D. *The New Male Sexuality: The Truth About Men, Sex and Pleasure* (Bantam, 1984)

Gay/Lesbian/Bisexual/Transgender

Atkins, Dawn, ed. *Looking Queer : Body Image and Identity in Lesbian, Bisexual, Gay, and Transgender Communities* (Harrington Park Press, 1998)

Bornstein, Kate. *My Gender Workbook: How to Become a Real Man, A Real Woman, the Real You, or Something Else Entirely* (Routledge, 1998)

Caster, Wendy. *The Lesbian Sex Book: A Guide for Women Who Love Women* (Alyson Publications, 1993)

Hart, Jack. *Gay Sex : A Manual for Men Who Love Men* (Alyson Publications, 1998)

Hutchins, Loraine and Lani Kaahumanu, eds. *Bi Any Other Name* (Alyson Publications, 1991)

Queen, Carol and Lawrence Schimel, eds. *Pomosexuals: Challenging Assumptions About Gender and Sexuality*

Vera, Veronica. *Miss Vera's Finishing School for Boys Who Want to Be Girls* (Doubleday, 1997)

BDSM – Bondage, Submission, Domination, etc.

Brame, Gloria G., William D. Brame and Jon Jacobs. *Different Loving: the World of Sexual Dominance and Submission* (Villard Books, 1996)

Henkin, William A., Ph.D., and Sybil Holiday, CCSSE. *Consensual Sadomasochism: How to Talk About It and How to Do It Safely* (Daedalus Press, 1996)

Wiseman, Jay. *SM 101: A Realistic Introduction* (Greenery Press, 1998)

Romance Novels

Rubenesque Romances
www.rubenesque.com
Rubenesque Romances
P. O. Box 534, Tarrytown, NY 10591-0534
Note: Rubenesque Romances has published 13 titles thus far.

Adult

Note: "Adult" here means "explicitly sexual in intent or content." Items included in this list may be softcore, hardcore, or some combination thereof.

Pictures and Art Books

Note: These books tend toward softcore rather than hardcore images, feature more "artistic" visual work, and, generally speaking, to be of a very high aesthetic and production standard. All of these books contain images of bodies of a range of sizes. Some contain bigger/fatter bodies than others.

Edison, Laurie Toby. *Women En Large: Images of Fat Nudes* (Books In Focus, 1994)

Néret, Gilles. *Erotica Universalis* (Taschen, 1996)

Rosen, Michael. *Lust and Romance* (Last Gasp, 1998)

St. Paige, Edward. *Zaftig: A Case For Curves* (Darling & Co., 1999)
Note: This is a book of fine art images of "zaftig" women of various degrees of plumpness. It is a completely non-explicit book of the "coffee table art book" variety.

Steinberg, David, ed. *Erotic by Nature* (Down There Press, 1991)

Heterosexually Oriented

Note: With rare exceptions, almost all the material in this category is geared toward men. This means that they will almost invariably feature images and texts that have women for their sexual objects. Please see notes on individual entries in regard to any individual publication's orientation in this regard. As with all companies producing sexually explicit material, the companies below require a signed statement that you are of legal age when ordering

Belly: Where Fat Chicks Are Cool
www.belly.co.uk
Single Year US Subscription $55 / Single issues $15
American Orders to: J. Kinnee, 2343 Parkwood, Toledo, Ohio, 43620, USA
Note: Belly also maintains a fairly extensive website.

Dimensions
www.dimensionsmagazine.com
Single year US subscription $30
Dimensions Magazine, PO Box 640, Folsom, CA 95763-0640
Note: Dimensions' website is extremely extensive and informative on many issues, with an excellent links section and extensive personal ads. The magazine and website alike are primarily oriented toward Fat Admirers who are heterosexual men. Photo layouts are exclusively of women. However, women FAs are also represented in articles. There is also a great deal of nonsexual content on issues including health, fashion, fat acceptance movement news, and so on. Dimensions *accepts and publishes feeder fetish material and personal ads.*

Plumpers and Big Women
www.plumpersmag.com
800-873-0366 for hard copy subscriptions
Note: This magazine's website is also a commercial (pay) porn website. You must use the 1-800 number to order the magazine.

Big Butt Magazine
www.bigbuttmag.com
One year US subscription $59.95
Jiffy Fulfillment, Inc., PO Box 1102, Cranford, NJ 07016-1102
1-888-664-7827

Zaftig! Sex for the Well Rounded
http://www.xensei.com/users/zaftig
One year US subscription $26
Zaftig!, 54 Boynton Street, First Floor, Boston, MA 02130
Note: Zaftig! *is the only pansexual, pan-orientational fat sex magazine on the market. It's edited and published by the author of this book. The entire editorial staff and the majority of writers are female, and the magazine has a strong pro-woman, pro-women's-sexuality ethic. The associated website is quite extensive.*

Videos, Magazines, and Miscellaneous

Vendredi Enterprises
www.dimensionsmagazine.com/images/ads/vendredi/
Vendredi Enterprises
P.O. Box 10
Garden Valley, CA 95633

Phone: (408)739-4192 Fax: (530) 622-7493

Note: Affiliated with Dimensions *magazine, Vendredi Enterprises carries perhaps the single most comprehensive selection of BBW porn magazines, videos, and other adult materials. Their catalog is uniformly oriented toward heterosexual men. Includes an extensive catalog of BBW dominatrix/ FemmeDom material, including smothering and trampling fetish materials in addition to the standard BBW and big breast fare.*

Maximum Density Videos
www.afterimage-studios.com
Maximum Density Productions
3020 Bridgeway Suite 184, Sausalito, CA 94965
Phone: (415) 339 –8816

Note: Primarily carrying videos of big queer men, the Maximum Density site catalogue also features some movies with heterosexual sex, all of which feature large men. Some also feature larger women. This is one of the few places where heterosexual women who prefer larger men, or straight men who want to see bodies like their own in porn films, can find videos to suit their tastes.

Homosexually/Bisexually Oriented

Note: Since the demise of FaT GiRL magazine, there is no current source of erotica specifically for fat queer women. Most of the material below is oriented toward gay men. As with all companies producing sexually explicit material, the companies below require a signed statement that you are of legal age when ordering.

American Bear
www.amabear.com
Single year US subscription $38, Single issues $10
American Bear, PO Box 7083, Louisville KY 40257-7083

American Grizzly
www.amabear.com
Single year US subscription $25
American Bear, PO Box 7083, Louisville KY 40257-7083

Bear
www.brushcreek.com
Single year US subscription $39
Brush Creek Media, 2215-R Market Street #148, San Francisco, CA 94114
Phone: (415) 552-1506 Fax: (415) 552-3244

Phone: (415) 339 –8816

Note: Focus here is on chubs, not bears.

BBW / FA Resources

Canada Wyde Personals

www.interlog.com/~cdawyde/date.htm

Dimensions

www.dimensionsmagazine.com

Single year US subscription $30

Dimensions Magazine PO Box 640 Folsom, CA 95763-0640

Note: Dimensions' *website is extremely extensive and informative on many issues, with an excellent links section and extensive personal ads. The magazine and website alike are primarily oriented toward Fat Admirers who are heterosexual men. Photo layouts are exclusively of women. However, women FAs are also represented in articles. There is also a great deal of nonsexual content on issues including health, fashion, fat acceptance movement news, and so on.* Dimensions *accepts and publishes feeder fetish material and personal ads.*

Extra Special Singlez

www.lrgsinglez.com

Generous.net

www.generous.net

Note: Of the BBW/FA/BHM personals sites available on the web, Generous.net's site is one of the best-organized, best-maintained, and most useful in terms of layout, design, and content.

Large and Lovely Personals

www.largeandlovely.com

Les Plus Belles Sont Celles Qui Sont Rondes

Francophone Canadian webzine with personals

www3.sympatico.ca/rondes/

Loving You Large Newsletter

1-800-689-2412

Thick (webzine, w/personals)

http://216.55.27.148/thick/

Fat Sex email distribution list
Subscription address: lists@rotunda.com
Message body: subscribe fat_sex (your email address)

CHUB/CHASER AND BEAR RESOURCES

Affiliated Bigmen's Clubs, Inc.
www.chubnet2.com/abc
ABC, Inc., 584 Castro St. - #139G, San Francisco, CA 94114
1(800) 501-3090
*Note: Includes listings (by geographical area) of all affiliated clubs and or-
ganizations for big men and the men who love them.*

Chubnet – The Wide Spot On The Web
www.chubnet.com
*Note: Without question the single most comprehensive fat-related gay men's
site on the Internet. Includes comprehensive US and international listings
of bear and chub/chaser organizations, an events calendar, and numerous
other links. Maintains an extensive online catalogue of clothing, videos, and
other merchandise.*

Amabear Publishing, Inc. Links
www.amabear.com/links.htm

Resources for Bears
http://www.resourcesforbears.com/

LESBIAN OR WOMEN-ORIENTED

National Organization of Lesbians of Size
www.breakinc.com/nolose
NOLOSE, 245 Eighth Ave. # 107, NY, NY 10021

Fat is a Lesbian Issue and Fat Lesbians Action Brigade (FLAB)
www.geocities.com/WestHollywood/Village/1336/
(201) 843-4629
*Note: As a group with regular meetings, this group is based in New York
City.*

FaT GiRL
www.fatso.com/fatgirl/
*Note: The print 'zine is sadly no longer in existence. The website, happily,
still exists, though it has not been updated since 1997.*

Full Bloom Women
members.aol.com/sussy34/fbw.htm
Note: Full Bloom Women is a South New Jersey / Philadelphia area group for women of size that is lesbian and bi-friendly, but is not specifically a lesbian organization.

SeaFATtle
www.wolfenet.com/~marymc/seafattle.htm
SeaFATtle, 10026 51st Avenue S.W. , Seattle, WA 98146
Note: SeaFATtle is not specifically lesbian. It is a women's collective of fat feminists and their allies, dedicated to activism and support.

Sisters of Size
Seattle support group for fat dykes. Find their contact information via the SeaFATtle website.

The Venus Group
234 Goodson Hall
Ypsilanti, MI 48197

WOW (Women of Width)
San Francisco area group for fat lesbians
Joyce Wermont, contact
Email: Jwermont@sonic.net

Fatdykes email distribution list
Subscription address: fatdykes-request@apocalypse.org
Message body: subscribe (your email address)

FatGrrlSex email distribution list
Subscription address: http://www.queernet.org/lists/fgs.html

SIZE ACCEPTANCE ORGANIZATIONS AND RESOURCES

NAAFA (National Association for the Advancement of Fat Acceptance)
www.naafa.org
NAAFA, PO BOX 188620, Sacramento, CA 95818
Phone: (916) 558-6880 Fax: (916) 558-6881
NAAFA has chapters in: Nebraska, Missouri, Montana, New Jersey, Pennsylvania, Washington D.C., Maryland, Colorado, Illinois, Michigan, Ohio, Massachusetts, Connecticut, New York, California, Nevada, Washington, Oregon, Arizona, Oklahoma, Texas, Eastern Canada, and Western Europe. Contact them or check their website for details on regional chapters.

...e Acceptance Association)

...rg

...eptance Association, P.O. Box 82126, Austin, TX

...uthern California, Chicago, New Jersey, Ohio, Texas,
...ds, Canada, and New Zealand. Contact them or check
their websites ... ls on regional chapters.

Council on Size and Weight Discrimination
www.cswd.org
P.O. Box 305, Mount Marion, NY 12456
Phone: (914) 679-1209

Largesse: The Network for Size Esteem
www.fatso.com/fatgirl/largesse/index.html

Les Plus Belles Sont Celles Qui Sont Rondes
www3.sympatico.ca/rondes/

Allegro Fortissimo – Paris, France
Home.worldnet.fr/abenk/index.htm

BBW, BHM e FA in Italia – Italy
www.geocities.com/NapaValley/9793/

DIRECTORIES AND INTERNET GUIDES

Bear Ring
www.webring.org/cgi-bin/webring?ring=bears;list

The BBW/FA Webring
ring.bbwqt.com
Note: This webring is specifically oriented toward non-adult BBW/FA
sites.

Bi/BBW Webring
www.geocities.com/WestHollywood/Village/1345/webring.html

Hot BBW Sites Ring
www.webring.org/cgi-bin/webring?ring=hotbbw;list
Note: This webring is specifically oriented toward sexually explicit BBW/
FA sites.

Chubs and Chasers Web Ring
www.webring.org/cgi-bin/webring?ring=gaychub;list

Largesse, the Network for Size Esteem
www.eskimo.com/~largesse/
Fax: (707) 929-1612

Plus Stop – Everything Plus Size on the Internet
www.plusstop.com

SizeNet – Information for Those of Fuller Figure
www.sizenet.com
Note: Based in, and oriented toward, the UK.

Size Wise
www.sizewise.com
Note: This very comprehensive Internet Directory is the web presence of a book by the same name, written by Judy Sullivan, which is also offered in a print version. It remains one of the best size-positive directories available.

Resources for Teenagers

Big Beautiful Teens Penpals
www.size-acceptance.org/penpals.html
Teen Pals, c/o ISAA, P.O. Box 82126, Austin, Texas 78758
Note: This Penpals resource is billed as "friendship only" and is not a service intended to help teenagers find partners or sexual activity.

Radiance Magazine – Kids Project
www.radiancemagazine.com/kids.html
Features essays by big teenagers and sources for information and support.
Note: Radiance also regularly publishes pieces by and for fat teenagers in its print magazine as well.

Pregnancy, Childbirth, and Infertility Issues

Ample Stuff
P.O. Box 116, Bearsville, NY 12409
(914) 679-3316
Note: Ample Stuff is a catalogue which provides a number of size-friendly resources. It is listed here specifically for its plus-sized hospital gowns, which fit both men and women.

Plus-Size Pregnancy Website
www.teleport.com/~rvireday/plus/

r Women of Size
org/faq/bbwfaq.html

Syndrome Association, Inc.
rg

roiycystic Ovarian Syndrome Association, P.O. Box 7007, Rosemont IL
60018-7007

Phone: (630) 585-3690

Fat-Friendly Physicians List
www.bayarea.net/~stef/Fat/ffp.html

SEX TOY AND BOOKSTORES

Note: the stores listed below are inclusive, sex-positive businesses that
promote sexual education, pleasure, and health for all people. They are
not specifically fat-related businesses, but they strive to accommodate a
wide variety of clientele, including people of size.

Blowfish
www.blowfish.com
2261 Market St #284, San Francisco CA 94114
*Note: Blowfish is a catalog sales business only and has no retail store. You
may order from their online catalogue or request a paper version.*

Come As You Are
www.comeasyouare.com
701 Queen Street West, Toronto, Ontario, Canada
Phone toll-free: 1-877-858-3160

Good Vibrations
www.goodvibes.com
1210 Valencia Street, San Francisco, CA 94110
Phone: (415) 974-8980
2504 San Pablo Avenue, Berkeley, CA 94702
Phone: (510) 841-8987
*Note: Good Vibrations is part of Open Enterprises, which also encompasses
the operations of Down There Press and The Sexuality Library.*

Grand Opening!
www.grandopening.com
318 Harvard Street, Suite 32, Brookline, MA 02146 USA
Phone: (617) 731-2626

Toys In Babeland
www.babeland.com
707 East Pike Street, Seattle WA 98122
Phone: (206) 328-2914
94 Rivington Street, New York NY 10002
Phone: (212) 375-1701

LINGERIE AND SEXY CLOTHES

Note: Most of these resources feature clothing for women only. Exceptions to this rule are noted where applicable.

Barb's Large and Lovely
www.bll.com
1842 Reddington Timbers, St. Charles, MO 63004
Phone: (636) 939-4070
Note: carries sizes 1X-8X

Big Daddy Boxers
Village Station
PO Box 423
New York, New York 10014
Big Daddy makes boxer shorts primarily for women, but at the time of this writing, they have announced plans to create a line for big men as well. Contact them for more information.

Fantasy Plus Fashions
www.fantasyplus.com
2015 South Arlington Heights Rd., Suite 112, Arlington Heights, IL 60005
Phone (800) 769-1736
Note: carries sizes L-4X

Fleur Lingerie Creations
fleur.sightspecific.com/default_f.htm
Phone/Fax: +(972) 9 766 3122
Note: online ordering only. Sizes to 5X.

Large Size Lingerie
choicemall.com/largesizelingerie/
Large Size Lingerie, Inc., Order Processing Dept., 31 East 32nd Street, 9th Floor, New York City, New York 10016
Phone: 1-800-527-0065 Fax: (212) 481-9582
Note: carries sizes 1X-6X

Leather Lady
www.leatherlady.com
Leather Lady, 248 Route 25A , Setauket, NY 11733
Phone: 1-888-LEA-LADY Fax: (516) 751-6761
Note: carries sizes to 4X

Love Your Peaches Clothing Company
www.loveyourpeaches.com
Love Your Peaches Clothing Co. Inc., 50 Webster Ave., 4th Floor, New
Rochelle, NY 10801
Phone: 888-274-7499
Note: Sexy clothes, beachwear, etc. to size 6X

Peggy Lutz Plus
www.plus-size.com
6784 Depot Street, Sebastopol, CA 95472
Note: Sexy and elegant clothes, including custom-fitted bustiers, kimonos, bodysuits, and French Maid's outfits in lush fabrics, with an exceptional quality of construction and great customer service.

Silver Lining
www.silverlining.com
Buckhead Court, 3872 Roswell Road, Atlanta, Georgia 30342
Phone: (888) 237-9911
Sizes to 26.
Note: Features bridal accessories and wedding gowns as well as lingerie and bridal lingerie. Several people have mentioned that the retail store has a much wider selection than the website. Reported to have exceptionally good customer service.

Stage Clothes
www.stageclothes.com
Stage Clothes c/o Worlwide Shops, P.O. Box 1178, Maple Grove, MN
55311-6178
Phone: 1-888-425-4545 Fax: (612) 425-6946
Sizes to 4X
Note: Also carries menswear, though not generally in extended sizes.

Wealthwood Enterprises BBW Lingerie
http://www.wealthwood.com/lingerie/AdBBMenu.htm
Wealthwood Enterprises, Route 1 Box 337, Aitkin MN 56431
Phone: (218) 678-3831
Sizes 1X-4X

Fetish Wear

Note: Many people, regardless of their size or weight, prefer to have their fetish gear and/or leather gear custom-made to their measurements. Particularly if you are considering substantial and expensive garments, it is well worth while to look into having them custom-made. There are numerous craftspeople who will be more than happy to work with you, regardless of your size. The time-honored and best way to locate a person who makes the kind of gear you want to buy is to ask those you know who own similar items. This way, you can also find out about any given merchant/craftsperson's comfort level in working with larger clients.

Barb's Large and Lovely
www.bll.com
4928 Woodhaven Drive, Jefferson City, MO 65109
Phone: (573) 761-0632
Sizes 1X-8X lingerie, fetish, and leatherwear

Leather Lady
www.leatherlady.com
Leather Lady, 248 Route 25A , Setauket, NY 11733
Phone: 1-888-LEA-LADY Fax: (516) 751-6761
Sizes to 4X

Purple Passion
www.purplepassion.com
Purple Passion, P.O. Box 1139, New York NY 10113
Phone: (212) 807-0486 Fax: (212) 807-7582
Note: Carries Direktor Leathers (to size 4X), a high-quality line of leather and rubber fetishwear. Carries men's as well as women's fetish and leather gear.

Stage Clothes
www.stageclothes.com
Stage Clothes c/o Worldwide Shops, P.O. Box 1178, Maple Grove, MN 55311-6178
Phone: 1-888-425-4545 Fax: (612) 425-6946
Sizes to 4X
Note: Carries some products for men, though not generally in extended sizes.

Stormy Leather
Retail Store: 1158 Howard St., San Francisco, CA, 94103
Retail Store Phone: (415) 626-1672
Mail Order: 1174 Howard St., San Francisco, CA 94103
Phone Orders: (415) 626-8259

Note: Among other things, Stormy Leather makes and sells the only large-size dildo harness around, the Crown. Some of their other harnesses are also available in larger sizes. In general, available sizes vary depending on the product. In some things, to approximately size 2X. In others, to a 60" hip. Check to be sure. Stormy Leather also carries products for men.

IF YOU LIKED *BIG BIG LOVE*, YOU MIGHT ENJOY:

GENERAL SEXUALITY

The Ethical Slut: A Guide to Infinite Sexual Possibilities
Dossie Easton & Catherine A. Liszt $15.95

A Hand in the Bush: The Fine Art of Vaginal Fisting
Deborah Addington $11.95

Health Care Without Shame: A Handbook for the Sexually Diverse &Their Caregivers
Charles Moser, Ph.D., M.D. $15.95

Sex Toy Tricks: More than 125 Ways to Accessorize Good Sex
Jay Wiseman $11.95

The Strap-On Book
A.H. Dion, ill. Donna Barr $11.95

Supermarket Tricks: More than 125 Ways to Improvise Good Sex
Jay Wiseman $11.95

Tricks: More than 125 Ways to Make Good Sex Better
Jay Wiseman $11.95

Tricks 2: Another 125 Ways to Make Good Sex Better
Jay Wiseman $11.95

ALTERNATIVE SEXUALITY

The Bottoming Book: How To Get Terrible Things Done To You By Wonderful People
D. Easton & C.A. Liszt, ill. Fish $11.95

Bottom Lines: Poems of Warmth & Impact
H. Andrew Swinburne, ill. Donna Barr $9.95

The Compleat Spanker
Lady Green $11.95

Jay Wiseman's Erotic Bondage Handbook
Jay Wiseman $15.95

Juice: Electricity for Pleasure and Pain
"Uncle Abdul" $11.95

KinkyCrafts: 99 Do-It-Yourself S/M Toys
Lady Green with Jaymes Easton $15.95

Miss Abernathy's Concise Slave Training Manual
Christina Abernathy $11.95

The Sexually Dominant Woman: A Workbook for Nervous Beginners
Lady Green $11.95

SM 101: A Realistic Introduction
Jay Wiseman $24.95

The Topping Book: Or, Getting Good At Being Bad
D. Easton & C.A. Liszt, ill. Fish $11.95

Training With Miss Abernathy: A Workbook for Erotic Slaves and Their Owners
Christina Abernathy $11.95

FICTION FROM GRASS STAIN PRESS

The 43rd Mistress: A Sensual Odyssey
Grant Antrews $11.95

Haughty Spirit
Sharon Green $11.95

Justice and Other Short Erotic Tales
Tammy Jo Eckhart $11.95

Murder At Roissy
John Warren $11.95

Please include $3 for first book and $1 for each additional book with your order to cover shipping and handling costs, plus $10 for overseas orders. VISA/MC accepted. Order from:

 greenery press

1447 Park St., Emeryville, CA 94608
toll-free: 888/944-4434 http://www.bigrock.com/~greenery